P9-BJR-791

ELAINE AND BILL

PORTRAIT OF A MARRIAGE

ALSO BY LEE HALL

Betty Parsons: Artist, Dealer, Collector

Common Threads: A Parade of American Clothing

ELAINE AND BILL

PORTRAIT OF A MARRIAGE

THE LIVES OF
WILLEM AND ELAINE DE KOONING

LEE HALL

HarperCollinsPublishers

HarperCollins books may be purchased for educational, business, or sales promotional use. For information, please write: Special Markets Department, HarperCollins Publishers, Inc., 10 East 53rd Street, New York, NY 10022.

FIRST EDITION

Designed by Jessica Shatan

Library of Congress Cataloging-in-Publication Data

Hall, Lee.
 Elaine and Bill, portrait of a marriage: the lives of Willem and Elaine de Kooning / by Lee Hall.—1st ed.
 p. cm.
 Includes bibliographical references and index.
 ISBN 0-06-018305-5 (cloth)
 1. De Kooning, Willem. 1904– . 2. Painters—United States—Biography. 3. De Kooning, Elaine. 4. Painter's wives—United States—Biography. I. Title.
ND237.D334H35 1993
759.13—dc20
[B] 92-54713

93 94 95 96 97 ❖/HC 10 9 8 7 6 5 4 3 2 1

To John Opper
and to Ernestine and Ibram Lassaw

CONTENTS

PREFACE

Elaine de Kooning possessed a rare talent for friendship. Over more than twenty years, she was a stalwart friend and a valuable colleague. She helped me organize and direct a special program on contemporary art for students who came to Drew University from other liberal arts colleges around the country; she also eagerly lectured and showed slides to students at three institutions I served: Drew University, State University of New York College at Purchase, and Rhode Island School of Design. In these formal situations I was able to tape-record Elaine's messages and talk later with her about what she really meant or why she held a particular opinion.

In a more casual manner, we visited one another in our homes and studios, and we talked regularly on the telephone—gossiping, lamenting current events, and talking seriously about painting. Elaine's stories, ideas, and comments often warranted notes and journal entries.

During the last several years of Elaine's life, when I was writing a biography of New York dealer and artist Betty Parsons, I talked often with her about artists whom Betty showed in her gallery, about other artists and their shows, about trends and directions in post–World War II art. Elaine's knowledge of the art world, her familiarity with artists, and her store of anecdotes were vast and enchanting. And as she talked about art, she always talked about Bill; as she dissected or formulated ideas, she always quoted him and always cited his paintings as examples of one point or another.

Elaine wanted everyone to like Bill, and she wanted friends to like friends. Thus, she introduced me to many people: Tom Hess, Harold Rosenberg, Rose Slivka, Mercedes Matter, Wolf Kahn, Emily Mason, John Ashberry, Rosalyn and Sherman Drexler, Barbara Schwartz, Aladar Marberger, Xavier Fourcade, Jim Bohary, Tom Ferrara, Herman Cherry, Ibram and Ernestine Lassaw, Karen Gunderson, Elaine Benson, and Robert Dash, among others. When she reconciled with Willem de Kooning, she invited me to meet him and to join them for dinners, studio visits, and casual chats. Through all of these colorful individuals—as well as those who do not want to be identified—I saw a vivid, highly energized world of art, poetry, politics, booze, and talk. Always talk. And of all the talkers in the world, Elaine may have been the champion—the hands-down winner for going the distance with a good story, for engrossing her listeners and making them believe what she believed, see what she saw. I knew Elaine not only as a great talker but also as an artist, thinker, writer, critic, and friend.

After Elaine's death, I turned first to the notes and tapes I had from our long friendship. Bill, by that time, was physically and mentally incapable of being interviewed. Elaine's family, under the pressure of settling her estate and preparing her papers for publication, decided to talk with no one and to refuse access to Elaine's papers. Recently, however, Marjorie Luycks, Elaine's sister, has helpfully agreed to make photographs available for inclusion in this book. Joan Ward, the mother of Willem's daughter, Lisa, chatted affably about her longtime relationship with Bill and with the art world, and she provided both anecdote and information valuable to understanding Elaine and Bill. (Lisa de Kooning, through her lawyers, declined several requests for conversation; the lawyers, too, refused to answer questions or to make material on Willem de Kooning available. According to her counsel, Lisa was bruised by published accounts of her life-style and efforts to be appointed Willem de Kooning's conservator.)

I am grateful to all of the people who provided help, those listed above as well as Nell Blaine, Carolyn Harris, Hedda Sterne,

John Opper, Charlotte Brooks, Rudolph Burckhardt, Leo Castelli, Andre Emmerich, Joan Washburn, JoAnne Lowenthal, and Grace Hartigan.

I am also indebted to the Mount Holyoke College Library, the Archives of American Art, the Library of Congress, and the New York Public Library.

Finally, I owe incalculable debt to my agent, John L. Hochmann, and to my editor, HarperCollins Vice President and Associate Publisher Gladys Justin Carr, and her associate, Tracy Devine. Their encouragement, suggestions, patience, and assistance have been received with both greed and gratitude.

THE EARLY YEARS

1

ELAINE AND BILL

Elaine and Bill de Kooning—this remarkable couple, these two artists—weren't *at* the center of the art world; they *were* the center for many years. What would American art be without them? One cannot imagine!

—LEO CASTELLI

Elaine and Willem de Kooning were among the discoverers and settlers of the new world of Abstract Expressionism, which swept like a fire storm through American art in the years following World War II. Both artists, they painted and lived according to the philosophical tenets of the mid-twentieth-century movement that many scholars believe to have been America's most important contribution to the history of art.

When Elaine and Bill met, says a friend, "they ignited. Being around them was like being in a radioactive area, a highly charged atmosphere of sex, ambition, talent, intelligence, and energy."

Elaine and Bill handled their life together and their lives apart as extensions of their painting. Their marriage of nearly fifty years simmered together psychological ups and downs, sexual infideli-

ties, alcohol addiction, and personal and public triumph and failure in a rich soup of energy that nurtured the development of their personalities and their careers. In life and in art, Elaine and Bill incited accidents that ordained the events that followed. Conventional meaning and direction lost currency, and excitement and adventure subsumed or overwhelmed orthodox events and images.

For more than fifty years Bill and Elaine lived at the epicenter of the art world, setting trends and style, inciting gossip and intrigue, and eventually amassing power and fame and fortune. They were well equipped and well disposed by circumstance, energy, and ambition to stand at the forefront of American art, where they created their destinies much as an Abstract Expressionist painter composes a painting from the energy, action, violence, and emotion he or she unleashes on the canvas.

Abstract Expressionism—an attitude, if not a proper philosophy, of art—pits the lonely and searching individual against the unknown (possibly unknowable) first forces of the universe, casting the painter in the role of voyager and seeker after truth. By courting accidents resulting from the manipulated collision of materials, by taking risks with the surprising imagery that results, and by exploring that imagery to discover new vision, the painter creates an order that embodies his or her quest.

To the Abstract Expressionist the process of painting is more valued than the product, the finished painting. To Elaine and Bill, the process of living and working as artists was more important than submitting to the conventions of marriage. They challenged and abraded one another, their strong personalities colliding and melding as they painted and lived together and apart. They honed and polished one another.

From the beginning, each possessed the vital ingredients for a vocation in art—a monolithic belief in the absolute supremacy of art and the kind of faith that produces zealots, saints, heroes, and lunatics. They also possessed an abundance of talent, intelligence, sexual allure, appetite for life, and energy to spend on art and

contrary riskiness and adventuring. They were ambitious, they were competitive—and neither was psychologically constituted to be an also-ran or to play it safe.

Before she actually ever met Willem de Kooning, Elaine admitted, she had been so attracted to the idea of him that she connived their first meeting. When she visited his studio with her teacher Robert Jonas, she found Bill's work to be as challenging and advanced as she had heard; and she found his actual physical and mental presence to be even more exciting than she had imagined. Later she said, "Bill was stunning. His work was stunning, absolutely the most interesting painting I had ever seen. And he was just totally involved in it. And I mean he was physically stunning, too, and just seemed to give off an aura of energy and strength. And he also had this amazing abstract spiritual quality about him. You just knew that he was a genius!" She smiled. "I found him, let's say, very attractive."

"Elaine was very beautiful," Bill told another painter, "and very talented. She was quick." To a friend he said, "Elaine is very beautiful and very attractive, and she knows it and everyone else knows it, too."

Elaine once said, "Bill has always been my anchor, my home base. And Bill is a genius." Grace Hartigan, a painter and longtime friend of the de Koonings, surmised that "Elaine helped put Bill on the map. But, then, Elaine herself would have had no place on a map, no career, without Bill. He was the genius. She was the manager of the genius. But she was a genius at that job."

BILL'S WORLD

Even then [1930s], Bill had a strange magic, and he already had a reputation. Every artist thought he was really something. People fell for Bill.

—IBRAM LASSAW

Willem de Kooning was born in Rotterdam on April 24, 1904, to Leendert de Kooning and the former Cornelia Nobel. In the first years of Willem's life, his father worked hard as a wine and beverage distributor, eventually developing a lucrative business. His mother owned and operated a bar on the Rotterdam waterfront, an establishment that supplied beer and gin to local workmen, sailors from around the world, and the women who sought their company.

When his parents divorced, in 1909, the court—doubtless alerted to Cornelia's tendency to rage and to her capricious punishment of her young son—assigned five-year-old Willem to his father. But Cornelia, maddened by the decision of the authorities, kidnapped young Willem and, after additional court battles, won custody of the child.

Cornelia, a tiny, fierce woman who later became obese, was tough in her dealings with her son as well as with the world. Never a model of warm and nurturing motherhood, she was often physically and psychologically abusive. In a rare moment with a friend, Bill confided that his mother once came upon him, then a toddler, playing on the floor with her shoes. He felt helpless and frightened, he said, when she became enraged and kicked him savagely for a wrongdoing that he did not comprehend. Other times, he said, for no reason apparent to her son, she boxed his ears, whacked him, or punched him. When he was not dodging physical punishment from Cornelia, Willem stayed out of her way to escape her tongue-lashings.[1]

According to Elaine, young Willem took refuge from his mother's temper in drawing and dreaming; he waited out his unhappy childhood and left his native country as soon as he was able. Elaine described Cornelia as "a tough woman. She could have been the model of a ship's figurehead, could have cut the waves with her face." Elaine usually added the observation that Franz Kline and Jackson Pollock also had mothers like Bill's, who "looked as though they could walk through a stone wall. These were domineering mothers and its effect on the sons was a rebelliousness, a kind of resistance, and their attitude toward women. These were nondrinking mothers, straight-laced, hard and with ramrod backs."[2]

During the years after he came to America, Bill saw little of his mother and rarely spoke of her. On their infrequent visits, Bill was formal and courteous but not affectionate toward her. Elaine recalled that de Kooning's mother, who was at least as tough as the sailors who frequented her waterfront bar, said she would stay alive until Bill came to Holland to see her; he did so in 1968—at the time of his retrospective, which opened at the Stedelijk Museum. She died the next year at the age of ninety-two.

Bill's sister, Maria Cornelia, and his half-brother, Koos, shared his aversion to his mother. "Willem was a nice boy," remembered his aging sister. "My mother was a tyrant and Willem was stub-

born."[3] Koos remembered, "When Wim visited Rotterdam the day after the opening of his exhibition, we took him to visit his mother. He didn't want to go. But we persuaded him and I think he was surprised by her fragility. And relieved. You see, she was a masterful woman who dominated the whole family. Only *she* mattered, and Wim and she fought constantly. . . . But after he was famous, she insisted on visiting him in America—twice."[4]

Long before his fame, at the age of twelve, Willem wanted to become an artist and embarked on the path toward that goal. Even then, he recalled years later in a discussion with art critic Harold Rosenberg, he responded to the power of visual imagery. "I remember that when I was a boy, on a cigar box they had 'The Modern Age,' the age of freedom and enlightenment, together with the great modern inventions. There was a blacksmith, bare-chested, with a leather apron, and a sledgehammer over his back, which was considered a modern tool. And the wheel of progress was the biggest gear you ever laid eyes on—it certainly wasn't something that was made by a computer. Those symbols were a romantic way of expressing the feeling of freedom."

Young Willem believed he could find his own freedom by becoming an artist. He left grammar school to become an apprentice to the local commercial art and decorating firm of Jan and Jaap Giddings, where for the next eight years he worked daily with established commercial artists—painting signs, decorating store windows, repairing and refinishing valuable pieces of furniture. At night he studied fine and applied arts at the Academie voor Beeldende Kunsten en Technische Wetenschappen (Rotterdam Academy of Fine Arts and Techniques). Both job and studies gave young Willem skills ranging from basic carpentry to exquisite drawing and a lifelong appreciation for fine craftsmanship. Later, Bill recalled that "it was a very good academy. Very systematic. But good training. Our models were muscular men then. For the anatomy. In American schools it's always naked girls. Nice to look at but," he laughed, "there are so many other things to draw in the world."

At the academy, in the tradition of European art, he drew from plaster casts as well as the live male models; he learned perspective and shading, practiced rendering scenes and objects in color, and mastered lettering, wood-graining, marbleizing, drafting, and portraiture. The practice of these crafts, augmented by lectures in art history and theory, constituted the Dutch curriculum in art at that time and were intended to prepare students to apply their artistic abilities to numerous practical and aesthetic projects and to enable apprentices to become fully fledged members of the artists' guild.

Discussions on creativity, originality, innovation, and self-expression—the concepts that would become central to Abstract Expressionist jargon and doctrine—were not included in the young European's education. To the contrary, while studying to become an artist, Willem anticipated a life of practical work, a means of earning his living by working with his hands. De Kooning later remarked, "When we went to the academy—doing painting, decorating, making a living—young artists were not interested in painting per se. We used to call that 'good for men with beards.'" He often explained to American-born friends that "the idea of a palette, with colors on it, was rather silly," and that being an artist in the modern world required more skills than those identified with the craft of painting.[5]

The work habits and talent of the compactly built, blond young man earned him the State Academy Award and the Silver Medal for excellence. With these achievements in his portfolio and with the boost they gave to his self-esteem, sixteen-year-old Willem began in 1920 to work with Bernard Romein, a department store art director. He was eager to know everything about art, past and present, and through Romein, Willem became interested in modernist European movements, in the de Stijl group and Jugendstijl, in Mondrian, avant-garde Paris artists, and the American architect Frank Lloyd Wright. Romein, more than any other figure in Holland, helped young de Kooning find the intellectual interests that would lead him to abstraction and to the pinnacle of the New York

School of painting. And it was Romein who strengthened young Willem's desire to seek his fortune in America.

After a *Wanderjahr* in Belgium, the completion of the academy's program, and work in commercial art studios in Holland, twenty-two-year-old Willem de Kooning immigrated to America, without telling his mother and stepfather of his plans. He dreamed, he later told Elaine, of long-legged beautiful American girls and of becoming a rich and successful man. He planned to earn a lot of money quickly—after all, he thought, that's exactly what a man did in America—and then devote his life to art.

Decades later, Elaine chuckled when recalling Bill's illegal immigration to America. He tried several times, she said, to enter the country legally but was unable to get clearance and appropriate papers. So, with the connivance of sailors he met in his mother's bar, he took a job on the SS *Shelley* as a wiper in the engine room, a hot and dangerous job. When the vessel docked in Newport News, Virginia, Bill jumped ship, as he had planned.

He knew only one word of English, "yes," but with the help of Dutch-Americans along the eastern seaboard he made his way from Virginia to Boston to Rhode Island, and then to the New York waterfront. He found lodging in a Dutch seaman's house in Hoboken, New Jersey, where there was a sizable Dutch community. His room, he remembered, "was neat and clean. I liked that. And I was there only about three days when I got a job as a house painter. I made $9 a day which was all right then, you know, although they certainly didn't think I was a genius. From America I wrote to my stepfather, asking him to forgive me. He was a nice guy. He wrote back saying, 'Don't worry. Everything's fine.'"[6]

Bill often recalled his attempt to earn his living as a commercial artist. He had reasoned that if he got $9 a day for painting houses, he would surely earn considerably more for applying his academic skills and knowledge. He said that after about four or five months, he "started looking for a job doing applied art-work. I made some samples and I was hired immediately. I didn't even ask them the salary because I thought if I made nine dollars a day as a house

painter, I would make at least twenty dollars a day being an artist."

Willem was surprised, however, at the end of two weeks as a commercial artist. His employer gave him $25. "I was so astonished," he said, that "I asked him if that was a day's pay. He said, 'No, that's for the whole week.' And I immediately quit and went back to house painting."[7]

Bill observed, "Sign painting was difficult for me because they used other letters here. How the hell those old guys smoking their pipes did it, I don't know. Terrific outdoor painters they were in the speakeasy days."[8]

During the ensuing years, Bill would earn needed money by picking up odd jobs that did not call attention to his status as an illegal alien. As an expert carpenter and housepainter, he found it easy to get as much work as he needed to earn his living. What was more important was that he learned that he could pick up jobs by the day or the week without the confinement of regular full-time employment. With his first earnings, Bill outfitted himself in handsome American clothes: "low-belted trousers and nice workman's clothes. In three weeks I could pay off my rent and had new underwear and socks. I'd worked in Antwerp and Brussels a few years before for three months without being able to buy a pair of socks."[9]

Though the work he performed as a housepainter and carpenter required physical energy as well as skill, it did not diminish either his initiative or appetite for painting. Moreover, he earned enough money to explore the fascinations of New York City. European in education and outlook, as well as in his tastes in art and in his skills and training as a painter, Willem de Kooning marveled at the rowdy, freewheeling, materialistic America that he discovered on the streets of Manhattan, in store windows, and in the bars and theaters that he frequented. He saw promises everywhere of the wealth he believed he would earn. As the young, academy-trained, certified European artist earned his living as a housepainter, he believed he could work hard, make a lot of money quickly, and then paint full-time. Anything, he thought, was possible in America.

When he arrived, the 1920s were roaring at full pitch. The young Dutch artist encountered John Held, Jr.'s popular illustrations of fast-stepping guys and flappers. To de Kooning, as well as to a large segment of the American population of the time, Held's flask-carrying, gin-swigging youth in Charleston frenzy and full pursuit of sensual pleasure epitomized the freedom and prosperity promised by America. And prosperity was a palpable American reality, unlike anything de Kooning had experienced or imagined in Holland. Like most of his friends in the Netherlands, he had depended on a bicycle for transportation; but at the time of his arrival in the United States, one of every six Americans owned an automobile. Moreover, in Holland he had lived simply and thriftily, with few luxuries; in America he was amazed by the consumer goods in store windows—clothing, gadgets, furniture, canned and packaged foods. Things—including objects he had never dreamed of—were being cranked out of rapidly expanding manufacturing industries, boosted by the new smart-ass boys and girls of the ad agencies and the swelling print media and bought by Americans of all economic stations. Bill saw people who believed in progress, expansion, and wealth. Fascinating.

Bill was especially engrossed by the entertainment world, which dished up disparate pleasures, including Mae West, who was arrested for lewd dancing in her play *Sex* because she moved her navel; Charlie Chaplin and Greta Garbo in the movies; Rudy Vallee and Al Jolson singing on gramophones and the radio. Over the ensuing years, Bill relished American popular culture: Mickey Mouse, Buck Rogers, Blondie and Dagwood, the Lone Ranger, Western movies, and Broadway musicals. Commercial illustrations and movie stars presented the American female beauty he had anticipated. He memorized American songs and eagerly picked up slang. He found his first American girlfriend in a popular cultural form—she was a circus acrobat. She was beautiful and daring: she was, for him, American.

As the immigrant artist became familiar with the language and mores of the United States, he watched the newspaper headlines

hawk the adventures and escapades of Al Capone for making a fortune in crime and Lucky Lindy for flying alone across the Atlantic Ocean. Fame, Bill quickly learned, had more than one face in America.

Lonely and aware of being a foreigner in New York, he said, "I was an alien, you know what I mean? But I picked up the language and found there were a lot of people in the same boat. It's a great city but it can be tough. In those days they would take advantage of you and give you a lot of pain, you know."[10]

During the two decades following his arrival in America, while still holding fast to ideals based firmly in traditional European art and still doting on the master painters he revered, Willem de Kooning explored and appropriated aspects of American culture, established friendships with members of the art community in New York, and gained a reputation for being, along with Arshile Gorky, the most interesting painter in the city. He remembered, "I had been in New York about six months before discovering that there were such people as American artists. . . . I'd moved into an attic on 22nd Street at $23 a month and was stealing the landlord's light by using a long wire from the hallway. After work, I used to meet other artists like Arshile Gorky, Stuart Davis, and John Graham at the Waldorf Cafeteria. But I met Mark Rothko in Washington Square Park, in the Village. I remember it was late at night and there was this kind of husky man sitting on the left side of a bench and me on the right with nobody else in the park. I didn't want to speak first in case I was mistaken for a queer or something. 'Nice evening,' Rothko finally said. We discovered we were both painters. A couple of days later he came to visit me in my studio and that was the beginning of our friendship."[11]

During the Depression years, while admiring the works of many of the members of the American Abstract Artists group, de Kooning worked incessantly on a series of paintings of male figures. As he worked in his studio, he used his own image in a mirror, drawing and erasing, painting and scrubbing out the compositions on his canvases. Bill had little furniture in his studio, but he had a

sophisticated record player built by his friend Max Margolies, and he listened to music while he worked. A neighbor of Bill's at the time, Rudolph Burckhardt, heard "the really loud music. It came from a very advanced and early hi-fi system. I was impressed because the music was so interesting. A lot of Bach, and some other less familiar music like Stravinsky. A lot of jazz. It was not the kind of thing that just anyone would have been playing at that time." Hearing the music, as well as the mysterious thumps and bangs from canvases being moved about, Burckhardt and his roommate, dance critic and poet Edwin Denby, were curious about their music-loving neighbor, Willem de Kooning.

On a blustery winter day, a black-and-white kitten meowed on the windowsill of the Burckhardt-Denby Chelsea loft. The men took in the cold and wet kitten, dried it and fed it, and considered the adoption accomplished. The kitten would be company, they told each other, during the long hours they worked at home. For they, like most of the New York artists of the time, organized their domestic routine around the necessities of work, making do with inadequate heat and homemade or scrounged furniture and arranging living areas around the darkroom and worktables where they spent most of their time. In the several days following its rescue, the kitten made itself a pleasant addition to the household; the men assumed that it would remain with them.

A few days later, however, Burckhardt answered a knock at his door and found Willem de Kooning—"a short, blond man searching for his lost kitten." The painter identified himself, and Burckhardt and Denby invited their music-loving, disheveled, paint-smeared neighbor in, returned the kitten, and fell into easy conversation—the beginning of a long and important friendship for the three men.

Burckhardt and Denby introduced Bill de Kooning to their circle of poets, musicians, artists, and critics. Burckhardt says that he was "always impressed by Bill's work—what was left after he went through his endless process of never finishing a painting. A painting would look terrific, but Bill would 'fix it up,' and paint over

sections, one after another, layer upon layer. He often said he didn't know what he would do next as he painted. Even then, he let the painting lead him."

In the late thirties, Bill's singular manner of painting was evolving from the conventional processes of drawing on a canvas and applying paint to that surface, to a more individualistic technique based on wiping out the image but keeping a ghost to paint and draw over and over. The ghosts of earlier layers of work combined with the artist's actions upon them to yield still more opportunities and choices for the direction of the work. In the small New York art world of that time, other artists recognized that Bill's emphasis on the process of painting—the act of painting—resulted in both freshness and authenticity of style. According to Burckhardt, Bill's ambition grew along with his style of painting. "Bill had a big ambition. He bypassed presentable paintings, probably missed out on shows and sales, as he really set his sights on being a Great Artist. He figured out that the guy to best was Picasso. Even then, you could see that Bill was setting out to do something different, something better."

During his early years in America Bill formed friendships with other men destined to be powerful forces in shaping American art. Later, Bill told his friend Harold Rosenberg, the art critic, "I was lucky when I came to this country to meet the three smartest guys on the scene: Gorky, Stuart Davis, and John Graham.[12] They knew I had my own eyes, but I wasn't always looking in the right direction. I was certainly in need of a helping hand at times."[13]

All three artists did, in fact, offer a helping hand to the intense young Dutch artist. Though Arshile Gorky and John Graham had arrived in America in the same year, 1920, and knew each other well, they differed sharply in personality. John Graham maintained contacts with the Parisian art world and claimed friendships with Picasso, André Breton, and others who advocated modernism. An émigré from Russia, Graham influenced the avant-garde American art world of the twenties and thirties with the power of his personality and his erudition. Gorky, on the other hand, was unsophisti-

cated, often in emotional turmoil, and interested in little outside his own work.

Abstract Expressionist painter John Opper emphasizes Bill's European sense of tradition: "Bill belonged to that tradition, and the rest of us—the rest of the American artists—were floundering. We really had no tradition at all. We didn't have what Bill had from the beginning—a clear idea of what we were doing and what art was all about." John Graham, like Willem de Kooning, was strongly rooted in the tradition of Western art. The older Russian artist—both a painter and a collector of advanced art, knowledgeable about European art and artists of the period—eagerly discussed theories and experiments related to modern art with younger American artists.[14] For many of the younger artists in New York before World War II, Graham was the teacher they wished they had had, the evocative and tireless mentor who knew his way through the still uncharted world of modern art, the master who articulated the issues as generously as he proffered encouragement.

In the twenties and thirties, espousing the theories of Marx and Freud along with modernism, insisting on the potency of the unconscious mind and of accident and automatism in creation, Graham held up the virtues of abstraction, and he encouraged de Kooning, Gorky, Jackson Pollock, and David Smith, among others, to boldness. In many ways, John Graham sparked the engine of the American avant-garde in those years.

However, it was the Depression and the WPA that nurtured American artists of Bill's generation. Unlike American-born artists working in New York at that time, Willem de Kooning, as an illegal alien, did not have full access to the Federal Arts Project. He signed on nonetheless and enjoyed WPA funding for a year. After that period of blissful support, officialdom decreed a crackdown on aliens, and Bill had to withdraw from the Project. But that one year of support gave him the determination to work full-time as a painter and to never again take a job that would interfere with painting.

Although Bill knew that his dear friend Arshile Gorky strongly embraced (seemingly with very little critical adjustment to contrary possibilities) Graham's theories and the similar ideas that floated freely among artists working on the Federal Arts Project, de Kooning himself remained aloof from doctrine. Though fascinated and enlivened by Graham's personality and erudition and by the political and social causes that appealed to artists in the Project, Bill was disinclined to appropriate anyone else's whole package of ideas, or to even accept precepts forged by another intelligence. Instead, he picked and tested his way through Graham's extravagant feast of ideas, as well as through the Trotskyite intellectual casseroles of the Project; then, driven by his own appetites, Bill helped himself to the ideas he found attractive and devoured the concepts he found useful.

Elaine believed that Graham reinforced Bill's dedication to the value of craft in painting, to solid drawing that could encompass the excitement of spontaneity and that could lead to further reaches into new patterns of organization. "Those are the things a teacher can do for a student," she said, "or the things an older artist can do for a younger artist. But even then Bill was fully his own person, and totally committed to his own direction in painting."

But, notwithstanding the conversations he had with artists and the works of art he saw, the most important influence on Bill came from the close friendship he developed in the thirties with Arshile Gorky. Through the sensitive Armenian artist, Bill gained greater awareness of himself as an artist and reaffirmed the centrality of his work in his life. With Gorky, Bill visited the Metropolitan Museum and the Frick Collection, saw shows in galleries, and pored over reproductions of great masterworks. The two immigrant artists shared art magazines—the few that were published in those days—and endlessly discussed painting and, especially, modernism.

While de Kooning found Graham's sophistication and wide knowledge of art impressive, he admired Gorky's natural dedication to painting and his passion for the vocation and tradition of

art. Bill later said of his friendship with Gorky, "It was nice to be foreigners in some new place." He also said: "I met a lot of artists—but then I met Gorky. I had some training in Holland, quite a training, the Academy. Gorky didn't have that at all. He came from no place; he came here when he was sixteen, from Tiflis in Georgia, with an Armenian upbringing. And for some mysterious reason, he knew lots more about painting and art—he just knew it by nature—things I was supposed to know and feel and understand—he really did it better. He had an extraordinary gift for hitting the nail on the head; very remarkable. So I immediately attached myself to him and we became very good friends."[15]

During the time that Gorky and Bill were close friends, their ideas about art were similar, and they often worked on coinciding issues in painting, especially compositional uses of line cutting through or defining fields of color. Although there are similarities between the resulting biomorphic shapes emphasized by both artists in the thirties, the two nonetheless developed distinctive styles of working. As is often the case with artist friends, they agreed about what they were against. To de Kooning and Gorky, both in love with drawing and the great traditions of European art, the American regionalism of Thomas Hart Benton and Grant Wood—the prevailing style of the twenties and thirties— promised little of what they sought in art. Unlike many of the American artists of their age, de Kooning and Gorky were not compelled to use painting for social comment or to depict activities or reveal passions associated with regional American life.

On the other hand, the two friends took an interest in the works of trail-blazing early abstractionists like Americans Arthur Dove, Marsden Hartley, Stanton MacDonald-Wright, and Georgia O'Keeffe and in the works of Europeans Josef Albers and Hans Hofmann. Neither Gorky nor de Kooning courted stylistic influence from these artists; both, however, did enter Picasso's territory and sought to analyze his work and to learn from his vision and manner of working.

Lofts were strictly zoned for commercial use only, but de Kooning was one of the first artists to violate the law and live illegally in the large spaces (first at 143 West Twenty-first Street, then at 156 West Twenty-second Street). In his spacious but often ill-heated studio, Bill worked on plans for murals (never executed) and on a series of abstractions notable for their high-key color and defined organic shapes. Unlike many of the other artists of his generation, Bill did not (and would never) reject the human figure in search of "pure painting," a predilection that probably accounted for his decision not to join the then-forming American Abstract Artists. John Opper speculates that it was de Kooning's sense of himself as a European, however, that kept him from joining a group of artists intent upon generating American art, as were the American Abstract Artists, led by Ibram Lassaw and others who would be important friends to the de Koonings. But it is equally possible that Bill felt constricted by the Constructivist ideas and largely geometric art produced and praised by the group.

With his steadily improving English, Bill managed to support himself not only with odd jobs in painting and carpentry but with commercial art work and department store display for, among others, A.S. Beck Shoes. He considered himself fortunate when he got an occasional commission to produce decoration or a mural for a nightclub.

By this time, Bill was no longer seeing his first American girl-friend (the circus acrobat and tightrope walker) but was living with Juliette Broewner, who later married artist Man Ray. While Bill seemed to enjoy her companionship—as, for that matter, he did the presence of any of the other string of women who were in and out of his studio—he was "more interested in his own work," according to a friend from the period, "and in sitting in cafeterias, drinking coffee, and talking. Bill liked to talk. If he happened to drop by, well, you would have Bill for the rest of the morning or for the day or the night."

"Bill enjoyed women sexually, and sometimes socially. But women as people weren't very important to him," suggests a male

artist who drank coffee and talked with Bill in the cafeterias. Somewhat sardonically, Elaine quipped, "Women, to a large degree, are interchangeable with Bill. He's never certain which one is with him at any particular time. For him, a woman is a woman is a woman."

Painter Robert Dash recounted several conversations he had with Willem de Kooning about his childhood in Holland and suggested that "Bill was deeply, deeply marked by his mother's hostility toward him. You don't have to be a certified Freudian to suspect that that was *the* formative relationship in his life, especially in shaping his feelings about women. Bill naturally wanted Cornelia's love, and Cornelia gave him anything but motherly love. Today, one would describe Cornelia as a child abuser. I believe everything in Bill's life was darkly shadowed by his early experiences with that awful mother."

ELAINE'S WORLD

Elaine had everything. She was beautiful, talented, sexy. And she managed to marry the man she thought was the best artist in the world.

—GRACE HARTIGAN

In a television interview shortly before her death, Elaine de Kooning waved aside questions about her early life, saying, "I always think my life began when I met Bill. I mean, that's when my life as an artist began."[1] While recognizing Elaine's serious intention to become an artist and her early display of talent, no one who has known the two artists questions that, indeed, Elaine's life as an artist began when she met Willem de Kooning and, moreover, that her career of close to fifty years took shape and direction alongside his ascendancy in the international art world. Some friends also insist that Elaine leveraged Bill's career to the highest plane of international success, that she scored the early attention given to him by publications and critics, and that she largely created and orchestrated the "de Kooning myth."

Elaine Marie Fried was born in 1918 to an Irish Catholic

mother, Marie Catherine Fried (née Mary Ellen O'Brien), and an earnest German Protestant father, Charles Frank Fried. While Willem de Kooning matured as an artist in New York City, becoming increasingly single-minded in attention to his work, Elaine evolved as a precocious and outgoing girl. Whether by natural inclination or early conditioning, Elaine became a gregarious and ebullient woman who enjoyed power and dominance, whereas Bill grappled with his equal proclivities toward solitary depression, amiability, and generosity.

The Brooklyn-born Elaine would often preface an amusing story with the cryptic comment, "Behind every artist is a mother." This drolly delivered assertion contained ironic truth for both Bill and Elaine, each a child of a strong and unconventional mother. But while Cornelia had done little to love and nurture Bill, Elaine's quirkily amusing and idiosyncratic mother daily extolled the brilliance, beauty, and talent of her firstborn.

While Elaine in later years talked about her mother incessantly, quoting her homilies and recalling with animated delight anecdotes featuring a paragon of early female liberation, Bill rarely spoke of his Dutch childhood or of his mother. And while Elaine's family— her sister and two brothers, and their children—remained important to her throughout her life, Bill closed a psychological door on the family he left in Holland and saw very little of them thereafter. Bill, an abused child, would later frighten his daughter with his extreme alcoholic mood shifts: sober, he would be affectionate and generous with gifts; drunk, he would be moody and at times threatening. Elaine, too, would reiterate the emotional patterns she learned from her mother in her relationship with Bill, often becoming a casualty of her need to excel and compete.

Elaine described herself as a competitive child and believed that her sense of competition—coupled with her conviction that she was fated to win any contest she entered—found an early and satisfying expression in art. "I never made a decision about being a painter," she said. "When I was five, I made drawings like all children. And when I was eight years old, my friends began to ask me

for my drawings. And so," she recalled, "I began to have a little ego about it. There were a couple of other children whose drawings also other children would ask for. And I became competitive with them."

She was competitive in other ways as well, especially in the exercise of what she only half-jokingly referred to as "my fine Machiavellian hand." She became a force in the art world not through talent alone but by charming and otherwise influencing others to exert their power for her benefit and Bill's. "I was so competitive," she boasted, "that I learned to *administer* competition. I just found that it worked better if you could sweetly persuade someone else that he *wanted* to do what *you* wanted done." Her brother Peter, speaking at her funeral and perhaps intending a whimsical tone, told stories of her youthful competitiveness—before the acquisition of the "fine Machiavellian hand"—and of her comeuppance. He remembered an exuberant young Elaine outrunning, outclimbing, and outsmarting everyone, and he told of her racing once to beat siblings to dinner, only to find that Marie had set before her daughter a plate of dog food, a joke that was also a reminder to Elaine that overt aggression set the stage for retribution.

But Marie also applauded Elaine's talent and stimulated competitiveness in her energetic and beautiful firstborn, a favoring of Elaine that may have also ensured rivalry among the siblings. By all accounts Marie doted on Elaine—sometimes excluding her other children—and encouraged her daughter to draw and paint, as well as urging her to read widely and strive for good grades in school. Marie also set an early example of nonconformity and liberation for her daughter and inspired the young artist to value freedom and the rewards of ambition. While she built Elaine's confidence and fanned her dreams, Marie promised her family that she would practice her own preachments. She said she would someday leave home and pursue her own interests when her duties of motherhood had been met. True to her word, when she reached sixty years of age, Marie left her husband, the mild-mannered accountant who gardened and raised rabbits in the backyard; she moved to Manhattan, where she studied French to

enable herself to read French novels; and she rode a bicycle around town with little thought to automobile or pedestrian traffic that might get in her way. Marie, like Elaine, took on all comers in arguments about any subject. "You could never say anything in my family without someone arguing," Elaine reminisced. "We didn't have conversation; we had arguments."

Elaine's attitudes about motherhood and about the role of a wife grew from Marie's example of independence and feistiness, of damning convention in pursuit of ambition. Over the years, Elaine often repeated a story about meeting her mother for a cup of coffee in a cafeteria. Elaine, then in her twenties, anticipated a pleasant mother-daughter visit, but Marie took little notice of her daughter. She was agitated by an ongoing argument with a friend and impatient to go to the New York Public Library to seek the information she needed to win the argument. Disappointed with the tone of the visit, Elaine nonetheless accompanied her mother to the Fifth Avenue institution and, professing fatigue, said she would wait in the entry area until her mother tracked down the needed facts.

Sometime later Elaine woke as a guard gently shook her shoulder and told her that the library was closed, that she was the only person remaining, and that she would have to leave immediately. Fearing that Marie was in some sort of trouble and perhaps locked in the library stacks, Elaine rushed to a public telephone to call her mother to find out whether she was home. Marie answered her telephone on the first ring.

"Why did you leave me in the library?" asked Elaine.

"Well, dear," answered her mother, "you were sleeping so peacefully that I hated to disturb you."

"Now that," Elaine said, laughing, "is a mother's concern."

But Marie's concern for Elaine's welfare and her program for educating her intelligent daughter also included numerous trips to libraries and museums. By the time she was four or five, Elaine reckoned, she had been taken to every museum and library in New York City. "I was taken to the Metropolitan when I was very young. Paintings immediately had some kind of glamour for me," she said.

Painting, more than sculpture, attracted the child-artist, who remembered that "those two-dimensional surfaces [of paintings] had something that seemed to encompass all kinds of excitement."

Well before her graduation in 1935 from Erasmus Hall High School, Elaine had discovered the great European painting masters; and she, like Bill, had set out to join their league. When she was ten years old, Elaine read "about a certain painting that Raphael had made when he was thirteen years old, and I thought, well, that gives me three years." Three years later, the still-competitive youngster "saw a Soutine and thought, Well, he can't even put the eyes on the level, so if he's in a museum, by the time I'm sixteen, I will be." In pitting herself against renowned artists, Elaine believed she "always had a kind of sense of the artist's position in the world." And it was a position she wanted for herself.

With Marie's encouragement, she followed her ambition. As soon as she graduated from high school, Elaine entered Hunter College. But she dropped out the following year because she wanted to become a painter. "I just couldn't stand not having a paintbrush in my hand," she said. "I didn't feel that I had time for that [i.e., college]. I knew what I wanted to do. And while college was interesting, it wasn't that important to me then."

She entered the Leonardo da Vinci Art School in New York City, where, she recalled, "I drew all day every day." To earn money for her art school tuition, the beautiful young student worked as a model, posing for numerous artists in Manhattan. Her slim figure and graceful movements, her strawberry-blond hair and golden eyes, made Elaine a handsome subject for artists; her ability to assume and hold a pose, and her chattiness, made her a pleasant presence in a studio. Making her way on the model's platform also proved educational for Elaine, who not only became acquainted with most of the artists working in New York at that time but also quickly grasped the ideas and rudiments of style that informed their work. Later, her familiarity with the New York art world enabled her to contribute prescient reviews to *Art News* and to become a popular teacher on several college and university campuses.

She made friends easily in the then-small New York art world and quickly found New Orleans–born Ernestine Blumberg (later the wife of Ibram Lassaw)—an attractive young woman, an easy companion, and a generous ally and foil to her own liveliness. "I had a job," Ernestine remembers, "and that meant that I could sign leases and rent spaces. And Elaine was often looking for a place to stay." In a short time, Elaine and Ernestine shared a studio on East Ninth Street and Fourth Avenue with Elaine's boyfriend, artist Milton Resnick, a fellow student who would also become a distinguished painter. The three artist friends organized spaces for their work and shared meals and social activities. "Milton Resnick," Elaine recalled, "was very vital, very handsome, and he was a gentle person. He is a terrific friend; he's one of us, one of the brotherhood."

Encouraged by Resnick's recognition of her talent, Elaine drew and painted cityscapes and portraits,* continued her studies and her modeling jobs, and enjoyed the artist's life. Artists in New York's downtown bohemia, according to Elaine, "jauntily dismissed poverty and just worked. Worked a lot, all of the time. And talked. And we had wonderful fun at it all." Yes, Ernestine Lassaw agrees, "it was fun, and Elaine was always at the center of fun. She was lively and daring. Even then."

As well as Elaine's interest in all aspects of art and the art world, Ernestine remembers her friend's beauty, her self-confidence, and especially her daredevil ways. "Elaine used to say that she was the best and most attractive model in New York," says Ernestine, "and the truth is, she probably was. She was very beautiful."

Ernestine, whose own sense of adventure had been whetted in her New Orleans childhood when she played in a garden that she shared with alligators, found Elaine to be more of a daredevil than she herself was. She recollects not only Elaine's habit of placing cups or glasses on the edge of a table or saucer, as if dar-

* She sold her first portrait, that of Bennington College professor Stephan Hirsch, for $10.

ing them to fall, but also her predilection for walking on the edges of rooftops when she visited friends in their lower Manhattan loft buildings. "Not only did she test fate with cups and glasses, and even by walking too close to the edge of the tops of buildings, but she never, never crossed a street at a traffic light," according to Ernestine. "And what was worse, she always set out into the middle of moving traffic and sort of pulled you along with her."

"By the time I was eighteen," Elaine recounted, "I was interested in the hard work of art. I mean, just making drawings every day, all day long, and just completely being submerged in that activity." At the Leonardo da Vinci Art School, Elaine studied with Conrad Marca-Relli, a teacher who encouraged her "to work my own way, to work hard. He was not intrusive, but he had a way of encouraging his students to bring out their best work."

While Elaine took classes, Ernestine worked in the cloakroom of the Art Students League and took courses at that school. Together, Elaine and Ernestine surveyed the New York art world and discerningly looked over the male artists. Ernestine Lassaw recalls that her exuberant friend seemed to know everyone and to be a part of everything that was going on in the New York world of artists and art students. Smiling, Ernestine contends, "Elaine was very ambitious and very competitive. She always liked to know everyone first, and to have all of the good ideas before anyone else did." Ernestine had hoped to introduce her good friend to the handsome and talented sculptor she fancied, Ibram Lassaw. "Oh," Elaine said, "*I* know Ibram Lassaw."

Elaine later proudly claimed, "I was a lot of fun. I mean *a lot of fun*. And I was beginning to make a life for myself, and not too eager to explain everything to my mother. I wasn't really promiscuous, just curious and full of energy. I mean there were interesting *men* around, and I was interested to find that they were interested in *me*. And I just thought life was terrific and art was terrific and that I was terrific, too. And when I met Bill, I just knew that that was the most terrific thing that had happened to me."

ONE AND ONE

Look, Bill was dynamite. And Elaine was dynamite, too. The explosion made history.

—GRACE HARTIGAN

From the first time she met him, in 1936, Elaine had conceded that she had set her sights on Bill. "And God knows, Bill seemed to be madly in love with Elaine," recalls a frequent companion in the cafeterias. "He seemed interested in her in a way that he had never been interested in any of the other women around him. He said—and I believe he was telling the truth—that he was prepared to be monogamous, that he didn't want any other woman. Just Elaine."

Elaine Fried was not quite twenty; Bill was thirty-four. She was a gifted art student; he was an acknowledged leader among the artists of the avant-garde. She was gregarious, ebullient, flirtatious, talented, and beautiful. She moved quickly, acted on impulse, and wanted to know everyone and everything going on in the art community. He was amiable but solitary, slow and deliberate in his work, and often gloomy. Elaine's recklessness as a per-

son matched in intensity Bill's established nonconformity as an artist; and her eagerness to learn appealed to his sense of his own authority—rightness—as an artist. He was poor but determined to escape the odd jobs as carpenter and housepainter that prevented him from painting full-time. She was an avid art student who thrived on drawing eight or ten hours a day at the beaux-arts-based Leonardo da Vinci Art School; he was a serious artist with an appreciative audience of other avant-garde painters and sculptors in New York. Both were ambitious.

Both were also sexually attractive and casual about their sexual activities. But their attraction to each other, according to witnesses, was incendiary.

"From the moment I heard about Bill de Kooning, I just knew I had to meet him," Elaine said. She remembered the occasion and circumstances of their meeting: Robert Jonas, an instructor at the Leonardo da Vinci Art School, took her to an exhibition sponsored by the American Abstract Artists. Jonas said, "The two best American artists—Willem de Kooning and Arshile Gorky—aren't in the show, and they aren't members of the group."

"Well," Elaine admitted, "that did it. I just had to meet these two best American abstract artists. And I guess," she added with a smug grin, "it took me about two weeks to meet Willem de Kooning."

Elaine was emphatic: "When I met Bill de Kooning, I just knew that I had met the most important person I would ever know. I was mesmerized. Even then I knew that he was a genius, a great painter—the most important painter at work in America. And I knew that I would marry him."

At the time Elaine met Bill, she and Milton Resnick were still lovers. "Oh, [that affair] was a big deal, all right," recalls an artist who knew both of them, "and Milt was especially crazy about her. She, I think, may have had a roving eye even then. I mean, Elaine just didn't seem even capable of settling down. Certainly not then." Ernestine Lassaw thought Milton Resnick very attractive, and when Elaine later took up with Bill de Kooning she wondered how Elaine could possibly find Bill more appealing than Milton.

Resnick, say artists who knew him and Bill de Kooning at the time, understood that he had lost Elaine to Bill, and he seemed to expand and adjust his affection to include de Kooning. "It was a kind of hero worship for Milt. He loved Elaine, so he decided to love Bill, too. And he loved Bill's painting. Even his own painting started looking like de Kooning's paintings," they say, "and, eventually, Milton started talking with a Dutch accent." For his part, Bill wondered aloud to friends, "Why does this guy hang around after I've taken his girl away from him? What's the matter with this guy?"

At first, when Elaine moved back to Brooklyn from the apartment her family believed she shared with Ernestine (though later Elaine surmised her family might have suspected Milton Resnick's residency) and began to spend most of her time in Bill's studio on Twenty-second Street, the lovers concocted a story for the benefit of Elaine's family: Elaine was studying with Bill, they said he was teaching her to draw. This was not entirely false. Bill did instruct Elaine in drawing, sternly requiring that she draw and redraw a figure or a still life and insisting on fine, accurate, clear linear definition supported by precisely modulated shading. Bill's harsh criticism of her drawings, and even his habit of destroying those drawings he did not like, impelled Elaine to strive for both precision and grace in her work. Elaine said many times that Willem de Kooning provided her with the best teaching she ever had and that the skills he taught her became the foundation for her confidence as a portrait painter. She said that she always felt that theirs was a "master–student relationship."

That master–student relationship was also apparent to other people who knew Elaine and Bill. When Grace Hartigan, who, like Elaine, was beautiful and talented and often called "a second-generation Abstract Expressionist," first showed her own early work to Bill de Kooning in the forties, he told her that she had "all of modern art wrong" and suggested that she change directions.

"I am teaching my Elaine," he told Grace. "Why don't you do what I have her do?"

"And what's that?" asked Hartigan, unprepared for Bill's description of his domineering form of pedagogy.

"Vell," de Kooning explained, "I tell Elaine to use the finest pencil in the world, and to make an exact and perfect pencil drawing of a still life—like a Dutch still life. And then she shows it to me and it is perfect and I tear it up and I tell her to do it again."

"And does she?" Grace questioned.

"Yah. She does," Bill assured her.

Bill recognized that women artists were seldom appreciated for their talent. "Nobody," he said years later, "takes a person very seriously when they're just starting to paint, particularly if it's a woman."[1] But Bill took Elaine seriously as an artist, and strong-willed Elaine acceded to his rigid and rigorous discipline. In the years before their marriage, not only did Elaine follow Bill's instructions for improving her drawing and painting, she listened to him as he talked incessantly about art. He showed Elaine his own new paintings, talked about his favorite artists of the past, and convinced her that modernism in all of its permutations was, in actuality, an extension of the great traditions of Western art. Though some doubted Bill's mastery of English, most of the artists who knew him in the thirties and forties agree that his intelligence was remarkable.

With Elaine and Bill, eager student matched eager teacher; and, as in all such cases, the teacher learned as much as the student. Bill learned words; he learned to articulate ideas about art. Their mutual education, however, was suspended in the powerful emotional chemistry resulting from the mixing of their two strong personalities. Although Elaine and Bill loved each other passionately and admired each other's talent and intelligence, it seemed clear to friends who knew them—as it did later to Elaine—that they were unprepared to deal with their sharp contrasts in personality. As Elaine's vivacity seemed more brilliant against the somber shades of Bill's deep anxieties and resulting depressions, and as Bill's desire for solitude pulled against Elaine's social bent, the conflicts accrued and resulted in emotional eruptions.

Nell Blaine watched Elaine and Bill at a party of artists, poets, dancers, and jazz musicians in her studio. "It was clear that they were sexually involved, that they were a couple. It was also clear that the mighty attraction they felt for each other didn't keep Elaine from flirting. At the party, Elaine had a few drinks and started giving some guy the eye. Bill, who didn't drink much then but who had also had a few drinks and had reacted pretty strongly to them, got very surly. After a while, I heard this terrible crashing sound and went to investigate. Bill was butting his head against a wall and hitting the wall with his fists, and he was making a terrible racket, cursing and crying. He was having a tantrum really. And he kept at it until he got Elaine's attention—which, after all, was what he wanted—and they left the party. Everyone sort of exchanged these sly smiles and knowing looks. It was like we all knew that the sexual thing was very strong between those two and that it was probably so strong that it would cause them a lot of trouble."

At first Elaine and Bill painted together in his loft at 143 West Twenty-first Street, where neighbors Edwin Denby and Rudolph Burckhardt had almost daily opportunities to see works-in-progress by both artists in the de Kooning studio. Denby, who became one of the first collectors of Willem de Kooning's work, believed Bill possessed a heroic talent; he found Elaine charming and brilliant. Burckhardt, from his first conversations with Bill that took place after the incident with the lost kitten, sensed that Bill's talent was matched in scale and intensity by his ambition; he saw that Elaine, if not in possession of a great talent, brought colossal ambition to the union.

"They both impressed me," says Burckhardt, "because they worked so hard. Life wasn't easy. For a while, Bill scraped by on money he earned from dressing windows for A.S. Beck. But he never faltered in his commitment to his painting. When Beck offered him a hundred dollars a week—and that was a lot of money in the late thirties—if he would move to Philadelphia and design store windows there, Bill turned the opportunity down.

Better, he thought, to be poor in New York and able to work, than to be financially secure in Philadelphia—a city that seemed to him to be nowhere near art."

Bill was already a serious painter, operating on a large scale, Burckhardt recalls. And Elaine, he thought, was "a kind of wonder woman," who would dare just about anything.

Even then, as Elaine and Bill joined friends for meals and conversations, for endless cups of coffee and talk in the cafeterias of downtown New York, Elaine promoted Bill as an artist. Even then, friends recall, Elaine quoted Bill on every subject. And even then, Ernestine Lassaw says, echoing similar comments by numerous people in the de Kooning circle, Elaine quoted Bill as saying things she might have wished he had said, that she found useful for him to have said, but that he may not have actually said.

Elaine's insights into the processes of art, as well as her ability to articulate complicated abstract concepts, pleased Bill, who at the time was often willing to let her interrupt his talk about art and, with her perfect English and flexible vocabulary, shape and set an idea precisely in place. Further, Bill was pleased to note that she soon won the respect of his friends, as they realized that she possessed a keen intelligence that she used to analyze ideas and images in art.

During their early years together, Bill and Elaine insatiably saw exhibitions, drew and painted in the same studio, partied and talked with a lively group of artists, poets, musicians, dancers, and critics. In this milieu of high-flying ideas and energetic creative people, Elaine Fried and Willem de Kooning forged their relationship, which would include not only marriage but inevitable competition—with each other and with other would-be giants in that world—for fame, fortune, and power.

"Elaine liked a lot of artists, but only one could be the king," insists Grace Hartigan. "And from the beginning, Elaine was going to make sure that Bill was the king." Elaine, say friends who remember her early admiration for Bill, was equally determined to be the queen to Bill's king.

Rudy Burckhardt thinks Bill decided to marry Elaine after "fussing about having to get up and take Elaine home to Brooklyn on the subway. That would be at one or two o'clock in the morning. And she would never stay over because she lived with her mother and had always to report in at least some of the time. Finally, I think that's why Bill married Elaine. So she'd stay over more of the time. So he wouldn't have to get dressed and ride the subway in the middle of the night."

Having surprised even himself by deciding to marry, Bill took the unprecedented step of ceasing painting in order to prepare for Elaine's presence in his loft. Scrupulously tidy and an excellent carpenter, Bill constructed a special bedroom for them to share, with built-in storage spaces and a platform bed. Placing the room in the center of the loft, he provided separate working areas on opposite ends of the gigantic space for himself and for Elaine.

At the time of their marriage, Elaine was beautiful—lithe, fair, with coppery hair and eyes that contained a deep golden light— and she was fun, daring, lively, and sexy. Ernestine Lassaw, along with Elaine's mother, thought Bill was unattractive—a short blond man with bad, yellow teeth. "I wondered," Ernestine admits, "why Elaine would be interested in—would marry—that old man." Other women, however—like Grace Hartigan and Nell Blaine—agreed with Elaine, who thought the young Bill de Kooning handsome and virile.

Elaine told writer John Gruen, "I decided to get married to Bill from the moment I first met him. We took a shine to each other immediately. It actually took a couple of years before we did marry, but we really knew we always would. Anyway, in December 1943—two days and two years after Pearl Harbor—we went to City Hall and got married. I was twenty-three years old.* My

* She was actually twenty-five. By the time of her interview with Gruen, Elaine had begun to lie about her age—a fact only discovered after her death in 1989.

brother Peter and my father and Bart Vanderschellen, who was a Dutchman who fought in the Spanish Civil War, all came to the wedding—and also Alain, the cartoonist for the *New Yorker,* whose real name is Daniel Brustlein and who is a terrific portrait painter."[2]

Elaine also reported: "Actually, the wedding was kind of bleak. Afterwards, we went to a bar in the downtown district and we all had a drink. Oh, I guess it wasn't that bleak. It was kind of amusing. But it was not festive. I mean, nobody rolled out the red carpet for us. And then we went back to Bill's studio on Twenty-second Street and we both continued to work."[3]

Marie Fried refused to attend the ceremony because, according to Elaine's sister, Marjorie, she thought Elaine—then twenty-five—too young to marry.[4] "Naw," says Rudy Burckhardt, "Marie just didn't like Bill then. Maybe she thought Elaine was too young to marry a man that much older, or maybe she just thought he wasn't good enough for her brilliant and beautiful Elaine."

Elaine was by all accounts the center of admiring attention from men. "A femme fatale," says artist Will Barnet. "Men were always after Elaine. She was very beautiful and very lively." Yes, agrees a female friend from the period, "and Elaine was the master—or should I say the mistress—of manipulating men. I mean, she crooked her little finger and got what she wanted. She was a very talented flirt. Really," she says, "I've always thought Elaine thought of herself as a great courtesan—a woman who used sex and allure and charm to control an empire."

Bill's habit of drinking coffee all day, along with his anxiety about his painting, often kept him awake at night. Restless and depressed, he took long walks along the dark lonely streets of Manhattan. A friend returning from a party just before dawn one morning remembers: "I was walking along the street and saw a figure coming near me. And when the street light fell on his hair, I knew it was Bill. He had that luminous blond hair that caught light. So," he continued, "I walked toward him and greeted him.

He nodded his head and I fell in alongside Bill and we walked and walked. After a bit, down near the docks, we sat for awhile on some empty wooden boxes. Bill said, 'You know, Elaine is very beautiful.' And I agreed. Then he said, 'Elaine is very beautiful to a lot of other guys, too.' Well, what could I say? He was right. But I knew that he was really saying that Elaine was breaking his heart, that she was out with some other guy. But that's all he said."

GATHERING FORCES TOGETHER

Parties were never as wonderful as in the 1930s, when everyone chipped in for whiskey and all the girls were beautiful.

—THOMAS B. HESS

The artists in New York, both those who were native-bred and those who had fled the war clouds gathering over Europe, worked and talked and partied. During the Depression, many found employment as artists in the Federal Arts Project—known affectionately as "the Project"—and experienced the euphoria of being able to work full-time as artists. Artists who remember the period before World War II speak of the innocence and happiness of the time, and they often long for the sense of community among artists that preceded the ascendancy of art as marketable goods. "Once there was money to be made," Elaine commented, "a lot of the artists started competing for the attention of collectors, and the collectors started competing for works of

art that made them look good. But before that happened, when I first met Bill, we hadn't a clue that it was possible *not* to be poor if you were an artist."

Like their artist friends in the years of the depression and World War II, Bill and Elaine lived an informal life ordered around the primacy of work and the fun of casual meetings and spontaneous parties with other artists. And like their artist friends, Bill and Elaine were largely free of the constricting schedules forced upon those who held nine-to-five jobs. One morning Elaine watched Bill leaning on his elbows on the windowsill, smoking cigarettes and staring at the street below. "He was totally absorbed," she said. Unable to determine the object of his interest, Elaine asked him what he was watching.

"Look," Bill spat. "Look at all those poor dumb sons-of-bitches. *They* have to go to work. We're so poor it doesn't matter. We can do what we want to do. All day."

Doing what they wanted to do all day, every day, became the central issue in their joined professional and personal lives. For Bill, that meant painting with as little interruption as possible. But it also meant that the anxieties that drove his obsession with painting induced dark, solitary depressions and hostility toward those who came near him.

For Elaine, doing what she wanted all day every day meant painting, too, but it also meant knowing about everything that happened in the art world and to other artists; it meant "making the scene" and it meant trading gossip. Elaine's intelligence— Esteban Vicente called it "a remarkable, perhaps sort of mad genius"—encompassed both her own studio and the embryonic cosmos that would become the New York art world, and she enjoyed the power of knowledge and control in each sphere of activity.

From the beginning of their relationship, Elaine had joined Bill at the cafeterias and on his visits to artists' studios; they talked with their friends continually and fervidly about art. Not one to listen passively to the conversations of older and more experi-

enced artists, Elaine participated fully in discussions of ideas and in the development of agreed-upon points that eventually would form the doctrine of Abstract Expressionism. Elaine seriously selected words to describe processes and ideas related to creativity, and she was both precise and logical in her attempts to clarify and articulate the artists' work that filled her world.

For the most part, artists lived in downtown Manhattan in a subculture contained within several dozen blocks, a geographic area roughly delineated by Twenty-third Street on the north, by Sixth Avenue on the west, and by Third Avenue on the east and extending to a few blocks south of Washington Square. But, like all communities based on shared interest, it was a subculture ultimately defined not by geography but by attitudes, topics of conversation, values, passions, meeting places (chosen by plan or chance), and people. When the Federal Arts Project ended, artists continued seeing each other when they attended lectures or took classes at Hans Hofmann's school on Eighth Street, and meeting in the cafeterias where they discussed endlessly the latest exhibition of the American Abstract Artists. In the thirties and forties, Elaine and Bill, along with other serious young people in the New York creative world, joined informal gatherings in tenement parlors, in side-street downtown loft studios, and in cafeterias that sold coffee cheaply—to talk, argue, and test ideas. And to have fun.

In that yeasty downtown subculture, Elaine and Bill lived and worked. They moved among other artists, not anticipating that in the future, friends would become associates, especially beloved friends would remain affectionate and generous, and allies would become competitors. "This," Elaine said, "was before there were many galleries or publications or all of the other formal means of communication in the art world. This was when the art world belonged to artists. And it was all very informal." Indeed, it was almost casual.

Elaine and Bill, fervent participants in the art world's intellectual and social activities in the years before Bill was widely recognized as a major American artist, helped set in motion the forces

that would later unify—more or less—some of the fiefdoms of American art. But even then the de Kooning camp, or kingdom, was forming.

As Elaine and Bill de Kooning, handsome exemplars of art-as-life-as-art, moved easily through the New York art world and into the circles around it, they were welcomed into the midst of conversations among artists in cafeterias, studios, and cheap restaurants. They knew the artists and art followers who, as Elaine said, "mattered. We knew everyone who was important or becoming important. And, " she added, "everyone was friendly. Competition hadn't set in yet. No one had any money and no one had any hopes of ever having money. There was nothing to compete *for*. So we talked. And we partied. And we had fun. This was before anyone drank very much so we all drank gallons of coffee."

The art world was small then, and as Elaine was fond of pointing out, "everyone knew everyone else." But, contrary to Elaine's insistence that the art world was a small, friendly brotherhood, free of competition among its members, groups were forming around ideas and styles of work, and power was brokered in the currency of influence.

In this milieu, not only did artists know each other, they shared ideas and meals, they exchanged criticism and techniques, and they celebrated and commiserated the good and bad fortunes that flowed through their community. Few of the artists had telephones, so they dropped in on one another casually and sat around studios drinking coffee and discussing each other's work. "We were all very poor," Elaine said, "and there just wasn't any money anywhere. No one had any money, and we didn't seem to need very much in those days."

In any event, at that time it was art, not money, that interested Elaine, Bill, and their community of artists. And art, even then, was measured in terms of recognition: the artist who sold a work or, better, had a piece chosen for a well-regarded and well-reported exhibition was applauded and celebrated by the downtown artists' colony. Shortly after Elaine met Bill, she had proudly

boasted to friends that in 1936 one of Bill's paintings had been included in a show, New Horizons in America, at the Museum of Modern Art. For her, this was an official affirmation of her own conviction that Willem de Kooning was an important artist, a major talent awaiting recognition. Moreover, she noted that Bill was in good company, his work exhibited with that of Ilya Bolotowsky, Byron Browne, Stuart Davis, Arshile Gorky, Balcomb Greene, Jan Matulka, and George McNeil, among others—all artists who were exploring various aspects of abstraction, all artists whose work Elaine admired.

Bill, disdainful of both the academic and the social-comment art of the twenties and thirties in the United States, was deeply committed to the embryonic American modernist movement, but he was not willing to sacrifice his own interests on the altar of consensus. In his mid-thirties, without having exhibited his work, Bill had a reputation among other artists for working out his own ideas in paint and for talking brilliantly about those ideas not only with other artists but also with poets, musicians, and others who lived in and around the lower Manhattan art world.

In her alliance with Bill, Elaine stepped closer to what she regarded as the "important art" of the time and into Bill's circle of friends. They continued to enjoy especially close friendships with Ernestine and Ibram Lassaw and with their neighbors Rudolph Burckhardt and Edwin Denby. And they extended their circle of friends steadily. Bill—to Elaine's delight—knew everyone in the art world; and eventually Elaine met them all. She found that many of the artists who had already acknowledged Bill as a leader among them now enjoyed her company as well. The newlywed artists regularly saw Barnett Newman and David Smith, artists they considered both serious and intelligent. They also met Harold Rosenberg, who would quickly become a friend and who later, as an influential critic, contributed to the wide recognition of Willem de Kooning as a major—perhaps the primary—figure in Abstract Expressionism, the New York School of painting of the fifties and sixties.

"I always think of them as 'the Brotherhood,'" Elaine explained. "Artists are like the Mafia. They look out for each other. They take care of things. They only let the right ones in on the secrets. The Brotherhood was forming when I first met Bill."

Dutch-born Bill, though not as gregarious a person as Elaine, had noted with pleasure that the population of artists in America—abstract and otherwise—swelled in pre–World War II days, as members of the European creative community fled Hitler. In the late thirties and early forties, Amedee Ozenfant, Stanley William Hayter, Fernand Leger, André Breton, Eschaurren Matta, Kurt Seligmann, Yves Tanguy, Max Ernst, Salvador Dalí, André Masson, Pavel Tchelitchew, and Piet Mondrian sought refuge in America and affiliation with the American avant-garde. All of these men—and others—would gain prominence in the United States and on the international art stage. And all of them would pass through the de Kooning sphere at one time or another.

When Bill and Elaine met, Arshile Gorky affixed himself to their expeditions and joined the couple in explorations of galleries and museums and in conversation with other artists. Elaine drew sharp contrasts between Gorky and John Graham. Gorky, she said, was tall and lean—"a little like a figure by El Greco"—and often wore unconventional clothing that elicited sidelong glances or remarks from strangers. Graham, she remembered, was small, compact, dapper, and self-assured to the point of arrogance. And she said that, even in those early years, Bill felt most comfortable in housepainter's clothing. The three artist friends were, she thought, a visually amusing combination.

Despite their differences in appearance, all three men came from European backgrounds and were familiar with a wide range of European art that, by and large, did not interest their American friends. Moreover, both de Kooning and Gorky drew with great facility, a skill that they considered fundamental to painting. These things, contended Elaine, set them apart in the hive of American artists.

These three immigrants had served as a nucleus of the New York art scene—and they had supplied the essential genetic coding for its further growth and division. They were soon joined by other artists, the native-born as well as the recent arrivals to New York, who wanted to share their ideas and sense of purpose. During the decades before World War II, circumstances did the rest, as the Depression forced artists deeper into poverty and as the Federal Arts Project allowed many of them—including, briefly, Bill de Kooning—to earn a living by doing art. The de Kooning circle included not only friends and fellow artists Arshile Gorky, Stuart Davis, and John Graham but also painter Franz Kline (fated to later become Bill's favorite drinking partner) and other artists who would form the ruling class of Abstract Expressionism.

Two other couples entered the lives of the de Koonings: Lee Krasner and Jackson Pollock, two painters who would marry and, as a couple, compete with Bill and Elaine for status in the art world; and May Tabak and Harold Rosenberg, who would side with Bill and Elaine against Jackson and Lee.

Some years later, reflecting on the importance of the artists' community during her early years with Bill de Kooning, Elaine said, "I was going to quote from the Old Testament, and say that 'a man sharpens his face on the face of his friends.' This is why important movements in art have always taken place where groups of artists could get together. And then something happens. It's some kind of electricity. A movement is never started by one; it's always give and take, and it's crucial for art. . . . This whole thing of the exchange between artists, even though artists work in form and they keep saying that they can't talk about it because they are trying to do something that can't be expressed in words. However, painters are the biggest talkers on earth."

What seemed to Elaine and Bill to be merely the work, talk, and social activities of artists eventually coalesced to form the kingdom of Abstract Expressionism. Even as the lively couple made their way among the studios and parties and meeting places of the

pre–World War II world, the would-be dukes and earls, the knights-errant, the court jesters, magicians, and ladies-in-waiting were assembling. As they displayed their costumes and manners, their wares and talents, Elaine and Bill looked them over and formed friendships, alliances of convenience, and social pacts.

Reading destiny in hindsight is dangerous business. Despite current speculation about Elaine's political skill and Bill's insistence on being recognized as "the best," no evidence suggests that Elaine and Bill consciously plotted the process for crowning Bill king of the art world. But Elaine—true to Ernestine's observation that she "always liked to know everyone first, and to have all of the good ideas before anyone else did"—was as smart as she was talented. "Elaine seemed to know before anyone else that the art world would expand, and that artists would either be powerful and famous or poor and unknown," observed Will Barnet. And circumstances—combined with Elaine's and Bill's natural sociability, competitiveness, and attractiveness—did establish the de Koonings as leading players in the avant-garde. From that recognized position, they set in motion forces that eventually identified Bill as "the greatest living American painter."

"Listen," says one survivor from the pre–World War II art scene, "Elaine knew *intuitively* what she was doing. And Bill—who always affected aloofness, a sort of innocence and purity—Bill was smart. They were both smart cookies, smart operators. And I think they caught on to what was happening very early, before anyone else. They were very competitive—and they were determined to be the top dogs."

When first married, Elaine and Bill, like other artists, lived illegally in a commercial loft, which provided the large, cheap space needed for work. Once used for manufacturing, their Chelsea loft had high ceilings, naked wooden posts and beams, and thick-boarded but uneven floors. In that rough but light-filled space, Bill had lived with a secondhand bed, a few chairs salvaged from trash heaps, a hot plate, a few dishes and cups, and an assortment of flatware gathered from cafeterias. He had built shelves for art

supplies, worktables, and a sturdy easel, and he had installed, with the help of a friend, a fine high-fidelity sound system before such a sound system could be purchased commercially.

When Bill and Elaine decided to marry, however, Bill built a bedroom for Elaine. "It was very handsome," according to Rudy Burckhardt. "He built in all kinds of furniture, and gave it the neat, well-planned quality of a ship's interior. Then he painted it pink. Everyone admired it very much. And of course Elaine was delighted with it and wanted everyone to see it."

In their loft, Elaine and Bill had no refrigerator, so they used the window ledge for keeping food in winter. "In summer," said Elaine, "we just bought our milk and drank it. We didn't try to save it. A refrigerator was unthinkably expensive for us in those days."

But the gadgetry of housekeeping and the appurtenances of interior decoration, like the then-orthodox covenants of marriage, did not interest the newlyweds. "Elaine was not a homemaker and didn't like to cook," Rudy Burckhardt said, repeating an observation made by other friends of the time. "She didn't want to be bothered with cooking or cleaning," says Ernestine Lassaw. "Elaine learned to do a few things like boil potatoes, but she was no cook and not very interested in cooking. Or in anything else to do around the house. And even if she bothered to cook a meal— which for her was a big undertaking—Bill probably wouldn't show up. He had a habit of not showing up. He'd be out talking with people in the cafeterias, or he'd stop by to visit somebody and just stay."

"Yes," remembers Ibram Lassaw, "Bill used to come to our place and start talking. Ernestine would invite him to stay for dinner and he would."

"But," Ernestine reminds her husband, "we often invited both of them to dinner. Very often. And they were glad to come."

During World War II, they were indeed still as glad to get invitations to dinner as they had been during the Depression years, according to Elaine, who added: "When we had no food and no money, and when the heat had been turned off in our building, we

sometimes got into bed. We had dinner in bed, but I didn't cook the dinner. I just read aloud to Bill from the cookbook. And we imagined what it would be like to eat fancy things, and that was our dinner."

In his search for ways to make money, Bill turned to Burckhardt for help. Could Rudy help him get work making drawings for *Harper's Bazaar*? In hope of laying hold of income from that source, Bill developed a portfolio of fashion illustrations. The art director at the magazine, however, rejected de Kooning's illustrations and instead asked him to do a series of drawings of hairdos for little girls, offering to pay him $75 apiece for the finished works.

Elaine posed for Bill, and he drew hair. "Well, that was pretty amusing," she remarked. "Bill, when I first knew him, always drew and painted men. They were mostly bald men. I asked why, and he said it was because he never liked to draw hair. But," she added, "he could draw anything. And pretty soon, he made wonderful drawings of hairdos and the money helped us a lot."

But money remained scarce for Bill and Elaine. It was difficult to pay the rent, though it was only $35 a month and Elaine was good at holding off the landlord. Mr. Finkelstein would climb the long flight of stairs, knock on the studio door, and demand his rent. Sometimes Bill and Elaine wrapped themselves in silence and pretended not to be at home; often Elaine met the beseeching landlord at the door and either she promised imminent payment of all rent owed or, more likely, she vamped him. Mr. Finkelstein rarely descended the stairs with any rent from the de Koonings.

Bill earned most of the money he and Elaine required, however, by his old standby skills—housepainting, carpentry, and commercial art. On the days when Bill worked outside the studio, he left before Elaine got up. Often, she recounted, he would leave slices of cheese, apples, and biscuits for her, a gesture she found "very thoughtful, very kind."

Elaine recalled that she tried to devise ways to earn some

money. Knowing that Rudy Burckhardt sold his photographs to *Harper's Bazaar*, Elaine asked him to help her create a portfolio that she could use to get work as a fashion model. In preparation for their photo date, Elaine visited a nearby retail store, S. Klein's-on-the-Square, and bought several outfits. When she posed in them, Rudy recalls, the price tags had to be hidden because Elaine planned to return the clothing the next day. But even with Burckhardt's glamorous photographs, Elaine was not able to get work as a fashion model, and she worked only sporadically in those years.

Later, however, in 1942, Elaine worked briefly at a full-time job at Liquidometer, helping the de Kooning household coffers as she helped the war effort by painting the dials for airplane instruments. She worked alongside Jackson Pollock, who was, like Elaine, another poor artist trying to make ends meet. "Jackson brought sandwiches to work," Elaine laughingly recalled, "and I always managed to share them with him. And after awhile he just knew that I would get most of his sandwich so he started bringing two. And they were good."

When Ernestine and Ibram Lassaw decided to get married, they asked Bill and Elaine to accompany them to City Hall and witness the event. Elaine's mother, hearing of the imminent marriage, asked her daughter, "Why couldn't *you* have married Ibram Lassaw? He's a real prince-charming—handsome and talented, and really much more interesting than Bill."

After the Lassaws exchanged vows and signed papers, they and the de Koonings walked over sixty blocks uptown to lunch at a Scandinavian restaurant that featured smorgasbord. "They put out quite a spread," Ibram remembers, "on a circular table that rotated, so that half of it was available for the diners while the other half was in the kitchen being replenished. It was marvelous looking, and there was a lot of food."

Elaine, on hearing that the restaurant management suggested three trips to the table and three plates of assorted foods, announced, "Oh I can't begin to eat that much." But, the Lassaws recall with humor and fondness, "Elaine ate about six meals. She

ate enough for days. She was always hungry and she always liked food. It was wonderful."

When they completed the festive lunch, the Lassaws and de Koonings spent the remainder of the day in the Metropolitan Museum, four happy friends together in the presence of a great art collection.

Neither Bill nor Elaine championed monogamy as a guiding principle of organizing life together, before or after marriage. At the time of their wedding, however, Bill told friends that he was prepared to live faithfully with Elaine. No one remembers Elaine having announced a parallel goal for herself.

Shortly after their marriage, Elaine made no effort to hide from Bill an affair she was having with another artist—and, indeed, she may have flaunted it in hopes of punishing Bill for paying insufficient attention to her. "Elaine had probably been sleeping with the guy kind of casually before and after she married Bill. It wasn't important to Elaine. But then Bill snapped at her, had one of his hellish tantrums, when she interrupted him at work," says a friend. "So Elaine just decided to show Bill that she had her own life, that she didn't have to take shit from him." Within days Bill retaliated: he, too, let it be known among their friends that he was sexually involved with another woman.

"Maybe it just started out with Elaine being flirtatious," says Rudy Burckhardt. "She was, of course, and casual about sex. She liked to dance with different guys, and kiss them, and flirt. And it was clear that she sometimes had sex with them, too. But it was strange. It didn't seem to matter much to Elaine. She was, oddly enough, a kind of loner. Sex was just something she did when she wanted to."

Another friend says, "I was always curious about Elaine and Bill. It was obvious that there were tensions in that relationship from the start. While they must have had some sort of understanding about each one's sexual affairs, I think they were both

jealous and it seemed to translate into competition sometimes. At parties or in groups of artists, you could see that Elaine made herself very visible and very attractive to other men—especially other artists—and you could see Bill burn until he picked up some chick or another. There were a lot of both men and women around who could be picked up pretty easily, and being able to display that you had picked up either Elaine or Bill was a kind of triumph. Even then. They were prizes. Trophies. Both of them. They were sexy as all hell, and they represented success even before they were well known—success at *being an artist*—which is what everyone wanted even then. Maybe," he adds with a chuckle, "some of us thought that success as an artist was a sexually transmitted disease in those days."

"From the first," insists a dealer who knew them both, "they got into an awful spiral of competition. She would do something awful; he would do something more awful. He would be inconsiderate and mean; she would be spiteful and cruel. There was never a honeymoon or a rosy glow around *that* relationship!"

Grace Hartigan says that Bill took note of Elaine's brash pursuit of other men and that he said, "She started it. She started all dat. I wasn't going to do it. But when she started it, I said, okay, I'll show you. And I did."

By 1944, when Rudy Burckhardt returned to New York after service in the Army, he found that the de Kooning marriage, though only a year old, had begun to fray. "Bill and Elaine," he said, "never seemed compatible. They were just different types. Bill explained that they had different rhythms—and he acted them out with his hands—he was slow and flowing, rhythmical; Elaine was staccato and chopping." Burckhardt noticed that Bill was irritated when Elaine finished his sentences for him and would sometimes snap at her, "I wasn't going to say that."

Soon after his arrival in New York in the forties, Spanish-born artist Esteban Vicente met the de Koonings and surmised from their behavior that they had what would later be called an open

marriage. "They seemed to lead separate lives even then," Vicente said. "Elaine was seeing other men, and making no secret of it. Bill didn't seem to notice or to care."

Regardless of the tensions that existed between them, Elaine and Willem de Kooning became the "darling couple of the art world," according to their friend Rose Slivka, a poet and art critic whom they admired. Elaine and Bill—attractive, lively, and talented—lived and worked at the center of the New York art world from the time of their marriage in 1943 until they separated amicably in 1957. They knew everyone who inhabited the rich subculture of the avant-garde—the artists, poets, musicians, critics, art dealers, collectors, and hangers-on. More to the point, Elaine and Bill—in word and deed and artwork—often cut the path for other artists.

Elaine dealt in certainties, whether espousing a political view or evaluating current fashions. Direct and prone to action rather than contemplation, she was impatient with ambiguity and infinitely intrigued by sharp contrasts. In her mind, Bill's significance was clear. To her—and, therefore, she was convinced, to others as well—Willem de Kooning possessed a mighty talent, visible in his work and mirrored in his conversation. He was chosen by the gods—by fate or genetics or other mysterious forces that ruled the universe—to be recognized as the most important artist of the century. "I just knew," she said, "that Bill was a very great artist. And always," she stressed, "always, I knew that about him."

Independent-minded Grace Hartigan thought that something must be deeply wrong with Elaine's strength of character. When she met the de Koonings in the forties, Hartigan wondered, "What was this marriage, and who were these beautiful, talented, bright people?" She said, "What always bothered me about Elaine was that she was willing to be queen to anyone's king. I didn't fault her for ambition. I thought that was fine. I just didn't like the ambition being, at the beginning at least, linked entirely to her identification as the *wife* of a famous or to-be-famous man."

But Elaine was programmed, in the society she then knew, to be a wife, and better to be the wife of a famous man than of an insignificant man. When she and Bill were first married, Elaine wanted the security and protection of marriage to an important man and the gratification of knowing that she contributed to his success. Even though she was ambitious, she felt it was better to exercise ambition on behalf of a husband than for oneself. It was not until the women's movement had created waves within the art world that Elaine decided to ride a different tide to its flood.

Elaine saw clearly that something was happening in New York and that younger artists were arriving, settling into the lofts and cheap tenements of downtown Manhattan. "Yah, yah," Bill agreed with her: something important was happening. But he was too busy to take time from his work and his conversations with other artists to analyze the social changes around him. Elaine, on the contrary, was as fascinated with the expanding world around her as she was with the growing possibilities of her own work as a painter and of her work on Bill's behalf.

"Bill was proud of Elaine," observed Rudy Burckhardt. "I think he enjoyed Elaine's humor and liveliness, and enjoyed the fact that other guys found her attractive. But Bill liked to be alone and to paint. Sometimes Elaine was distracting, to say the least."

Although Bill and Elaine each flaunted sexual conquests, they were artists first; and, as artists, they were fast friends. But by the middle forties, the de Kooning marriage showed the accrued tatter of competition between strong-willed and talented individuals. Elaine recounted that at one time, while they were still sharing a studio, working at opposite ends, she unthinkingly began to whistle as she worked, a habit she believed she picked up from Bill. Concentrating on her work, she was unaware of her whistling (which, she admitted, "was pretty tuneless") until Bill shouted from the other end of the loft, "No whistling!"

She apologized, and both artists returned to their work. Before she realized what was happening, however, she began to whistle again. Soon, as the volume rose, Bill shouted again, "No whistling!"

She stopped. She apologized again. And they returned to work.

The hours passed, until Elaine realized that Bill stood beside her, talking. She looked up, amazed to see him. He rubbed his stomach. In mock-caveman talk he said, "Elaine. Hungry. Eat."

Sherman Drexler says, "Bill realized that he had interrupted another artist at work, that he had impinged on the spaces of an equal. And Elaine realized that Bill knew that."

They both laughed because they both knew that Elaine was not any more interested than Bill in the wifely duties of preparing meals. Bill shrugged and said, "Elaine, we're like two bachelors. And what we need is a wife around the house to take care of us."

They laughed and left the studio together to search for a cheap restaurant and a cheap meal. Workers have to eat.

6

ART WORK

Bill and I always thought it was the *work* that counted—and that work counted more than anything else for an artist.

—ELAINE DE KOONING

As Elaine and Bill scraped together a living from odd jobs and imagination, they invested their energy in art, working steadily on their paintings and drawings, working very hard and very long hours in Bill's studio. But even when deeply in love, the two did not always fit well in the same space. Without reference to her own musical tendencies, Elaine told John Gruen, "I hate to say this, but Bill whistled while he worked. You know, Mozart and Stravinsky. Bill could whistle these fantastic melodies. But I found it just a little, tiny bit irritating. I like silence when I work. Also, Bill would work at a very slow pace. He'd make a few strokes, then go back and sit down, whereas I continued painting away. Bill said my pace was like Gorky's—hacking away at the canvas. Bill wasn't like that."[1]

Elaine, giddy with an admiration for Bill that surpassed her irri-

tation at his whistling, and delighting in her own daily work as a painter, remarked to Bill at one point that she loved hard work, "loved the sheer joy of doing art work."

Bill looked at her a few seconds before he reminded her, "When painting gets interesting, it's no fun."

Bill's work habits were well established when Elaine moved into his studio, and he was neither inclined nor able to alter them to meet the requirements of someone else—even, or perhaps especially, a woman he loved—in his domain. For awhile, when Elaine was eager to play the role of obedient pupil to the grand master, they occupied the same work space with only mild abrasions.

Elaine continued to draw under Bill's direction, often repeating and varying compositions based on still life arrangements that the two of them concocted from odd objects around the studio. Bill studied each of Elaine's drawings, made suggestions for improvement, praised some and ripped some up. Then he directed her to go back to work, to make still more drawings of the still life.

While she worked at one end of the studio on still life drawings, Bill stood before his canvas at the other end, painting, wiping out, drawing on the surface. He repeated again and again his personal ritual of making and destroying images. Layers of ghost images combined with opaque fragments of fresh paint, and Bill watched, considered, took action again and again. "But it was all really spontaneous with Bill," said Elaine. "He never had a picture in his mind; he was always trying to *find* the painting by painting."

Despite the apparent spontaneity with which he applied and manipulated paint on his canvases, Bill was a slow worker. And, though engaged in the most meticulous and painstaking style of academic drawing at that time, Elaine was a rapid worker. Bill spent hours looking at a canvas, smoking and silently reflecting on what he saw. Elaine worked feverishly, grasping quickly the basic volumes and shadows of the still life set up before her, making quick and sure decisions about shading and line. "Bill said that I

worked like Gorky. Chop, chop, chop. He thought that was very amusing," she recalled.

Elaine also recalled that, "in those early years, Bill kept destroying everything he'd paint. You see, he'd get furious—and he'd be depressed and angry with his work. There were always people around who thought Bill was absolutely fantastic and great. But Bill used to be extremely irritated at certain of these admirers— especially when they came around to his studio and watched him paint. I'd never encourage him about his paintings. I just thought he was great, which he knew. Also, I didn't feel at all competitive. I was painting what I was painting—and he did the same."[2]

Bill, preoccupied with his search for an imagery that could hold his passion for painting, often acknowledged the loneliness and difficulty of being an artist. Frequently he would tell friends, "I'm beating out my brains. I'm getting nowhere." And while other artists eagerly watched Bill's work (sometimes, say friends, being influenced to the edge of plagiarism), Bill often destroyed work that he found inadequate, and he painted over work that fell short of his expectations. But even when he was despairing darkly and being brutally critical of his efforts, Elaine championed Bill's painting. "Every time he touches a canvas, he makes art. He can afford to waste parts of paintings that other artists would have to work a whole lifetime to even get," Elaine pronounced.

Bill painted as if in a continuum, never breaking the flow or chain of imagery by finishing a painting. In this pattern, he continually reaffirmed painting as a metaphor for life. Finishing a painting thus symbolized death, an ending or completion of work. Work is the constant theme that runs through the story of Elaine and Bill de Kooning: his work and her work; work as action that defines life; work as the center of life itself. Work was the core around which all other aspects of their life—including friendship and marriage—were organized.

Work—the gestures, accidents, and processes of exploiting the physical properties of paint on a flat surface—simply dominated the thinking of the archetypical Action Painter, Bill de Kooning, as

three important women in his life—Elaine, Joan Ward, and Ruth Kligman—have all testified. Bill really only cared about painting, and he never wanted to be out of his studio or more than superficially attentive to anything or anyone else.

Burckhardt says, "While Bill's big ambition drove him to more and more extreme risks and experiments in painting, Elaine had her own big ambition. She didn't want to be just an artist's wife; she wanted to be a fully fledged, fully appreciated, and fully active artist. She wanted her part of the action." Elaine and Bill each wanted the same big prize from life: to be a master painter. But if their goals were the same, each worked along decidedly different courses.

For Elaine, work was a means for proving herself, and it was the base from which she built a far-reaching social life. Less single-minded than Bill as a painter, and less obsessed with the process of painting, Elaine enjoyed company. Her studio became a meeting place for her friends, for younger artists, for those slumming in the art world who would not have been admitted to other artists' studios.

Elaine admitted everyone into her sphere of work and focused attention on questions related to working in art: What does a work of art embody, evoke, or mean? Since all who are called cannot be chosen, who will be the workers of art; how and by whom will they be chosen? And how are works of art—the products of a mysterious form of labor more widely parodied than understood—to be judged? Elaine, unlike Bill, rarely distinguished between working as an artist and being an artist. She worked at art and was therefore an artist, but Bill thought of himself as an artist first and therefore forever yoked to the work required of him. Elaine's more American way of thinking, however, led her to work toward the goal or reward of being an artist. She was ambitious, competitive; she wanted a career as an artist. And she wanted a career for Bill.

Whether missionary, proselytizer, or pamphleteer, or the art world's version of the beckoning and welcoming Statue of Liberty,

Elaine invited everyone she met onto the shores of art. For her, the world would be perfect if everyone became an artist, albeit subject to the king, Willem de Kooning.

On that they agreed. Elaine said, "I always knew that Bill was special." And because he was special, Bill told Elaine, "I always think the subway turnstiles will open for me and let me pass."

Neither of them wanted to dilute energy or jeopardize talent by working at something other than painting. Despite the grinding poverty that Bill and Elaine shared, she, too, decided against doing outside work, jobs that would interfere with painting. She said she earned "a few dollars as an artist's model, sold a few paintings, and worked for awhile in a defense plant that made airplane dials. . . . But I just never thought an artist should do *other* things. There was always some way to make or get money. And that wasn't what was important. Bill and I had jobs, you might say; we were self-employed full-time as artists."

Very soon, however, Elaine found Bill's daily routine boring. She wanted to leave the studio more than he did, and she wanted more company and more often than he did. In a short time Elaine sought conversation and amusement in the cafeterias on her own, and she began the fabrication of her singular combination of social-political-intellectual life.

Often, while Bill worked in the studio, Elaine broadcast to eager listeners his latest accomplishments and repeated his latest comments and insights about art. In the cafeterias and in her visits with other artists, Elaine began to further Bill's career, simultaneously securing her own recognition as a painter. This, too, proved to be work for her—very difficult, very important work that continued until the end of her life.

When Denby and Burckhardt first knew de Kooning, he was painting a series of male figures in interiors and schematic still lifes, and for awhile he worked on a commission for one section of a three-part mural, *Medicine,* for the New York World's Fair Hall of Pharmacy (in 1937). Elaine remembered her earliest impression of Bill at work: "The year after I got out of high school, I vis-

ited [Bill's] studio. He was working on paintings of men—all of the paintings were imaginary. However, he worked from drawings of himself. Using mirrors, he drew himself, so the shoulders, chest, and neck were very much related to Bill's own physical characteristics." Others from that early lot, she noted, included the "fragile face" of Edwin Denby, "one of Bill's best friends at that time when I first met him."

Explaining Bill's evolution toward Action Painting, Elaine said: "In the thirties he was already involved in gesture—in gestural painting. But he knew the gesture he wanted after the fact. He had to work—and that's what he obsessed about, working—to make the gesture and to work to understand or recognize the gesture. He was always pressing and reaching through paint until he found the gesture he wanted and had what satisfied him." Elaine's description of Bill's manner of working—spontaneity of action, paint recording the gesture of the artist's action, and action-as-search—resembles the doctrine of Action Painting, which became codified in the fifties.

Elaine remembered that Bill then worked "a great deal on Masonite and at the end of each day he would sandpaper the Masonite to smooth down the surface. He hated to have a rough surface at that time." Many of the paintings he did at this time incorporated actual or ghostly remainders of lines of charcoal drawn into wet paint, and they contained rectangles in their composition. Elaine explained that "it was the figure related to rectangular forms that [Bill] would work on . . . for months and months all day long, ten, twelve hours a day."

In these long days of work, according to Elaine, Bill often laid wet paint into wet paint, "a process which resulted in the colors often sinking in, a response which infuriated Bill. So he would often take a spatula and scrape off a surface. Sometimes he would leave a color to cover a large area, and later on he would cut in—stripes, for example, are left over from areas underneath. He would just not paint a stripe on top of a painting."

Bill, said Elaine, used his rigorous academic training in his

vanguard pursuits, often employing a small, fine, curved brush—the sort used by decorators and sign painters to emphasize or underscore a form—to "make a contour more definite, to develop a play between contours and flat areas of color." But, despite his long hours of drawing at the Rotterdam academy, Bill, as Elaine observed, "always had difficulty with hands; he constantly complained and he would paint them away and draw over and over them. He often had the same problem with feet and would frequently do a three-quarter figure and paint away the legs and feet."

Given his work habits and his compulsion to paint over and over surfaces without finishing a painting, the early works of Willem de Kooning that exist today were taken out of the studio by people who dropped by and bought them "when they were soaking wet," according to Elaine. Elaine particularly liked to recall the time that John Graham "came in and saw a painting on Bill's wall and said, 'That's an absolutely terrific painting.'"

Bill responded, "If someone gave me $50 I'd let him have it."

Graham said, "Wait just a minute."

Then, as Elaine told it, Graham went away and returned with $50. "Bill was a little taken aback," she thought, "but on the other hand the rent was $35 and that left $15 for meals."

John Graham, delighted with the slightly abstracted male figure, kept it for ten years. Then he offered it back to Bill for $500 and Bill bought it.

Burckhardt confirms Elaine's belief that, even in the early days when he was most influenced by academy standards for judging a painting, Bill never finished paintings. The early paintings that still exist survived (whether purchased by someone else or forsaken by the artist) Bill's reluctance to call a work finished. That call remained his, however, and his alone. No one else had the right, in his opinion, to participate in making decisions about a painting's process and degree of finish. He was especially irked by Peggy Guggenheim, the patron and dealer, who visited his studio, looked around, and seemed to think it her right to judge his work. Bill found her imperious air infuriating. He glared silently at her, his

arms crossed over his chest, as she pawed through his work. "He didn't like her," Rudy Burckhardt said. "She came to the studio yawning, hung over, inattentive, snappish, and arrogant."

When Peggy pointed to a painting tacked to the wall, one on which Bill was working, and demanded it for an upcoming show in her gallery, Bill testily informed her that the picture was not finished. Ignoring his mood as well as his message, she commanded, "Finish it and deliver it to the gallery." Bill glared at her as he opened the door for her to leave.

According to Burckhardt, after Peggy left the studio de Kooning was furious. "Bill unfinished [the painting] even more and didn't take it to her."

Elaine, who found the story about Peggy Guggenheim "very amusing," understood the emphasis that Bill placed on painting as work, rather than on a painting as a finished object; it was the difference between process and product, between the creative process and a commodity. Elaine proudly recounted the anecdote to friends in the cafeterias, leaving no doubt as to Bill's dedication to painting, his integrity as an artist.

In their studio, Elaine watched Bill's work progress and took to heart his advice on her own painting. "Work," he told her, "as if every stroke might be your last."

It is often remarked that Bill's semiabstract paintings of the late thirties and early forties resembled those of Gorky, although Elaine objected to any suggestion that Gorky "influenced" Bill, insisting instead that the two artists "shared" ideas and concerns. De Kooning and Gorky, unlike their friends who organized the American Abstract Artists, refused to limit themselves to—or direct their work toward—purely abstract painting. Instead, they extracted imagery from the figure and from nature, from Surrealism and even traditional European academic painting, rather than from the purity of geometry, Neoplasticism, and Constructivism.

When Bill first took Elaine into his studio, he was too poor to afford models and had constructed a "funny mannequin—a male

figure with movable joints, a big doll—that he painted from."
Elaine found the mannequin amusing but reminded Bill that she
was "the best and most beautiful artist's model in New York," and
she asked him why he didn't paint women. He teasingly told her,
"I don't understand hair."

Shortly thereafter, Bill accepted Elaine's offer to pose, and his
drawing of her brilliant coppery hair served as the source for the
series of drawings of hairdos that he did on commission for
Harper's Bazaar in 1940. More significant, however, was that these
early drawings of Elaine drew Bill into his first series of paintings
of women, resulting in *Pink Lady* (1944).

The woman theme, which was to become a major preoccupa-
tion in Bill's painting, has always elicited speculation regarding its
sources. Those who judged de Kooning's women to be monstrous
looked for psychoanalytical foremothers in Cornelia and Elaine.
Those who saw them as outward emblems of Bill's relationship
with women found evidence of sex, violence, and eroticism. Those
who saw them as political statements—an idea that evokes laugh-
ter from friends who knew Bill well—originate "paradigms" and
"iconic significance" to explain the violence and imagery of de
Kooning's women and to suggest that these women reveal the hos-
tility that they felt directed toward themselves, that the painter
bared the souls and minds of women.

Later, however, according to Elaine, Bill did not understand "all
the fuss about his girlies. He thought they were cute. He said that.
He said, 'I think they're cute.'" If Elaine's account is true, and not a
humorous effort to deflect attention from the violence of the women
paintings, it is likely that Bill is the only person, male or female, who
described the grimacing, tortured, writhing women as "cute."

But whatever Bill's subject matter or technique, according to
Elaine, he "didn't like things to come easy. He wanted to have his
images evolve out of a sense of conquest. It wasn't so much that he
wanted it to come out of conflict as it was that he was born with
divine discontent."

Well before their marriage in 1943, Bill learned that Elaine had her own share of divine discontent and that she, too, saw herself as an artist and had no intention of settling into a conventional role as wife. Elaine credits Bill with appreciating her for what she was and what she wanted to be. She insisted that he contributed to her convictions about art and her development as a person, as he instructed her in art and, she believed, reinforced her determination to cut her own path in both her art and her life.

As she came to know Elaine, Grace Hartigan learned that Elaine, like Lee Krasner, who was married to Jackson Pollock, called her husband a genius. And Elaine loved the idea of Bill's genius as much as she loved Bill. Yes, Grace thought, she loved Bill all right; but she loved him more because he was, Elaine was convinced, the most important painter of his time and place. Grace believed that Elaine was prepared to protect, support, preserve, and bask in the presence of Bill's genius forever. "That's what she wanted then," Grace thinks. "She wanted to be the wife of the genius."

Being the wife of a genius is hard work. Elaine was prepared to do the job. But she wanted more than being the passive wife of a genius. She wanted to participate actively in the expression of genius. And she was willing to do her share of that job, too.

While Elaine was eager to know what other artists—especially Bill—thought about her work, about the work of other artists, and about art, she stubbornly refused to accept any idea on anyone's mere say-so on any subject. "I am argumentative," she said. "I mean, I am argumentative in terms of painting. I think any artist argues with himself, with his tools, with the process of painting. The very act of picking up a brush—let's say—if the brush is your tool, is an argumentative act, because you're putting yourself in conflict with what's gone before. You're competing. You're saying, I have something to add. And from the beginning, I had that feeling, and Bill had that feeling, too. I think we encouraged each other."

Drawing deeply on a cigarette and exhaling, she added, "I feel that love is important, too. Especially for young artists. I feel that for young artists, to love something, to not just say, well, I'm interested in my own identity—I feel that that's important. I don't think anyone can become an artist without having a sense of passion toward another artist. I had that passion about Bill—about Bill as an artist as well as Bill as a human being."

But, Elaine knew, while one individual's passion might lead to submission, another's led to opposition—"another kind of argumentativeness. After the initial passion, later on, one becomes so involved with one's own imagery that another artist's presence seems intrusive. I mean presence in one's mind as well as in one's spaces. But," she reiterated, "any great artist has come out of his passion for other artists. Cézanne with his passion for Poussin. Or Rodin with his passion for Michelangelo. Gorky with his passion for Picasso, Kandinsky, and Miró. And then, usually, what one is involved with is the passion for a good many other artists. Bill was, for example, just passionate about *art* and about *all* great artists. I think he taught me that, too. But, this feeling of emotion—it's not just an intellectual response, but an emotional one—that's what counts, what sets the tone, what keeps an artist going when everything is bleak. Remembering these things, keeping them in your mind, that's an artist's work."

In looking at art, Bill and Elaine could exchange passionately perceived ideas on neutral territory. Many years after seeing Picasso's *Guernica* with Bill, Elaine recalled the awe that they felt in the presence of the forceful painting: "We were stunned—really bowled over—by *Guernica*. Talk about passion. It was just pouring out of that enormous painting. Bill and I just stood before it—in awe, in wonder, and in a kind of terror. We didn't talk for a long time." Elaine added, laughing, "And not talking for a long time was itself an indication of powerful passion. . . . We both had this tendency to talk and one thing would lead to another, and we argued. We did that passionately, too."

In the forties, Elaine and Bill lost their loft. When they found a

cheap flat on Carmine Street, on the edge of New York's Little Italy, they leased it. But Bill needed more space than the cold-water flat supplied, and both of the artists had learned that they worked best in separate quarters. Moreover, the segregation of working spaces undoubtedly reflected the increasingly divergent paths their lives had taken and doubtless provided each with easier access to the company of other sexual partners. In their new arrangement, each could pick up people for casual sex or could engage in an affair without invading the other's space, time, and privacy. And, understanding that the apartment on Carmine Street was "home," they could maintain the structure of marriage and friendship.

"We could have fought losing our loft," Elaine said, "but we didn't. We decided to get separate studios. I took a cold-water flat [on Carmine Street] to paint in, and Bill took a studio on Fourth Avenue, right across from Grace Church. Neither of the places was ideal. Bill would come to my place to sleep. We held to a kind of schedule. We'd like to get up late in the day, go to our studios, and work until about eleven at night. Then we'd be beat and we'd stroll up to Forty-second Street. We'd walk up and down that street and then go to a movie and come out around three or four in the morning. Then we'd walk back home."[3]

After a ten- or twelve-hour day of working, Bill and Elaine often also met for dinners in cheap restaurants in the Village or Little Italy. One winter evening, when they were both exhausted and frustrated from work, the de Koonings walked together along Carmine Street and turned onto a smaller, darker street. Though they wore their heaviest coats they still hunched their shoulders against the cold, razor-sharp wind that whipped through the narrow Greenwich Village streets. Suddenly, they saw movement in the shadows and heard a woman begging for help.

Bill, without thinking further, stepped forward to rescue the woman, Elaine close behind him. A man stood over the woman he had knocked to the gutter; she bent her arm over her head to ward off his blows. Seeing Bill and Elaine, the angry man stopped

roughing-up the downed woman and turned his wrath toward them. As the woman leapt up and fled, her enormous attacker—towering above the short, compactly built Bill and the slight Elaine—demanded that Bill give him his coat. Without a word, Bill peeled off the coat—a new and fine coat, bought with money from the recent sale of a painting—and handed it to the man.

"The goon just wasn't expecting that," speculates Sherman Drexler. "He wasn't expecting someone to hand over his coat on demand. He expected—and probably wanted—a fight. So when Bill gave him the coat, he must have thought that he had met Jesus Christ. Or a freak. Or someone as strange as himself."

Without speaking to the menacing stranger who now wore Bill's coat, Bill and Elaine started on their way to the restaurant that they had chosen for that night's dinner. The man in Bill's coat followed them, muttering, apparently trying to figure out what had happened. Almost immediately a policeman appeared, headed toward the threesome.

"Well," continued Sherman Drexler, "the guy in Bill's coat was terrified. This was it. The game was over. He expected Bill to hand him over to the cop."

Instead, as the policeman came closer, Bill edged nearer to the man in his coat and nodded to the policeman as he passed. "You see," Drexler guesses, "Bill didn't like cops. Didn't like authority of any sort. He and Elaine were alike in that—in their work and in their lives. So, if they had a choice, they'd prefer the criminal to the cop. But," he laughs, "the guy in Bill's coat must have gone nuts trying to figure out what happened. And Bill and Elaine never said anything at all."

"We never expected to have anything," Elaine said. "There was no money and we lived anyway we could. Bill and Gorky came close to living off their work, and that was all anyone wanted. We just wanted to work."

If they were lucky, Bill and Elaine had dinners with friends. At that time, neither one drank excessively, though friends remember that Elaine drank alcohol more than Bill did then. He drank coffee

continuously, and he occasionally liked a beer or two. Elaine, however, liked alcohol and lamented their inability to afford a bottle now and then. Neither of them objected when alcohol began to appear on the social scene. As for many other artists, alcohol was a psychological solvent for them that dissolved fatigue, shyness, and frustration.

As World War II ended, work that artists did in their studios began to attract attention among affluent New Yorkers, and artists were invited into new social orbits. People interested in vanguard art—whether friends of the de Koonings or collectors, curators, or people curious to learn more about a colorful group of artists in downtown New York—invited the attractive couple to cocktail parties and dinners. "They were the darling couple," says a friend, "attractive and involved in the art world. Everybody wanted to know them. They knew everyone. They were fascinating. Elaine was the liveliest woman in town. So, naturally, Bill and Elaine were invited to a lot of parties and dinners given by rich people. And there was always a lot of booze. And they started to drink."

Elaine, recalling their social whirl of the mid-forties, insisted, "Work was always first with us. But the art world was expanding, and people were giving parties, and we were swept into the parties. We were always glad to get invited to dinner. It seemed like a windfall. I mean, we didn't have to buy our dinners. So," she laughingly recounted, "we figured that we could afford a taxi. Ordinarily, that would have been a real luxury for us, but when we were invited to dinner, we rationalized by saying that we had saved the money we would have spent for our dinners. And we spent twenty-five or fifty cents on a taxi and felt rich."

By the late forties, Bill's reputation extended uptown to the collectors and dealers, and he was almost able to make a bare living by selling his work. At that time, he was combining close-value colors and biomorphic forms in surreal abstractions (*Pink Angels*, 1947, is an example), a direction he followed until about 1950. Simultaneously, he began experimenting with another series of woman paintings, which he pursued until 1949.

Bill and Elaine had their work cut out for them, even if the patterns were different. Until 1948, they got by in the small world they knew in lower Manhattan, and they gave little thought to the future. But that year, two events brought mortality and the future into sharp focus for them. Arshile Gorky, who had been physically ill and mentally depressed, killed himself. Bill, heartbroken, struggled with inadequate words to express his grief: "He was gifted. We shared a lot. . . . Gorky and I had a good time together. I was so sad when the poor guy got sick and died."[4] Elaine said, "Gorky was like Bill's brother, and when he died, Bill was devastated. He thought he lost a part of his own life. And he just always grieved for Gorky, and always talked about him."

But also in 1948, Bill embarked on a new and public life. He had his first solo exhibition and the world changed.

THE SCENE

ELAINE AND BILL AND HAROLD AND TOM AND CHARLIE IN 1948

Life for Elaine was just such a hell of a good time. That was part of her creativity, her real and true and deep creativity.

—GRACE HARTIGAN

A dealer wryly notes, "If Elaine had slept with different people—or, god forbid, if she had remained faithful to Bill—the whole history of American art would be different." Another observer, an elder statesman in the New York art world, sits reflectively among his plants, his own work, and his collection of early clay figures. Musing about Elaine's role in the art world, he insists that he—and "everyone else"—knew that when Bill de Kooning had a particularly favorable review by Harold Rosenberg or Tom Hess, or when a reproduction of Bill's work appeared in

Art News, or when Bill's work was included in an exhibition, "Elaine had been sleeping with someone again. It wasn't a secret. When Elaine slept with Hess, Bill got publicity in *Art News.* When Elaine had an affair with Harold Rosenberg, he paid Bill off with attention."

Elaine, who admired the great courtesans, relished her power over men and advertised her sexuality with her smart-mouth wisecracking and flirty ways with the guys. But she was more than a mere vamp: Elaine de Kooning was intelligent and talented. She knew art and artists; and she unerringly harnessed the breezes that would become the gale-force storm of Abstract Expressionism. By the late forties, Elaine herself was a force— and all the more powerful because she veiled her strength with female allure. Elaine attracted and influenced three men who would establish and extend Bill's domination in the art world.

Of these three men—Thomas Hess, Charles Egan, and Harold Rosenberg—no one was to exert greater influence on the lives of the de Koonings than Harold Rosenberg. No one—save Elaine herself—contributed more potently to the apotheosis of Willem de Kooning in post–World War II American art. As Rosenberg later commanded attention as a powerful critic who dispensed rank, he effectively anointed Bill the king of art. But Bill and Elaine were not surprised. Harold, when they first met him in the thirties, was already honing his talents for polemics, politics, and power. "When I first knew Harold," Elaine said, "he was interested in politics and in poetry. And then he began to see that art was a kind of politics and a kind of poetry. And then he realized that he could think poetry and write politics by writing about art. It was just a natural thing for him to do."

A large man with a craggy face dominated by a strong nose, flaring nostrils, and a bristly mustache, Harold Rosenberg had once wanted to be a tango dancer. But illness that took him near death left him with a stiff leg. He turned to the study of law but never became a lawyer. By the time Harold became friends with Elaine and Bill, he wrote poetry, drank coffee with artists and

poets, and debated anyone who felt inclined toward an intellectual romp. Later he would write for *Art News* and *The New Yorker*. Doctrinaire in his Trotskyite politics, Harold nonetheless roved freely through the ideas that sprouted in the atmosphere around the artists in their studios and in their favorite cafeterias, where a nickel cup of coffee could be made to last for hours.

Rudy Burckhardt recalls Harold Rosenberg as "a man of ideas." To Rudy, Elaine described Rosenberg's first visit to Bill's studio: "He didn't look at paintings at all; he doesn't have an eye. He's a talker and a teacher."

As a Trotskyite, Rosenberg hated Stalin, and he measured everything—concrete object or swirling conversational abstraction—against the tenets of his political hero. When the WPA provided work for artists, Harold looked to cut a deal, to get "on the Project." He presented as evidence of his vocation as an artist a hastily painted picture of "Pilgrims and Indians." Laughing about the picture later, Harold said that he had watched his artist friends at work, decided he could do that—"up to a point"—and determined to turn out something "suitably historical." The hastily prepared picture accomplished Harold's purpose and he was soon assigned to work as a studio assistant to a mural painter.

Ibram Lassaw was a friend of the mural painter, and he recalls visiting the painter's studio. Lassaw's friend had been endowed by the leaders of the Federal Arts Project with two assistants. When Lassaw arrived, he noticed that one assistant was hard at work. The other, Harold, was sprawled in a comfortable chair, one foot resting on the rim of a red-hot coal-burning stove, reading a book and sputtering, "Did you ever read such junk? Did you ever hear such nonsense?" According to Lassaw, Rosenberg was reading a book by Stalin. And while the Project-supported artist and his assistant worked on plans for a mural, the future art critic represented his idol Trotsky in a debate with Stalin's book.

Later, Harold moved temporarily to Washington, D.C., to write and edit for the Project. Returning to New York as often as possible, he made the rounds of artists' studios and hangouts, enjoying

equally their talk about art and their recognition of his intellectual superiority. "None of the artists ever knew what Harold was talking about," concluded a painter, "but they thought it sounded good. He made what you did seem important. He connected your work with things you didn't even know about and it sounded good, sounded dignified and important."

Harold's prowess with women was legendary—"the girls seemed to chase after him," said an admiring artist—and perhaps second only to his reputation as a pinch-penny and a man who could hold his liquor. But well before his accomplishments with women, booze, and check-avoidance had become common knowledge, Harold held court among the artists and poets as a talker, a storyteller, a clarifier of ideas, and an identifier of issues.

"My grandfather," he boasted, "was the most famous *mohel*—circumciser—in Brooklyn. I used to watch him sharpen the knife he used. On summer nights, when the windows were open—there were no screens then—the flies would come into the kitchen. My grandfather sat at the kitchen table and tested his knife. When a fly came near, he sliced it in half while it was still in the air." Asked jokingly if that experience had made him an art critic, Harold nodded and, eyes twinkling, allowed that it had helped.

From their first meeting, Elaine and Harold enjoyed talking, telling stories, and arguing. "Elaine learned a lot from Harold. She looked up to him. She was intelligent, but she had never been to college and she admired people she considered intellectual," observed Ernestine Lassaw. "Elaine soaked up information. When she was around someone, she learned everything that person knew, just soaked it up, and knew it. Elaine was always bright."

"Harold learned a lot from Elaine, too," says Ibram Lassaw. Other artists agree. Harold, they say, never had an eye, never really had much interest in looking at paintings; and, if he did look, he saw only superficially what the painting was about.

Harold, they say, let Elaine show him paintings by artists she liked—"and that damn well included Bill, you can be sure"—and he listened to what she said. "Elaine was Harold's seeing-eye woman," says Robert Dash. "He'd never have had even a notion of painting—and certainly not *Action* Painting, as he later called it— if Elaine hadn't been around in the early days to seduce him into looking."

Elaine said of Harold, "He was brilliant, just brilliant. He was a man of ideas. He was profoundly intelligent, and very funny. I mean, he knew almost everything. Everything except how to look at a painting. He would stand in front of a painting—Bill's painting, Franz's painting, anybody's painting—and talk about great ideas." She chuckled, and added, "But it didn't matter because he just wrote those brilliant articles which made nothing absolutely clear and made everything about art totally fascinating."

Elaine soon found another brilliant writer about art.

In 1948, when Tom Hess met Elaine and Bill de Kooning, he was curious about abstraction and about the relationship of the vanguard American painters to European modernism. Well steeped in the artists and works of the cubist and surrealist movements, and schooled in art history and the liberal arts and sciences, Hess plied his analytical skills and broad knowledge for points of intellectual reference between painting and philosophy, painting and politics, painting and poetry or psychology or even sports. "He was rabbinical," Elaine said, "in the way he argued points and analyzed words and ideas down to the minutest portion. And he was obsessed with the differences between vision and words, between what he saw and what he could say about what he saw. Tom, after all, was a real intellectual."

He was also, according to Elaine, "trapped in a very unhappy marriage. Audrey [his wife], who was very rich, was in the process of starving herself to death. Tom was more interested in Marilyn Monroe-type women, but he was married to a woman embarked

on what I've always called 'death by couturier.' As she got thinner and thinner, I think she got weaker and weaker. Tom just wasn't interested, but she had money and they had children."

By the time Tom Hess became managing editor of *Art News* in January 1948, he tried to appear—if not actually to be—nonpartisan in the de Kooning–Pollock competition that was developing. His efforts, however, were compromised by his affair with Elaine de Kooning and further complicated by his appointing her to the staff of *Art News*.

"Well, no, I didn't have any real experience in writing reviews," Elaine said. But, when she had moved in with Bill and met Denby and Burckhardt, she had been impressed by Denby's facility in writing dance criticism, and she began to follow him about and join him in evenings at dance recitals and musical concerts. The former dancer wrote intelligently provocative and richly imagined poetry as well as dance criticism. Elaine was, she said, "just terribly fascinated with his mind, with his language." He, in turn, found in Elaine an eager student and a companionable friend. After the dance concerts, Denby often invited Elaine to tag along with him to the *Herald Tribune* and to comment on his reviews as he wrote and filed them.

"Let me try," she asked one evening. Denby, amused, gave her his space at the typewriter. She wrote a few sentences, then a paragraph. "Well," she admitted, "I was hooked. I found it fascinating to use words to communicate movement and sound. And I began to look at paintings in a new way, and to think about what I would say about them if I were writing reviews of shows."

She also thought about how reviews should not be written, and she often fingered specific passages in *Art News* as examples of failed criticism. Grousing about the quality of the reviews appearing in an issue of *Art News*, Elaine said, "They seemed to have been written by graduate students in art history—students who had never looked at anything and who got their ideas from books."

Someone repeated her comments to Tom Hess, who, half

amused and half earnestly trying to include new ideas and insights into what had been largely regarded as a stuffy publication, asked Elaine if she thought she could do better. Without a second's hesitation, Elaine snatched the challenge. She was certain of her grasp of Denby's explication of writing criticism, and even more certain of her own ideas about the purposes of art criticism. Over the next few years, Elaine contributed regularly to *Art News,* leaving in print a trail of ideas and insights that influenced two generations of artists.

"I got $4 for those reviews," she recalled, "and we could use the money. But, I also got a chance to write about art. And I liked the process very much."

Some years later, writer John Gruen spoke for many when he voiced admiration for Elaine's early art criticism. She, he said, "wrote from the inside in a way that was absolutely clear and lucid. Her style was very personal. . . . She would get right to the heart of a painting or a piece of sculpture, describe it, and then say what she thought about it. There was nothing fancy or frilly about her writing."[1]

At the time Elaine began to write reviews for *Art News,* she and Tom Hess developed a deep affection for one another. Their affair lasted for years, with neither of them excluding other partners, and it grew into an important and abiding friendship for both of them. From the time they met, Elaine made a point of taking Hess to artists' studios, introducing him to "the brotherhood, and . . . going with him to the Cedars [a Greenwich Village tavern where artists gathered]. He wanted to know what was happening. And he wanted to know firsthand," Elaine recalled. "And he already knew everything, had read everything. He wanted to see the point of it all—and painting that he saw just seemed to him to be the point of all of the ideas that interested him. Tom didn't want to write captions for paintings. It was the other way around. Art was what made sense of abstract ideas for him. He had a lot of ideas, but when he saw an authentic painting, he would say, 'Ah ha, now I see what such and such an idea is about.'"

As Abstract Expressionism dominated American art, Thomas Hess, Harold Rosenberg, and Clement Greenberg became the most powerful critics in the art world, the unmoved movers and primary shakers of that world. Each ruled his own empire and could anoint princes, canonize saints, and deify geniuses. Of the three, only Greenberg was not influenced by Elaine de Kooning. Rosenberg and Hess—the two who most blazoned Bill de Kooning's genius—were Elaine de Kooning's lovers and more than a little biased toward her viewpoints on art, including her axiom that Willem de Kooning was a genius.

Grace Hartigan says, "Elaine found out that she could sleep with Harold Rosenberg and Tom Hess, that they would be sort of slaves to her, and that she could enjoy dominating them—which they didn't suspect, you know—and at the same time, she could help Bill a lot. Yeah, I think that's one strong motivation there: I think she—maybe not entirely consciously—had affairs with both Hess and Rosenberg, and some other guys, too, like Charlie Egan, to help Bill's career."

Hartigan continues: "At that time [the late forties], no one really had a career. But everyone sort of knew that it was about to happen, that the time was ripe, that there was an interest in the air and that pretty soon there would be interest, and money, and fame. That's what careers are about. There was a lot of talk about 'making it' and that just meant being successful. Everyone would have denied it, of course, all of the artists claiming to be too pure to really care. But, underneath it all, they wanted to be known, they wanted to be famous, they wanted to be powerful, and they wanted money."

Finally she says, "Elaine knew how the world worked. And she understood how to get what she wanted for Bill; and she understood that that was what he wanted too. He wanted that recognition more than he wanted anything—even more than he wanted Elaine."

And Willem de Kooning was on the threshold of the recognition he wanted. "Of course Bill wanted to be recognized," says

Esteban Vicente. "He worked hard, and he believed recognition was due him. Yes, I think he knew that Elaine helped him. A lot. And I think he urged her to speak for him, leaving him silent and mysterious, leaving him alone to work."

If any single event marks the beginning of de Kooning's ascendancy to the top of the art world—a rise that would necessitate competition with Jackson Pollock but result in recognition and wealth for Bill de Kooning—it was his show at the Charles Egan Gallery in 1948. The Museum of Modern Art purchased *Painting, 1948* from the show, and *Art News,* under Hess's direction, reviewed the show and published a photograph of a painting in it. With a museum purchase and coverage in a major national art journal, Bill became known as a painter well beyond the New York art world.

Bill's career—that is, his public recognition and acclaim and sales of his work—began with the 1948 Egan show, even though some critics found that exhibition confusing. Sam Hunter wrote that the works "either add up to an impression of imprisonment with possible contemporary spiritual implications, or one of lugubrious vacillation."[2] The *Herald Tribune*'s critic wrote, "Although some of his forms hint at reality, close study reveals him as inscrutable as ever."[3] And Emily Genauer, writing for the *World Telegram,* called the work "loose, arbitrary, unconventional and curiously anguished expressions. . . . What exactly he is trying to get at is not entirely clear."[4]

But *Art News,* the most widely read and respected art journal of the period, under its managing editor, Thomas B. Hess, carried Renee Arb's enthusiastic review of Bill's work:

> To his New York debut, William [*sic*] de Kooning, Dutch-born artist who has devoted twenty years exclusively to painting in New York City, brings a singular concentration of passion and technique. His abstractions with their fierce energy are the results of months of sketching and alternating, and they reveal a new, self-contained per-

sonality. For here is virtuosity disguised by voluptuousness—the process of painting becomes the end. Technique is lavish and versatile; draftsmanship elegant and concise; his range of color seems as rich in black and white as in the brilliant hues. In the compositions, there is constant tension as space envelops and then releases these ambiguous forms. Indeed, his subject seems to be the crucial intensity of the creative process itself, which De Kooning has translated into a new and purely pictorial idiom.[5]

Taking into account his later criticism of Bill's work, Clement Greenberg, in retrospect, offered the most surprising review of Bill's show. He called de Kooning "one of the four or five most important painters in the country" and lauded the "indeterminateness or ambiguity" of the work, which Greenberg believed resulted from Bill's "effort to suppress his facility. There is a deliberate renunciation of will in so far as it makes itself felt as skill, and there is also a refusal to work with ideas that are too clear."[6]

Even with such lavish praise, Bill's paintings, then priced from $300 to $2,000, did not sell well. "Charlie [Egan] tried very hard to sell the work," Elaine recalled, "but there was just no market. He even kept the show up two months longer than it had been scheduled. But nothing sold and we all got a little embarrassed."

But everyone in the art world was aware of the exhibition. "More than Bill's work got exhibited," remarked an artist who also showed in the Egan Gallery. "The affair between Elaine and Charlie was pretty visible, too. The most obvious thing, though, was that Bill didn't seem to care. Everybody knew about Charlie and Elaine, and nobody wanted to say outright and cynically that, maybe, it was good for Bill's career that Elaine had this thing going with Charlie. But it sure didn't hurt Bill's career."

Another artist recalls that Bill, sitting hunched over a drink at the Cedars bar with his back to Egan and Elaine, who were aglow in one another's presence, may have shrugged off the relationship between his wife and Egan. Bill had shrugged off other men who enjoyed Elaine's favors; moreover, he shrugged off the women

who made themselves available to him. At the end of a night's drinking, Elaine and Bill might go home together or they each might leave the bar with someone else.

But Egan's wife, Betsy, had no such understanding with her husband, and she declared war on Elaine. "It was like Betsy was already jealous of Elaine. Jealous of her relationships in the art world. Jealous of her as a painter. Jealous of her popularity and style. And very by-god jealous of her relationship with Charlie. And, one night at the Cedars, when everybody had drunk a lot, Betsy challenged Elaine to an arm wrestling match," recalled Sherman Drexler.

The onlooking artists, noting that sturdily built Betsy Egan outweighed and appeared far stronger than Elaine, thought the contest would end quickly. But Elaine, more than half drunk, thought otherwise; she roared into battle, laughing. The two women put their elbows squarely on the table and grasped each other's hand.

"After a lot of grunting and heavy breathing, it was just a tie. Neither of them could really defeat the other. So they became immediate best friends; they sort of fell in love with each other." Drexler adds, "That was the way with Elaine. She was just terribly, terribly competitive. But she was also curious about people, and she loved fun. And she wanted to be liked and wanted to like everybody. So, when Bill had a girl, Elaine sort of always thought that that girl was her friend, too. And it seemed that if Elaine found some guy in a bar very interesting, she thought Bill should find him very interesting, too."

But, as Elaine should have known better than anyone alive at that time, Bill did not find anyone or anything as interesting as his work. While Elaine was enjoying her affair with Egan, Bill dallied casually with sexually available women, the first wave of "art tarts," or, in today's parlance, groupies. But sex did not divert Bill from his work—he was always the painter first. He painted steadily in his studio, concentrating on the canvases that appeared in the show at Egan's gallery.

Although the exhibition would garner praise for Bill and place

him in competition with Jackson Pollock for center stage in the art world, the works suggested that de Kooning agreed with Pollock's ideas about art. As a consequence of his own experimentation with commercial enamels, Bill had painted a series of black-and-white abstractions with strong overall patterns. Bill knew that Jackson Pollock had used similar materials in the paintings he had shown earlier at the Betty Parsons Gallery and that Pollock had insisted on the necessity for overall imagery in modern painting.

De Kooning's show at the Egan Gallery met Pollock's (and Greenberg's) criteria for modern painting. But people, especially other artists, who knew both de Kooning and Pollock compared the work of the painters, arguing that one was better than the other. Irrelevant and specious as their debate was, the babble nonetheless delineated the battlefield and summoned Pollock and de Kooning to an eventual contest. Within a year, *Life* magazine, with its publication of a feature article on Jackson Pollock, would fling gasoline on the sparks that flew from the abrasion between the two artists and their camps.

Meanwhile, the masthead of the *Art News* issue that followed Bill's show at the Egan Gallery included a new editorial associate, Elaine de Kooning. Over the next few years, she wrote reviews and articles still considered by many students of the period to be brilliant art criticism, and she also kept Hess and other influential critics aware of Bill's work and persona.

WIDENING THE CIRCLE

Every single artist in New York—every single modern artist was influenced by Bill. Whether they admitted it or not. Some of them got their whole career through him.

—ERNESTINE LASSAW

The 1948 exhibition of Willem de Kooning's work at the Egan Gallery in New York affirmed the painter's reputation among New York artists; and, as a result of published reviews, it extended his audience. The work in the show, moreover, gave notice that Bill, though well grounded in the ideas and modes of the art world, remained a maverick more interested in process than product, in ambiguity more than certainty.

The exhibition also resulted in an invitation to Bill to teach during the summer at Black Mountain College. Josef Albers, a distinguished German painter who headed the art program at the experimental college in the North Carolina mountains, saw the illustration of Bill's painting in *Art News* and offered the New York artist train

fare for himself and Elaine, as well as what seemed at the time to the de Koonings to be princely wages—$200 for the summer.

"We were excited," recalled Elaine, "because it seemed like a vacation as well as a chance to be with interesting people. What could have been better? We were very, very poor, of course, and decided on the train that we didn't have enough money to rent pillows for the night. It was a long, hot, slow train ride, and we were exhausted."

But after that long train ride away from New York's promise of summer heat and noise, Elaine and Bill arrived at Black Mountain College and its paradisiacal setting. "It was heaven," Elaine remembered, "and we had never seen landscape—mountains—like Black Mountain before."

During the summer months at the small college populated by talented, energetic, and squabbling students and faculty, Bill concentrated on painting and teaching. Elaine, however, saw the college as an enormous intellectual and social smorgasbord, and she gobbled up all of the choicest dishes. "At Black Mountain College," Elaine said, "I dipped into everything. I was in a play; I went to all of Josef Albers's classes; I religiously attended Merce Cunningham's dance classes—and they were wonderful. I sat in on all of Buckminster Fuller's classes. And they were fascinating." Elaine developed a lifelong admiration for Fuller and often attended his six- and eight-hour-long lectures in later years. (The length of his lectures, she surmised, more than the designer-teacher's avant-gardism, caused students behind his back to dub him "Fuckmister Buller.") That summer, Elaine's admiration of Fuller's mental agility was so great that she said, "If I had been eighteen and not twenty-eight, I would have just become an engineer and dropped painting. Bucky made it all that entrancing."

In the stimulating atmosphere of Black Mountain College, Elaine made a series of abstract paintings that, in their technical dazzle and biomorphic imagery, reflect ten years of lessons well learned from both Bill de Kooning and Arshile Gorky. Often casual, even slapdash, in both her method of working and her

treatment of her finished paintings—and, until much later in her career, unable to afford the expensive artists' materials that she preferred—Elaine painted with cheap enamels on wrapping paper that summer.

Tacking large sheets of thick paper to the walls of her makeshift studio, Elaine drew abstract shapes and applied the viscous color, mixing and blending directly on the surface as she worked; she then drew with brush or charcoal (as Bill often did) into the wet paint before applying still more layers of liquid pigment. As she scraped away excess paint with her palette knife, again like Bill, she discovered passages of paint that she incorporated into the next evolutionary stage of the painting. And thus she worked: drawing, painting, scraping.

At the time, Elaine thought of these works as studies. But in the highly charged creativity of Black Mountain College, she was maturing as an artist, synthesizing what she had learned from Bill and Gorky, looking at works by artist friends and those in the New York museums. Elaine de Kooning came of age as a painter that summer.

Meanwhile, Bill was immediately popular with his students, although he fretted that they took too much of his time and that he had little left for his work. Nonetheless, he generously praised each student's work, found positive features in everyone's efforts, and encouraged all of them to leave college and go to New York if they seriously wanted to paint.

Even with his self-imposed burden of uncommonly conscientious teaching, however, Bill worked hours each day in his studio. There, combining drawing and painting, scraping and reworking areas of the canvas, and working over and over the same surface, Bill completed only one canvas that summer, *Asheville*—an oil and enamel painting on cardboard (later mounted on composition board), dominated by ocher and white passages laced together by black enamel that is both brushed on and dripped and let run, Pollock-style. Although it is not a large work (26 x 32 inches), *Asheville* was a turning point for Bill's painting, a precursor for

works—like *Excavation*—regarded as his most significant paintings of the fifties.

When it came time to leave Black Mountain College, Elaine casually rolled up her paintings and took them back to New York. Over the years, still rolled up, the paintings were moved from one studio or house to another, nearly forgotten by their maker. Toward the end of her life, as she worked with assistant Edvard Lieber on a master inventory of her work, she found the enamels on paper from Black Mountain College. Noting the frayed and crumbling edges of the paper, Elaine said, "Oh, just toss these out."

"No," Edvard urged, "they're interesting; they're good. Let's see if they can be restored."

Elaine shrugged her acquiescence, and Edvard and Elaine's sister, Marjorie, arranged to have the Black Mountain paintings restored and backed. Shown posthumously in the Washburn Gallery in New York, the paintings provided startling evidence of Elaine de Kooning's early accomplishments as an artist. The Metropolitan Museum added one of them to its collection.

When Elaine and Bill ended their summer at Black Mountain College and returned to their schedules of work, each artist continued to explore his or her territory in painting. Elaine, invigorated by her Black Mountain experiences, worked in strong gestural strokes, which brought her closer to the basic tenets of Abstract Expressionism.

Bill enlarged the scale of his work, including, according to Elaine, "the actual size of the painting, the size of the brush stroke, the sweep and kind of forms. These huge gestures sometimes reminded him of places—of landscapes. For instance, some reminded him of David Smith's place up in the Adirondacks."

In 1949 Bill and Elaine were included in an exhibition at the Sidney Janis Gallery, Artists: Man and Wife, which also featured Jackson Pollock and Lee Krasner; Ben Nicholson and Barbara Hepworth; and Jean Arp and Sophie Taeuber-Arp. "It seemed like a good idea at the time," Elaine said, "but later I came to

think that it was a bit of a put-down of the women. There was something about the show that sort of *attached* women—wives— to the *real* artists. Well, maybe it was just too cute. You know, a cute idea; something to get attention for the gallery."

That same year, however, Elaine participated wholeheartedly in activities that did not attach her to Bill. She appeared in Rudy Burckhardt's film, *The Dogwood Maiden;* she spent the summer in Provincetown, where Bill visited her only once or twice; and she painted seriously in her studio at 63 Carmine Street, the cold-water flat in which the de Koonings had lived since 1944, when their building on Twenty-second Street was sold and they were forced to move.

They were still desperately poor, but both Elaine and Bill worked hard, and each respected the work that the other accomplished after that summer. However, though mutual respect for work can nurture good friendships, good marriages require more than each partner acknowledging the professional excellence of the other. "Bill was the best artist I ever knew," Elaine proclaimed, "and we respected each other's work." (Elaine's friends chuckled at her pronunciation of the word *work*—the Brooklyn-born Elaine, after years with Bill, said *verk*.)

One artist says, "It wasn't just Elaine who knew how hard Bill worked. All of the artists knew; and, as younger artists wanted to be identified with Bill, they copied him. They wore his kind of work clothes; they drank like Bill; they screwed every woman they could find; and they tried to give the appearance of *working* like Bill.

"There was one guy," continues the artist, laughing, "who had this vision of Bill in his studio, flinging paint off his spatula, and working in a frenzy. So that's what he did. And, one day, there he was working in a frenzy. Suddenly, he hurled a blob of yellow paint at a canvas and missed. The paint flew out the open window and, just like in some crazy movie, landed on a guy in a suit. A truly square guy. The guy in the suit was pissed off, so he ran up the stairs and into the building and banged on the artist's door. The painter opened the door and saw this raging man in a suit, saw the

yellow paint all over the front of the suit, and just knew that trouble had come calling."

Another artist says, "We all knew that all Bill cared about was painting and that was what he did. And, you know, we all envied and admired him, and we wanted to be like Bill."

Others, too, recognized Bill's extraordinary dedication to his work. Andre Emmerich, for example, recalls his first encounter with the artist at work. Emmerich, an impressive young dealer who was interested in both very old and very new art, accepted an invitation by Tom Hess and his wife, Audrey, to a fancy party in Westchester County. When the Hesses fetched Emmerich in their car, they then directed their driver to take them downtown to pick up Bill de Kooning.

Emmerich was aware of de Kooning as an artist, was familiar with his paintings, but he had not yet met the painter. He looked forward to meeting the man whose work he admired. To him, Bill was a puzzle—an artist who combined figurative and abstract painting, who never seemed to arrive at conclusions in his work.

While Audrey and the driver waited, Hess and Emmerich entered a shabby building and climbed several flights of stairs to find Bill de Kooning at work in his studio. "He was absolutely filthy," Emmerich remembers, "unshaven, disheveled, and totally covered with paint. And there was paint everywhere—on the floors and walls. There were paint-saturated newspapers all around. I had never seen such a mess and, at that time, really didn't know what to think. It was clear that he had no recollection at all of having been invited to a party, and that he couldn't be bothered."

Hess informed Bill that the car was waiting to take him to the party.

"No," Bill said, "I'm not going. I'm working."

Although Hess urged Bill to reconsider, the painter was adamant in his determination to work. Emmerich was impressed by the artist's absolute concentration on his work. "It was appar-

ent," the dealer says, "that Bill was not interested in anything at all except the painting on his wall at that moment."

Hess, in an article he later wrote for *Art News* on de Kooning's mode of working, described a disciplined and skilled craftsman, as well as a driven, restless artist. According to Hess, Bill began one of his *Woman* paintings in June 1950 by preparing a seven-foot canvas. The painting, on the woman theme that would almost absorb Bill for several decades to come, underwent numerous versions during the months that followed. Hess described Bill's applying and scraping off paint and his drawing and redrawing of segments of the canvas.

After about a year and a half of work, Bill reluctantly judged the picture nearly completed; then, immediately afterward, according to Hess, the artist afflicted with "divine discontent" was overcome with a frenzy of doubt. Frustrated and angry with the painting, he ripped the canvas from its stretcher frame and banished it.

Several weeks later, according to Hess, art historian Meyer Schapiro visited de Kooning's studio and asked to see the abandoned painting. De Kooning brought it out and the two men looked at it. Bill, caught by the emotional undertow of the still-unsatisfactory image, tacked the picture back on a stretcher and, after a week or so of work, deemed it finished.

Portraying de Kooning as an existential and heroic man beset with anxiety and cosmic dread, Hess stressed the artist's sense of uneasiness, of being off balance in his work. For de Kooning, all gestures made and decisions taken limited probabilities, yet they opened a further infinity of possibilities—everything had to remain in flux. To keep himself out of what he described as an "easy chair" of predictability in his work, de Kooning kept his painting changing, mutable, for as long as possible. He drew continually, extracting bits and pieces of a painting's imagery to form a new composition. Then he tore up the drawing and rearranged its pieces. Sometimes he copied large sections of a painting onto tracing paper, cut the drawing laterally into several sections, and taped them to the painting, varying their baselines to create a broken

rhythm that suggested movement. Hess wrote of this combined technical and conceptual process, saying that, technically, the method permitted the artist to study and edit "possibilities of change before taking irrevocable steps" and that, conceptually, it allowed de Kooning to "approach what [he called] the 'intimate proportions' of anatomy." According to Hess, de Kooning hoped to recapture in painting "the feeling of familiarity you have when you look at somebody's big toe when close to it, or at a crease in a hand or a nose or lips or a necktie."

At no point, however, did Hess—nor anyone else who ever described de Kooning at work—suggest that the painter worked entirely spontaneously or free from second-guessing and editing. He was a modern painter, but his work habits had been forged in the academy.

However much Bill tried to cage his emotional life within the rigors and requirements of his discipline as an artist, he failed to whip into submission his mounting anxiety. He roamed the streets of Manhattan in the dark morning hours, or he sat alone with a bottle of liquor. Sometimes work was impossible; it no longer shielded him from depression. Neither the camaraderie of artist chums nor the favors of women provided more than brief respite. Increasingly, Bill's temper flared unexpectedly at his friends, and he struck out either verbally or with his fists; when upset, he raged, cursed, and broke anything at hand.

Known in the past as a quiet and courteous man with women, Bill stormed disapproval and abuse at women who chose the wrong moment to flirt. "Yeah," recalls a woman who thought she might cheer up the sullen-looking artist chain-drinking scotch, "he could be vile. Obscene. Really nasty. I've been called a bitch and a slut before. Like in a joke. But Bill, well, he really meant it and it made you feel like something decomposing."

Bill's external display of agony, however, was a pale reflection of the terror he felt. Liquor, however, helped dilute his pain, and he frequently reached for the solace he found in a bottle.

THE CLUB AND THE CEDARS

It is very interesting to notice that a lot of people who want to take the talking out of painting . . . do nothing else but talk about it.

—WILLEM DE KOONING[1]

By the fifties—the decade in which Abstract Expressionism matured and came to public attention—artists gathered at a downtown loft in a loose organization they called the Club and at the Cedar Street Tavern to talk and drink. Both places—almost institutions in their significance to the art world—supported the habits and needs of the New York art world as economic and social pressures, combined with the growing power of the media, transformed it from a poor tribal community contained in a few blocks of downtown Manhattan to a major commodities market.

As the art world began to expand, artists recalled the years between World Wars I and II, when they had had few opportunities to exhibit their work or to engage in formal activities associated with it. They had grown accustomed to seeing themselves as

society's outsiders, as individuals who chose freedom over security and art over income. With few exceptions, artists in the fifties still lived in poverty—their social lives revolving around cheap restaurants and cafeterias, their intellectual and professional activities centered in discussions and friendships with other artists.

If they showed their work at all, artists in Willem de Kooning's circle before World War II exhibited in the Washington Square Art Show or in a handful of galleries that showed the works of living American artists (collectors and patrons—though few in number—sought European art almost exclusively). For the most part, until the fifties, artists served as the audience—as critic, teacher, patron—for other artists.

Although three upstart museums had avowedly promoted works by living artists in earlier decades—the Museum of Modern Art, the Whitney Museum of American Art, and the Guggenheim Museum of Non-Objective Art—the downtown artists suspected that the museums were the spoiled brats of rich collectors. After all, museums had not traditionally emphasized—or been expected to show—works by living artists. While artists visited museums and probably dreamed of their work being included in museum collections, none of them expected support or appreciation from the museum establishment of the day. It would not have been surprising to the de Koonings and their friends to have heard that one museum director remembered an often-repeated quip among his colleagues: "The only good artist is a dead artist."

Yet artists wanted to be recognized even though they knew that an artist was an artist—and an outsider. In the fifties, prizes were few, and they fell mostly to traditional work that featured scenic vistas, sentimentally rendered females, or illustrations of the worker's plight in a capitalist society. Until the G.I. Bill sent thousands into higher education, few colleges and universities had offered courses in studio art, and lucrative teaching jobs for artists were scarce. Thus, as artists gathered to drink and talk, they also hoped for sales to collectors or to people simply interested in art and artists.

Despite the moribundity of the art establishment, American artists individually and collectively were feeling an increasing sense of importance at the end of the forties and the beginning of the fifties. Some remembered the support they had enjoyed from the Federal Arts Project, which had enabled them to work without the constant threat of poverty. With federal support during the Depression years, they had worked and discovered that their work stood up well to the modernist art of Europe. They discovered that they had something to say, and they wanted to say it at least to each other if not to an appreciative world.

But artists in America traditionally recognized that they were their own best audience and that artists looked at work by other artists. Until the Abstract Expressionist boom, sales were few and prices were low. It seemed miraculous to the artists who worked in downtown Manhattan in the late thirties and early forties that Bill de Kooning was rumored to sell almost enough paintings to support himself. "Fifty dollars for a painting would almost cover our expenses for a month," Elaine recalled. "After we paid the rent, we had $15 for art supplies and meals. Fifty dollars for a painting meant that we had that much more time for work in the studio."

As the fifties dawned, New York—with its empty lofts that once housed small manufacturing industries and its sheltering anonymity for individuals who disdained conformity—allowed artists to live in dignified poverty. Scrounging for a livelihood, making do with cold water and insufficient heat, taking comfort from salvaged or ingeniously constructed furniture, artists worked and contributed to the evolution of a sustaining subculture. They managed to wire into meters and steal electricity and to tap into telephone lines and get free telephone service. They knew where to buy cheap goods and how to use them for maximum practical and expressive purposes. In this milieu, individual life-styles resulted from clever combinations of cheap garments, delicious meals of brilliantly combined bargain foods, and excursions by foot or economical public transportation to entertaining places. And what has come to

be called "professional growth" and "networking" occurred in conversation.

After years of this informal bohemian life, the American avant-garde art community felt the need for a more formal organization, perhaps presaging the professionalization and careerism that would soon overtake the art world and transform it into another big, corporate-style enterprise. But, as with almost all feelings that come to artists—individuals, by definition, who do not easily accept membership in a tribe—ambivalence pushed the idea first one way and then another. In the end, ambivalence won. Artists established a formal members' organization—the Artists' Club—in which they debated purposes; and they flocked informally to another spot—the Cedars—where by mere attendance they agreed to the conformity of nonconformity.

"The Club," as it came to be known, was formed in 1949 and members met in a building located on West Eighth Street, in a loose affiliation with the Hans Hofmann School. The Club and the Cedar Street Tavern, a nondescript bar on University Place near East Eighth Street, combined to serve as the Mount Olympus of Abstract Expressionism. If, as some claim, Bill de Kooning's ideas and work came to dominate the Club, he and Pollock vied for preeminence in talking, drinking, and brawling at the Cedar Tavern. If the Club fostered discussion of serious ideas and furthered the course of Abstract Expressionism in America after World War II, the Cedar Street Tavern became the exhibition center for sexual conquests and exploits; for maudlin, enraged, or stupefied drunkenness; and for macho contests among artists who valued power and force as evidence of artistic potency and innovation.

Both the Club and the Cedars provided artists with an intense sense of community based on the shared perception that they were outsiders, that they did not fit into the materialistic world of expanding corporate America, and that—however ineffable and difficult it might be—their work mattered. Together, the mostly male members of the Club concocted the shared image of the

Great American Artist as a cowboy-Paul Bunyan-longshoreman-existentialist hero who was hard-drinking, virile, and doomed to misunderstanding. These loners huddled together, burnished their purity and integrity, and damned the world that ignored them.

As early as the twenties, artists and poets found each other in Hubert's Cafeteria, on Sheridan Square. When that closed, the coffee-drinking talkers shifted to the Waldorf Cafeteria on Sixth Avenue near Eighth Street. As some of the favorite cafeterias closed—or just became too grungy to be comfortable—artists began to hang out in Washington Square during fine weather and in first one studio and then another as space permitted and weather required.

In 1948 the idea, or at least the terminology, of Abstract Expressionism was being shaped by artists arguing and talking in cafeterias. As the population of artists grew, and as more of them tried to mine the riches of Surrealism and abstraction for their own purposes, many of them—along with Harold Rosenberg and Clement Greenberg—realized that, though styles differed, there was a loose and informal bond among the artists. What was it? Not style. Not technique. Not patrons or schools.

Conversations grew serious and often turned to arguments as the artists expounded ideas. Bill de Kooning talked about *his* Cézanne or *his* Picasso; other artists, with equal passion, talked about their versions of the same artists. Similarly, as an artist stated emphatically the meaning of Surrealism, Cubism, abstraction, or expressionism, he invariably met another artist's counterargument, contrary view, or flat disagreement. Yet, despite their exasperation, even anger, with each other, the artists depended on these conversations, even drawing energy and ideas from the fights that blossomed in the heat of discussion and disagreement. "Hey, listen," said one of these artists, "de Kooning even took a couple of swings at Gorky. His revered pal Gorky. It was because he disagreed with Gorky about Surrealism."

The fights among artists flared and faded, rarely threatening

real damage or danger. Ironically, real laborers—and not just artists who wore the clothing of housepainters and longshoremen—began to frequent the same cafeterias as did the artists, and they introduced a more lethal style of fighting. For them, a pop to the jaw was more than a punctuation mark in an abstruse argument. Sometimes, as the tough guys slugged it out, the artists retreated to the sidewalks outside the cafeterias and continued their conversations.

At one point, perhaps a little frightened by the rowdy workmen (described by artists variously as "unsavory," "a rough element," and "just plain crazy"), someone suggested that the artists should have a meeting place of their own. Aristodemus Kaldis, a Greek artist known equally for his simple, powerful paintings and his love of gossip, suggested that they open a restaurant; someone else suggested "a club room."

It was natural to look to an established artists' organization for direction. Everyone knew that in the fall of 1948 David Hare, Robert Motherwell, William Baziotes, and Mark Rothko had founded a school at 35 East Eighth Street. Following Barnett Newman's ironic suggestion, they named it the Subjects of the Artist. The teachers had all exhibited their work at Peggy Guggenheim's gallery, Art of This Century, between 1944 and 1946; and, at the time of the founding of the school, all exhibited at either the Betty Parsons Gallery or the Sam Kootz Gallery. At that time, these galleries also provided meeting places and rallying points for artists.

Motherwell and Newman organized a series of Friday evening lectures at the school by artists they admired—again, artists who revolved around the galleries hospitable to their advanced styles and ideas. Although these sessions were open to the public, they were particularly interesting to other artists. During the 1948–49 season, Bill de Kooning was one of the lecturers ("A Desperate View"), along with Fritz Glarner, John Cage, Ad Reinhardt, and Harry Holtzman. Artists found the atmosphere exciting, and they

wanted more of the same charged statements, searching discussion, and sense of common purpose.

When the school failed financially and closed in the spring of 1949, the artists determined to continue their meetings and discussions. They located a "club room" on Eighth Street and initiated a series of Friday night symposia with Franz Kline, Conrad Marca-Relli, Philip Pavia, and others. In the fall, the Artists' Club was founded, and it remained the epicenter of the Abstract Expressionist movement through the 1950s. Charter members included de Kooning, Al Copley, Giorgio Cavallon, Charles Egan, Franz Kline, Ibram Lassaw, Landes Lewitin, Conrad Marca-Relli, Philip Pavia, Milton Resnick, Ad Reinhardt, James Rosati, Ludwig Sander, Joop Sanders, Jack Tworkov, and two women—Elaine de Kooning and Mercedes Matter.

Governed by a voting committee of those charter members, sometimes called "the Board," the Club admitted or rejected members and set an agenda for programs. Those who recall the early days of the Club agree that it was led largely by sculptor Philip Pavia, who did whatever had to be done to keep the premises in order and to keep conversation lively.

At the time of its organization, the Club gave artists a place to meet and talk about the ideas and modes of working that still elicited hostility in the non-art world. The animosity of outsiders proved a powerful cement for the artists. If they could not agree about what they liked, they could agree about what they disliked— not having an audience, not having their work seen and understood. Soon the Club instituted a slightly formalized version of the long-cherished artists-talking-to-artists form of social intercourse. What had been a lamented fact—that vanguard artists worked without benefit of audience or support—became acknowledged and celebrated among Club members as a badge of integrity and moral superiority. The Club belonged to the insiders, its members; the rest of the world could be written off as hopeless.

The Club, comprising highly individualistic and diverse mem-

bers, never elevated any one point of view to the level of guiding principle. True, most of the members were involved in abstract art, but within that category there existed a wide range of styles, each with its own implicit meaning and role in the life of artist and audience. Agreeing to disagree on almost every point, the artists still respected one another; and, more important, they agreed not to adopt a single doctrine (in any case, it would have been impossible to issue a single-doctrine manifesto, given the diversity of viewpoints). Here, among other painters, Bill refined and extended his conviction that painting existed as an extension of a man's life, that the processes of painting were autobiographical, and that, in effect, the meaning of a work of art rested in the artist's being. He articulated his position on the nature of art for a symposium held at the Museum of Modern Art:

> The first man who began to speak, whoever he was, must have intended it. For surely it is talking that has put "Art" into painting. Nothing is positive about art except that it is a word. Right from there to here all art became literary. We are not yet living in a world where everything is self-evident.[2]

Harold Rosenberg liked to say that the Club had been organized around a coffee pot and plans for washing cups and glasses and sweeping the floor. "They had a central committee—they called it the Board—and when they met, they always talked about who would sweep up and who would wash up and who would make coffee. Then," Harold laughingly added, "someone—often Bill de Kooning—would say, let's have a discussion about art and poetry, or let's have a discussion about something else. It was informal. And it was mostly guys. Elaine de Kooning and Mercedes Matter were the only women involved at first."

The Club members wanted to keep out not only women but also homosexuals. "It was like a boys' club. All they needed," said one woman close to the scene at the time, "was a tree house and some stolen cigarettes and dirty pictures."

Rudy Burckhardt recalled simply, "[The Club] was fun; they had very good New Year's Eve parties. There was always plenty of whisky—and a lot of willing drinkers. Bill was active, of course, and influential."

If the Club had been organized around a coffee pot, as Rosenberg suggested, and if it had existed as a boys' club, it changed rapidly with the inclusion of more women and the further availability of liquor. Drinking, which was to become a plague to Abstract Expressionists, became the real reason some members attended the Club's meetings. When asked to participate in a program, an artist might ask, "Will there be a bottle?" At first there was one bottle on the table—ostensibly a means of encouraging conviviality and of overcoming inhibitions about speaking in groups. "Then there were more bottles, and still more bottles. And after awhile, it was just assumed that everyone got dead drunk at the Club. Those who didn't kind of kept it quiet. It was expected," says a Club denizen, "that the guys—and, yes, finally, the women, too—would just get blind drunk."

Elaine de Kooning, while recovering later from alcoholism, traced the beginning of her addiction back to the Club. "I mean," she said, "we used to drink until all of the booze was gone. That's what was expected. If there was one bottle, we drank that. If there were ten bottles, we emptied them."

A friend of Elaine and Bill believes that they succumbed to alcoholism during the Club years but points out that "Elaine always drank pretty enthusiastically. If it was around, she would drink it. And she liked to party. Elaine may have been shy in those days, or at least reticent. And drinking tended to make her the life of the party."

Continuing, he says: "Bill, on the other hand, mostly drank coffee. Occasionally he would drink beer. And then booze became a part of the artists' social life. Openings in galleries had bars. Pretty soon, artists went to the openings and drank the bars dry. Bill sort of went along at first. And then, he was a real drinker. And he was a mean, rotten drunk."

Several friends remember vividly the de Koonings' alcohol-induced fights. "Once," according to a woman artist, "Elaine and Bill had been drinking. Bill had become very, very drunk, and was behaving badly." He would curse, trying to pick fights, ranting that he was "no good as a painter. No good at all. Just hopelessly beating his brains out. Elaine tried to soothe him but he was not having that. Bill slapped Elaine's face as hard as he could. The sound was terrible, and there was an angry red welt across Elaine's cheek. Her eyes filled with tears from the pain. But she leaned over and picked up Bill's hand and kissed it. She said, 'Thank you, darling.'"

Was that sarcasm? No, thinks the observer, it was Elaine's attempt to transform violence into something erotic, to suggest to onlookers that "physical contact of any sort was sexual."

Neither Bill nor Elaine labored under a burden of monogamy, and their individual descents into alcoholism were scattered with sexual exploitations. Bill went home with women he met at the Club or the Cedars; Elaine, challenged to display a brighter trophy than Bill's latest conquest, chose from among many suitors the one most likely to attract Bill's attention. Or, needing more attention than Bill offered, Elaine dared a kilted Scot to let her see for herself what he wore under his skirt.

By the fifties, membership in the Club had grown from the approximately twenty artists who first joined to nearly a hundred. Most of the artists identified with Abstract Expressionism during the first months of the organization had insisted the Club be private, and that it not be publicized in any way. When an eager newspaper reporter turned up, wanting to write a human interest story about the Club, he was turned away roughly. Outsiders were not welcome. But as coffee turned to alcohol, aloofness was replaced by overt pursuit of publicity. Any number of articles appeared in popular magazines, but two served as battering rams to break the doors to the artists' fortress.

In 1948 *Life* magazine's special feature "A *Life* Round Table on Modern Art" introduced a wide group of Americans to advanced

art. The public, even if affronted by the images and ideas of abstract art, took notice. And the notice, even if hostile, proved seductive to the artists—they began to think that it was better to be visible than invisible.

In 1949 *Life* featured Jackson Pollock in an article illustrated with photographs showing a brooding artist whose appearance conjured up a romantic vision of the suffering, lonely, artist—the existential man. Pollock, cigarette dangling from his mouth and thoughtful frown creasing his brow, was shown painting his famous "drip paintings." With the appearance of the article, Jackson Pollock became famous. People who had never been spotted inside an art gallery before appeared at Pollock's next show at the Betty Parsons Gallery. They crowded around the artist. They bought his work. They invited him and his wife, Lee Krasner, to parties. He was a celebrity. And as celebrity paid off, other artists wanted some, too.

In the wake of the *Life* article, the Club, which had been intended to be private and informal—"a place for artists"—changed. Its program took on a self-conscious air and often seemed to be pitched over artists' heads to writers, curators, dealers, and collectors—those who possessed the power to further a career by attention in the press or by purchases. While early programs had been arranged haphazardly by telephone conversation and the promise of a bottle of whisky on the table, later programs—often involving panels of artists—seemed to be addressed to outsiders and to call attention to artists. Finally, though the founders of the Club had actively avoided publicity and refused entrance and participation to journalists, some of the artists who joined later now swung around and sought every opportunity to be seen and heard as artists, "to make a name," "to make the scene," or, simply, "to make it."

Jackson Pollock had never frequented the Club. That, along with his growing fame, invoked considerable hostility toward him within its ranks. Conversely, Willem de Kooning was "one of the boys." Amiable and self-effacing, generous with his praise to other

artists, Bill washed glasses and swept the floor. He lived in the artists' community, unlike Pollock and Motherwell, who were—in the view of artists who lived in poverty in downtown Manhattan— "putting on the dog" and "trying to set style" or, worst of all, "living graciously." Bill seemed interested in the "guys at the Club," sensitive to their work, unpretentious, and humble about his own talent. Moreover, he seemed to stumble into repeatable witticisms.

Artists enjoyed telling each other at the Club about Bill's sorties in the Outside World and about his mixed-meaning quips. At a reception at the Museum of Modern Art he once told Mrs. John D. Rockefeller, Sr., "You look like a million bucks."

At the Cedars, according to an often-repeated de Kooning story, Bill's drinking was once interrupted by a homosexual poet who confronted him, saying, "I hear you don't like homosexuals, Bill."

"That's right," de Kooning answered. "You guys give me a pain in the ass." Was this an attempted double entendre? Or merely mushy-minded alcoholic surliness? Bill's friends believed his utterances to be clever wit; his enemies chalked them up as instances of his drunken boorishness.

At both the Club and the Cedars, stories about Bill and about Jackson Pollock, repeated and embellished, began to pit the reputations and significance of the two artists against one another and, at the same time, to generate publicity. Already famous among other artists, they were becoming known outside the art world; and word of mouth—or gossip—provided a forceful means of communication. As chat rolled from person to person, picking up details and subtle meanings, both Pollock and de Kooning acquired the status of legends and began to take on the simplistic characterization and coloration of myths.

Jackson, said Bill's followers, was crazy and self-absorbed, a braggart and a bully. They said he was not a real painter at all but a severely neurotic man who had only one trick in his bag. Bill, suggested Jackson's friends, was a violent drunk, an opportunist, a

bully, and an ambitious conniver who furthered his career through women. According to Jackson's emulators, Bill was not creative but was instead a slave to outmoded forms of European craftsmanship. He was not even an abstract painter, they said, but a figurative painter who pretended to put freedom and spontaneity in his work. Bill, they scoffed, was an "easel painter," not modern at all.

By the 1950s, as Abstract Expressionism flourished and collectors began to take an interest in works by Pollock, de Kooning, Kline, and other artists, the Cedar Street Tavern was the favored hangout of artists as well as art world hangers-on. Established artists talked and drank there. Younger artists appeared, hoping to hitch themselves to the ascending thermals of the established artists. Collectors and dealers surveyed the scene, looking for bargains. And women—the "chicks" of the art world—came to the bar to attract the attention of the male artists.

One young woman, who later had an affair with de Kooning, began to frequent the Cedars shortly after she arrived in New York. As she recalls, "The guys at the Cedars [were both important and attractive]. It all depends on how you thought about the artists. It was history. You knew that you were a part of an important time, that you were close to important people. You thought that the things the artists were talking about were like the things that scientists and senators might have been talking about at the same time. What they said was different, of course, and how they said these historical things. But these artists were leaders—the movers and shakers and shapers—of our time in history. You just knew that the artists who hung out at the Cedars were the important artists of the twentieth century. I knew this in my bones."

Other young women, fresh from the provinces, also sought action at the Cedars. Soon the story made the rounds of an encounter between an artist and one of the recently arrived "chicks," Martha. Typical of other young women from all parts of the country, Martha began to frequent the Cedars, expecting to find "an attractive bunch of men who were getting famous." Martha fitted names she knew to men she saw. She soon attracted

attention from a strongly built man with dark hair, dark eyes, and dark mustache and allowed him to pick her up. The next morning, she lay in his bed and watched as he began preparations for breakfast.

"How would you like your eggs?" he asked.

"Anyway at all, Franz, dear," she replied.

The artist froze. He was not Franz Kline. True, he bore a superficial resemblance to the artist whose swashbuckling black-and-white paintings were evoking attention in the art world and among a gathering group of collectors. His memories of the pleasures of the night were diminished, he later admitted, when he realized that Martha's enthusiastic response had depended (at least in part) on the belief that she was in bed with Franz Kline, a trophy she might have boasted about to her friends.

When the misidentified artist met Franz Kline at the Cedars, he recounted the incident. Kline listened attentively, pointed a finger at the artist's chest, and said, "Listen, you owe me a fuck."

In the years prior to their separation, Bill and Elaine participated fully in the free-for-all intellectual and social life of the Club and the Cedars, gaining influence and power in the emerging art world and establishing reputations for hard work, hard drinking, and carelessness about themselves and the people who entered their orbit. Arriving together or separately, they drank heavily, lapsing inevitably into characteristic behavior: Bill, suddenly angry, would curse and fight; Elaine, life-of-the-party giddy and vivid, would argue and charm her way through the night. Each occupied the center of a circle of admirers, and each was a power and a leader within the art world.

A few years into the decade of the fifties, success—public acclaim and money—seemed to be just around the corner, and everything seemed possible to the Abstract Expressionists who talked and drank at the Club and the Cedars. The ensuing "long bender" that Elaine later said began in 1950—and which still holds segments of the art world captive—resulted as much from sniffing success as from drinking alcohol.

THE SHAPE OF WORDS

A contemporary painting or sculpture is a species of centaur—half art materials, half words. The words are the vital, energetic element. . . . It is its verbal substance that establishes the visual tradition in which a particular work is seen.

—HAROLD ROSENBERG[1]

Americans—even American artists—believe that hard work begets success, and in the fifties artists glimpsed the possibility of prosperity and recognition as results of the work they had done.

Elaine and Bill worked hard. A lot of artists worked hard. But they knew that on their own, logging in their hours of hard work and counting the resulting works of art, all of the artists taken together would have attracted very little attention in materialistic, on-the-move-upward America in the years immediately after World War II. Fame for artists was similar to name recognition for brands of consumer goods: it was not acknowledged by laurel wreaths but by attention in magazines, on the radio, and on televi-

sion. The several industries that constitute the art world—artists, galleries, dealers, curators, collectors, critics, publications— finally and utterly depend on words.

In the beginning of the art world was the word, and it was shaped in the light of conversation among artists in the Club and the Cedars. As the word went out, spreading and being repeated through the expanding network of interdependent dealers, curators, critics, collectors, and publications, it was accepted, eventually changing the art world.

Articles about Abstract Expressionism overflowed the pages of the art journals and saturated popular periodicals. Abstract Expressionism and Existentialism were the intellectual rallying points after World War II. By that time, Abstract Expressionism was the only game in town, and it was played in its own theater of the absurd. The script was set, the curtain raised, the players poised and roles assigned.

Abstract Expressionism had roots in Surrealism, Dadaism, and Cubism and in both European and American modernist yearnings. Once the province of a small band of artists, the movement caught public attention, becoming for some the butt of jokes and for others evidence of a new level of human creativity.

Artists who had taken up brushes in the cause of abstraction had insisted that the essence of nonrepresentational art lay precisely in its freedom from words. To the question, "What is that?" artists answered (often with snarling vehemence), "It's a painting."

The conversations that had begun within a small group of artists living poorly in downtown Manhattan generated a spark, then a hearth fire to warm the initial few participants, and then a roaring bonfire that attracted those who saw its glow and wondered at its source. To those outside the sanctum of the originators of Abstract Expressionism, the paintings displayed under that label seemed to be an affront to traditional ideas about painting. To the uninitiated, these paintings seemed overlarge, unnecessarily violent, without meaning, and born of no discernible skill. What were these pictures about? Who were the artists? Was the

movement a hoax? Or, as its proponents insisted, was Abstract Expressionism the first sign of a new world of the mind and spirit?

"Abstract Expressionism was the only truly American movement in art history," proclaims Rose Slivka, a fluent art critic and poet who was intimately associated with post–World War II American art and artists. Slivka's statement is widely accepted, and no one doubts the impact of the Abstract Expressionists on the history of American art and world culture. Until the ascendancy of post–World War II painting, American artists had lived and worked in relative obscurity born of the country's attitudes and values: art was sissy stuff that detracted from the real business of taming wilderness and industry and of accruing power and making money in the young, rich country. Further, art—especially Art—was suspected of harboring spiritual time capsules that might invade the nervous system of an otherwise red-blooded American and, when least expected, kick in to gentle his two-fistedness and diminish his aggressive ambition. Art, to some, was an affliction akin to impotence.

But the country changed. The ending of the Great Depression and victory in World War II brought home to Americans the possibility of material gain and, with it, upward social mobility. Further, the expanding population of European artists and intellectuals and the growth of public higher education contributed to the development of "art appreciation." Art, once seen by working stiffs as the foolish trinkets of rich ladies, became in an upwardly mobile society a symbol of conspicuous consumption. To own and display art—and to thereby evidence sophistication and erudition in arcane matters as well as money to squander on nonessential goods—marked an individual as both affluent and cosmopolitan. In this way, a market was set for art; the demand awaited the supply.

Meanwhile, the artists had the wares but were by and large oblivious of an incipient market. Who would see the opportunities for gain? And who would transport the artist's goods to market and exchange them for currency? The market itself was small at first,

and the marketplace consisted of a handful of mid-Manhattan galleries. However, publicity changed all of that.

As attention shone on specific artists, those outside the spotlight moved closer, jostling and elbowing to get their share. Gallery exhibitions were open to the public; anyone with the money to purchase a painting could be a collector. As an example of the financial base of the art world at that time, it need only be noted that Betty Parsons sold paintings by Jackson Pollock from his first shows in her gallery for $50 and $75; a few years later, Pollock and Parsons were exultant when Roy Neuberger paid $1,000 for a large drip painting.

As paintings sold and prices moved steadily upward, the stakes rose in the game of art; and the prize—the big prize that both Jackson Pollock and Willem de Kooning sought—increased in value. A painter could become famous, and if famous, his works would sell. Artists and dealers knew that fame, or reputation, grew and spread from publicity—from published articles about art and artists. It all turned on words.

It is ironic that work intended to surpass the confinement of language depended for an audience—a market—on the printed word. Those who shaped those words, who crafted the articles and professed the cause of avant-garde art, became very, very powerful.

The 1948 and 1949 *Life* magazine articles that catapulted Jackson Pollock to prominence underscored the power of the printed word, inaugurating ripples of conversation that grew into waves of jealousy and competition. Overnight, Jackson Pollock was famous. Others could be, too.

Artists who wanted the same attention realized that power resided in those who could confer attention. Artists who could not have been bothered to so much as hoist a rude salute to art critics in the past now looked anew at these dispensers of fame. A recognized critic's good word was an authoritative sanction, and it was worth courting.

The critics, for their part, looked to the artists for ideas and

actual words for their articles. In this milieu, it became advantageous for artists to be both articulate and aggressive in stating their views.

After the dissolution of the Subjects of the Artist school in May 1949, Tony Smith and a few other artists took over the lease on the loft at 35 East Eighth Street and continued the Friday evening lecture series, called Studio 35 after the address of the loft. De Kooning participated occasionally in lectures and discussions at this site, and in February 1949 he had delivered his now famous lecture, "A Desperate View," there. As a respected member of the inner circle of the avant-garde, Bill's views on his own work and on the forces behind creativity carried an aura of authenticity. Widely quoted since that time, his paper revealed a searching, lonely artist—a version of the ever-popular theme of artist as romantic hero. Bill said that his art issued from his sense of desperation, but "very seldom do I start out that way. I can see of course that, in the abstract, thinking and all activity is rather desperate."

After comparing the artist with God the creator, as depicted in Genesis, de Kooning continued:

> It is so mysterious that it takes away all doubt. One is utterly lost in space forever. You can float in it, fly in it, suspend in it and today, it seems, to tremble in it is maybe the best or anyhow very fashionable. The idea of being integrated with it is a desperate idea.

One idea in art is as good as another, he insisted, but "the only certainty today is that one must be self-conscious. The idea of order can only come from above. Order, to me, is to be ordered about and that is a limitation." He continued: "If you take the attitude that it is not possible to do something, you have to prove that it is not" possible, by attempting to do it. He argued that art should not have to have any certain look, or to be any particular way:

> Style is a fraud. . . . It is impossible to find out how a style began. I think it is the most bourgeois idea to think one can make a style

beforehand. To desire to make a style is an apology for one's anxiety.

De Kooning concluded:

> An artist is someone who makes art too. He did not invent it. How it started—to hell with it. It is obvious that it has no progress.
>
> The idea of space is given him to change if he can. The subject matter in the abstract is *space*. He fills it with an attitude. The attitude never comes from himself alone.
>
> You are with a group or movement because you cannot help it.[2]

In identifying the subject of art as space and in characterizing the artist as a godlike creator who fills that space with "an attitude," de Kooning said exactly what his artist listeners wanted to hear. In effect, he summarized years of conversation and wrangling over vocabulary. Few realized at the time—perhaps few still realize—that Elaine contributed heavily to the preparation of that paper. "Well," she admitted, "Bill never liked to write. He talked and I took down his ideas for him and then we went over his statement again and again. Naturally," she added, "I made suggestions. And after days and days of work on his paper, Bill made a very, very important statement. I mean, he just said what had to be said and there was just no room for argument. He was just totally right in what he said."

And what Bill said (as well as what Elaine said that Bill said) soon resulted in an image, a public persona. Bill himself became the subject of art. Stardom would follow.

Elaine contributed to the making of the image and to the elevation of the star. Younger than Bill and not recognized as his equal as a painter, she was a natural critic. Words fascinated her; ideas, she believed, were intended to foster argument among friends. And for her, art criticism—that which she wrote and that which she shaped in the minds of other writers—was a means for assert-

ing ideas that she had developed in association with Bill, for catching attention for Bill and other artists she admired, and for competing with them for recognition. Art criticism gave Elaine the immediate power that enabled her to create and shape Willem de Kooning's reputation and, later, the legend and myth that surrounded him.

And when Elaine reviewed "one of the guys" for *Art News*—that is, any of the artists in Bill's circle, another contender for the championship of twentieth-century American art—she praised those features most consonant with Bill de Kooning's own work and philosophy and dealt deft put-downs to aspects of imagery or technique that might be construed as challenges to his work or ideas. In 1949, for example, Elaine described "Jackson Pollack's [*sic*] new paintings" at the Betty Parsons Gallery as "violent in drawing and in application of pigment [but] paradoxically tranquil in expression." Continuing, she wrote:

> Here, complex luminous networks—most striking in the huge dazzling *No. 1,* with its remarkable range of whites—give an impression of being frozen in position. His flying lines are spattered on in intense, mixed colors to create wiry, sculptural constructions, which stand mobile and apart, uninvolved with the backgrounds. . . .

She concluded, however, that Pollock's work was "curiously uniform in emotional content."[3]

Elaine earned $2 for each review that she wrote. And, as she said, "the money helped. I always needed money for supplies." Although she enjoyed reviewing shows and especially liked visiting artists' studios to see work, Elaine considered herself a painter, not an art critic. While she delighted in the power she wielded over Hess and Rosenberg, men she considered to be major critics but under the sway of her feminine charms, she wanted to be known not as a writer about art but as a maker of art, as "one of the guys."

As early as the thirties, Elaine and Bill and their circle of artists had begun to explore new territories in the realm of art. But they did not—despite efforts of art historians to suggest otherwise—formally assemble sometime during World War II, set an agenda for an onslaught on established modes of art, and systematically attack public tastes with their work, their life-styles, and their pronouncements. On the contrary, the American abstractionists—an inadvertent community of artists interested in disparate aspects of modernism—viewed themselves as individualistic, held together only casually by shared concerns, greatly separated in matters of style and direction in art. Further, as the vanguard artists had embarked on explorations of abstraction, they had always insisted that they did not give a damn about public recognition or about monetary gain (a protestation open, of course, to skepticism). Selection of abstraction as a direction for work was, in itself, they said, evidence of not seeking to please or gain an audience, evidence akin to public sacrifice, they said, evidence that they were outsiders (whether by choice or by fate).

Before Jackson Pollock's big splash in *Life* magazine, painters had every reason to assume that to be an abstract painter was to be unknown and unrewarded. Pollock's appearance in the popular press, however, called attention to "outrageousness" in art, and it brought artists and the public into contact—if not communication—with the world of expanding media. As *Life* presented the romantic genius Pollock—heroic, lonely, dedicated, and working in realms too advanced and visionary for the minds of ordinary folk—the article also established a mode of operation for artists and members of the media: shock sells.

Jackson Pollock's work, as presented to the magazine-reading American public, shocked and offended them. The lanky artist with the dangling cigarette seemed to disregard technique, a traditional and visible display of standards for evaluation. He splashed and slashed out at the canvases he spread on the floor; he shunned the recognizable world for images based on accident;

he even threw sand and other extraneous materials onto his canvas. He was not an artist, clucked laymen and art world denizens alike.

Disbelievers asked: Is Jackson Pollock a crazy man, a charlatan, or a clown? Among themselves, some of Pollock's friends asked the same questions. Through the article, however, Pollock, in the tested and revered tradition of the avant-garde artist, had helped identify the philistines—and thereby established a common target for artists to attack.

Life's attention to Pollock also demonstrated the bankable power of fame. Soon other artists—as well as wives, lovers, dealers, and collectors—understood the significance of Pollock's celebrity. Words were powerful, publicity potent. To be written about as an artist bravely searching for new forms of human expression, to be photographed as an archetypical artist-hero or -saint or -clown, to be publicized as individualistic and outside the common mire of humanity—in short, to be the object of attention—was tantamount to being certified as an artist. To be castigated publicly for shocking, outrageous, or nihilistic affront to the standards of traditional art was sweet, sweet attention, which paid the price of admission to the Big Contest. In an age of uncertain standards, publicity—more than work—bought an artist entry into that contest for the title of Genius.

In the parlance of the Cedars, artists began to discuss "making it," meaning the passing from the near-obscurity of life in the artists' world to recognition in the philistines' world that resulted in sales. It meant having works in collections. "Making out" meant sex; "making it" meant having sex and everything else, too—money, power, fame. Along with teenagers who drooled over the movie stars in dream-mongering pulp magazines, a lot of artists also lusted after a life of glamour.

While the *Magazine of Art*, a periodical with a small circulation, had featured articles from 1948 to 1951 on de Kooning, Clyfford Still, Motherwell, Rothko, Pollock, and Gorky, it was *Art News*, under the managing editorship of Thomas B. Hess, that gave

prominence to Abstract Expressionism. When Hess took the helm of *Art News* in 1948, he was already attracted intellectually to the work of de Kooning and his circle of downtown artists, and the magazine already noted exhibitions of Abstract Expressionists. By 1950, however, Hess had adopted the new art as a cause, and *Art News* ran feature articles on the artists who—despite myriad stylistic and philosophical differences among themselves—would be identified as "first-generation Abstract Expressionists." *Art News,* in effect, became the journal of (some said "mouthpiece for") Abstract Expressionism.

"Yeah," says an artist's wife, "Tom Hess adopted the Abstract Expressionists, but only after Elaine de Kooning adopted Tom Hess. He was crazy about her. He loved to talk with her, and she was very smart, very influential. Hess always made a big deal about Elaine never writing about Bill. But Elaine didn't have to write about Bill. First, she wrote about Bill even when she wrote about other people. Whatever she wrote was, underneath, really about Bill. Second, she really influenced Hess and Rosenberg to write about Bill. Elaine made sure that Bill was the subject of *Art News.* Some of the artists used to joke about it, a little bitterly maybe, and get drunk and count the number of times de Kooning's name was mentioned in a single issue of *Art News.* Everyone knew what was going on. But no one—I mean no one—would have said anything about it to either Elaine or Bill. Instead, they all tried to be close friends with the de Koonings. That way, they thought, they'd get attention, too."

Elaine often explained to friends and students that in the early days of Abstract Expressionism artists identified or selected other artists, that "you joined the brotherhood when the other artists accepted you. And that's how you got into galleries, got shows; that's even how collectors got interested in artists. Artists supported other artists." Elaine was an artist who, in fact, always took an interest in the work of other artists. "One of the best things about writing for *Art News* was being able to look at work by artists."

In short order, Elaine contributed to *Art News* not only reviews of exhibitions but major articles about artists and, stitched deftly throughout, ideas and points of view vital to Abstract Expressionism. Before Harold Rosenberg published his definitive article on Action Painting—his name for Abstract Expressionism—Elaine wrote about a friend, sculptor David Smith, in the fall of 1951, establishing the approach that others would use in writing about American abstract artists in the middle of the twentieth century.[4]

Elaine described the sculptor's manner of working—the actions he took with materials—and, from that description, extracted an aesthetic: an artist's moral integrity stems from his honest collaboration with materials, and from his willingness to find, not reiterate, an image; the final work is the sum of gestures made in material. These ideas, in various permutations, lay at the heart of critical thinking and writing about abstract art. And they are similar to the ideas that permeated Bill de Kooning's 1949 paper on desperation.

Elaine also depicted the prototypical American-artist-as-hero. She described the powerfully built Smith, clad in workman's clothing, living like a religious hermit in the wilderness, engaged in a deep and difficult quest for knowledge of an unknown dimension in art. Up in the mountains in his industrial-style studio—with its concrete floors, north-facing skylights, a pot-bellied stove for heat, and power tools run by a Ford motor—Smith enjoyed few comforts, but he listened to classical music on the radio as he worked. Elaine described Smith, as she did the painters associated with Abstract Expressionism, as the quintessential existential hero, as a rebel with an obsession if not a cause, and as a very attractive and very masculine man.

A tough-guy college dropout and former automobile worker, Smith had studied with John Sloan at the Art Students League, but he had left that behind him—so much baggage to be abandoned as he stripped down, jettisoned unnecessary distractions, and moved up the mountain of art toward his own truth.

Now a semirecluse, lonely and consumed by his work, Smith

occasionally came down off the mountain, according to Elaine, and went to New York "after several months of good work," where he went to galleries and museums and ran into "late-up artists chewing the fat at the Sixth Avenue cafeteria, the Artists Club, the Cedar Tavern . . . then back to the hills" to dream and to work.

The essential portrait—though based on closely observed details about Smith as well as about the studio and his style of living, the materials of the artist and his manner of deploying them—could have applied to Franz Kline, Jack Tworkov, Robert Motherwell, Jackson Pollock, or Bill de Kooning. Elaine diagramed the archetypical Abstract Expressionist, holding up a mirror to the collective identity being forged at the Cedars and at the Club. In the 1951 article about Smith and in other articles and reviews, Elaine de Kooning bridged the chasm between art and public, and in the eyes of the "guys at the Club" she became an anointer of artists, a star maker.

If Elaine had not won from the brotherhood full recognition as a painter, she caught their attention as a writer. With access to *Art News* and Tom Hess, she could lay an artist's yellow brick road to the magic city of acclaim and success. She could shape with words the identity—the self—an artist sought in his work and in the reflection he saw of himself in other's eyes.

Meanwhile, Harold Rosenberg and Elaine—who had known each other since the late thirties—had also become romantically involved. And Rosenberg, like Hess, loved discussion, argument, and intellectual speculation and word-jousting on the uneasy seam between abstract ideas and concrete paintings. Elaine, Hess, and Rosenberg often became entangled in hours of drinking and talking, arguing and agreeing, shouting and proclaiming evident or subtle truths on art and politics and life they thought important to discuss.

The threesome made a drunken pact: any one of them was permitted to quote any other member of the group and to make up quotations if that would win an argument. Elaine loved the game,

and for the rest of her life she characteristically introduced topics by such devices as, "As Tom Hess says, . . . " or, "Harold Rosenberg has always insisted that . . . ," or, "Bill said the other day. . . ."

Elaine also loved to tell of a typical evening when the three met at the Cedars, drinking and talking until four in the morning when the bar closed. "Highly drunk," she said, "but intellectually roaring," they adjourned to Elaine's nearby loft-studio. She produced a bottle of Armagnac that Tom Hess had given her earlier—suggesting that she try "this really powerful French brandy that was better and stronger than Cognac."

Harold sank into her most comfortable chair, his stiff leg stretched out before him and his cane leaning against the chair arm. Tom perched on the edge of his chair, gesticulating to emphasize ideas. And Elaine alternated between sitting in a straight chair and standing, her platform-heeled shoes contributing only slightly less than her blood alcohol level to her unsteadiness, with one arm crossing her breast to provide a hand-cup for the elbow of the other arm, which, like an upside-down pendulum, swung a cigarette to punctuate her sentences. "Even Harold, who just never got drunk no matter how much he drank, was, let's say, high," Elaine explained.

As the light of dawn touched the large dirty windows of the studio, Tom Hess departed, saying that he had to get some sleep in order to face the day. But Elaine and Harold continued to talk and drink until, about an hour later, the telephone rang. It was Tom, who warned Elaine that Armagnac destroys brain cells. "He had remembered that," Elaine said, "on his way home and by the time he got there, he urgently wanted to tell Harold and me to stop drinking right away."

Elaine turned to Harold and relayed the message.

"Tell him," Harold told Elaine, "that I don't care. I have too many brain cells. I need to lose some."

Two articles—one by Rosenberg, one by Hess—in *Art News* contributed significantly to Bill de Kooning's apotheosis. Rosenberg's

seemingly established general standards for thinking about the work of Abstract Expressionist artists, but it actually defined the movement in such a way as to suggest that Bill was the most innovative and sincere of the contenders. Hess's article described Bill at work in the studio and in effect revealed an artist-hero. "When Harold and Tom thought about art, they just naturally thought about Bill," Elaine said. "They knew that Bill was a genius."

In December 1952, in the now-famous *Art News* article, Harold Rosenberg defined, or canonized, the aesthetic fundament of Abstract Expressionism and dubbed the new painting "Action Painting," a term that Jackson Pollock believed Rosenberg picked up from him on a train ride from Manhattan when the painter claimed he had described his own work as "Action" Painting.[5] Pollock's claim to having coined the phrase may have been accurate, but there was no doubt about the origin of some of Rosenberg's concepts. For those who knew both Harold and Elaine and who had heard their passionate arguments and continual word contests, Harold's article plainly showed Elaine's influence. But whatever his sources and influences, Rosenberg's article accomplished several goals at once: it planted his flag on the critical territory of Abstract Expressionism; in high intellectual tones, it excoriated his rival Clement Greenberg; and it elevated Willem de Kooning and deftly diminished Jackson Pollock.

Rosenberg backed into a definition of the movement, paying heed to the difficulty in characterizing any movement or school in which such diverse personalities figured prominently. He alluded to the immediate necessity of separating the men who served in the advanced guard and those—usually by virtue of learning second-hand tricks in universities—who aped their betters. "Yet," wrote Rosenberg, "without the definition something essential in those best is bound to be missed. The attempt to define is like a game in which you cannot possibly reach the goal from the starting point but can only close in on it by picking up each time from where the last play landed."

And where did the last play land? And on what playing field?

Rosenberg acknowledged the existence of "a scattering of new heroes—ambitions stimulated by new galleries, mass exhibitions, reproductions in popular magazines, festivals, appropriations." Europe had long fostered a rich art world of collectors, museums, dealers, and artists, but, said Rosenberg, the appearance of a vital and wealthy commerce in art in America was new. Newness or originality, he said, was exactly the issue: something new was happening in American painting. Artists, he said, had separated themselves from recent European art history and had embarked bravely on a new path. This new painting was not a school of painting in the traditional sense; rather, it (like existentialism) sprang from consciousness. And, as Rosenberg clarified, "not only is a new painting consciousness needed but a consciousness of that consciousness—and even an insistence on certain formulas."

By reasoning, as Rosenberg did, that a school of art is "the result of the linkage of practice with terminology," or the words used to describe what the artist does or has done, the writer emphasized the primacy of the word and, lest anyone forget, the importance of the writer of the word. The historian, critic, collector, or artist himself could employ specific words to describe experience or differentiate between objects and experiences, but, cautioned Rosenberg, the words of the American vanguard belonged not to the movement or school but to "the individual artists. What they think in common is represented only by what they do separately."

From this vantage, Rosenberg nonetheless gathered individuals into a generalized characterization when he penned the often-repeated description of Abstract Expressionism, or Action Painting:

At a certain moment the canvas began to appear to one American painter after another as an arena in which to act—rather than as a space in which to reproduce, re-design, analyze or "express" an object, actual or imagined. What was to go on the canvas was not a picture but an event.

According to Rosenberg, the new American painter no longer began to paint with an image in mind but collected his materials and confronted his arena—his canvas—to live through the process of working, of making decisions spontaneously. The artist acted in the faith that an "image would be the result of this encounter" between himself and his materials.

Rosenberg conceded that his vision of the artist could not include Michelangelo or Rembrandt. He must have known, too, that without modification it could not include de Kooning, who drew and edited his paintings by consciously preserving some sections and painting out others. But, argued Rosenberg, an underlying principle—more than a manner of working—separated the new and creative American artist-hero from the painters in art history books. While artists in previous times used sketches as a way of developing images, contemporary artists use sketches for themselves, as ways of working for the work itself, not as a means of planning an image that would later be applied to the canvas as the basis for a painting. For the new American artists, both sketches and paintings existed as evidence of the mind recording its contents; both could be finished, or abandoned. Sketches did not precede paintings. In drawing or painting the artist did the same thing: activated materials, allowed accidents, made spontaneous choices, and discovered new realms of his own mind. Rosenberg was certain that "what matters always is the revelation contained in the act [of painting or drawing]. It is to be taken for granted that in the final effect, the image, whatever be or be not in it, will be a *tension*."

Having laid a foundation for what would become the de Kooning throne, Rosenberg had also headed off the major argument that might be made against de Kooning as a member—let alone the leader—of the Abstract Expressionist movement, the argument that he was not a pure abstractionist, that he employed images of the figure. In bounding over this tall intellectual hurdle, Rosenberg included de Kooning in his pantheon of heroic new artists. Some say Harold accomplished his goals brilliantly.

And there was more. Swifter than a speeding bullet, Rosenberg simultaneously lobbed heavy intellectual artillery at Clement Greenberg's "formalist" criticism. Rosenberg, almost as if addressing Greenberg, postulated that since painting is biographical, it cannot be without subject; it cannot, as Greenberg contended, be configured from the design elements of visual art—color, texture, line, shape—without carrying meaning. Indeed, insisted Rosenberg, great art, that made by geniuses, was deeply meaningful because it captured the genius's struggle in paint to find the meaning of meaning. The act of painting—the action by which paintings were made—had to be based on the integrity and sincerity of the artist himself, and had to reveal the artist's mind in the process of finding meaning. Anything could be relevant to the making of a painting—"philosophy, history, psychology, mythology, hero-worship." In what is often viewed as a one-two punch at Jackson Pollock and the critic who promoted him, Clement Greenberg, Rosenberg cautioned that some painters, "having insisted that their painting is an act . . . then claim admiration for the act as art. This turns the act back toward the aesthetic in a petty circle. If the picture is an act," he continued, "it cannot be justified *as an act of genius* in a field whose whole measuring apparatus has been sent to the devil. Its value must be found apart from art. Otherwise, the 'act' gets to be 'making a painting' at sufficient speed to meet an exhibition date."

And, in what are often viewed as words championing Willem de Kooning, Rosenberg wrote:

> With traditional aesthetic references discarded as irrelevant, what gives the canvas its meaning is not psychological data but *role*, the way the artist organizes his emotional and intellectual energy as if he were in a living situation. The interest lies in the kind of act taking place in the four-sided arena, a dramatic interest.
>
> Criticism must begin by recognizing in the painting the assumptions inherent in its mode of creation. Since the painter has become an actor, the spectator has to think in a vocabulary of action: its

inception, duration, direction—psychic state, concentration and relaxation of the will, passivity, alert waiting. He must become a connoisseur of the gradations between the automatic, the spontaneous, the evoked.

Since its publication, Rosenberg's article has been quoted and subjected to exegeses of all flavors. Lauded as the primary document—almost a manifesto—for Action Painting, it has been seined for splinters of the unmoved mover's first truths about painting. From the other side of the art world, Rosenberg's article has been derided as self-serving sophistry designed to gain the critic's crown for himself and the artist's crown for de Kooning.

"Rosenberg wanted to make sure that Bill was seen as the greatest painter of the time, and that he—Rosenberg—was seen as the greatest critic, the only critic who could penetrate the mysteries of Action Painting," says a painter who often drank and talked with Harold Rosenberg. "The truth is, I think, that most of the painters didn't have a clue about what Rosenberg's article meant. It sounded good. It sounded intellectual. It sounded a call to battle: join the right side and take literary-sounding pot shots at Jackson and Greenberg."

Three months after the Rosenberg article appeared, Thomas Hess's article "De Kooning Paints a Picture," accompanied by photographs taken by Rudy Burckhardt, praised Bill's work.[6] In addition to describing de Kooning's manner of working on one of his *Woman* paintings, Hess referred to the painting's "energetic and lucid surfaces, its resoundingly affirmative presence" that does not reflect the artist's long and ardent struggle with the accidents and decisions that combined to produce the image of the seated female figure.

According to Hess, "*Woman* appears inevitable, like a myth that needed but a quick name to become universally applicable. But like any myth, its emergence was long, difficult and (to use one of the artist's favorite adjectives) mysterious." The writer alludes to de Kooning's romantic voyage—"not a mission or an

errand"—which resulted in the picture, and he continues to establish a portrait of the artist-as-hero. Reminiscent of Elaine's portrait of David Smith as a brawny workman who listened to classical music, Hess portrays de Kooning as a poet who does physical labor, as a pilgrim who journeys to find metaphysical truth.

Buffeted by divine dissatisfaction with pure abstraction but believing in its essential doctrine, de Kooning, acording to Hess, struggles to let his painting evolve into what it will—all the while believing that the sturdy craft of painting will lead him past the sirens, beyond the storms, away from the dangers that beset the mythical voyager. The painting was photographed at several stages, which are seen as "the stops en route—like cities that were visited, friends that were met. They are neither better nor worse, more or less 'finished,' than the terminus. They are memories which the camera has changed to tangible souvenirs. . . . [They are records of] the exploration of a constantly elusive vision. . . . The ending is like the poet's ending, too; the voyage simply stops. You are not necessarily 'home again'; need for the particular journey no longer exists. The results, like that of all works of art, can be compared to a new map of the human sensibility."

Hess says of the smile on de Kooning's *Woman:* "It can be properly compared to the curling lips of the Greek Kouros and the medieval Virgin." It is an ambiguous smile, he says, and "ambiguity exactingly sought and exactingly left undefined has been the recurrent theme in *Woman*."

"Tom Hess took the time to understand Bill's way of working," Elaine said. "Harold was interested in the psychological impulses behind the work—what made a genius a genius, what made a painter paint, that kind of thing—and he was interested in understanding the importance of art, the meaning of art and what it had to do with philosophy and society."

Then Elaine added, with her own version of an ambiguous smile, "Bill and I were always just interested in work. We really believed in work. Mercedes Matter wrote about what it takes to become an artist, and she wanted to remind students that the

operative word in the term *art work* is *work*. Well that's something that I always knew, and Bill always knew it, too. Intellectuals like Harold and Tom, men who dealt with books and with words, were just fascinated by artists at *work*. That's really what they wanted to write about. But there aren't words to truly describe an artist's *work*."

In fact, Tom Hess and Harold Rosenberg—and Elaine herself—had spent thousands of words describing artists' works; and, more to the point, they had fabricated a stalwart word-picture of the artist, with characteristics and outlines that only Bill de Kooning filled. If they had not written the script for the role of the artist in mid-twentieth-century America, they had nonetheless cast Bill de Kooning as the hero of the drama.

WHO SHALL WEAR THE CROWN?

Jackson and Bill were different beasts. . . . But the most brutal of gods put Jackson and Bill into competition. [They] found themselves on the same playing field, competing for the One great Big Prize. There was to be no runner up. The century would have One Great Genius Artist. Jackson had come from out west to win the prize; Bill had come from Europe. Here they were, face to face, and there would be some kind of violence before sundown. So to speak. . . .

—ANDRE EMMERICH

In the lore of the New York art world, among those who knew Willem de Kooning and Jackson Pollock and those who venerate the legends that often cloud the history of Action Painting, a predictable array of words is used to describe the relationship between the two men, but *competition* and *hostility* are among the most often invoked. Each artist, by all accounts, had set his sights on the pinnacle of twentieth-century art; each, driven by his own

devils and angels, saw himself as the twentieth-century master who would take his place in the pantheon of art history. Each married another artist; and each wife led a campaign to win the kingdom for her husband. And neither artist wanted competition from the other. By definition, only one can be the best—all others are also-rans.

The conflict between the two artists did not end with Jackson Pollock's death in 1956. The question—Who was the better artist, Jackson or Bill?—is still argued by those who believe it pertinent to the history and understanding of American art.

Given the strong-willed wives of the two men, the legendary competition between Willem de Kooning and Jackson Pollock would not be confined to the canvas, or even to the war of words waged by Greenberg and Rosenberg. Accounts differ as to when the seeds of conflict were sown, who started the antipathy, and who controlled its direction.

When the two artists first met, in the thirties, they respected one another, enjoyed talking together, and each openly admired the work of the other. The two couples attended the same parties and shared friends. Before the onset of the competition between them, Pollock often spoke of his esteem for Bill's paintings, and often urged fellow artists to get to know Bill, "one of the important guys." Bill is widely quoted as saying that "Jackson broke the ice." He also recommended Jackson's work to other artists as "important to see." And Grace Hartigan, whose painting would be compared often with that of de Kooning, remembers the generosity that Pollock and de Kooning displayed toward one another when she first met them, in the early fifties.

Hartigan had moved from her New Jersey home to the New York art frontier, knowing that she wanted to be a painter and determined to fully invest her life to that calling. Like other young artists who were drawn into the New York art world, Hartigan made the rounds of the few galleries that showed vanguard painting. She met Jackson Pollock soon after she saw his first drip paintings at the Betty Parsons Gallery. She was, she remembers,

"bowled over, really confused and moved in an extraordinary way." That encounter with Pollock's paintings changed Hartigan's life, she says—she didn't know what or how she wanted to paint, but she knew that Jackson was on the right track and that she should learn from him.

When she subsequently visited Pollock and his wife, Lee Krasner, on Long Island, Pollock got blind drunk. Quiet, almost inarticulate when sober, the drunken Pollock ranted obscenely and seemed on the edge of physical violence. As if dealing with a tantrum-pitching child, Lee comforted Jackson, reasoned with him, soothed him until he sank into alcoholic stupor. She also dutifully showed Pollock's work to the admiring Hartigan, promoted him as a genius, "sold" him to Hartigan.

Grace Hartigan at that time did not realize that Lee also painted. (Grace thinks now, in fact, that Lee was not painting then.) Nevertheless, Hartigan thought that Lee "forfeited her identity to her single-minded advancement of Jackson Pollock's reputation."

Pollock was a nasty drunk who raged and stormed, hurling profanity and hate at anyone in his view. When sober, Hartigan noted, this "tortured man, self-destructive, sensitive, and at odds with himself and the world," could hardly speak. Sober, he was "an incompetent, silent, perhaps confused man. But he considered himself a genius; and his wife knew that her role was to serve genius."

During the visit to Long Island, Hartigan listened as Pollock, loosened by a few drinks, talked about art, about his work, about the direction of painting and the work of the handful of artists he admired. "There are only two guys in town," he told her finally, "Pollock and de Kooning."

"Who is this de Kooning?" Grace asked. "I never heard of him."

"He's a really good painter," Pollock told her. "He shows with Charles Egan. There's a show up now; go see de Kooning's work. Then, go see de Kooning. Tell him I sent you."

Hartigan found the Egan Gallery and saw the de Kooning paint-

ings, his second show in that gallery, in 1951. "They were, well, magnificent," she says of the large black enamel drawings exhibited. "Very different from Pollock, but somehow related, somehow *about* the same things—energy, defiance, rebellion, a new order, creativity itself, gesture. Yeah, something male; but more than that—something, well, maybe universal—searching, deep: powerful. That's it, you know, I just have to keep coming back to that idea—powerful."

Of course Grace Hartigan went to visit de Kooning as soon as she could locate his studio, which at that time he shared with painter Jack Tworkov. At the Fourth Avenue address Hartigan banged on the door downstairs, and a window above opened. Bill's head popped out, and Grace heard his Dutch accent, "Who's dat?"

"Grace Hartigan," she yelled. "Sent by Jackson Pollock."

"Come on up, den."

"And there he was," Grace remembers. "Compact. Beautiful. Those fantastic eyes, and the most perfect hair in the world. Really movie-star beautiful. Striking. Breathtaking. And quiet."

The two artists talked. Grace looked at Bill's work and thought it was, simply, "wonderful painting." At that time—before Bill had uttered his often-repeated derisory remark that Jackson Pollock's painting was "like chain-smoking"—Grace was struck by the mutual respect between Pollock and de Kooning. "Yah," Bill told Hartigan, "Jackson is something."

Hartigan knew de Kooning was married but admits that she "didn't think much about his wife. Artists' wives didn't matter much; they were there to serve and support their husbands. No serious female artist could be a *wife* of an artist—well, you know what that means." Artists' wives, she thought, were like Lee Krasner—subservient, self-effacing, and nurturing to the genius child-husband.

During Hartigan's visit with de Kooning, "Elaine bounced in, vivacious, saucy, and beautiful. She was," Grace contends, "the most beautiful and most sexy woman I had ever seen. Red hair, pale green eyes; a perfect body; that slightly husky voice with the

residue of Brooklyn and the overlay of rubbed-off-from-Bill Dutch accent. She was flirtatious. Very flirtatious with Bill. As if I weren't there."

At that first meeting, Grace didn't like Elaine at all. She thought she was sexy-silly, and she didn't like her manner with Bill—flirting, trying to get money from him, wanting a new winter coat. Bill said he had already given her money for a coat. Yes, Elaine said, but she had spent it and now needed more money.

Grace left not knowing how Bill and Elaine resolved the domestic crisis that was budding, and she admits that she didn't really care. But she met Elaine again afterward and began to think that she "was quite smart—really intelligent, and really somebody special, though maybe not a very serious person." But she was serious about one thing, Grace thought, and that was Bill's genius. As different as they were in appearance and personality, Lee Krasner and Elaine de Kooning anchored their lives to the same premise— each believed she was married to the genius of the twentieth-century art world.

By that time—whether out of his own conviction, Elaine's persuasion, or the promises of fame and fortune that hung in the New York air—Bill wanted to be the genius. And Jackson Pollock wanted to be the genius. "They figured it this way," Grace surmises. "Picasso was the greatest innovator, creator, thinker in art of the twentieth century; and Matisse was the great colorist. They had to do something different; they had to challenge Matisse and Picasso. It was inevitable that they would also challenge one another; and maybe inevitable that Elaine and Lee would clash."

The competition and hostility grew from each artist's personal insecurity and jealousy. One friend recalls, "Bill and Jackson started out being polite to each other, maybe even respecting each other. But after Jackson started getting famous, a terrible hostility developed between them. If one got more coverage in the art magazines than the other, there was some kind of hell to pay. Or if one sold a painting, the other one just had to sell a painting for more money. Neither of them would exactly admit that they were

competing in this way; but everyone else sure as hell knew it."

Through the theater of their competition, if not through their actual work as artists, Jackson Pollock and Willem de Kooning became for many the poles that defined the planet of Abstract Expressionism, or Action Painting. To begin with, the two men displayed almost opposite personalities. De Kooning was, in the view of several of his contemporaries, "one of the boys," an honorific confirmed and furthered by his membership and participation in the Club. Pollock, according to the same sources, did everything possible to set himself apart, to be better than everyone else from the beginning.

When Jackson sold a painting, recalls an artist, "he couldn't wait to swagger into the Cedars and flash a big roll of bills. The fool even liked to compare his initials—J.P.—to those of J. P. Morgan. What he was doing to the guys at the bar, of course, was boasting about his masculinity. It was like this: he was a tough hombre from out of the west—a go-getter, a shit-kicker—and he had taken on this two-bit fag-town. He had money. Money meant power. And money and power implied sex. Virility. That galled the hell out of de Kooning."

A young painter, Ruth Kligman, an Elizabeth Taylor look-alike from New Jersey, came into focus for the crowd at the Cedars as Jackson Pollock's latest love. In her book about her affair with Pollock, Kligman looked back on and described their tender-violent relationship, as well as her concern for Pollock's suffering as an artist and as a man. Ruth Kligman spent the last days of Pollock's life with him in the Springs, an area of East Hampton where Pollock had his studio. She was with him in the car crash that killed him, and she survived to mourn his loss. "He died at the height of his greatness, at the height of our great romantic love," she said. "He lived hard, died young, and had a beautiful corpse. That's what we were supposed to do, wasn't it?"

In the early days of her affair with Pollock, Ruth met Bill at the Cedars. "Bill razzed Jackson about Ruth," recalls an observer. "He pretended to grab at Ruth, and he rather lewdly suggested that

Jackson had got hold of more woman than he could handle. Bill treated Ruth at that time like an insensate object—like some kind of trinket or toy that Jackson had—and he really went after Jackson's balls with a verbal knife."

Another artist who knew both de Kooning and Pollock rolls his eyes heavenward and remembers, "There for awhile, there was a real pissing contest between Bill and Jackson. And everyone egged them on. It was better than cowboy movies. They would get drunk, be abusive and violent to one another at the Cedars, and just end up by each making a big show of taking some girl home for consolation."

Conflict produces news, and the de Kooning–Pollock skirmishes and cease-fires alike fed gossips, journalists, and those who labeled their writing as art history. Harold Rosenberg and Clement Greenberg, waving their banners for intellectual and social causes, took sides. Rosenberg became de Kooning's champion; Greenberg, Pollock's.*

As Jackson Pollock and Willem de Kooning came to symbolize different life-styles and value systems as well as artistic points of view or opposing directions in modern art, each stood at the front of an army of spearbearers, foot soldiers, storm troops, and trampy camp followers. Behind the lines of battle, critics, journalists, and scholars played at diplomacy, intrigue, and power brokerage; gallery owners and museum directors cut deals and cut in the col-

* It is rarely mentioned that Clement Greenberg, in 1953, wrote enthusiastically about Bill's work, at the time of a survey exhibition at the Workshop Art Center Gallery in Washington, D.C. In his review, Greenberg identified de Kooning's work as among "the most advanced in our time," as well as connecting it with the past, citing it as a continuation of "the great tradition of sculptural draughtsmanship which runs from Leonardo through Michelangelo, Raphael, Ingres, and Picasso." He concluded that de Kooning painted in "the grand style, the grand style in the sense of tradition but not itself a traditional style, attempted by a man whose gifts amount to what I am not afraid to call genius." It is ironic that only three years later Greenberg compared de Kooning to Lucifer; and by the 1960s he regularly attacked de Kooning's art.

lectors. Territories were marked, bets taken, troops deployed, and battles staged and recorded.

And then there were the wives and the girlfriends. "Women," says the eminent art dealer Andre Emmerich, "did not fare so well in the macho Abstract Expressionist world. Those who were associated with the artists worked to support their husbands or lovers; and they worked at difficult, low-paying, long-houred jobs—secretaries, teachers, whatever they could get. Many had abortions—literally gave up their children—because their husbands or lovers didn't want the competition of a child around; and because there wasn't enough money to add a child to the already straitened circumstances of the households."

No wonder, Emmerich thinks, that wives and mistresses, seeing that the world had changed and that there was a market for the painting that their men did, wanted a share of the rewards. In the case of the Pollocks and the de Koonings, moreover, both Lee Krasner and Elaine de Kooning were themselves artists and had had their careers eclipsed by those of their husbands. In those eclipses, both Lee and Elaine saw the first indications that publicity, galleries, museums, exhibitions, and collectors were aligning in a new way, and that the result would be both fame and money for artists who "made it." If each wife wanted recognition and financial reward for her husband, each also wanted vindication. Whatever time was lost (for their own careers) and talent misdirected had been well spent in service to genius (their husbands) and to art as a high calling.

Both artists held the attention of groups of critics, other artists, and collectors. Pollock's mounting success rested on *Life's* focus on him and his several controversial exhibitions, first at the Betty Parsons Gallery and then at the Sidney Janis Gallery. As Pollock's reputation spread, however, so did de Kooning's. Following the 1948 Egan exhibition, Bill's work was included in numerous group shows and one-man exhibits over the ensuing several years. In 1949, dealer Sam Kootz enlisted Harold Rosenberg to help him organize and present an exhibition entitled Intrasubjectives,

which included works by de Kooning as well as William Baziotes, Arshile Gorky, Adolph Gottlieb, Morris Graves, Hans Hofmann, Robert Motherwell, Pollock, Ad Reinhardt, Mark Rothko, Mark Tobey, and Bradley Walker Tomlin. In 1950, Museum of Modern Art director Alfred H. Barr, Jr., chose both Pollock and de Kooning, along with four other artists, for small one-man shows in the U.S. Pavilion at the Venice Biennale. That same year, de Kooning—along with Baziotes, Gottlieb, Hofmann, Motherwell, Tobey, and Tomlin—appeared in another show at the Sam Kootz Gallery, Black on White: Paintings by European and American Artists.

By 1950—with the de Kooning–Pollock competition growing and with partisans tipping the scales of criticism toward one or the other according to their bias—the two artists had indeed embarked on distinctive, if not mutually antagonistic, paths in their work. Hess, in reviewing the Whitney Annual, 1949–50, for example, noted that "a happy incident of installation" had placed work by John Marin, Jackson Pollock, and Willem de Kooning in proximity, juxtaposing "de Kooning's abstraction, *Attic,* and one of Jackson Pollock's poorer improvisations." Faintly praising while not so subtly damning Pollock, Hess lamented that the Pollock was not "up to this artist's usually high standards" and continued:

> De Kooning's all but unrecognizable figures—whose sections interchange with the marvelously confusing rapidity of images in a metaphysical verse—and his textural nuances would set off a good Jackson Pollock painting to its best advantage. As it is, however, the de Kooning's ruffled, talc-soft whites which turn tawny as hooking black lines fold them, and the curious anti-collage device of having offset images of newspaper advertisements and columns of print appear like ghosts throughout the painting, only show up the Pollock's weakness.[1]

Both de Kooning and Pollock showed black-and-white paintings in 1951, prompting their followers to argue over which artist first took on the formal and expressionistic problems of a palette lim-

ited to black and white.* Betty Parsons, Jackson's dealer, recalled public reaction and Pollock's anger and hurt to find that the word "shit" had been scrawled on one of his paintings. "He said he didn't care, of course," Parsons remembered, "but it made all of us damn mad." Pollock could dismiss philistine scatology, but salvos from the de Kooning camp struck home. Charles Egan, Bill's dealer, visited the Betty Parsons Gallery, saw the Pollock show, and, encountering Jackson, quipped, "Good show, Jackson, but could you do it in color?"[2]

Each camp filled its arsenal with cheap shots, acerbic wit, and verbal barb-bombs, and the game was on. Recounting, revising, and recording the skirmishes soon became a cottage industry in the art world.

In the early fifties, East Hampton, a then-small and -quiet village toward the eastern end of Long Island, was a popular outpost of the then-small (if not quiet) New York art world. Leaving New York in pursuit of cheaper accommodations and a quieter life, Jackson Pollock and Lee Krasner moved to the Springs and subsequently lived there year-round. Among the other art world figures who lived and worked in the area or rented houses there for the summer, Leo and Ileana Castelli kept a spacious house where they entertained friends.

When the Castellis invited the de Koonings to stay with them in East Hampton during the summer of 1952, Bill and Elaine, like the majority of middle-class Americans with a little money in the till, began to plan a vacation. Bill, who never before had wanted to leave his studio, liked Long Island; Elaine thought he liked the area partly because the light and flat landscape

* The debate continues: Which New York abstractionist first used only black and white paint? In addition to de Kooning and Pollock, Arshile Gorky, Jack Tworkov, Robert Motherwell, James Brooks, and Franz Kline all produced at least a series of black-and-white works. Franz Kline, however, staked the largest claim to the black-and-white struggle with his first one-man show in 1950 (also at Egan).

reminded him of Holland. With the Castelli invitation, they remembered the cool mountain air of their summer in North Carolina and anticipated a summer away from New York heat.

They looked forward to the open landscape of the eastern end of Long Island and to the promise of solitude, a simple life centered on work in the studio, and the company of people with interests akin to their own. They—like other artists in their circle and earlier generations of American painters, sculptors, writers, poets, critics, actors, and patrons of the arts—planned to join the summer population of the region and to combine work and play.

Leo recalls that Bill wanted to be left alone during that first summer on Long Island. While others organized picnics, went to the beach, and generally drank and helled around, Bill just wanted to work. He established a studio at the end of a huge porch on Castelli's house. There, day after day, he painted. When Elaine and friends set out for the beach, de Kooning begged off, preferring to stay on the porch and paint.

Elaine set up her own work area on the open porch, and she loved the effect of the changes in sunlight had on her work. On rainy days, she moved her easel inside and worked in her bedroom. During one day of torrential coastal rains, when nobody in the Castelli household could go to the beach and no one seemed caught in a mystery novel or by the television, Elaine invited everyone to watch her paint Leo's portrait. "Well, of course," she said, "everyone there was some kind of expert, some kind of kibitzer. So I painted and everyone watched and talked. I've always enjoyed having people around when I'm working on portraits, so I just went ahead with my painting and, in the end, had a pretty good picture."

At night, the Castellis and their guests shared dinners, often adding other artists and the Rosenbergs to the party. Elaine remembers that there was much conversation, much drinking, and good food. Harold and Bill tended to monopolize the conversations, but in different styles. Harold held forth on his pet ideas, playing word games rather brilliantly and sometimes pontificating

about things that no one else even understood. Bill, often drunk, held everyone's wary eyes as they nervously wondered what he might do or say next.

Almost every day, Leo Castelli remembers, Jackson Pollock would arrive in his dilapidated car and leave it huffing and puffing in the driveway while he sought out Bill. Leo confessed that he expected the chattering car to blow up in the driveway. Elaine remarked, "I always thought Jackson himself might blow up. Anywhere. Anytime."

Drunk or sober, Jackson was not always a welcome guest at the Castelli house, where his antics and tantrums were all too familiar. Another frequent visitor remembers that "Jackson had some sort of compulsion to see Bill. He desperately wanted Bill's approval, I think, but he damn well wanted to fight with Bill, too. You never knew whether Jackson would arrive, fall all over Bill and weep and moan about his suffering as an artist, or whether he would be surly and vile and would want to fight—verbally or physically—with Bill. Worse than that," he recalls, "Jackson in a fighting mood would strike out at anyone—man, woman, child, or kitten. He was a mean customer, and crazy."

Reports about the frequent encounters between Pollock and de Kooning—what Jackson said or did, how Bill responded— hummed over the telephone lines and through the gatherings of artists on Long Island and in Manhattan. An observer believes that "there was, I have to say, a lot of titillation over the Pollock–de Kooning scenes. Someone would race to tell his twenty-two best friends that Bill, in drunken exasperation with Pollock, had pissed on Jackson's car. Or that Jackson, probably frustrated because his own work was going so badly, had accused de Kooning of putting him down, and had then tried to fight Bill. You have to wonder," he concludes, "if those two drunks would have kept at it if nobody had shown any interest. It all had this terrible smelly theatrical tone."

In their prize-winning but controversial biography of Jackson Pollock, Steven Naifeh and Gregory White Smith place the

beginning of the public competition between Jackson Pollock and Willem de Kooning in events surrounding a party at the Rosenberg house in the Springs during that summer of 1952. Naifeh and White recount that the Pollocks, along with several other couples, gathered at the small house on Neckpath Road for drinks and dinner. Harold, as was his custom, dominated the conversation. Pollock, already depressed and angry, drank heavily and soon began interrupting Harold's lofty pronouncements with furious remarks like "What a lot of shit" and "horse piss."

After a period of ignoring Jackson and smoldering, Rosenberg turned on him and devastated the drunken, rude artist with condescension. Disdainfully, Harold told Jackson that he had had enough to drink and told him to go upstairs and sleep it off. Jackson, drunk but docile, obeyed Harold's command. But Lee, always thin-skinned and short-fused where Jackson was concerned, "erupted in a blinding rage."[3]

Lee thought that Rosenberg had set Jackson up, had planned to make a fool of him and to humiliate him. She believed that Rosenberg deliberately set out to destroy Jackson Pollock and to use the process for enlarging his stature as a critic and man of letters. In short order, Jackson, too, believed that Harold was trying to destroy him.

Harold considered himself a serious critic, perhaps the only one capable of unknotting the dense problems presented by Abstract Expressionist works. Clement Greenberg also wrote about artists and problems within the avant-garde, and Harold made no effort to hide his contempt for him, whom he regarded as a fraud. May Tabak, Rosenberg's wife, held Greenberg in even greater contempt. Harold had written extensively about art, often to have his wisdom obscured by Greenberg's commentaries. Both men had their followers, and both were widely quoted among artists. Like de Kooning and Pollock, Rosenberg and Greenberg were on a collision course. Several observers believe that Rosenberg coolly chose Pollock as the instrument for damaging Greenberg.

Prior to the flare-up at the Rosenbergs' party, Harold and his

wife had become close friends of the de Koonings. To the Rosen-
bergs and their friends, it seemed that Greenberg high-handedly
dictated who was and wasn't an artist, what was and wasn't art.
Bill de Kooning told of Greenberg's visit to his studio, of the
critic's looking around and pronouncing, "You can't do this. You
can't do that." Having none of it, Bill related, he threw Greenberg
out. When Harold heard that Bill had sent Greenberg packing, he
was elated. As the story of Bill and Greenberg made the rounds
among artists gathered in New York and East Hampton to talk
and drink, the message soon became this: throwing Greenberg
out was throwing in with Rosenberg, and Rosenberg and de
Kooning stood together, united in their view of art.

Rosenberg and de Kooning stood on one side of the battle line,
Greenberg and Pollock on the other. The de Kooning–Pollock
war escalated, but it did not assimilate the battle between Harold
Rosenberg and Clement Greenberg; rather, it became a conve-
nient vehicle—if not an essential cause—for public jousting
between the two powerful critics. Through Rosenberg and
Greenberg, the two artists' conflicts with one another took on
symbolic portent for an entire epoch in the history of American
art. As Rosenberg and Greenberg cranked out reams of criticism,
often with thinly veiled and derogatory references to the artist
championed by the other critic, sides drew up and issues were
created to elevate ruthless ambition to the status of aesthetic
cause.

Andre Emmerich sighed as he recalled the Rosenberg–Greenberg
fight and the related de Kooning–Pollock competition. "Rosenberg
and Greenberg," he said, "those two nitshit pickers. Both were intent
on keeping the fight alive whether either had anything to say or not.
And, really, they—along with the artists' wives, Lee Krasner and
Elaine de Kooning—kept alive the competition between Bill and
Jackson."

But the grand-scale contest between the two painters, which
erupted in a number of both public and private skirmishes,
appears by all accounts to have been fanned to frenzy—if not ini-

tiated—by the two wives. On its own, the enmity between Lee and Elaine might have been contained in the artists' community, cosseted by hangers-on with various permutations of self-interest, nurtured by gossips who loved nothing more than a real or imagined cat-fight to recount. But once attached to a conflict, real or imagined, between the two rising stars of Action Painting, the fight between Lee and Elaine was absorbed into the larger war.

Both Lee and Elaine dedicated their singular talents enthusiastically to winning the war. The strategies adopted by each woman reflect their sharp differences in personality. Lee bludgeoned and blustered, attacked frontally and with the strongest language, threats, and emotional force she could muster. In short order, a lot of her "friends" went to pains to avoid contact with her and cringed when they answered her telephone calls, knowing that any encounter with Lee would consist of her monologue against de Kooning, against Rosenberg, and against anyone—especially Elaine!—who supported them.

Elaine, a consummate politician who later in her life laughingly compared herself with the manipulative heroine of *Les liaisons dangereuses,* took what was patently intended to be seen as the high road. It simply meant that she—with what she herself called "my very fine Machiavellian hand at work"—avoided direct confrontation while managing to get others to either take Lee on publicly or cut Jackson down.

With no hint of irony, Elaine once told a friend, "You know, Bill was never good at playing the game. He never had Jackson's skills. Jackson and Lee were masters of style; they had wonderful style. They were attractive." Did she admire this? asked her friend. "Oh, yes," Elaine insisted ingenuously, "I admired their sense of style very much. I mean, when we first visited them, we were very poor. We had nothing. And Lee and Jackson were deeply, deeply into gracious living. They wanted everything just so, they were very aware of appearances. I mean, Jackson wore just the right costume and Lee had everything organized in just the right way, even the things in the kitchen. It was all *very* designed."

Asked to explain further, Elaine said, "Well, take Jackson in all of those photographs. What a sense of style! Really, a sense of theater. He knew exactly the image he wanted to project and he knew exactly how to project it. But Bill," she added, "never understood any of that. He just worked and let people think what they would."

Elaine confidentially issued her faint praise of the Pollocks—like so many daggers—to friends who sharpened the weapons and used them well. Elaine watched. And smiled.

A retired dealer recalls:

Now, everyone knew about Jackson Pollock and about Bill de Kooning. [A lot of people believed that] Jackson was surly and crazy and rude; that was how he proved how virile and rugged he was. Bill, sugar and not vinegar to the flies from the beginning, flattered and praised everyone; no one was too stupid or ridiculous for Bill's warm praise. [De Kooning] was able, of course, to go into flights of fulsome flattery because he really didn't give a damn about anyone else or about anyone else's work. He had learned—learned early and well, mind you—that every time he built someone else up, he built up himself. Every time he gave a high opinion of someone's work, that person—in order to gain anything by repeating Bill's opinion—had to recognize Bill as a higher authority than himself. Do you see what I mean here?

Moreover, according to the dealer, who by his own admission "learned to take advantage of publicity, and to build an artist's public persona," Elaine learned from Bill some very important lessons about competing and winning in the art world: "Later," said the dealer, "Elaine fit right into that mode of operation":

From the very beginning—oh, I'd say sometime in the forties—the two couples [the de Koonings and the Pollocks] competed for fame and fortune. Elaine competed with Lee, and Lee with Elaine.

Bill competed with Jackson and Jackson with Bill. And Bill and Elaine competed with Jackson and Lee. For people who made a great deal of professing distaste and disdain for social climbers in the middle class, believe me, these folks were masters of the tournament. Grand masters . . . and in the end, hasn't it been a draw?

The dealer recalled the artists' early careers and the roots of their hostilities:

Jackson, because of his connection first with Peggy Guggenheim and then with Betty Parsons, had his work exhibited to the general public—such as it was then—before de Kooning was known outside the little New York art community. Jackson was given artistic bona fides, you see, in this way. And Jackson—partially because he used cleverness instead of intelligence—caught on very quickly to the importance of publicity. What's more, he knew that he could attract attention by behaving savagely, outrageously, insultingly.

The public behavior of both de Kooning and Pollock was "pigsty disgusting," according to the dealer, who insists that the stories of the drunkenness and violence of the two couples are based on truth:

I wish I could say that it's all untrue, or that it is mostly exaggerated. There are some distortions here and there, of course, but, yes, they were violent, often drunk, men. And they were truly disgusting. But they were also charming when they wanted to be.

The biggest difference between Bill and Jackson . . . [was] intelligence. Bill in his strange Netherlandish way, was really quite intelligent, even brilliant, and certainly original in his way of thinking. He did think. He could probably have been a philosopher or mathematician if he had been educated in that direction. Jackson, however, was rather on the dull side. Like many people so afflicted, he had devices for concealing his intellectual limitations and his overall thick-headedness. During conversations, he made faces that, though

the grimaces of a small bad boy, were intended to be read as symptoms of deep intellectual goings-on. He, I am convinced, put on an act of shyness—a rather convenient act, I must say, that kept at arm's length those he wanted kept at arm's length.

It did not take a clinical psychologist to measure Jackson's mental equipment. He was dumb as a stick, I think, and deeply, deeply psychotic. Notice that I do not say neurotic—*a term more applicable to nasty nippy dogs and spoiled women—but* psychotic. *Jackson Pollock was deranged, and he was thoroughly capable of atrocious behavior. Some found that attractive; I found it disgusting and a little frightening, I confess.*

After a pause to refresh his drink and reflect on the forties and fifties in the New York art world, the dealer continued:

I think Jackson would have been crazy no matter what he had done or where he had lived. God, Jackson was capable of being a serial killer. And, well, in the end, he almost was, wasn't he? But, to give Jackson what is his due, he was driven *crazy, too. Lee drove him crazy, to begin with. And once he started getting successful and famous, the other artists drove him crazy, too. They bullied and mocked and belittled him. I think I'll never forgive them for that. They knew he was in a poor way.*

Bill de Kooning, according to this observer, played a double game: on the surface he gave the appearance of being conciliatory toward Jackson, of being concerned and wanting to be helpful; but at times when Jackson was particularly vulnerable he dealt some destructive blows. "Bill knew all about Jackson," says the dealer. "Bill had once enjoyed—I mean really enjoyed—making a fool of Lee when she was throwing herself at him. He made sure that everyone knew that she was after him and he made equally sure that everyone knew that he had in the most brutal way turned her down."

He continues:

Oddly enough, that's what he did to Jackson, too. Everyone talks about Bill's cruelty to women, and somehow that gets dismissed or overlooked. Bill, I think, was a very cool customer; what the kids today would call very laid back. Without seeming to manipulate, Bill got his way and Bill got all of the attention.

[At the beginning of their careers], when Jackson got famous and started making money, Bill just set out to destroy him. He had help, of course. But poor Jackson wasn't equipped to know what happened to him and I think the treatment he received at the hands of his friends caused him to drink more and more and to work less and less and, finally, to kill himself.

Jackson was a fool and a public menace. Bill was different. He had an almost silly side, and a lot of charm. He could be abusive and violent—especially when he had been drinking or when he felt that he had not had enough attention—but he carried with him an aura of European civility, too. And, as I said, he was intelligent. Not educated. There's a difference. Let me give you an example. He carried a book by Wittgenstein about for ages, maybe years, and he always seemed to be reading it. He was genuinely fascinated and he read and reread passages. He believed that Wittgenstein held something out to him, and he applied his mind to solving the puzzles of language and thought. Jackson would never—could never—have done that.

To this dealer, Pollock's drip paintings began as abuse to his canvas: "In fits of self-indulgence if not rage, Jackson started flinging his paint around." The results, he thinks, can be "absolutely beautiful . . . simply and unbelievably beautiful. But I don't think they mean flyspeck diddly. I know that's heresy. So be it. They're just great energetic examples of decoration."

After all, that's the difference between Pollock and de Kooning, isn't it? Pollock capitalized on beautiful accidents, but de Kooning pretended to attack the whole idea of beauty. Perhaps Bill honestly had a compulsion to destroy anything that he thought beautiful.

*And I may have just said something very, very profound....
Didn't Bill destroy beautiful people? Well.*

Having sold and owned works by both painters, and having sold
their works for his clients who bought them early and later "cashed
in," the dealer hazards further heresy: "But, listen, Bill's work was
very contrived. Never mind the Harold Rosenberg claptrap about
the Action Painter cum noble savage. Bill wanted to be a master;
he wanted to be the next in a single-file line of masters; he thought
he had to step on Picasso to become that super genius of the twen-
tieth century. Bill *worked*—really worked—at painting."

In 1954 Elaine and Bill, with Ludwig Sander and Franz Kline,
rented the "Red House," as it was called—a modest Victorian
structure—in Bridgehampton, another community on the eastern
end of Long Island. Nancy and Joan Ward, twin sisters who
enjoyed the company of the artists, were frequent visitors, along
with a cluster of friends from New York and acquaintances redis-
covered in one of the local pubs. "In some ways," Elaine remem-
bered, "it was hell. In other ways, a lot of fun."

The artists in the Bridgehampton Red House joined in the
unending round of parties—drinking and talking all night, sharing
meals and picnics, swimming, and recuperating, on the beach,
from hangovers. Elaine remembered "twenty-four-hour-a-day
parties. Drinking. Talking. Wonderful dinners. People dropped
in, dropped out, passed out. Beach parties; picnics. It was wild."
Elaine considered it "too much, just too much of what was once
considered a good thing."

Jackson Pollock, a frequent visitor to the Red House, as he had
been to the Castelli summer home, often arrived in his battered
car, helped himself to a beer from the refrigerator, and sought
Bill. Pollock was often drunk and made a pest of himself by want-
ing to fight or wrestle with anyone—especially Bill. Boasting of
his Western background and tough-guy ways, Pollock liked to

challenge people to wrestling matches, but no one wanted to play with Jackson. His friends recognized that he was a mean and violent drunk, and that what started as a game for Jackson would very likely turn into a real fight.

If sober, Jackson often climbed the stairs and joined Bill in front of an old television set where Bill spent hours silently looking at old movies, especially Westerns and musicals. Bill, as usual, preferred to stay indoors and paint. He hated the sand and sun, he told Elaine, and didn't like to sweat for no reason. She knew, too, that he was edgy, often frustrated by his painting, and that he was prey to depression, which would inevitably result in a drunken binge. Bill's binges, Elaine thought at that time, were part of his genius, a necessary outlet for psychic pressures.

As Bill's reputation grew, and as prices for his paintings began to climb steadily, he became enmeshed in the vicious binge cycle— drinking alternated with long periods of sobriety and intense work, which often led to frustration, depression, and an extended drunk. Sober, Bill de Kooning was amiable, often helpful to his friends, and articulate about his work; but, like Jackson Pollock, he was a raging and sometimes violent drunk. And as Bill and Jackson competed in painting and for the fame and money that came with the power of being crowned "the best painter alive," so Pollock and de Kooning competed in drinking.

Leaning on the bar at the Cedars, Bill boasted to his drinking companions, "Now I drink as much as Jackson." No one argued about that. And by the early fifties, both Bill and Jackson were often out of control and self-destructive.

Shortly after the birth of Lisa de Kooning, Jackson Pollock showed up at the Cedars. Drunk and raving, he spotted Bill and, spoiling for a fight, inquired sarcastically and profanely about Bill's recently born illegitimate daughter. Bill, also drunk, punched Jackson squarely in the mouth, drawing blood. Urged by onlookers to retaliate, Jackson shook his head sadly and said, "What? Me hit an artist?"

In 1956, when artists who gathered at the Cedars learned that Pollock had died in a car crash, there were a variety of responses. Some insisted that the "accident" was actually suicide. Some saw Pollock's death as the inevitable conclusion to his violence and drunkenness. And some put forward the convoluted argument that he would not have been killed if he had been drunk, that drunkenness was his natural state and that sobriety had killed him.

"They were bound to fight each other, weren't they?" wonders a collector who knew them both. "When there was no money around, no fame, there was nothing to fight about. Jackson always had a little more than Bill—a little more money because of Peggy Guggenheim, a little more fame because he showed earlier. But Bill had more dames, and that really drove a stake into Jackson's insecurity about his sexual attraction. I've always thought that was one of the reasons Jackson behaved like a cave man, strutting around drunk and trying to pick a fight. Ironic, isn't it," he asks, "that after Jackson's death, Bill just took over his girlfriend, Ruth Kligman, and made sure that everybody knew it. What a way to win."

But with Pollock dead, Willem de Kooning became the uncontested king of Abstract Expressionism.

THE KINGDOM
COMES

THE KING OF
ALL HE PURVEYS

De Kooning . . . courts his fate, which is to see his independence disappear into an institutionally approved notion of greatness.

—**CARTER RATCLIFF**[1]

By 1951 Abstract Expressionism had emerged from the studios and lofts and had been seen on the stark white walls of a few galleries and museums. A perplexed public jeered, and an occasional self-breveted guerrilla warrior for "tradition" defaced a work. Abstract Expressionism was denounced as symptomatic of lunacy, as self-indulgent wallowing in neurosis, as anti-American and procommunist, and as one enormous plot to dupe the public. While Rosenberg and Greenberg crusaded for the new art and for the artists who advanced the frontiers of creativity, other critics were not convinced that the movement warranted serious attention, or if, indeed, it was coherent enough to be identified as a movement or a school.

But the artists themselves were undismayed, undeterred. They, after all, were their own best audience and their own best critics. In 1951 a group of artists, encouraged and supported by Leo Castelli, took over a large vacant commercial space on East Ninth Street and installed examples of their work. Now known simply as the Ninth Street Show, the exhibition had the effect of bringing together in common cause an array of varied and individualistic artists, among them de Kooning, Pollock, Franz Kline, Robert Motherwell, David Smith, and Jack Tworkov. It attracted sufficient attention outside the art world to warrant an extended viewing at the Stable Gallery. But in retrospect, the major effect of the exhibition was to identify publicly those artists who would be recognized as the core of Abstract Expressionism, and thus relegate artists not in the show to the status of also-rans.

Also in 1951, Bill had his second one-man show with Charles Egan, this time presenting large black enamel drawings and vivid Abstract Expressionist paintings. Like the earlier show with Egan, these muscular works—built from layer upon layer of sweeping gesture, reconsideration, obliteration, and more sweeping gesture—won critical praise but generated very few sales of work. The aesthetic issues implied by black-and-white painting did not excite audiences beyond the art world itself. But even without the blessing of private collectors or patrons, Bill's reputation grew, and his work was selected by prestigious museums for important international exhibitions. He was a serious artist; and he was taken seriously. Many curators who did not think that they fully understood de Kooning's work joined their colleagues who insisted on his importance in exhibiting or purchasing de Kooning paintings for museums. The Art Institute of Chicago's Sixtieth Annual American Exhibition featured his *Excavation*, a powerful work that culminated Bill's Abstract-Surreal style; it received the Institute's Logan medal and purchase prize in October 1951. I São Paulo, an exhibition organized by the Museum of Modern Art, displayed Bill's figurative and abstract paintings of 1947–52. Further, in 1952, Bill's work was exhibited in the important

Pittsburgh International Exhibition of Contemporary Painting at the Carnegie Institute.*

The so-called art establishment was small in the early fifties, centering around New York's Museum of Modern Art. Still a relatively young institution, MOMA was guided by dedicated collectors and informed curators. For them, modern art was a cause, and the museum sponsored symposia, lectures, publications, and exhibitions in a campaign to educate the American public to the powers and merits of modernist art from Europe and the United States.

In 1951 Bill de Kooning was invited to participate in MOMA's symposium "What Abstract Art Means to Me"; his statement was subsequently published in the 1951 *Bulletin of the Museum of Modern Art*. The symposium, held in conjunction with the museum's exhibition Abstract Expressionist Painting and Sculpture, stood as a who's who of the American modernists. In addition to de Kooning, participants included Alexander Calder, Stuart Davis, Fritz Glarner, Philip Guston, Hans Hofmann, Robert Motherwell, Ad Reinhardt, and Bradley Walker Tomlin.

Artists in Bill's circle who had for years been listening to him talk about art had accepted (and perhaps helped shape) his ideas about the role of the artist and about the creative process. But when these same thoughts were published by the Museum of Modern Art, they stirred excitement among a wider circle of people interested in the new art. In opposition to a major traditional tenet regarding the artist's role, Bill said, "The attitude that nature is chaotic and that the artist puts order into it is a very absurd point of view, I think. All that we can hope for is to put some order into ourselves. When a man ploughs his field at the right time, it means just that."[2]

It was the right time in post–World War II America for Bill's idea of "[putting] some order into ourselves" to set off a flare for

* Willem de Kooning's paintings were subsequently included in the Pittsburgh International in 1955, 1958, 1961, 1964, and 1970.

people looking to art to light the existential void. In the prosperous years following World War II many Americans aspired to material goods, status symbols, and the cozy security of the nuclear family depicted in popular media. But those who were uncomfortable with the shibboleths of status-quo politicians and the materialism of the marketplace bleakly acknowledged membership in "the lonely crowd" or "the age of anxiety." Bill put the artist in the same boat with the rest of the human species: Would Humanism, largely freed from religious doctrine, find new meaning as the "lonely crowd" struggled for inner order? And would artists—human beings who chose to manifest their sensibilities and insights—show the way?

Like the Ninth Street Show and to a lesser degree the theme shows at the Kootz Gallery, the symposium and exhibition that were stamped with the authority of MOMA effectively validated a group of artists, identifying them as leaders in the struggle to find and formulate a new sense of personal order and worth. While a layman might disparage the works of artists informally presented in a vacant store on Ninth Street, only a philistine would dismiss (and many did!) the authority of the Museum of Modern Art. And while the bourgeoisie might joke about psychoanalysis and angst, intellectuals turned their attention to what was happening—and being said—among America's advanced artists. The first-generation Abstract Expressionists—along with writers associated with the Beat Generation and film stars who, like James Dean and Marlon Brando, personified the antihero—not only challenged the accepted limits of art but, by presaging changes in several aspects of style, heralded the beginning of deep and abiding changes in social standards, mores, and values in America.

Style, whether in art, fashion, or public persona, results from distinction, from identifiable uniqueness based upon a characteristic manner of making or performing works of art, of dress, of behavior, or of expressions of character or intelligence. Although Abstract Expressionists publicly disdained style as a manifestation of "fashion" or "trend," they nonetheless competed with them-

selves and others to achieve an identifiable style—a signature, a uniqueness of statement—in their work. When artists painted saints, one artist was deemed better than others on the basis of style—an amalgam of technical skill, composition, display of knowledge, emotion, and characteristic manner of handling materials. Connoisseurs spend years articulating the difference between the brush strokes of artists of a given period and in arguing the merits of one style over another.

But Abstract Expressionists rejected style in art, along with traditional attitudes about composition, color, technique, and the very nature of a painting; and in the rejection of virtually everything the public identified with art, Abstract Expressionists epitomized rebellion. Their insolence—itself the model of a life-style of defiance—overflowed the confines of the Lower Manhattan art world, flooding college and university art programs, the pages of popular magazines, and eventually the awareness of a broad spectrum of the American public. Their controversial works, as well as the published and quoted statements of artists like de Kooning, Pollock, Motherwell, Tworkov, Newman, Still, and Rothko, spawned debate regarding the nature of art, along with the style of art and life associated with Abstract Expressionism. And both art-style and life-style encouraged a swarm of young artist followers.

Style has a place in the market, too. The smart trader or investor catches a trend, takes it to the point of maximum profit, and cashes in. If the connoisseur speculates on authenticity and intrinsic value of a work of art, the marketeer can gamble on the monetary worth of a new commodity and attempt to identify a winner, corner a market, buy low and sell high.

As the decade of the fifties unfolded and Bill's work highlighted major national and international exhibitions of modern art, his reputation began to extend beyond the edges of the art world. He became identified widely with the emerging New York School—or Abstract Expressionism, Action Painting.

Yet an artist cannot live on reputation alone. While Willem de Kooning's works were acclaimed internationally and his shows at

the Egan Gallery were critical successes, his paintings sold slowly and for only a few thousand dollars at the most. Under Egan's management, Bill, though getting famous and "making it" in the eyes of his peers, still earned only a marginal living through his work. To make matters worse for the artist, when Egan did sell his paintings, Bill had difficulty in extracting his share of the money from the often-inebriated dealer.

At one point, Elaine recounted, Bill was desperate for money. He confronted Egan, demanding payment. Egan, notorious for his slipshod manner of running the gallery, was drunk. Brushing aside Bill's demands for money, Egan asked, "Don't you want the gallery to stay open? Have you no loyalty? No gratitude? I need the money for the gallery, Bill." Offended and furious, Bill punched the drunken gallery owner and stalked off to find a drink for himself.

But Bill remained grateful to Egan for showing his work, and he sold his work only through the gallery, an ethical nicety ignored by most of the other artists. At that time, with a shrug and a wink at contracts and business ethics, many artists sold their work from their studios, frequently offering prices lower than those required by the gallery, and often not paying a dealer his share.

Painter John Opper, then a professor at the Woman's College of the University of North Carolina, tells of going to New York to purchase a de Kooning for the college collection. He visited his friend Bill in his studio. "No," Bill told him, "I have no paintings for sale. You'll have to see my dealer." Opper went to Egan and bought the painting, one of the *Woman* series, for less than $2,000 and had it shipped to the Greensboro, North Carolina, campus, where its reception was similar to one it might have received on any number of American campuses during the conservative McCarthy era. A few faculty members and a small group of art students welcomed into their lives what they considered a masterpiece. But the painting extracted venom from citizens and tobacco-spit politicians who questioned the propriety of spending

public funds on such a painting. Bible-choked preachers railed against the meaninglessness of the painting (nonetheless getting its message of godlessness). (The prurience-seeking student moralists in Peter Pan collars who blasted the de Kooning *Woman* as an ugly waste of money tried to decode the semiabstract painting and to behold forbidden nudity. Now, as middle-aged alumnae, their talk is of monetary value: "Did you hear? That de Kooning picture is worth ten million dollars!"

At the time the painting sold, Bill looked forward to the check. He still resented having to leave his studio to earn money as a commercial artist or as a carpenter or housepainter. He needed money for his own and Elaine's expenses. The sale of paintings simply meant that he could avoid what he considered diverting labors outside the studio.

Elaine believed that "Charlie's bad handling of money just drove all of the artists away. They needed money. Every one of them was trying to make enough money to live and work; and every one of them wanted more than anything else to be able to make enough money from painting to avoid taking other jobs. So, finally, when paintings started selling, they thought they had walked onto Easy Street. They just didn't reckon with Charlie's little ways. And even though he kept their money and ran the gallery in such a sloppy way, all of us loved Charlie. He was one of us." Laughingly, she added, "That, of course, was exactly the problem. Artists don't need dealers like themselves; they need dealers who are sympathetic to them but who are efficient and worldly and good at business."

At the same time that Abstract Expressionism precipitated intellectual and artistic activity, energized a new generation of American artists, and baffled practitioners of traditional connoisseurship, it also opened new vistas on the art market and provided astute gamblers a chance to place bets on a daring new product. In the past, American collector-connoisseurs had tended to buy older art, works understood to embody history and to possess intrinsic value. Among those few who presumed to be of the collecting elite, art

represented high culture and was understood to emanate from the hands and minds of unusually gifted human beings.

After the fire storm of Abstract Expressionism, however, art itself was in question. If these seemingly violent, chaotic, but highly charged works did not fit neatly into the obtaining characterization of the tradition of Western art—if they did constitute an additional chapter to the textbook on art appreciation—how were they to be seen, understood, and valued? If art had no intrinsic value, if works of art contained no embodiment or symbolization of Art, what were they about, what were they of? And, indeed, what was their worth?

Artists and critics alike insisted that a work of art did not *mean* anything. Art existed. No, they said, citing Louis Armstrong's dictum that "if you have to ask, you'll never understand," art does not have to be available, does not have to communicate, does not have to represent familiar experiences or ideas. Art, they said, was whatever an artist said it was.

Well, then, who is an artist?

Why, anyone who makes art.

And who makes art?

Why, an artist. You know, artists: the funny guys in funny clothes, the strange crowd of misfits who do things that the rest of us don't do, or can't do, or won't do.

The challenge was set for the art makers and artist makers alike. Opportunists moved quickly. While the first dealers to show Abstract Expressionism—Betty Parsons, Sam Kootz, Charles Egan, and a few others—evidenced little interest in appropriating the techniques of advertising to create a demand (i.e., an audience) for the art they showed, another group of dealers, fully equipped with the arsenal of hype, arrived on the scene. They cast the bait and watched the small barrel that was then the art world. The fish gathered densely, begging to be shot.

Hollywood made stars through publicity; Madison Avenue sold useless, ugly, and possibly harmful substances and objects. And, yes, a number of seekers of intellectual status believed that they

were somehow honor bound to acknowledge as art pictures they neither liked nor understood. As post–World War II Americans enjoyed both more money than they had ever expected to earn and a media-fed vision of upward social mobility, they had the wherewithal and inclination to collect art. Established collectors who believed the standards of taste and tradition had been devalued by war and a changing society were joined by newly monied would-be collectors in sniffing the lures set by dealers who talked openly of "investing" in art.

And artists, though muttering about purity and integrity among themselves, turned neither a deaf ear nor a cold shoulder to the prospects of selling work. By 1955, collectors competed with each other for the latest works by the most acclaimed Abstract Expressionists, de Kooning and Pollock among them. And artists— including the justifiably acclaimed, still undiscovered, and already discarded—vied for gallery representation, museum recognition, and collectors' dollars.

During the fifties, three women painters—Elaine de Kooning, Joan Mitchell, and Grace Hartigan—were often identified as "second-generation Abstract Expressionists," and their work was often compared with that of Willem de Kooning. Clement Greenberg's protégée, Helen Frankenthaler, younger than the other three women, worked in a way that pulled her closer to Pollock. Grace Hartigan laughingly points out, "Joan Mitchell and Helen Frankenthaler were different from Elaine and me; they were rich. Joan wore this cute little mink thing around her neck; Helen was careful never to come downtown in her fur coat. But they were rich; they sometimes played at being poor. And sometimes they seemed to be playing at being artists, too."

By the middle of the fifties, sales of Bill de Kooning's work provided a reasonable income, with works selling for several thousand dollars apiece. Tallies at the end of the year provided far more money than Bill and Elaine had ever seen before. Bill was able to actually afford the top-quality paints, brushes, and canvases that

he had always preferred and had often bought by not paying the rent or scrimping on meals.

Though Bill and Elaine were largely maintaining separate lives, with each free to select or reject sexual partners, friends, and activities, divorce was not an issue. They were married, and each observed certain formalities of conventional marriages. As husband and breadwinner, Bill paid the rent for separate studio space for Elaine and for himself, ensuring emotional and physical distance and neutrality for them both while providing large, bright space for working on several big pictures at a time. Elaine identified herself as "Bill's wife," used his name, and loyally worked to further his reputation.

As Willem de Kooning came to be widely acknowledged as the master proponent of Action Painting, the ironies of the accolade were largely ignored by critics, by other artists, and by Elaine. De Kooning's work, born of European academic training and rooted in the stern discipline of his never-ceasing compulsion to revise a work in process, did not fit well the requirements for spontaneity, accident, and on-the-spot creativity that suffused the philosophy of Abstract Expressionism (at least as it was discussed among artists and written about by critics of the time). But, as if by tacit agreement among critics and other artists in Bill's circle (Elaine among them), Willem de Kooning—a Dutch-born and -educated artist who reworked, edited, and revised his works endlessly—was elected champion of the New York School painters, the leader of the movement built on immediacy, unrehearsed action, and the celebration of accident.

"Bill was it," said a younger male artist of the time. "I mean he was just IT. There was Jackson, doing his trick over and over, but we all thought that de Kooning was the *painter*. He led the way in Abstract Expressionism."

The majority of artists around the Cedars did indeed believe de Kooning to be the major painter of the period, but some, like Ethel Schwabacher, an Abstract Expressionist keenly aware of the prejudice against women artists, noted in her journal features that

must have troubled many women who confronted Bill's paintings: "Restlessness. Don Juanism, i.e., search without fulfillment . . . love of a woman's breasts, hatred of her soul expressed in her physiognomy . . . tremendous sense of masculine power . . . [but] too much dependence on sensuality. . . . [D]e Kooning has sunk into a sea of sensuality, tactility, narcissistic isolation, loss of the true object, reduction of the subject [to] self."[3]

Bill's controversial paintings of women, in opposition to the vaunted tenets of Abstract Expressionism, contained imagery. Whether from love or hate of women—or from some sado-voyeuristic twist in his personality—de Kooning used the human (female) figure as an arena for violent action. Dismembered and reconstituted as monstrosities, de Kooning's women snarled and leered, staring maniacally beyond the viewer. Their bared breasts and bared teeth testified to violence done and threatened violence to be done. In short, de Kooning's paintings contained recognizable imagery, and they invited interpretation.

But if Bill's work was not trimmed to the requirements of the style of painting associated with Abstract Expressionism, it was born of the personal turbulence, anxiety, and existential search requisite for the spirit of the movement. If his paintings veered from the doctrine, de Kooning himself was the very model of the New York School painter. Appearing in the Cedars in his characteristic garb—seaman's knit cap and heavy sweater, workman's pants and shoes—he drank until the bar closed. As he turned more and more frequently to alcoholic binges to assuage his anxieties, Bill "blacked out," as Elaine explained it, and "just began to forget what happened to him when he was on those binges." Bill's drunkenness, angry outbursts, and powerful influence over other artists solidified his credentials as tortured artist.

In addition to the near adulation of Bill in the art world, he was becoming famous outside that small subculture. He was becoming a public figure, a celebrity whose monster-women paintings were instantly recognizable to art students and museumgoers across the country. Art historian Leo Steinberg described de Kooning's

Woman as "part witch, part farmer's daughter, part mother and part whore; a power too comprehensive and immediate to be watched and rendered with controlling skill."[4]

Over the next few years, as the women paintings erupted on the growing art scene, they continued to elicit controversy. Artists focused on de Kooning's women as an issue in the ongoing debate regarding the relative importance of abstract and figurative styles of painting. Critics often found them perplexing, describing them as "monuments of confusion."[5] They cited them as examples of the artist's failure to "commit himself to either their representational or their Abstract Expressionist possibilities" and of his "[hesitation] constantly between the two, and the result is a splashy and confused muddle of pigment that obscures as much as it reveals of the subject."[6] *Time* was one of a few publications to inform readers that de Kooning's women paintings marked him as "one of the most original artists of the day."[7]

The guiding philosophy of contemporary painting, pounded into shape at the Club and the Cedars and reformed by Harold Rosenberg and Clement Greenberg to meet extra-artistic and political criteria of their own, rested on one irrefutable fundament: the act of painting, embodying and externalizing the essential being of the artist, was a form of autobiography. Autobiography could be a postulated version of the life of painting—and conform to Greenberg's formalist criteria. Or, a particular painting could be a fragment of the artist's autobiography—and reflect Rosenberg's Expressionist values. The painting itself came into existence, and it could be justified only as an authentic revelation of what the artist saw, found, or created—in himself and in his experiences or in what he knew about painting. At a simplistic level, Greenberg's artist was an intellectual; Rosenberg's, a romantic hero.

In the marketplace, the issues were simple; and the promotion, often couched in the high tones of learned art criticism, was effective. Dealers marketed artists identified with Greenberg as exponents of a historical imperative that made them the conduits

of a preordained progression in art. Artists identified with the Rosenberg camp—Bill de Kooning preeminent among them—were packaged by dealers and their affiliated critics as personalities.

The Museum of Modern Art purchased *Woman I, 1950–52*, which soon became one of most widely reproduced works of the 1950s and one of the paintings to appear regularly in textbooks, slide lectures, and popular articles on art. Critical success, along with ever-widening publicity, made de Kooning a good investment for the more aggressive dealers in New York. As de Kooning became successful, he also became less dependent on Egan or any other single dealer. Other dealers—like Martha Jackson, who in anticipation of significant financial gain bought a group of paintings from Bill, exhibited them, and sold several to West Coast dealers—were eager for a part of the action surrounding de Kooning. His reputation for success was making him a bankable talent in the still-small but increasingly important art market. But Bill did not relish handling the business side of painting. When he was invited to join the prestigious Sidney Janis Gallery, a Fifty-seventh Street mecca for both museum and private collectors looking for established European and American artists, he accepted, knowing that success was assured.

In 1953, with his third one-man show in New York—this one at the Sidney Janis Gallery—de Kooning rocked the art world with a display of his women paintings done in the previous three years. In April and May of that year, when Bill was forty-nine years old, he had his first retrospective exhibition at the School of the Museum of Fine Arts, in Boston. The retrospective was also shown in Washington, D.C., at the Washington Workshop Center of the Arts. "Bill had made it," according to Elaine, "and he knew it, and he knew that he would never have to look back and explain anything he did. He just set the standard."

Younger artists understood that de Kooning set the standard, and, just as Bill had decided that he had to compete with Picasso, ambitious members of the new generation decided to challenge de

Kooning's supremacy. Scores of young artists in Navy watch caps and sweaters could be seen slouching along the downtown streets of Manhattan or lurking on the edges of openings in galleries; in the downtown galleries, hundreds of paintings mirrored de Kooning's style. But the most obvious challenge (both actual and symbolic) came from Robert Rauschenberg. The talented former Black Mountain student, having settled with Jasper Johns in a Lower Manhattan loft, knocked on Bill's door one day and requested a de Kooning drawing to erase. Bill, according to Elaine, was "amused and fascinated by Rauschenberg's nerve. After all, it was an insider's joke, and Bill liked offbeat jokes like that."

Bill's prominence expanded with the 1954 Venice Biennale, where his work was selected to represent the United States; with a retrospective exhibition of his works, selected by Andrew C. Ritchie for the Museum of Modern Art; and with his inclusion in the Whitney Museum's exhibition the New Decade: 35 American Painters and Sculptors. The bona fides of the art establishment notwithstanding, however, de Kooning remained controversial. When A&P heir and art collector Huntington Hartford published a full-page letter entitled "The Public Be Damned?" in most major American newspapers in May 1954, he attacked modern art and Abstract Expressionist artists in general. But he singled out de Kooning for special disdain, thereby giving Bill national publicity.

Bill's reputation had its own momentum, and he was untouched by overheated and overstated attacks by anti Abstractionists. His work was included regularly in such prestigious shows as the 1955 Pittsburgh International Exhibition of Contemporary Painting, held from October to December at the Museum of Art, Carnegie Institute, which purchased *Woman VI* (1953). Somewhat later, Katharine Kuh, a highly regarded critic and curator, selected de Kooning for exhibition at the Art Institute of Chicago.

By 1955, still continuing to paint women, Bill had begun to work on abstract urban landscapes, producing such paintings as

Easter Monday (1956), *Gotham News* (c. 1955), and *The Time of Fire* (1956). These titles refer to times and events surrounding de Kooning as he made the paintings. For example, *Easter Monday* was completed on that day in 1956, and *The Time of Fire* refers to the July 1956 conflagration that destroyed the Wanamaker Department Store between West Eighth and Tenth Streets; Bill, along with other artists who lived in the neighborhood, watched the flames consume the familiar landmark. These paintings, born of violence equal to that which begot the women paintings, are battlefields of sharply cutting and abrading strokes, of paint intersecting and slashing paint. Sidney Janis noticed that de Kooning's paintings sometimes contained wounds or holes inflicted by the artist, whose fierce application of paint resulted in his ramming his brush through the canvas.[8]

Bill's 1956 one-man show of abstract urban landscapes at the Sidney Janis Gallery proved to be a dealer's dream and a resounding commercial success. While the work remained controversial enough to attract those Elaine fingered as "the right enemies," it also brought in collectors eager to buy works by the acknowledged master of the Abstract Expressionist movement. With success among American and European collectors and continuing purchases by museums, Bill de Kooning, fifty-two years old, was a star, a critical success, and a money maker. The public was now interested not just in his work but in him—Bill de Kooning, man and artist. He was photographed and filmed.

So far as Bill was concerned, his fame and fortune meant that he could do exactly what he wanted to do. Unlike the many artists whose dead signatures line the paths of modern art, Bill continued to paint variations on women and landscapes, experimenting in a limited manner within the confines of each genre. In 1957, with a well-established market for his work, Bill produced a series of large, simplified landscape and parkway abstractions—among them *Palisade 1957*—and continued until 1961 to mine his allusions to urban and natural landscapes. He also made his first print around this time, an etching for Harold Rosenberg's poem

"Revenge," which he executed in 1960 and which was published by New York's Morris Gallery in the portfolio *21 Etchings and Poems*.

Critical and financial triumphs continued with Bill's first exhibition at New York's Leo Castelli Gallery; his inclusion in the Minneapolis Institute of Arts exhibition American Paintings: 1945–1957 and the Whitney Museum of American Art's Nature in Abstraction, which traveled until 1959 throughout the United States; and his appearance in the International Council of the Museum of Modern Art's 1959 exhibition, The New American Painting, as Showing in Eight European Countries, 1958–1959, which then circulated in Europe. In 1959 de Kooning's work was shown again in New York at the Museum of Modern Art, in an exhibition entitled New Images of Man; and in Kassel, Germany, in Documenta '59: Kunst nach 1945.

These exhibitions and numerous articles laid the foundation for another successful show, in 1959, at the Sidney Janis Gallery, where the abstract parkway landscapes continued to elicit good remarks and good sales.

During the final years of the decade and into the sixties, de Kooning's triumphs persisted. In the winter of 1959–60, he worked in fellow artist Afro's studio in Rome, completing a series of abstract black-enamel-on-paper drawings. His election in 1959 to the National Institute of Arts and Letters affirmed not only his stature but also the importance of Abstract Expressionism to the intellectual life of the country.

13

LORDS AND LADIES
OF THE REALM:
PRIVATE LIVES, PUBLIC VIEWS

Becoming over being, expression over perfection, vitality over finish, fluctuation over repose, feeling over formulation, the unknown over the known, the veiled over the clear, the individual over society, and the "inner" over the outer.

—WILLIAM SEITZ, ON ABSTRACT EXPRESSIONISM[1]

As the fifties progressed and word of the lively New York art world spread through the art journals and popular magazines, and as the college and university grapevine transmitted the allure of bohemian tumult among famous and nearly famous artists, waves of predatory young women—some bannering themselves as artists, others ignoring ruse and simply calling attention to themselves by action or dress as available sex objects—trolled the Cedars in hopes of hooking "a famous artist."

For many of the artists who took the bait dangled before them, the young and available women became prizes to be won in the game of cock and chicks. Using macho boasts about their conquests, many of the artists exchanged appraisals of "the twins," "the big blond," the "tight-assed brunette," and those women who were recognized by (and answered to) actual names.

Another artist remembers the often-lewd talk about "the art tarts. The women who hung around the artists to get laid, and who seem to get some special pleasure out of making out with these guys. The girl artists—Elaine and Joan Mitchell and Grace Hartigan and some others—weren't in the same category. They slept around a lot, too, and made a pretty big scene of it, but they were sort of fringe members of the group. They never liked that fringe status—and why should they have?—so they kind of set out to outdrink, outswear, outfuck all of the male artists; they acted like the guys—only more so. But the so-called art tarts—they were what we'd call groupies today—they were the untalented chicks, the easy lays. And, god, there were dozens of them."

Bill had his pick of the art tarts.

"But," insists a long-standing member of the de Kooning circle, "Elaine screwed more than anyone. She started the thing—that competitive sex thing—with Bill. He was prepared to be monogamous, he was prepared to be faithful to Elaine. I don't think he really cared much one way or the other. He loved Elaine. He liked to have someone around to sleep with. Better to sleep with someone he loved than with someone else. But, basically, he didn't care as much about that as he did about his work. I sometimes wondered if he had sex just to sort of keep it off his mind and leave him free for work. But Elaine started sleeping around."

"Bill could have his pick of the women around," concedes an artist who drank with him at the Cedars, "and Elaine, I'd say, had to fight off the guys. But I don't think she did much fighting. They were both having a good time, and each was kind of looking over their shoulder to see how well the other was making out. And both of them were drinking very, very heavily. I'd say that they

got drunk every time they came to the Cedars and that was often."

"It got awful," says a friend of both. "They really tore each other up. And they always came back to one another and tore each other up again. And later, when the booze got to be so much in control of both of them, it was really rotten. I mean terrible."

Elaine and Bill had worked separately for almost a decade, and now they increasingly lived separate lives. Even when they summered on Long Island with the Castellis, Elaine traveled to and from Manhattan with Leo. She continued to write reviews and articles for *Art News*. In New York as well as in the artists' summer colony on Long Island, she went her own way and lived her own life—she was both Mrs. Willem de Kooning and Elaine de Kooning, painter and sometimes-writer for *Art News*. "Elaine probably should not have taken Bill's name," says Andre Emmerich, "because that de Kooning name robbed her of some of her own identity. He was a very powerful painter, and so long as she had his name, her work was looked at as that of his wife. I always thought Helen [Frankenthaler] was smart not to take Bob's [Motherwell] name. She remained herself."

Another dealer views the matter differently: "Elaine *liked* being Mrs. Willem de Kooning. It was a kind of cover, after all, that gave her a lot of privileges. Look. She paid her dues. She put up with Bill and protected him and, I think, promoted his career. He owed her something. That name owed her something. Elaine was a very free spirit, and totally social. When she came into the city, she wanted to drink and screw and be outrageously herself. And she succeeded."

Rudy Burckhardt remembers that Elaine was one of the most socially active people in the art world. He said, "Elaine cultivated friends, and she was naturally friendly. She had hundreds of friends. But still," he added, "some artists resented Elaine. She was widely quoted as having said that anybody who was a good painter could have a show—but many who thought themselves good painters could not get shows in New York at that time. So they resented Elaine for her arrogance, her lack of sensitivity, her

privileged position. Some felt that Elaine rode on Bill's coattails—
or that she slept with powerful guys of the art world—and that
neither her talent nor her work habits justified the success she
enjoyed."

Bill, too, went his own way, which increasingly included alcoholic
binges and resulting blackouts, temporary losses of memory.
Nothing—not parties, not friends, not even respect for his own
work—could detract Bill from his singlemindedness when he
started to drink. In his quest for oblivion, he drank everything he
could find and moved religiously through the stations of intoxica-
tion. At first, liquor freed him and he became loquacious, even
jolly; more alcohol, and he was verbally abusive. By the time he
wanted to fight anyone in view, he was usually too physically
impaired by alcohol to be effective as a warrior. Eventually, he
passed out.

Everyone understood that that was how Bill was. Elaine
shrugged. Everyone understood that it didn't matter that Bill and
Elaine lived and worked separately; they understood that the de
Koonings were together at the center of the art community, a pop-
ulation joined as much by social life as by shared artistic concerns.

Social life for artists in Manhattan revolved around the Cedars
and the Club; but on Long Island, parties glued the community
together. One day during the summer of 1954, artists Charlotte
and Jim Brooks drove by the Red House and noticed cars parked
along the street—a party was beginning. They stopped and joined
the group. "There were wheelbarrows full of hard-boiled eggs,"
Charlotte remembers, "and a lot of wonderful food." Elaine, in
preparation for the party, had made hundreds of crepe paper
flowers and attached them to the trees in the yard. And flowers,
she thought, should be fragrant, so she fetched a bottle of spray
cologne from the house, climbed into the trees, and sprayed the
flowers until they emitted suitable perfume for the festive occa-
sion. For his part in the preparations, Bill painted the outhouse
toilet seats and helped lay out the course for lawn croquet. (The

toilet seats, because Willem de Kooning applied paint to them, have become recent objects of attention. Are they properly de Kooning paintings and, therefore, worth a great deal of money? Or are they mementos of the then-vigorous artist's life in the Hamptons and, therefore, worth a great deal of money? Or, because they are toilet seats—and no amount of paint applied by any artist can alter that lowly status—are they worth nothing save the interest they create? Are they vestiges of a stunt and, therefore, a stunt repeated? The partygoers did not calculate the value of the toilet seats in terms of money but in terms of enjoyment: another irreverent gesture, a bit of fun made more lively by its in-group quality.)

But parties and booze could not hide the fact that Bill and Elaine were increasingly edgy with one another, that their tempers flared easily when they were together. Bill showed his exasperation when Elaine interrupted his conversation and, when drunk, he slapped or cursed her in public. Elaine, teasing Bill and flirting with other men, dismissed Bill's annoyance with her and, as one observer noted, "if anything, she needled him harder."

Though legally still married, Elaine and Bill tacitly agreed to maintain a comfort zone of distance between them. "What marriage could survive what theirs did?" asks Grace Hartigan. "And it doesn't matter how conventional or unconventional it might have been. Both of them were promiscuous; both of them drank heavily. And after awhile—though I think there was always a strong fondness between them—there was no marriage. There was no marriage well before Joan and Lisa, and both of them must have known that."

Elaine knew that Bill had taken more than his usual casual interest in another woman—an attractive, vivacious younger woman, Joan Ward. Joan and her twin sister, Nancy, had come to New York to study art; they lived in an apartment their father rented for them on East Eighth Street, just around the corner from the Cedars. Often stopping nonchalantly in the bar for a drink, the attractive Ward sisters soon got to know the artists who frequented the Cedars and quickly joined conversations among

them. Soon, Nancy was seen with Franz Kline; Joan was seen with Bill.

Bill was serious about Joan Ward, and Elaine was frightened. The unconventional, rollicking life she shared with Bill allowed her to do exactly what she wanted, but it also provided the protection of marriage. Now she felt the marriage threatened.

Looking back years later, Elaine identified her unplanned pregnancy as a crisis in her relationship with Bill and as the beginning of a two-decades long separation. "I thought it might be fun to have a baby," she said, "but I couldn't be sure. I mean it would have been unsettling, at the very least. Bill and I had talked about having a baby, but we just never had enough money. So, when the opportunity for a baby arose, I decided to test out the idea. I borrowed a baby.

"It was easy. A friend had a baby, an adorable little baby. And she wanted to take a trip, so I volunteered to take care of the baby. It was very, very seductive, that baby. My friend brought the baby and all of the baby's things—tiny clothes and shoes, little blankets, little soft toys, bottles, diapers, a playpen, and a crib— all those things, darling *things*—to my loft.

"We cleared a place and made a nursery for the baby. I was enthralled. And I learned all the things to do for the baby: how to change its diapers, how to change its clothes and what it should wear during the day and what it should sleep in at night. I learned to mix its food and heat its bottle. I thought it was just terrific fun.

"So my friend left and I had this adorable baby in my studio. When I fed the baby, it closed its eyes and snuggled up against me. It smiled at me. And if I offered my hand, it kicked and gurgled and grabbed my fingers. In no time—I mean within hours— I just felt that I was a very important person to the baby.

"And it was a good baby. So I fed the baby and the baby went to sleep and I started painting. I was on one end of the studio and the baby was on the other. Pretty soon, I started worrying that the baby might be too quiet. So I tiptoed over to check on the baby. It was just sleeping sweetly. And I went back to work.

"After awhile, I realized I was whistling while I worked and I stopped so that I wouldn't disturb the baby. Then, just as I would be getting really into my work, I would find myself worrying about the baby. The baby was just on my mind all of the time.

"Well, at the end of the weekend, I knew that I couldn't have a baby around and be a painter. I would always have my mind on the baby. I would never be able to concentrate on my work. And that was that. No baby." Then she added, "But I always thought that Bill really did want a baby."

If Bill had really wanted a baby, however, the de Koonings might not have avoided parenthood throughout the first decade of their marriage. Bill, Elaine acknowledged, resented distraction from his work and, as a man shaped emotionally by an abusive mother, he was not a good candidate for fatherhood. Elaine, while accepting the strong influence of her family, had not fully challenged the mores of femininity that prevailed in the art world as well as in American culture. "Well, a woman was just supposed to have children," she said, "and it took me a long time to say that that was not always a good idea, that it was not always the best thing for a particular woman."

Later, Elaine often advised other women artists to avoid motherhood. She would say, "You just can't divide yourself between a baby and painting. I mean, painting is just a full-time occupation and so is a baby." Elaine claimed that "the best thing to be is a fairy godmother. I mean, a fairy godmother is powerful, and just steps in at the right time and gives you what your heart desires. When I was growing up and read the fairy tales, I never wanted to be a princess or a prince. I wanted to be the fairy godmother. I wanted to be in charge of giving out prizes!" And so in countless friendships with children, Elaine passed out prizes—encouragement, praise, and respite from harsher parental requirements of behavior. "Listen," she told a visitor who chastised a child, "in *my* house, you never say *no* to children or dogs."

But regardless of their individual opinions regarding children, Elaine and Bill by the middle of the fifties had, in the word most

often used by their friends, "split." And, whatever they knew or accepted about the condition of their marriage, both Elaine and Bill seemed unprepared for the public dissolution of that bond. "You know," recalls a friend, "for awhile it was as if they were terribly embarrassed to see one another. Elaine was deeply hurt, and tried not to show it. Bill was angry and depressed, probably because losing Elaine was losing the only security—weird though it was—that he knew. They were both unhappy people."

The essential pattern of Elaine and Bill's marriage had emerged by the time they exchanged vows, and throughout the years between their marriage in 1943 and their separation in 1957 they were often competitive and frustrated. Bill and Elaine had fought with each other; when wounded, each had sought solace in other people; disappointed and lonely, they had gotten together to both heal and fight one another again. And again.

That pattern changed, however, when Bill's attentions shifted to Joan Ward, who remembers fondly her first impression of Bill: "Someone described Bill's gait as like that of an old sailor running to a brawl on Pier 66." She laughs, adding, "With his sailor's cap and dark sweaters, he did have a nautical air. And, of course, he was a wonderful talker and already a very important painter." Joan understood that "Bill was totally involved in painting. Bill's compulsion to work interfered with all of his relationships—with his friends, with other artists, with women in his life, and [later] with his daughter."

Joan soon found Bill "very defensive about new things. He didn't like extreme experimentalism in art or poetry or music but preferred the familiar and rather classical." In this respect, she thought, he was very European, "very much a product of his academic training." That training, Ward observed, included respect for traditional artists. She was fascinated by de Kooning's talk about Picasso and Cézanne—"always gesturing as if he were laying bricks" to describe the forms constructed by those artists. He talked, too, about his own work, "about working out of doubts, and painting away from the familiar structure of Cézanne or

Picasso." She was, she admits, immediately drawn to the older artist.

But Ward also remembers Bill's drinking, recalling an afternoon when Bill, Franz Kline, and Earl Kerkham "had drunk everything that could be afforded, found, or scrounged except some blackberry wine." When they got to the blackberry wine, a friend appeared and asked what they were doing. "We're drinking this rare old-world booze," Kline teased, "so potent and raw that very few people can even swallow it."

The artist friend was intrigued and wanted a drink.

"Well, maybe it wouldn't be the right thing to do," Kline said, "to give you something that could be so bad for you."

Now thoroughly challenged, the artist insisted.

Kline resignedly poured out a tumblerful for him, and he knocked back the syrupy liquid. "Jesus Christ, Jesus Christ, Jesus Christ," he wailed, spitting and gagging. Kline, Kerkham, and Bill laughed uproariously.

Ward found that Bill, drunk or sober, "would get angry about inexplicable things," some amusing and some frightening. She recalls his fury about Einstein, recounting that Bill ranted and swore when someone described the scientist as "a genius." Another time, when someone praised Albert Schweitzer, Bill said angrily, "He's not real. He's just something they thought up to make us feel bad."

When Joan Ward became pregnant with Bill's child, Bill's delight at the prospects of fatherhood was as apparent to Elaine as it was to the guys at the Cedars. He was happy, and he confided to friends that he looked forward to "dis baby."

One woman admits to "chasing after Bill at the same time Joan Ward was the one who had his attention. He was the *most* important and *most* famous of the artists. Everyone looked up to Bill. You were really somebody in his crowd if you were with him. And believe me, there were a lot of us trying to be with him. A lot of us—girls around the Cedars—went to bed with Bill any time we had a chance, and each of us thought, I guess, that he'd carry her

away to some sort of happiness-ever-after. That's how dumb we were. Joan Ward was the smart one: she had his kid."

Elaine's usual insouciance failed in the face of Bill's happiness. "He really wanted this child," says a friend, "and it was the one thing Elaine couldn't give him. She couldn't have children by that time. She had had abortions, and once said that at least one was Bill's baby. So she surely thought that Joan's bearing Bill's child would be the one absolute thing that would capture Bill. Elaine was morose. I've never seen her so depressed. And drunk."

Although Elaine and Bill had gone separate ways for years, each pursuing sexual trophies for display among friends, neither of them considered divorce. Elaine made no demands on Bill that he could not dismiss if he chose; Bill shrugged when Elaine followed sexual whims or absorbed herself totally in the art world politics of the moment. But the birth of Lisa shook Elaine. "I just knew," she said, "that Bill would feel responsible for a baby. Even if he hadn't wanted it. Even if he had resented the idea. Even if he felt trapped. He was just that way, and he had this incredible respect—honor—for the role of father."

Elaine let it be known that she was not stepping aside voluntarily. When she visited Joan Ward in the hospital at the time of Lisa's birth, Elaine observed that Joan had registered as "Mrs. de Kooning."

"Oh," Elaine said, "Bill and I always wanted a child."

Even as her quip was repeated around the art world, Elaine confirmed that she would not have children. Previous pregnancies, she said, "were just too inconvenient and so I had had abortions." Moreover, at the time of Lisa's birth in 1956, she was thirty-eight and had had a hysterectomy. "Just before Lisa was born," she told a friend, "I had surgery. And that did it. No children."

Elaine turned for solace to alcohol and to men. "She kind of got more wild than usual about then. She just seemed to go in every direction at once," says one of Elaine's friends.

At the time of Lisa's birth, Joan admits to wondering if Bill

would be a good father, if he would even be interested in their child. Bill's friends wondered, too, if the artist so absorbed in his work and so prone to abusive language and tantrums when that work frustrated him would accept the responsibilities of father-hood.

Shortly after the baby's birth, however, Joan held the pretty child for inspection by admiring friends. She noticed Bill arrive quietly, smiling. When she saw the new father, standing behind the visiting friends, still smiling, rocking back and forth on his heels, Joan Ward was convinced that he "would be all right as a father" and knew that she didn't have to worry.

But others worried if the infant girl would receive the care she needed. Bill drank, and the community into which she was born was not an ideal situation for a child. Esteban Vicente recalls visit-ing Bill when he was too drunk to handle conversation. Lisa, a small child not yet able to walk, played quietly on the floor, a peripheral creature. "How quiet and good she was," recalls a visi-tor. "It was as if she had already learned not to expect much atten-tion from her parents."

Even with Bill's fatherhood, divorce was out of the question for Elaine. It was unthinkable, not so much because of her Catholic upbringing, Ernestine Lassaw thinks, as because "Elaine had mar-ried Bill and was going to stay married to Bill. Bill was her mas-ter—her art master—and that was that, so far as she was con-cerned."

Elaine, as in the past, lived by her wit and by her wiles. Bill, as obsessed as ever with his work, seemed to assign Joan and Lisa to the periphery of his life. The long-established patterns that Bill required for painting did not succumb to domesticity.

Elaine and Bill—never shackled to a conventional marriage, never partners in an easy alliance—separated. They went different ways, but they remained two very colorful and potent characters in the same theater of operation. Both continued to paint, both pur-sued and were pursued by sexual partners, and both sank deeply into the dark caverns of alcoholism.

THE RULE OF BOOZE

We just all began to drink and around 1950 everyone just got drunk and the whole art world went on a long, long bender. And what happened is that we turned into alcoholics.

—ELAINE DE KOONING

Willem de Kooning's march through the corridors of alcohol dependency almost exactly paralleled his progression as an artist. In the thirties, when poor, he drank coffee; in the forties, as he became an artist-about-town, he enjoyed the free drinks and free food of his numerous hosts; by the fifties, de Kooning boasted that he drank as much as Pollock and, with public outbursts of alcohol-induced hostility, secured his reputation as a "nasty drunk." The rest of the route was an easy downhill slide as Bill's binges became more frequent and lasted longer, as he was sober less and less of the time, and as groupies brought him alcohol in exchange for the beneficence of his attention to them.

By the middle of the fifties, drunkenness was deemed the natural state of many Abstract Expressionist painters, Bill among them. But Bill, in drunkenness as in painting, brooked no peers—the best painter was also the worst drunk. And risks taken in the act of painting were matched in intensity by the recklessness displayed in drinking.

Esteban Vicente, who worked in a studio in the same building as Bill's loft, remembers strolling along Tenth Street one morning, thinking about the unfinished paintings in his studio and the day's work that lay before him. Just outside the studio building, Vicente saw Bill de Kooning asleep, or passed out, against a lamppost. The artist whom Harold Rosenberg and Tom Hess called "the greatest living painter" hardly looked the part that morning as he sprawled, feet in the gutter and back against a lamppost, sleeping on a filthy street. Vicente thought that Bill rather looked like one of the bums from the nearby Bowery who often hung around outside the studio building.

Vicente, shocked to find Bill on the street if not surprised to find him drunk, bent over him, trying to get a purchase under his arms and to lift him to his feet. Bill, deadweight, did not move easily. He woke immediately and angrily asked, "Why do you make fun of me?"

"I don't make fun of you. What are you talking about?" Esteban responded quietly.

"People tell me that you make fun of me," Bill said, almost whimpering.

"That's a lie. That's nonsense," Esteban assured him. "Now come, let me help you inside."

Esteban hauled Bill up the stairs and into his studio, put him to bed, and asked if he wanted anything. "No," Bill said, "but I won't forget this. If you ever want anything, just ask me."

With that, Bill sank back into his drunken torpor. Esteban chuckled at Bill's grandiose offer of help, left the painter to sleep it off, and went to work in his own studio. Some months later, Este-

ban was astonished when Bill, talking to a friend, recounted the whole incident and said, again, "Esteban. If you ever need anything, ask me."

Bill was well known to the bums who gathered on the steps of his studio building, sharing their brown-bag-sheathed bottles of wine and cheap booze, talking and dozing. Occasionally one of them would get rowdy, or one would weep, or one would embark on an extended and incoherent monologue having to do with great wrongs done him. A harmless lot. A sad lot, Esteban concluded. They moved aside to let Esteban pass in and out of the building, sometimes nodding, sometimes offering a greeting. But Bill was a different matter among the bums, according to Esteban; he was a brother. They had seen him drunk, seen him on the street, and they had welcomed him into their midst, offering him the warmth of their booze and physical presence on cold winter nights.

Over the years, Bill chatted with them, gave them extra change that he drew from his pockets. As Tenth Street changed, the bums dwindled away. They moved on, perhaps; they died, perhaps. One day, long after Bill had moved to Long Island, one of the bums once familiar to Esteban appeared—a short, squat, squalid creature with dirty hands and face. "Hey," he accosted Esteban, "where's Bill?"

"Oh, Bill," Esteban answered. "He's moved to Long Island."

The bum nodded. "Yes," he said, "I heard he was doing well."

By the fifties, Elaine, unlike binge-drinking Bill, drank steadily, beginning in the morning when she found it helpful to "add a little something to [her] coffee," through the day, and, as she said, "into the evenings when everyone drank. That's what you did then. You worked all day and you met and drank and talked at night." For Elaine, drinking had become a serious habit linked to social occasions. "I did not think," she said later, "that I was an alcoholic, and I didn't really know what an addictive personality was. But I was addicted to alcohol, and so was almost everyone else on the scene at that time."

Like Bill, Elaine opposed her creative urges with strong self-destructive habits. For years Elaine had smoked continuously all day and every day; by the fifties she seemed to her friends to be determined to kill herself with alcohol and reckless behavior. Friends shook their heads in wonder, marveled at her physical constitution, which sustained the abuse she mercilessly inflicted on it, and speculated on her odds for survival through the next decade, the next year, the next month, the next week.

Drunk or sober, Elaine was sociable, however, and her studio— her encampment in the New York art world—became a meeting place for other authentic artists as well as assorted art world hang-abouts, spongers, drunks, and punks casing the joint in preparation for ripping her off. She wove together the threads of her social and professional life, adding gritty textural strands from events of the day and from the lives of friends and lovers. Increasingly over the years, strands were added from acolytes who sought from Elaine connection to the art world, introductions to people who mattered, attention, praise, support, and substantiation as artists or merely as people who mattered to someone. Over the years, Elaine's studio became a loony command center in the art world, a hurly-burly of activity, ambition, and assault on the enemy of art and people, the status quo.

Bill remained as insular and often depressed as Elaine was gregarious and generally ebullient. His close friends knew that Bill was a drunk, and knew that he was endangering his work and his life with his addiction to alcohol. They shook their heads; they whispered their concerns to one another. No one knew what to do. Bill, after all, was sacred and untouchable, rendered as bigger than life by the art-media hagiography. Those who continued to see him only through the adulatory scrims of pop-hero worship prepared for what seemed an inevitable and tragic end: Romantic Hero Drinks Self to Death, Art Survives. Those who cared about the man who happened to be a painter worried, talked among themselves, and felt helpless.

In the fifties and sixties, Willem de Kooning painted steadily as

he drank. Reviews and prices remained favorable, but no one who knew Bill doubted that his obsession with alcohol threatened to consume him and his commitment to his work. Accounts of de Kooning's drunken escapades—always good fodder for gossip—buzzed through the artists' bars, over telephone wires, and into circles well removed from the artist himself.

Some of the stories dealt with the danger he brought close to himself. Drunk, he picked fights with real toughs—not just macho-manqué artists. Drunk, he wandered the streets of Manhattan in the early morning hours. Drunk, he slept in doorways or on the streets, where, mistaken for one of the bums who surrounded him, he was threatened and beaten by both cops and punks.

Some of the stories about the drunk artist also exposed the airs and graces of the glitzy set that had begun to revolve around the art world. Drunk, he broke dishes and glasses; he threw drinks at other guests; he tried to pick fights; he used profane and abusive language. At fancy parties—where social-climbing hostesses trotted him about as if he were on a show lead—half-sober Bill smiled and feinted at conversation. "Yah, that's good," he would say to anything he was expected to admire. "Yah, it's a mystery," he would say to ears tuned in for the master's dollop of wisdom. He attempted grace in the face of praise; he sidestepped hot-issue questions about the art market and other artists; and he resisted most of the women who wanted trophy-sex with him. The parties, he said, were "pretty much the same. Pretty people. Pretty boring."

If he arrived sober, he quickly anesthetized his sensibilities with alcohol. Once drunk, he gave up all pretenses of what he scornfully called "gracious living" and could be counted on for excitement, if not for entertainment in the usual sense of the term. What could be better than the celebrity who also supplies the fun and games? What is more compelling than to witness in the living theater of a cocktail party the Great Man Disintegrating?

"Bill had always had a tendency to be a nasty drunk," said the

wife of one of his artist friends, "and it was not unusual for him to go on a rampage and break furniture, pick fights, or throw glasses. Everyone just looked the other way as much as possible. After all, he was a great artist and everyone knows that great artists act like sons of bitches. It's part of the whole genius thing."

Meanwhile, as Bill alternated between life-threatening benders and sobriety, as his work increased in value, and as his fame extended around the world, Elaine drank steadily all the time, seeming to become all the more sociable as she drank her way through the day and into the convivial hours of the evening. For years she ended each day with friends by smoking, talking, drinking center stage at social gatherings until she passed out. Over the years, Elaine's friends had come to expect evenings with her to culminate in chaos created by her drunkenness. Routinely, whether among friends in her own studio or among strangers at a party in her honor, when Elaine could no longer stand up, or when she fell asleep on the floor or a convenient sofa, or when she had to be sequestered in an unfamiliar guest room overnight, the curtain fell on the festivities. Her behavior, however, failed to elicit the tolerance extended to Bill, "the genius."

"To say that Elaine tested your loyalty with her drinking," recalls one hostess, "hardly describes what happened. She got drunk, she spilled food all over the table or the floor, and she knocked over glasses at the table or spilled her drinks on the furniture. She left burning cigarettes in dangerous places, and she dropped ashes on everything in sight. She was loud and argumentative; or she was loud and flirtatious with someone's husband. She absolutely insisted on being the center of attention every minute and on wrecking all social situations until she passed out. When I knew that I had to invite her to my house or that I had to go to a party where Elaine would be a guest, I dreaded it. I knew exactly what would happen and I knew that everyone would be disgusted and no one would want to say anything. A drunk Elaine was, I assure you, a disgusting force guaranteed to produce havoc. And a passed-out Elaine was a relief and an embarrassment."

Elaine's rejection of all things "standard," "expected," "established," and "ordinary" resulted in a chaotic life-style. It is not surprising that Elaine was no better housekeeper by herself than she had been when she lived with Bill. Dirty dishes filled the sink; overflowing ashtrays dotted the surfaces of tables, chairs, counters, and radiators; and magazines and books (with protruding bits of paper marking passages Elaine found significant) speckled all areas and all surfaces of the vast studio she eventually set up for herself at 831 Broadway (where Bill had his studio on another floor).

Friends from those years recall Elaine's studio and life-style, and they recall being amazed at the string of interrupting telephone calls and people dropping in unannounced to visit Elaine. Throughout the chain of intrusions, Elaine smoked, paced the floor, drank, talked with telephone callers and visitors simultaneously. She rinsed cigarette butts and dried coffee residue from cups, and made instant coffee for herself and guests. In the middle of sentences—her own or another's—she remembered telephone calls she had to make and gossip she had to pursue with an important source. And, on the telephone or in face-to-face conversation, she interrupted her own remarks by digressing into the subjects of sudden associations that came to mind.

Her work spaces were equally chaotic. Finished and unfinished paintings leaned several deep against walls and pieces of furniture; worktables overflowed with brushes, paints, solvents, glues, and tin cans for mixing colors; papers and tools strewn in several layers about the floor gathered dust; and articles of clothing and shoes lingered wherever they had been removed, flung aside, and forgotten.

Despite her alcoholism, Elaine, like Bill, worked steadily. Her New York studio served as a launching pad for her numerous projects: writing, painting, political causes, and expeditions into higher education, where she sparked the art programs of colleges and universities in almost every section of the United States.

A KINGDOM
DIVIDED:
UNEQUAL PARTS

THE QUEEN IS IN HER PARLOR

I trusted Elaine. I believed that she gave me extraordi-
nary powers; that, in her aura, I could accomplish things
I had never dreamed of doing. Elaine made everything
wonderful or fabulous. Good. Well—magical, I guess.

—AN ARTIST

The image of artist as existential hero and social rebel, as
described by Harold Rosenberg and exemplified by Willem
de Kooning, continued to bind Elaine and Bill to each other,
if not to their own permutation of marriage. During the
twenty years of their official separation, Bill and Elaine were teth-
ered to one another by tacit agreement that Bill was the master of
Abstract Expressionism and that Elaine, a painter in her own right,
was his wife. Elaine never even considered dropping the de Koon-
ing name, and she continued to speak of "Bill de Kooning, my hus-
band," throughout the decades of separation.

But proper names and labels did not completely contain Elaine.
She might be Mrs. de Kooning, but she was first and foremost
Elaine. And she might be a wife—a role she considered important,

perhaps even necessary, for a woman—but she was an individual. She might advertise Bill's greatness at every opportunity, but she pursued her own private and professional life, an amalgam of spontaneity, improvisation, accident, violence, and energy that matched the forces and style of Action Painting. Even when promoting Bill's career, Elaine kept for herself the right not to perform that service; and because she remained free to give to him or withhold from him attention—as well as love, admiration, and even conversation—she remained independent. But Bill was as indifferent to Elaine's independence as he was to her loyalty to him.

Elaine expressed her independence in action limited only by money or lack of it. She did what she wanted to do every day; she worked in whatever medium and manner she chose; she befriended whomever caught her fancy. Like other strongly independent women, Elaine understood that sexual freedom—as much as artistic rebellion—manifested her autonomy and her liberation from convention.

One of Elaine's oldest friends, another woman painter, boasted, "Some of the women artists slept with men who could help them out. I always slept with guys I had the hots for. I always screwed from passion—or lust, or heat, or whatever. I never screwed for gain. I was not one of the art tarts. And Elaine wasn't either. She just had too much style and class."

Elaine's sense of self-worth and independence flagged as she and Bill parted, leaving her with few emotional resources and with a growing addiction to alcohol and cigarettes. A friend analyzed Elaine's activities after the birth of Lisa, when she was convinced that she had lost Bill, his financial and artistic support, and his companionship and, in losing him, that she had lost a significant portion of her identity: "First, she redoubled her efforts to give Bill fame—that was her almost-sane side. At the same time she started drinking even more and sleeping around even more, and picking up guys from bars—that was her totally insane side.

And somehow, almost miraculously, she also got more serious about her own work—and that was her sane side, the side that saved her."

Elaine's paintings of the period, despite their lively Abstract Expressionist brush work, are somber and dark-hued, their color opaque and almost muddy. Dismissing later suggestions that the paintings mirrored her emotional state at the time, Elaine said, "Well, they were *urban* paintings. The city just had taken over my life."

She invested a new level of attention and determination in her own career, and like a powerful and beautiful tigress, Elaine strode her path through the art jungle in those days. If she was to live apart from Bill, if she could not be queen to his king, then she would establish and rule her own territory. Free to compete without apology and without diluting her assertions with protestations of wifely duty, Elaine acted to become Bill's full artistic colleague (if not quite his equal).

As Elaine redoubled her efforts as an artist, she seemed also to flaunt with renewed vigor her sexual promiscuity. During the fifties and sixties, she touched a lot of lives. She influenced other artists and she beguiled men. Sometimes she did both, as in the case of one artist-lover of the period, who admits to being "still in love with Elaine" and devastated by news of her death. "I hated hearing that she had died. . . . And after a few days I started knowing that I would never see her again and I cried and cried. She was that powerful. She was that kind of friend."

The artist was married when he met Elaine and, despite having had extramarital affairs before and after her, considers himself happily married, a proud father, and a good husband. At the time he fell in love with Elaine, in 1957, he was worried about supporting his family and was considering giving up his dream of being an artist to look for "straight work." Elaine changed that, he says, and left her mark on his life. He says:

Elaine was something else. I really went for her. I mean seriously. I can't say I was unfaithful to my wife only with Elaine. I suppose I'm kind of a sexual opportunist and I've never felt especially guilty, never felt that having it off with somebody other than my wife was very important. I think I think like most men. But Elaine was different. She was different to me. I mean she was different from anybody. She just sort of took me over. Before I knew what was happening. It was like she had this power over me, and I can tell you that I didn't want to resist that power. And if she walked in here right now, I think I'd fall at her feet, do anything she wanted.

I used to hang around the Cedars and drink, you know, with the guys there. I had seen Elaine around. I knew who she was. Everyone did. I saw her flirting with everybody, and flattering everybody, and saying intelligent things about everybody's work. That's just how she was. To me, then, she seemed to be a busybody, sort of an art world gossip. I mean, she was always the life of the party—always gesticulating and talking and being a little too flamboyant. Before I knew her I sometimes watched her, saw her at parties and at bars, and I felt some embarrassment for her. You know. She just came on really hard. And she got drunk in public. We all got drunk in public, but I had this male chauvinist thing about not wanting to see women drunk in public. For the men, it was okay; it was a macho thing and we all did it and were sort of proud of it. But Elaine did it, too, and I thought that was kind of disgusting.

Elaine was not the only woman who got drunk in the bars. All of those lady painters got drunk all of the time. And they talked rough—I mean using really foul language—and they showed off all of their sexual prizes. There was a lot of that. I had some interest in it, I admit, and always wanted to know the gossip.

Well, one summer day I was on my way to buy some cigarettes and some art supplies at the hardware store. As I passed Elaine's building on Broadway, she just happened to come out at the same time. And we sort of walked along together. She had on some funny

shoes with soles about, I swear, four inches thick; and she had on tight pants and some kind of bright colored blouse.

So we greeted each other. Pretty soon, I had this feeling that no one had ever been as interested in me as Elaine was, as interested in my work as she was. So I asked her if she'd like a cup of coffee and she said no, she'd like a drink. Well I didn't drink that much in the afternoon then; like I tried to wait until the end of the day so that I wouldn't get subhuman drunk or anything.

But I just wanted to go on being with her, you know, so we went to a bar. And we talked. We were more talking than drinking, but we were also drinking. I was telling Elaine about my work. She asked me questions which I was happy to answer. I'd been working a lot and feeling that nobody gave a shit what I did. I had the usual artist's paranoia and self-pity. I was strung out. Nothing seemed to be going anywhere and I was running out of money. Shit, I was out of money. I was always out of money. And Elaine didn't have anything then either.

So we talked about being poor. And I remember Elaine quoting her mother, Marie, saying, "Just take care of the luxuries, the necessities will take care of themselves." And we laughed and talked some more and pretty soon we just began to think that we were somehow very important to each other. There was sexual chemistry, and a lot more heady attraction, too. I couldn't believe there was anyone in the world like Elaine—anyone who talked all the time and still seemed to hear everything you said.

I knew that Elaine and Bill were separated. I don't think they ever got divorced—you know, officially—but I don't think they ever lived together much either. And Bill was living with Joan Ward. Sort of. And he was drinking himself to death. Everybody was just fascinated by all the stories about his drunks.

And I thought that maybe Elaine was drinking herself to death, too. But Elaine had this way about her, even when she was drinking. And pretty soon, I just felt myself being grateful and happy and feeling good, feeling really good being with her. It was like a lot of anxi-

ety was just dissolving. I felt that the bills would get paid and that my family would be okay, and I felt that pretty soon I would be making it as an artist. That's how Elaine treated me—like I was successful, like I was important, like I was fun for her and like I said important stuff.

The artist smiles and continues.

You know how Elaine was. She found everything amusing. Amusing. Remember how she would say that word? A-muuusiing. Sort of extending it over a long breath. She found me amusing. Man, I was flattered. And I found her amusing. And we drank and got more amused than drunk.

And then we went to my studio. We were pretty mellow. Elaine wanted to see my work and, Christ, I wanted her to see it. She had this way of looking. It was like she was totally on the side of the work, and totally absorbed in it. It was like she just forgot you. She had this way of crossing her arms, of holding one arm with the other hand, hugging her breast. She walked around the studio a lot. She looked at everything. Don't forget, Elaine was a beautiful woman. A world-class beauty. And sexy. So I was happy to watch her move around the studio.

She even found a stack of paper things and she went through those, too. Christ, I hadn't even looked at those things after I did them. But she didn't dismiss them or think them trivial. She was interested and her interest was about a hundred volts of power.

He stops pacing, stands looking out his window, and runs the back of his hand across his eyes.

And all the time that she was looking, she was saying really nice and insightful things. She noticed unusual features in a work. She sometimes noticed things I hadn't noticed. You know, an unusual color, some little accident that was just right. That kind of thing. I was flying!

I have to admit that I found it exciting. I mean exciting. I mean physically. Sexually. Exciting. So I tried to act cool. I did the Bogart thing with a cigarette. I offered her one. I did the James Dean thing—leaned against the wall and scowled. I mean I was really going for Elaine.

I knew that she was too good for me, in a way, that she was like royalty—like a different class. Man, I was in a state. I thought she'd reject my ass if I came on to her.

But, man, I was scared and I wasn't going to make any dumb move on her. Well I didn't have to do that. She just came and stood in front of me and the next thing I knew we were all over each other.

After a few drags on his cigarette, he continues.

Now. Elaine was special in that way, too. She really liked sex. I think she found sex amusing, too. She was this kind of daredevil, and she was fun. A lot of fun.

So. I guess we had this affair. I hate that word. I hate relationship more. But, anyway, we had sex many times, over several years. Elaine was having sex with other people, too. I always knew that. I knew that she picked up guys at the Cedars or the Lion's Head and I worried about that. I mean I cared, but I had to not care. I could have become jealous, crazy jealous. You know what I mean? That's just how Elaine was; there were always a lot of guys around and you just had to know that.

He paces, his head bowed. Then he goes on.

Was I in love with her? Oh, man, was I? I would have done anything for her. I would have left my wife, god knows, and gone anywhere Elaine wanted to go. But that was never a possibility. Elaine just didn't have the same interest in me that I had in her. I hated that.

After awhile, I got to think of Elaine as a force—as some really amazing force that was infusing energy into my paintings. I got

really superstitious for awhile. I thought that my work was sort of coming from Elaine, that she, like, dispensed art. And it felt that way. Hell. It still feels that way sometimes. And maybe that's what she did. I just don't know. But, you know, I think that if she walked through that door this minute, I think something fabulous would happen to my work. No kidding.

But I'll tell you this. Sure, I loved Elaine. I was in love with Elaine. I never felt that way about anyone. But that's maybe not the important thing. The important thing is that she really did have this magic thing about her, this power that she used on people. She really did make me into a different person. What's the point of this? Maybe the point is that that's what she did for Bill, too.

Yeah. Yeah. I mean, shit, she had good stuff to work with in Bill. But you have to wonder—I mean you really have to wonder—if Bill de Kooning would have the recognition he has if he hadn't had Elaine out there telling the world that he was the best goddamn painter in the universe. She did all of that publicity stuff for him, you know, and I think she really got Tom Hess and Harold Rosenberg and Charlie Egan interested—or at least more interested—in Bill than they would have been if they hadn't all been crazy about Elaine.

And you know what? I think Bill was crazy about Elaine too. And I think she made him crazy—like it made him crazy to be crazy about someone, you know?

I'll tell you something else. I've always been a little jealous of Bill. Not jealous of Bill as an artist—or at least not very jealous in that way—but jealous of Bill because he really had Elaine's soul. She slept with lots of men and she fooled around, but she was completely loyal to Bill. Funny, isn't it?

But he isn't smiling.

Women friends, too, remember Elaine's humor, loyalty, and generosity, as well as her dependence on alcohol and cigarettes and her reckless sexual adventuring. "Not all of the men in Elaine's

life were exactly nice," says a friend who often visited Elaine in her studio. "She had some real creeps around. Elaine liked danger, liked being daring," her friend explains. "That's the reason she was so attracted to the tough-guy types. Not the cop or the boxer—they were okay—but some of the gangster types she found around the bars. Real dregs. Potentially dangerous."

Friends and lovers alike lauded Elaine's attractive and zany personal style. Grace Hartigan says, "Elaine was always chic. She could turn the damnedest garments into chic. She did stuff like go to Klein's-on-the-Square—that enormous bargain basement store on Union Square—and she'd buy something like a nightgown and turn it into a dressy dress, and maybe she'd spend two or three dollars. Even then, though, she had this thing about shoes, and every time she had a chance and a little money, she bought shoes."

Elaine admitted that she was a clotheshorse and that she enjoyed buying and wearing certain clothing. "I always like clothes that have their own allure. I like to put on something that has its own character and feel that I add to it, or contradict it, or fade into it, and that the whole—the clothes and me—become greater than their parts." Teased about buying sleazy nightgowns and wearing them as "cocktail dresses," Elaine laughed. "I have always loved turning trash—I mean real junk—into something interesting."

That particular manifestation of Elaine's creativity was not confined to dressing. The story of one of her escapades circulated among her friends, causing some to shudder in horror of what might have been, others to swear angrily at Elaine's stupid behavior, and a few to make another attempt to help Elaine put her life in better order.

She left the Cedars alone one night and walked unsteadily toward her studio, several blocks away. A man followed her. In the time required for her to find her keys and open the door, he pressed himself into the entryway, grabbed her, and began to choke her and bang her head on the stairs. Elaine managed to mime her passivity. As the attacker loosened his grip on her throat, she said in a croaky whisper, "Laryngitis. Laryngitis." Convinced

that she was not going to scream, he released her throat. She handed him her purse, which he grabbed eagerly. Then, standing up, she turned to him and said, "You look cold. Come on upstairs and I'll make you some coffee."

At about that time, another artist in the building, having heard the sounds of the scuffle below, yelled downstairs, "What's going on?"

"Nothing," Elaine replied. "I just had a hard time finding my key."

Elaine took her attacker upstairs, heated water, and made instant coffee for both of them. She explained, "He was just a poor defeated junkie who needed money for a fix."

When he worked the neighborhood after that, he often stopped by to have coffee with his artist pal, Elaine. "He's very interested in painting," she insisted.

Elaine's easy inclusion of assorted bar pickups, junkies, prowlers, and crazies into her territory inevitably resulted in theft. She was robbed of sentimentally valuable jewelry given to her by Bill and of priceless antique pieces from Tom Hess. Books disappeared. Cash—little enough of it under the best of circumstances—vanished.

Elaine's friends worried. In conversation mostly behind her back, friends wondered when (not if) Elaine would pick up or discover the incipient "art lover" or the latent "artist" who would harm her. Those who gathered the courage to urge Elaine to reconsider her life-style halted their campaigns at the wall of Elaine's laughter. "No," she said, "it is absolutely impossible. I have this theory. People who know that you will not harm them will not harm you. No one has anything to gain by murdering me. And besides," she added, "I just will not live in fear of other people."

THE KING'S PLEASURE

Some guy came to my studio for fifteen minutes and wrote something that took six hours to read.

—WILLEM DE KOONING[1]

Ialways called them 'The Snobbish Vaginas,'" says artist Hedda Sterne. "By that I meant those women who always were around wanting to sleep only with famous men."

Bill was one of those famous men. Friends noticed that women threw themselves at Bill and that he caught their pitches almost reflexively. "Listen," says an admiring man, "I couldn't begin to list the women in Bill's life then [at the end of the fifties, beginning of the sixties]. But let's just say that there were many, many, many dames and that he probably didn't even bother to learn all of their names. Why should he? He enjoyed pleasures offered. He didn't have to think. He didn't have to change the way he lived or worked. He could have all the sex he wanted, and he barely had to stop painting to do it. It was ideal."

————

One of the women in Bill's life in the fifties assumes that her "on-again, off-again public and ugly love affair with Bill de Kooning" was not a secret. While she does not say so, it was one of several such affairs for him. "I had a terrible time, an awful time getting over Bill," she says, and she does not want to draw attention to "a painful, hurting episode with a lot of humiliation and a lot of masochism that [she's] not proud of."

I don't like that term, groupie. *I didn't think of myself that way back then, and I don't think of myself that way now. . . . Yes, I was after something. I wanted to be somebody important and I thought that would happen if I knew important people.*

I came to New York to get away from unimportant things—from my family and my hometown and from a dreary kind of life. I was creative, and I wanted to be in a creative atmosphere. I had always felt—had a sense of predestination—that I would be famous, that I would be a part of something important. I didn't know when or how it would happen, but I knew that I would be famous.

[When I first came to New York] I didn't know from the Cedars, but I was bored and willing to try anything. I had never seen anything like it, never been anyplace like that. [In the fifties] there were all of these people—mostly men—into serious drinking. I mean serious.

It was not a place where a "nice young girl" went to drink, or to engage in conversation. "Nice" girls then didn't leap into bed with any guy who came along, and they didn't really drink all that much, either. The Cedars [in addition to being the setting for high-toned or bare-knuckled disquisitions on art] was basically a pickup spot for the artists. Women—[other than a] few girl artists who were accepted as kind of borderline artists—[who entered the tavern on University Place] did so for one purpose: they wanted to play the game of "pickup artists."

[When I went there with friends,] we hadn't been there very long before a scruffy-looking guy came over to us and started try-

*ing to pick us up. He wanted to impress us so he started telling us who was who around the bar—you know, Jackson and Franz [Kline] and Mike and Bill and a lot of others. He called all of these older guys by their first names and acted really impressed with himself. But that line didn't mean a thing to me. I didn't know who these people were, but of course they were the Abstract Expressionists, the painters who were making all of those fabulous paintings that I found out about later. Really, no one knew about them then.**

I was simply fascinated. Fascinated. And I soon learned who these men were and then I was even more fascinated. I thought— here am I, a little nobody, a small-town girl, a naive kid—and I wanted to be a part of the scene. I was tired of being a nobody, tired of being naive. There was a sort of game that went on. First there was this hierarchy among the artists. The top tier—that was Jackson and Franz and Bill—everybody agreed that they were the important artists—and they could just have any girl they wanted. And so on. The girls wanted to be picked by those guys. So there was a lot of competing and flirting and manipulating to get laid by Jackson or Franz or Bill. The joke is that we thought we needed to compete or flirt. We thought we had to plot to get into their beds and lives. That just wasn't the case. Those guys didn't care a hoot about us. They probably didn't even notice us very much, they just wanted to be laid.

[I believe that the artists in the Cedars] wanted to talk to each other and I think they really probably loved each other. Not in a queer way, but more in the way soldiers or outlaws who've been through a lot together love each other. They were ambitious. They were against the world. They saw themselves as romantic figures, like the French Foreign Legion or something, in some kind of lonely

* The woman later describes a time in the late fifties when the Abstract Expressionists were in fact well recognized in the art world and among collectors who bought their work. Several galleries featured their work. Willem de Kooning and Jackson Pollock, among others, were recognized beyond the art world as well. It is true, however, that they did not then have the fame that subsequently came to them.

place that only they understood. They had this atmosphere around them of duty, of having to do something dangerous and important. I thought it was all very, very sexy. I was definitely turned on.

Well, I could see that the guys liked having women around who admired them. They probably especially liked having admiring women around who also had a little dough. None of them had any money and all of them needed everything—they needed money for rent, money for food, money for liquor and cigarettes and clothes, they needed money for paint. They all pretended not to care about money but they all liked money a lot. They made fun of artists who had money—you know, like Motherwell—and implied that they were less masculine, less into painting. But I think every last one of them wanted money.

And, if they got it by screwing a woman, that was just fine. Women were expendable. Good, as they say, for one thing only. Or two things, if you count money and screwing.

Oh, I don't think I'm bitter. It was a tough life for a young woman, yes, but it was also exciting.

I began to see Bill. I admit it. I really chased him. He didn't run, though, not at all. I was young. I was sure as hell naive. I convinced myself that he was interested in me as a creative person, as an equal—as someone who understood him and who could share his life. That was a laugh. A joke. I was young and I was a silly fool. I'm not sure now that he knew my name—or much more than that.

Here's how it went. I always called him. I always went to his studio. He acted glad to see me. We had a lot of sex. And I bought things for him, left a little money around for him. I knew that Bill's paintings were selling, and that he was making a living, but he seemed poor by standards I was accustomed to. I was happy to feel useful to him.

But I can't believe Bill was ever interested in me. While I was seeing Bill, I started drinking too much—more than I had—and got careless. I wasn't the only one to get pregnant and to have an abortion. I was disgusted, but what could I do? What could I do? What could anyone do then?

Her voice breaking, she squeezes tears from her eyes and continues.

> *Joan Ward had already done it, hadn't she? She'd got pregnant and got Bill. That's what we thought. Only she really didn't have him. No one had Bill—except, finally, maybe Elaine did—and Bill had everyone.*
>
> *Remember, Bill was absolutely gorgeous. He could have been a movie star. And he was very, very sexy; a very good man in bed. Harold [Rosenberg] went around acting like a stallion—flaring his nostrils and glaring in what I suppose he thought was a sexy and a little dangerous way. But Harold was not much—a lot of promise with too much wifey in the background and too much drink. But Bill turned me on and on and on.*

Her voice lowers. She almost whispers.

> *I almost died when I had to admit to myself that I never had him and never would have him. I had this breakdown and, well, it was awful. . . .*
>
> *But, eventually, I got my head on straight, got everything in perspective. You should remember that that whole scene was in some ways terrible and destructive. Now, looking back, I'm really surprised at how stupid and how phony we all were. . . . Does that include Bill? Oh yes, I think so. Yes, I think he was—is—a phony. I think he pretended to be a suffering genius and posed as a lonely man who needed comforting. I think he knew exactly what he was doing. . . . I think the great Willem de Kooning was along for a free ride in this life. He was never, never what he pretended to the world—especially the adoring world—that he was. . . .*
>
> *Elaine? What do I think? There was a time when I hated Elaine. But not any more. I think she made up Bill to a great degree—made him known as an artist more than he would have been if she hadn't talked about him all of the time to everyone who mattered. . . .*
>
> *There were a lot of painters in lower Manhattan. Most of them*

were supported by wives or girlfriends or fathers or somebody. What Elaine did was make Bill stand out more. You know, Elaine charmed and seduced Rosenberg, Hess, and that dealer [Egan]— three of the most powerful people in the art world—and Bill got a lot of benefit from that. He got attention. I think all of them liked Bill—he was likable after all; and I think all of them admired him as a painter. But I don't think they admired him as much before Elaine got to them as they did after. You see?

Bill got attention, got established. He got famous. So when collectors started buying the Abstract Expressionist art, they naturally started by buying Bill de Kooning and Jackson Pollock and a few others that they had been told were far out. Bill was very, very lucky. . . .

No, of course I'm not saying he wasn't talented. He must have been talented. But he had a lot of luck, too, and there was a lot of maneuvering and if he didn't do it himself—and I think he did do a lot more of it than people think—it was done for him by Elaine— mostly Elaine. . . .

No, I don't know what she got out of it. Hell, perhaps she just loved him that much, or controlling Bill's destiny was her best power trip or something like that. I never understood Elaine. I didn't even know that they [had never been] divorced until just before she died. . . .

After a reflective pause, she continues.

There is one joke that might interest you. I had some of Bill's drawings—things that even he didn't think were very significant— and I sold them for one hell of a lot of money. So, in the end, Bill repaid me . . . with this house, that car, some trips, and a lifetime's supply of a shrink. Now, is that not justice?

She laughs, and mascara-tinted tears run down her cheeks and cut gullies in her makeup.

Despite Elaine's momentary belief that the birth of Bill's daughter would domesticate him, the presence of Joan and Lisa

did little to change his promiscuity. Moreover, it protected him from unwanted complications with women. There were two notable exceptions, however, to Bill's usual treatment of women— Ruth Kligman and Marisol, both artists. It was rare for him to encourage talent in a woman, as he did with sculptor Marisol; and it was even more remarkable for him to display signs of affection, as he did with Ruth Kligman.

By the time Bill was in his mid-fifties, he was as well known for his drunken escapades and his powers over women as for his talent, his prodigious productivity as an artist, and his steadily growing success. As Bill left the Cedars with his girl of the day, drinkers at the bar exchanged smirks and nods: the artist-stud had done it again. When his good friend Franz Kline teased Bill about his legendary prowess with women, de Kooning smiled. "Yah, Franz. I'm the best."

After the death of Jackson Pollock, de Kooning believed he was the best, and unchallenged, as drinker, painter, and lover. Bill's affair with Ruth Kligman, according to an artist's wife, "just sort of proved that Bill had finally buried Jackson. She had been so obviously Jackson's girl. And when she became Bill's girl, Bill bragged that he got her."

But Ruth seemed not to notice; she thought Bill handsome, and she knew him to be an important painter. After Jackson's death and a period of recovering from her injuries in the car crash, Ruth willed herself away from mourning and back toward her own sunny, fun-loving disposition. One evening, dressed beautifully, she encountered Bill and Elaine having dinner together in a Lower East Side restaurant. Bill was, Ruth noticed, very attractive. When she next met him—at a New Year's party—she told friends, "We really met. We really came together. It was a great love."

Middle-aged Bill "fell for sexy, beautiful, warm, younger Ruth in a big, big way," recalls a man who knew them both. "And pretty soon she had him doing things he would never have done otherwise. And he seemed to enjoy doing these new things. He really liked pleasing Ruth. He went to Europe. He dressed up sometimes, and he bought clothes for Ruth, and trinkets. He seemed

always to be so proud of her when they were together, and he seemed to want to show her off to everyone. She was, I guess, in her twenties. And she was a mighty delicious dish! She was just too gorgeous to be real, she could have been a movie star.

"Ruth Kligman was not just another tootsie for Bill," says the friend. "He was daffy over her, happy as a kid. She was just about the sexiest woman around, and she was truly a very sweet and lovable person—vulnerable like Marilyn Monroe and gorgeous like Elizabeth Taylor. Bill loved to show her off, loved to be seen with her. You know," he adds, "I think Bill smiled more around Ruth than he had in years. I mean, I think Bill de Kooning was happy with Ruth Kligman."

Writer Curtis Bill Pepper remembered meeting Bill with Ruth Kligman in Rome in 1959: "Rome had been all triumph—Willem de Kooning, the long years of poverty behind him, near the apex of his fame. Rome had been bright sun and dark church cloisters, refracted in his stark black-and-white abstractions." It was late fall, and Pepper met de Kooning at the Café Rosati, "surrounded by friends and admirers, in the company of Ruth Kligman, a painter and the latest woman in his life. You could see Bill was crazy about Ruth. He was fifty-five, she was in her twenties, and there was a strong sexual attraction between them."

He recalled: "Bill and Ruth had come from a clothes-buying spree for her, and she wore the rags of riches with a seductive air. Italian men strolling by the outdoor café stared at her, and Bill seemed to enjoy that."[2]

Years later, artist Marisol told John Gruen:

One time when I went to Europe, I met Bill de Kooning, who was there with Ruth Kligman. Before that I had had a little affair with him, but it didn't really amount to much. It must have lasted three months. I hero-worshiped him. He's so interesting. At the time, he had about three women, and I was very disappointed. So I just dropped the whole thing. He was very gentle, very nice. We used to go out and get drunk all the time. That's what we did in

Italy, too—Bill, Ruth, and I. We were there for six months, and I think we were all alcoholics—drinking all day and all night and making scenes. All the Italians were very shocked.

I liked Ruth a lot. She was a very good friend, and she believed in me. At first I thought she was taking advantage of the artists. But then, I immediately became very friendly with her. She's very interesting, lively, amusing, and good natured.

Considering the older and better-known artist's influence on her life, Marisol said, "I used to drink an awful lot. I think it was the influence of Bill de Kooning."[3] But she also credited Bill with helping her career, saying, "He wasn't like some of the other artists I met who didn't like women to do things. Bill was very encouraging." After meeting Marisol, Bill called friends at the Museum of Modern Art and insisted that "someone there take a look at her work. Her very good work." The result boosted the young woman's career and eventually resulted in her work entering the Museum of Modern Art collection.

After de Kooning and Ruth Kligman spent time together in Rome—where Bill produced numerous black-and-white drawings (1959–60)—Bill celebrated Ruth in the title of *Ruth's Zowie*. But her presence in his life, and their joy with each other in the landscape of Long Island, may also account at least in part for a significant segment in the artist's oeuvre. Is it coincidence that Bill changed fundamentally his image and definition of women during his relationship with Kligman?

From their first appearances in the early fifties, the women in de Kooning's paintings were associated with sexuality. But the nature of that sexuality remained troubling for many critics and viewers. These freakish women—though often seen as mutilated and mocked fertility figures, or the driven-mad grotesques abandoned by a sadomasochist—could also strike an oddly humorous note. Was the artist serious? Elaine joined Tom Hess in identifying Bill's feelings about his mother as the origin of the woman image. In the last

decade of her life, Elaine quoted Bill as having said: "I don't see what all the fuss is about about my girlies. I think they're cute."

No single word could be less appropriately used to describe de Kooning's women paintings, however, than *cute*. They might be called grotesque or monstrous, powerful or overpowering, but they could not be characterized as either delightfully pretty or dainty or obviously contrived to charm, the usual meanings of the word. Bill's description of his women—"my girlies"—could have stemmed from his lingering uncertainty with the English language or from his enjoyment of going counter to prevailing perceptions. Or, given the unlikelihood that he would engage in either irony or dissembling, the remark may be one that Elaine uttered for him.

Whether Bill actually originated the sentiment that Elaine quoted, however, she did not appreciate the suggestion that she herself might have inspired Bill's woman paintings. But Bill's interest in Elaine as a subject is attested by his early Düreresque drawing of her, as well as by her own jolly description of Bill using her as a model to learn to draw hair in the forties. At the time of their marriage, moreover, Bill painted an androgynous figure with features identifiable as both Elaine's and his own—a painting that can be construed as a "marriage painting," a visual joining of separate individuals.

Without suggesting that de Kooning's treatment of women in his paintings parallels his involvements with specific women, and without overindulging in tabloid psychiatry, it is noteworthy that the artist began working on the women paintings at the same time that his marriage to Elaine began to disintegrate and as he began to drink heavily. It is inconceivable that subject matter as pervasive as women in Bill's painting could be unremarkable. All artists travel through stages of style on their paths to maturity, and the obvious changes in Bill's on-canvas visualization of women suggest that he experienced different attitudes and markedly different emotions regarding women.

De Kooning's first women are unlike Elaine in their squat fig-

ures and pendulous breasts, but they often include her reddish
hair and large eyes. Whatever their source, however, the de Koon-
ing women of the fifties differ vastly in appearance from good-
looking Elaine, evoking comparisons with the Venuses of Willen-
dorf, witches, and vulgar and stupid whores. They may have been
born of a violence that provoked writers Harriet and Rudi Blesh to
assert, "Perhaps never before has an artist placed an image on the
canvas in order to attack it physically. Van Gogh and Soutine
painted violently but their paintings were momentary releases
from the battle they waged with themselves. De Kooning, attack-
ing the canvas, attacked himself."[4] The paintings promote the con-
clusion that Bill acted out his feelings about women.

No wonder that numerous women view the de Kooning women
as monumental icons of male chauvinism, supported by the artist's
admission that "women irritate me sometimes. I painted that irri-
tation in the 'women' series. That's all." He added, "I *like* beautiful
women. In the flesh; even the models in magazines."[5]

Whatever else de Kooning painted, he seemed rooted in his
own reinvention of the female form. For example, his land-
scapes—whether referring to urban similes or to the vistas and
light of Long Island—suggested the contours and physicality (if
not sensuality) of his women. Despite the geological evocations of
the textured surfaces and the allusions to natural force, the land-
scapes evidenced the artist's fascination with the skin of the paint-
ing, a visual parallel to the skin or surfaces that constituted his
women paintings. His landscapes differed from the women most
noticeably, however, in their higher-keyed tones and their flirtation
with pure light. Some of them, painted in cheap-candy colors,
flirted also with emptiness if not silliness.

In the sixties, it was an easy move from those landscape paint-
ings to a new women series, but it was a move perhaps made still
easier by de Kooning's relationship with Ruth Kligman. His
women of the sixties, painted in yellows and pinks and whites,
cavort across the canvas. These new figures do not grimace, bare
their teeth, or threaten; they are no longer squat and bizarrely

menacing. But, frozen in dance-frolic and play, they are blatantly erotic. Art critic Vivien Raynor thought these "recent wenches must come across as fundamental as a belch."[6]

De Kooning also changed the ground on which the new women played, exchanging his previously preferred almost-square canvases for elongated vertical surfaces—80-x-36-inch hollow core wooden doors that he bought from a local building supplier on Long Island. Of the first of the series, an elongated figure, *Woman, Sag Harbor,* de Kooning commented, "When I made *Woman, Sag Harbor* I just titled it that, because I go to Sag Harbor and I like the town and I frequently have this association. While I was painting it I said to myself, 'That's really like a woman of Sag Harbor, or Montauk, where it's very open and barren.'"[7]

In this and the other women paintings of the early sixties, de Kooning's subject matter is unmistakably sex. Unlike his earlier women, these long-legged dollies are delicious sex objects, often shown with their legs splayed to reveal confection-like genital areas. In an interview with Harold Rosenberg, de Kooning (consciously or unconsciously) evoked a symbolic connection between water and sex when he said, "*Woman I* reminded me very much of my childhood, being in Holland near all that water."[8] The later women, more visibly than the earlier *Woman I* or her sisters, did indeed appear to symbolize the artist's association between female sexuality and water, a major feature of work completed during the time he and Ruth Kligman enjoyed each other and the beaches of Long Island. When Bill suddenly, and seemingly inexplicably, left Ruth and returned to Joan Ward and Lisa, Ruth turned to Bill's best friend, Franz Kline, a relationship that lasted until Kline's death.

But from her own experience with de Kooning, Elaine said, "Bill just never trusted pleasure. He just wanted to work, and I think he always thought that working—painting all of the time—would maybe make him happy. And if he thought somebody was in the way of his work, he just always turned his back and concentrated on painting. He was totally obsessed by painting. And that was his total pleasure in life, too."

THE KING IS IN
THE COUNTING HOUSE

I get freer. I feel I am getting more to myself in the sense of, I have all my forces. I hope so, anyhow. I have this sort of feeling that I am all there now.

—WILLEM DE KOONING[1]

L ook," says a fellow Abstract Expressionist artist, "Bill was making it then [at the end of the fifties, beginning of the sixties]. And that's all that mattered to him. He didn't give a goddamn about anything—or anyone—else: he was just totally obsessive about being a great painter. And by the time he and Elaine split, well, drunk or sober, he knew that he was just that, and that he was becoming a part of history."

In 1961, after summers in the country, Bill began to think of living year-round in the Springs, East Hampton. He bought a house on Accabonac Road from his brother-in-law, Peter Fried. In that simple country house, across the street from the cemetery in which Jackson Pollock is buried, Bill worked on numerous small

paintings and drawings, and he began to design and build his studio in the Springs.

On March 13, 1962 (the day after Elaine's forty-fourth birthday), Willem de Kooning became a citizen of the United States. After years of anxiety about his illegal alien status, Bill followed legal advice, went to Canada, reentered the United States under a quota, and applied for citizenship through proper procedures.

Bill, though deeply attached to Lisa, had moved in and out of Joan Ward's apartment. But in June of 1963, when he moved with Joan Ward and Lisa from his New York loft to Long Island, he may have believed his personal life could share the success of his career. By this time his works were included in museum and private collections, and the collectors awaited latest reports from his studio as if they were tips for insider-trading. Collectors commonly competed with each other and with the agents representing the world's most powerful museums to buy new works by de Kooning sight unseen, a phenomenon that made Willem de Kooning a very desirable artist indeed for dealers. His fame—and therefore the value of his paintings—increased with honors, salutary reviews, admiring criticism, and important sales.

New York, once the center of Bill's universe, had soured for him. Before he was successful, he had looked on New York as the only place where an artist might find freedom and like-minded friends; but, as the art world churned with ambition-driven and Machiavellian machinations, Bill often found himself victimized by obsequious, pandering wannabes and groupies. Strangers interrupted his work, invaded his studio, and followed him down the street.

The Cedars was now packed with young artists who wanted to appear on "the scene" and who specifically wanted to be seen with Willem de Kooning, the king of the art world. With the rise of pop art, it seemed to Bill, it was difficult to tell the art world and the rock-music sphere apart. Scores of ambitious young artists told everyone who would listen that their work had descended directly from that of Willem de Kooning. "Dese kids," Bill noted, wanted a piece of the action.

Bill recognized that his old art community and its bohemian ways had been subsumed into a fast-paced, high-rolling, corporate-style world of publicity, promotion, packaging, and public relations. Glitz and hype were the currency on the new exchange. He was no longer comfortable in any of his familiar haunts, including his own studio, which in desperation he equipped with a peephole and a telephone-answering service. When Bill's landlord suggested the installation of an elevator to make it easier for Bill to move his paintings in and out of the loft building on Broadway, Bill offered to pay him if he would *not* install a mechanism that would make it easier for uninvited visitors to get to him.

Although he was often apparently amiable in his dealings with younger artists who openly competed with him for power and fame while simultaneously seeking his blessing and help, friends believe that de Kooning resented their competition. Harold Rosenberg was convinced that, despite his self-effacing manner and flattering comments to other artists, Bill firmly believed that he was "the most important painter in America; the most important painter of the twentieth century." Artists who watched Bill first resist and then accept success say that by the sixties he believed that he had worked hard, indentured himself to the great tradition of Western art, and believed that he had earned his success and his position in the art world. He, they say, simply believed that he was "the best."

At one point, Bill strongly avowed dislike for the country and had grown uncomfortable when he ventured off Manhattan Island. Now however, he wanted to live in a quiet place far from distractions. He had worked happily during his summers on Long Island, and he turned naturally now in that direction for solitude and a place to continue his work without the irritating buzz of supplicants. Like an aging king forced into exile by obstreperous pretenders, Bill moved to Long Island and reconstituted there his court of the kingdom of Abstract Expressionism—complete with seers, jesters, ladies-in-waiting, knights, and fools.

Living again with Joan Ward and Lisa, Bill doted on his daugh-

ter. Lisa was a combination of the good looks of both parents, and she was also a combination, if not amplification, of their troubled lives. Neither Joan Ward nor Bill de Kooning receive high marks from their friends for their nurturing of Lisa during her early years. While not deprived of material goods—indeed, she was often buried beneath toys and gifts that were lavished on her— Lisa was deprived of the deeper security built on parental love, steadfastness, and emotional consistency.

"What a pretty child she was," remembers Esteban Vicente, "and Bill was so pleased by her beauty. When Bill was sober, he wanted to be a good father. He would say sweet things about Lisa, about how pretty and smart and funny she was." But drunk, Bill's attention fixed on his own miseries, and as his frustrations with painting subsumed him, he turned Lisa's surroundings into an extension of his own hell as he slammed around the furniture, banged his fists on the walls, and loudly cursed his demons and tormentors, real and imagined. His anger was neither at Lisa nor himself, but at his fate: "I am beating my brains out," he bleated. "I am beating my brains out."

Frustrated as much by success as he had been by the insecurities of being unknown and poor, Bill found no more solace in sharing life with Joan Ward and Lisa than he had found with Elaine. Bill's attention did not linger on people but remained fastened to his painting, and that attention was broken only by his drunken binges. Friends of Bill and Joan believe that Lisa never had a chance for healthy emotional maturation. By the time she entered school, she was having difficulties, having been spoiled with the goods that money can buy yet deprived of the stability a child needs. Later, when Lisa was away at boarding school, Bill pointed to a drawing she made when younger. "Look here," he said, "you see this is pretty good."

But Lisa was overshadowed in Bill's mind by his dream of a perfect studio. He bought a large piece of wooded land, located a source for the industrial building materials he wanted to use to

span large interior space, and immediately began to plan and over-
see the construction of a large, steel-framed and -trussed, glass
and cement-block studio. Bill approached the building of his stu-
dio, which reportedly cost over $200,000 to build, in the same
manner in which he painted: he tested and changed the design, he
tore out and rebuilt walls, he demolished and reconstructed
facades. For several years, as the building project moved forward
and then backward, his friends speculated that he would never
move into the dream space that he continually "made better."

Willem de Kooning's studio has been compared to a great ocean-
going vessel and to an airplane hangar. It has elements of both.
Shiplike in neatness and underlying order, it has built-in cupboards
designed by Bill for storing truckloads of art materials. He installed
special mechanical easels for raising and lowering huge paintings so
that he did not have to climb a stepladder to touch his brush to the
tops of his paintings. He had openings cut in the floor so that paint-
ings could be easily moved in and out of the basement storage area.
The studio resembles an airplane hangar in its scale and in the vast
open expanses made possible by the steel Y-beams that carry the
roof. The functional and gleaming stainless-steel kitchen could
serve a great ship's galley or a busy high-toned restaurant in one of
the world's large cities. Bill said he planned to have "marvelous din-
ner parties" when he moved into his finished studio-home.

The artist's own Spartan bedroom is a glass-enclosed aerie above
the studio. He never wanted to be far from his work and was most
comfortable when unfinished paintings were in his sight. A large
television set and a group of handsome modern leather chairs and
sofas set on a tiled floor define a living area. The long, built-in
wooden dining table just outside the kitchen accommodates eight
or ten people and could indeed support Bill's dream of having
marvelous parties.

Grace Glueck reported on her visit to "the 61-year-old man
some critics and collectors consider America's greatest living
painter" and described "the short, handsome man wearing a Bea-

tle-type haircut, baggy blue jeans, and a loose denim shirt." She met him in his "huge, theatrical house-in-the-woods that he can't seem to stop building."[2]

Calling her attention to his thirty-foot ceilings, Bill told Glueck, "I've designed it like a loft. . . . I guess I was one of the first painters in New York to have a loft, back in 1930. Now I want this feeling of great, open space. The whole thing is really a workman's dream." A few minutes later, when Glueck admired a sculptured fireplace, de Kooning worried, "Don't you think that looks a little too arty?"

Everything in Bill's studio was designed to exist peripherally to the work and storage spaces; everything had one purpose—to support the work of a great artist. But at the same time that Bill was building his dream studio in the woods of the Springs, he was being swept higher and higher on the ladder of critical and financial success with a series of exhibitions that elicited almost universal praise and continual sales of his work. He was also the victim of his drinking.

Glueck had listened to Bill talk "knowingly of pop, op, and newer art trends." But four years later, another visitor found Bill, again separated from Joan Ward and still not moved into the studio, in a different condition altogether. John Gruen telephoned Bill to request an interview for a book he was writing on the fifties in New York. "I called his number repeatedly, but there was never any answer. Finally, I heard a rather tentative voice on the other end. It was Bill," Gruen wrote. The author noticed the tremor in Bill's voice as well as his hesitation to receive a visitor. Eventually, after several telephone conversations over the following few days, Bill agreed to see Gruen and said, "Well if you're coming, maybe you could bring me a small shot of whisky. I don't want a whole bottle, just two fingers' worth . . . maybe in a glass."

Recognizing that Bill "was having the shakes and trying not to drink," Gruen nonetheless bought a bottle of scotch to take to the artist in his house across the road from the Springs cemetery. Arriving at the gray shingled house, Gruen knocked and shouted but roused no response, then entered the house as he called Bill's

name. He observed a quite ordinary living room, "even depressing in the 1930s middle class way. No one was in sight, but a large television set had been left on." Ignoring the soap opera sounds and images pouring from the TV, Gruen continued to call Bill's name until he heard "a shuffling overhead. In a moment, Bill slowly walked downstairs. He was unshaven and looked a wreck."

Gruen was jolted to see "America's most famous painter in this condition—to know that he was totally alone in this drab little house, to notice how his hands shook." After peremptory greetings, Bill nodded toward the brown bag containing the bottle of scotch and asked his visitor, "Is that it?"

Gruen handed over the bottle and watched as de Kooning picked up a glass, poured a drink and tossed it back.

Bill told him, "I don't think I could talk to you unless I've had a little shot. I'm kind of under the weather."

Somewhat restored by the drink, Bill continued, "You know, it gets pretty lonely out here. That's why I keep the television running. What I do, see, is I turn the TV on, then I go upstairs and lie down, and then it sounds as though there were people downstairs. It makes me feel that I'm not alone in the house."

After a period of genial conversation, Bill suggested that he and Gruen visit the new studio. At the end of a short drive along the lanes of the Springs, the two men turned onto a winding drive and arrived at Bill's studio. As Bill showed his visitor the vast interior spaces, Gruen realized that the structure was also "an elaborate dwelling where several dozen people could live in the greatest comfort and privacy."

They surveyed Bill's work in progress, several women paintings that Bill had stacked against walls of the studio. As they discussed the paintings, Gruen listened to Bill describe "his women [as] creatures that excite his imagination as he observes them walking down the street, perhaps dressed in gaudy clothes, caught out of the corner of the eye as they pass."

Bill also showed Gruen some drawings in progress, saying, "These are kind of interesting. . . . I do these with my eyes closed.

I just sit in this chair and let the pen do what it wants, without my looking—and without my thinking of anything. It's funny the things that come out, and it's terrific exercise."

As Bill led his guest through other parts of the house-studio, they came to a large row of closets, all totally empty except for numerous clothes hangers. Bill, holding a hanger out for Gruen's admiration, said, "These are the most expensive hangers you can buy. I always promised myself that one day I would own the most expensive clothes hangers available. I never wanted to see a wire hanger again in my life. Anyway, these hangers cost me $12.50 each."

Realizing that he was in Bill's dream house, Gruen wondered if the artist would ever live in it. "I can't bring myself to live here," Bill said. "I can only come here to work. I always say, maybe one day we'll all move in here and I'll get rid of the little house. But I can't seem to do it. I always think I ought to have great big wonderful parties here, but I never do. It's a crazy thing."

When Gruen's book appeared in 1967, Elaine was furious. Although she, too, had been interviewed and was extensively quoted, "she went ballistic, over John Gruen's treatment of Bill," according to Sherman Drexler. "She felt that Gruen had taken advantage of Bill, had set out to get Bill drunk and make him talk and to show the world this helpless, pitiful, old guy—this *rich* old guy who cared about expensive clothes hangers." Others, who also received telephone calls from Elaine on the subject, recall her efforts to discredit Gruen and his book. "It was not the image," says Elaine Benson, "that Elaine wanted the world to see. It was not the image of Bill that she protected and projected."

Bill, typically, was not thinking about what other people might think of him but was working hard between binges. Throughout the five-year period of designing and overseeing construction of his studio, Bill worked on paintings and drawings, producing both large and small pieces. His 1962 exhibition with Sidney Janis, consisting of both drawings and paintings, inspired *New York Times* critic Stuart Preston to write: "Willem de Kooning is rightly

recognized as one of the principal founders of Abstract Expressionist painting, and one, too, who has stuck to the original guns that first fired, some fifteen years ago, that salvo heard 'round the world." The art critic lauded de Kooning's "big, brusque gestures with the brush; the powerful athletic, anti-esthetic forms hurtling this way and that; the happy improvisations, lucky finds and the color, equally dramatic in black-and-white contrasts and in bright configurations."

Continuing, Preston declared that "de Kooning remains a spellbinder and a wonderful performer. It is a rather exclusive and haughty way; a shrill, violent projection of self; a flashing illumination of things seen or felt as with a burning glass rather than by a gentler or more searching light."[3]

Later that same year, the same critic commented on an exhibition at the Allan Stone Gallery that contained works showing Bill to be "engaged vehemently in powerful shape, imagery and paint-color manipulations." He also determined that "de Kooning obviously abhors any narrow conception of the resources of art, plunging deep and recklessly into means and ends and sinking mineshafts into the recondite sources of imagery. His are the most profound, densest and most generous explorations of this style."[4]

In 1963, while he watched over preparations for installation of a solo exhibition at the Jewish Museum in New York, Bill began a new—and fifth—series of women paintings, one of which is *Clam Diggers, 1964*. During this time, too, he painted the series of women for which he used doors as his canvas, including *Woman, Sag Harbor, 1964*.

In the same year, Bill received the Freedom Award Medal from President Lyndon B. Johnson, as well as the Guggenheim International Award. Along with other recipients of the Freedom Award and a select group of artists and intellectuals, Bill found himself on a White House list for invitations to receptions and dinners orchestrated to mingle international dignitaries and politicos with representatives of American culture. In 1965, however, while in Washington to attend a White House dinner, Bill signed a petition

to protest the Vietnam War and was apparently dropped from the list of tame artists and intellectuals.

Bill, increasingly identified as a blue-chip artist, had taught briefly at Yale University at the invitation of Josef Albers, who took the helm of the graduate program in painting at the New Haven institution after he left Black Mountain College. At the Ivy League university as in the experimental college in the North Carolina mountains, Bill was popular among his students because, according to Elaine, "he was so different from the rigid, austere Albers." But Bill hated the loss of time in his studio, and so he rejected other offers to augment his income as a painter by teaching. He concentrated on painting all day every day and let dealers, critics, collectors, and fate add to his status and to his wealth.

During the sixties, when that spreading fame and growing wealth were called to Bill's attention, he often seemed to friends to be bemused, if not incredulous. Yet he did not resist the efforts of dealers to make him very rich, and to make themselves rich in the process.

But not all dealers found Bill to be an unmixed blessing. Leo Castelli recalls that fellow dealer Sidney Janis confided to finding "Bill even more difficult to work with than Jackson." And Bill complained that Janis tried to influence the direction of his work, an effort Bill considered a violation of the artist's sacred quest for the secrets embedded in his own talent. "He said he couldn't sell the women pictures; he wanted abstractions. He said he could sell the abstractions."

Though collectors in the past had found the controversial women paintings not as desirable as the less violent landscapes, they now wanted any de Koonings and were willing to write large checks for what they wanted. And as de Kooning's reputation flowered, they wanted his "signature" work; they wanted anything recognizable as a de Kooning.

Bill continued to paint women, using both single and paired figures; and in 1965 he produced a multitude of vigorous drawings of female figures. Both the paintings and the drawings from

this period are strong, animated, and sure-handed. After his com-
mercial success in the late fifties, Bill had money enough to pur-
chase the best available art materials and to use them profligately.
For the first time in his life, he could buy quarts or gallons of the
best paint made; he could order dozens of brushes and buckets of
solvents; he could have special stretcher frames made to suspend
expensive canvas; and he could afford to work on as many pictures
simultaneously as he desired. As he worked, moreover, the pic-
tures flowed steadily from his studio walls into the cultural main-
stream of America and onto the market.

Bill often gave the appearance of being disinterested in his
growing wealth and fame, but in 1965, through his lawyer, Lee
Eastman, he filed suit in the New York State Supreme Court
against his longtime dealer, Sidney Janis. After over ten years of
affiliation with the Janis gallery, de Kooning claimed that Janis
owed him $150,000 for paintings sold and that the gallery had
made a number of sales to itself. He said that the gallery had
"capriciously set more favorable prices for itself or those whom it
favored for its own benefit and account, all to my damage and
injury." Through Eastman, de Kooning indicated in his suit that he
did not know the exact amount of money owed him and claimed
that the gallery was using his name to promote an exhibition of his
paintings without his consent.[5]

Janis, claiming that Bill owed him money on two loans (one for
$50,000, the other for $75,000) to help complete his studio, told
the *New York Times,* "So many people are beating at de Kooning's
door that he feels a dealer is no longer necessary. He is selling the
paintings himself." Janis also wanted it known that "our contract
with de Kooning goes back about 13 years. . . . Like our contracts
with all our artists, it's a verbal one. The gallery pays the expense of
storage, delivery, of exhibitions, of catalogues and receives one-
third commission."[6]

Bill left legal matters to Eastman and turned his attention to a
series of exhibitions that filled the mid-sixties. Bill's work was
shown at the Tate Gallery, London, in an exhibition entitled Paint-

ing and Sculpture of a Decade: 54–64. He was also represented in the most vanguard of all international exhibitions, Documenta III, in Kassel, Germany. In 1965 Smith College (Northampton, Massachusetts) mounted a retrospective exhibition, which was also shown at the Massachusetts Institute of Technology.

Elaine Benson, who presides over the gallery that bears her name, moved to the Hamptons in 1966. Long interested in contemporary art, Benson knew that Willem de Kooning lived in the Long Island community. She happily anticipated meeting him when the Rosenbergs invited Benson and her husband, Immanuel, to a dinner party. "Perhaps," Benson says, "the only one the Rosenbergs ever gave and they probably gave that one only because they were strong-armed by Denise and David Hare. And they invited really everybody. Saul Bellow was there, Saul Steinberg, Willem de Kooning without a woman, and, of course Harold and May [Rosenberg]." Benson says that she thought, "Wow, this is how it's going to be to live in East Hampton—really exciting, a lot of intellectual people, a lot of fascinating ideas. But," she laments, "it was never that way again. There were never any more parties like that one. Saul Bellow moved away about that time."

At the dinner party, Elaine Benson found herself seated next to Bill de Kooning, who seemed shy or preoccupied. She initiated conversation, saying, "We're just back from Las Vegas." Bill said, "That's nice. I've always wanted to go to Las Vegas."

"Well," Elaine asked, "why don't you go?"

"You see," he answered slowly and solemnly, "I'm a painter. And the trouble is, if you're a painter, you get up in the morning and you work for awhile. Then you have something to eat. And then you go back to work. You stop and you worry about what you are doing. And you work some more. Then you stop and have something to eat. Then you're tired, so you watch some TV. Then you go to bed, but you worry about what you did in your work that day. So you get up and you work some more. Then you go back to bed, and you worry."

Elaine Benson nodded to Bill her understanding and listened as he concluded his account of how he spent the day.

"So," said Bill, "on what day would I go to Las Vegas?"

Elaine Benson was fascinated, she says, by Bill's "total concentration. It was clear that he didn't like much of anything else very much. He really only liked painting. Nothing else really pleased or amused him, or even distracted him. He was polite—most of the time—but preoccupied."

But when a new girlfriend entered Bill's life, remembers a painter in the Long Island art community, she diverted his attention from painting and persuaded him that he was important, and rich, and famous. She convinced him that he should learn to enjoy himself in the manner of other rich and famous and powerful men. "God knows, Bill may have been drunk but more likely he was just under the spell of the new woman in his life," says the painter. "Anyway, she persuaded Bill that they should spend a weekend at the Plaza Hotel in New York. And that they should enjoy all of the pleasures of the very rich. So Bill put on his one suit and they had themselves chauffeured into New York, where Bill had rented a suite at the Plaza.

"Well," he continues, "Bill had a miserable time. He was fidgeting and pacing. He started drinking his way into one of his benders. He hated everything about the Plaza—the people there, the surroundings, the bathroom, everything. He felt that he was caged, and somehow the victim of a plot to keep him away from his work. Within hours, he left and had himself driven back to his studio. He just didn't like not painting."

Other women also attempted to change Bill's work habits, to lure him into pleasures more consonant with their own interests, or simply to be seen in public with him and to be identified as the latest woman in his life. As in the earlier days at the Cedars, Bill amused himself with women who aspired to the status of his lover, his keeper, his muse, or his salvation, but he continued to disappoint the women who sought to capture him as the ultimate trophy.

MEANWHILE ELAINE...

Elaine knew everyone. And she made you feel very much a part of the bigger world of art. She talked about what other artists were doing, and talked about them and their work as if you—a student—were a part of the whole picture. It was very, very exciting; and she was a great teacher.

—BARBARA SCHWARTZ

Entering the decade of the 1960s, friends on each side of the de Kooning separation marveled that the two alcohol-addicted artists seemed to have survived the accumulated ravages of years of debauchery, let alone that they continued to work as artists. But, whether blessed by indestructible physical constitutions, watched over by sympathetic gods, or merely held on course by their long-standing combinations of psychological compulsion and well-grooved work habits, each artist painted steadily, showed work, and ascended in reputation and influence.

While Bill would continue to live very much as he had in the past, Elaine's life would have to change dramatically, because Bill

had money and Elaine had none. Elaine, alcoholic and unsteady in every aspect of her life, was desperately poor; Bill, by the standards of the art world at that time, was both famous and rich, and he was visibly in the process of getting more famous and richer with each exhibition and each critic's paean to his genius. He needed only to paint; his dealers and the art industries did the rest. Bill's career was, as Elaine said, "just taking off. There was no stopping him. He was at his full power as an artist and simply the most creative person on the scene." Her own career, she recognized, was "not exactly thriving."

Elaine, behind her thinly veiled brave front after the public break with Bill, felt humiliated and hurt by what she considered Bill's rejection of her. For her, the fact was clear: she and Bill—in the eyes of their friends if not by law—were separated and pursuing different paths as people and as artists. Moreover, even as Elaine proudly refused to ask Bill for money, she needed it desperately. When he remembered to offer money to her, Elaine was grateful. "Well, of course," she said, "Bill had his mind on other things. And he just gave money to anyone who was around. He really didn't care about money. And a lot of the time he just didn't think that it was an issue for anyone else either." Money, however, was a very big issue for Elaine.

Unable to count on steady support from Bill, Elaine continually dodged financial disaster by a series of teaching jobs and portrait commissions, including her much heralded commission to paint a portrait of President John Kennedy. In those two areas—teaching and portrait painting—Elaine was at last able to assert her artistic individuality and to be acknowledged as "EdeK" (the signature she adopted for her work), rather than as "Bill's wife, Elaine de Kooning." But the irony did not escape Elaine: "It just never hurt to have that name—de Kooning. And I mean I just never felt that separate from Bill. He was my home base in art. But there are a lot of people who expect the wife to be the home base keeper, and if the wife is an artist, too, then there will be conflicts. And there were."

Despite Elaine's efforts to establish herself as a painter in her own right, she admitted that her career as an artist looked like that of a "wife" or, worse, like that of an "artist's widow." Her talent, though recognized, did not yield paintings with the razzle-dazzle edge that filled Bill's work; and her shows, though respectable, did not elicit enthusiasm from the major critics. In part, Elaine was a victim of the fashion that Bill epitomized. And, in part, she suffered from being a woman in the very macho world of Abstract Expressionism—a world that, ironically, she had labored to construct.

Her first one-person show, in 1956 at the Stable Gallery, called attention to her work but also inevitably invited comparison with Bill's style and imagery. Nevertheless, *Art News* (not, of course, the least biased authority where Elaine was concerned) heralded the show as one of the "ten best" for the year. Moreover, in the year the de Koonings separated, 1957, Elaine's work was included in a group exhibition organized by the Museum of Modern Art, Young American Painters, and in the Pittsburgh International, both prestigious exhibitions. These events contributed more to Elaine's teaching career, however, than to inclusion in bigger and more influential international exhibitions.

In what she regarded as the quintessence of karma, Elaine, without setting out to do so, had prepared herself for university teaching. First, while under Bill's influence and roof, Elaine mastered drawing in the beaux arts tradition; she produced a number of well-organized still life paintings and a series of handsomely rendered portraits. After that apprenticeship with her master, Willem de Kooning, while at Black Mountain College in the summer of 1948, she leapt boldly into the uncharted depths of abstraction and, for ten years, exuberantly explored Abstract Expressionism.

But Elaine was not a purist, and she adapted Abstract Expressionist ideas to fit her changing interests. After the summer in North Carolina, for example, asserting the energy of her brush and manner of seeing, Elaine did something completely unortho-

dox for an Action Painter. She embarked on a series of sports pictures, often based on photographs appearing in newspapers. She emphasized masculine musculature and beauty as well as the movement and grace inherent in athletics, using all of these factors to display her dashing skill with a wet brush.

These boldly drawn and richly colored works won her an invitation to travel, in 1953–54, with the New York Yankees and Baltimore Orioles. "Of course," she laughingly recalled, "I loved every minute of it. I mean, they were just beautiful men, and they moved beautifully, and they were like paintings happening before your eyes. Also," she said, "I liked the challenge of catching likeness and mood and movement quickly. I mean I had to work fast. It was like painting was a sport, too, and I had goals and scores to make. I loved it."

Second, during the time that Elaine worked as a painter, earning a tenured position among the second-generation New York School, she wrote criticism for *Art News*, appearing on the publication's masthead in 1948 as editorial associate. Many artists admired Elaine's reviews for the magazine and regarded her as an excellent critic. Whether written about established artists, young artists, or borderline artists, Elaine's reviews carried a hum of her own values and standards for art and were marked by the fluidity of her vocabulary and the precision of her thinking about art. Although her tastes were broad, she impressed artists because she understood what they were doing and how they worked, describing photographs as "opulent" and ink drawings as "intricate";[1] charcoal and gouache drawings as "luminous, subtly graded . . . and warm-toned";[2] and paintings as "Arp-like shapes, bolstered by stone-like construction lines. . . ."[3]

Elaine's talent melded a solid grounding in traditional skills and techniques, exploratory work in advanced painting of her day, and tough intellectual grappling with the ideas and issues related to art in the twentieth century. As a mature artist, she was uncommonly ready to teach and uniquely qualified to articulate the bridges between idea and action in art. By the time Elaine entered her for-

ties, she was conversant with the ideas and directions of vanguard art, as well as with the historical antecedents in both traditional and experimental art. She painted and she could explain painting, a rare combination of endowments and a near-perfect combination for teaching.

But her drinking habits seemed to condemn her to both poverty and unemployment. "I just never wanted to apply for a job," she said. "I wouldn't even know how to go about it." When in 1958 Robert Mallary, a sculptor she admired, "just mysteriously turned up and offered me this chance to teach in New Mexico," Elaine claimed to be influenced by the "right stars." By her own admission, Elaine accepted Mallary's offer to teach at the University of New Mexico as a means for making money. It is ironic, however, that she soon discovered that teaching gave her a new and often adoring audience of students, fellow professors, and local townspeople who often turned to a provincial college or university for exposure to new ideas and new art. Elaine had found an audience. During the remaining decades of her life, she taught and lectured at institutions of higher learning, small museums, and art groups around the country, gaining a prominence that painting alone did not allot to her.

Elaine admitted that she accepted Mallary's invitation to New Mexico for three reasons: she found Mallary "irresistible" with his enthusiasm and intensity about his sculpture and about teaching; she needed money; and she thought the experience would be "amusing." And, yes, she admitted, it was a good time for her to get away from New York and Bill's circle of influence.

Elaine traveled west for the first time and became the visiting professor of art at the University of New Mexico in Albuquerque. In the oldest section of the city, near a square with shops and restaurants, she found a glass-fronted garage, which she refurbished as a studio. With canvases tacked to walls and her customary litter of paints, brushes, solvents, rags, tin cans, and assorted tools of the painter's trade, she worked on brightly colored landscapes inspired by the New Mexico desert and mountains.

Elaine also quickly became the center of a social whirl fueled by high-octane talk about art, life, and politics and lubricated by high-proof booze. Martinis, her preferred drink at that time, were plentiful, and numerous faculty hosts were eager to serve them to her. In addition to Robert Mallary, Elaine also enjoyed drinking and talking with Blair Boyd, another professor at the university, and his wife, painter Connie Fox.

Elaine's drinking escapades in Albuquerque were widely recounted until they took on the authenticity of legend. It was said that if she arrived at a party early or on time, she would get drunk as quickly as possible; if, on the other hand, she came late, it was because she was already drunk. In either situation, hosts observed, she often had in tow an uninvited student, faculty member, or "very interesting guy" that she had found in a bar near her studio.

Arriving early for one now-famous faculty party, she rapidly consumed several martinis and, explaining to her host that she had not eaten that day and felt "a little tired," asked if she might "just lie down and rest a minute." Shown into the guest bedroom, Elaine flopped onto the bed and fell immediately into a deep sleep. As guests arrived, they tossed their coats onto the bed in the darkened room and she was soon totally concealed beneath a large pile of outer garments.

As the party progressed, other guests drank themselves into states of self-proclaimed intellectual profundity or outright bellicosity. Two men from the faculty, as their ponderous discussion became heated and then hostile, began to fight. Clambering about and falling into furniture, each tried to land a blow on the other, until they stumbled, still punching and clinching, into the room where Elaine slept. Their fight ended abruptly when Elaine rose from under the mound of coats and imperiously commanded, "Please, gentlemen. No fighting."

Elaine always described herself as "a total New Yorker" and had gone west unable to drive an automobile. In that part of the country, however, she soon wanted to learn to drive and to be able to explore the enormous countryside. Three friends later compared

notes, each believing that he or she had taught Elaine to drive, and each prepared to accept a degree of responsibility for having created a dangerous monster-of-the-roadways. Bob Mallary believed that he had taught Elaine to drive, poet Margaret Randall believed that she had risked life and automobile in preparing Elaine for her driver's license examination, and Connie Fox believed that Elaine had learned to drive in her silver Porsche. Each doubtless contributed to Elaine's confidence, if not her skill in driving, an occupation she approached with her customary disdain for regulations. Nonetheless, after passing tests and gaining a valid license, Elaine bought a very-used car and eventually drove it home to New York.

While she was living in Albuquerque, Elaine went with Connie Fox and Margaret Randall to visit the bullfights in Juarez, Mexico, from which she derived a series of paintings based on that blood sport. Connie Fox remembers Elaine's fascination with the "choreography of bullfighting, the color and movement. And, of course, she liked the maleness of it all, too, and was obviously captivated by both matador and bull, these two masculine forces pitted against one another."

Elaine's bullfight pictures, largely abstract, contain allusions to and evocations of the pageantry, sexual force, and movement that she saw in the contests. Startling slashes of blood-red in these pictures punctuate the brush strokes that describe the movement and meeting of bull and man in the dusty Juarez arena. The series now appears as a prelude to Elaine's last works, which are based on the prehistoric animal paintings in the caves of France and Spain.

As a teacher at the University of New Mexico, Elaine's energy and fresh point of view impelled students to a new boldness in their work. Fox remembers that "all of a sudden, after Elaine had been there for only a week or so, the students were using larger brushes, working on bigger canvases, and painting more vigorously than they had been. Their colors got brighter; their work got more daring. Everyone was excited by her presence, her ideas, her example of what an artist was about and who an artist was. She

was like a vision to many of the students, a radiant vision of art."

Recalling that first experience in the university classroom, Elaine said, "Teaching was a godsend. I needed the money, and I liked teaching. I always thought of it as a kind of shop talk among friends."

Later, in 1960, as visiting professor at Pennsylvania State University, she refined her style of teaching, charmed her students, and added friends to her life. By then she had learned the ways of the academic world and, realizing that visiting professors possess star status, insisted that her teaching be restricted to only one or two days a week. She also insisted that the host college or university provide a studio for her where, using whatever materials she could afford or find, she could work steadily.

By 1961, when her work was included in the Whitney annual, Elaine was recognized within the New York art community as a painter. Moreover, she was known to be one of the few contemporary artists who painted portraits. Unlike the smooth-skinned, mellow-toned academic portraits—their measure taken by their resemblance to a studio photograph—her portraits captured both likeness and psychological coloration with her dashing, fluid Abstract Expressionist brush. She described her approach to portraiture in this way:

> I can see someone and say that I'm going to paint them—but it's impossible to say that I'm going to paint that person just the way that I see them, because while I look at a person, I'm not just seeing that person at that moment, but all kinds of possibilities. If someone is wearing a lavender sweater and blue pants, for instance, I might just see the portrait as colors. But I could also see it in terms of contour, black and white and gray. So the actual looking is already an infinite thing. I mean, lunacy can be seeing too much; sanity is to limit what you see.

While Elaine thoroughly understood and even accepted some aspects of the traditional concept of portraiture, and while she

considered capturing a degree of verisimilitude to be a challenge, she was a painter as opposed to a portrait painter. With that distinction, she assigned to portrait painters the process of mirroring for sitters their images of themselves, or of treating portraiture as ornamentation for the tasteful home. She thought of herself as a painter who chose to use portraits as "a jumping-off place," and she aimed to mine the contours, colors, and volumes of a sitter for the ingredients of a painting.

She liked to tell a story about her portrait of Harold Rosenberg. A potential buyer was "absolutely mad about [the] painting" but decided not to buy it after his wife objected, saying, "The last thing I want is Harold Rosenberg hanging in our apartment and watching everything we do."

Even when she worked on commission, Elaine believed the painting was hers and that she as an artist held all moral and aesthetic rights to its content, appearance, and state of finish. A few clients, rankled by what they considered her arrogance, objected to her images of themselves. A dentist, for example, after numerous long and tedious sittings, looked at Elaine's portrait of him and, shaking his head, said, "You make me look like a creep."

Elaine, her arms folded across her breast, exhaled cigarette smoke and said, "Well?"

"I had worked on the painting for a year," she recalled, "and I found him very difficult, and that's why I began to brutalize him in the painting."

In 1962, Elaine accepted a commission to paint a portrait of President John F. Kennedy. She became so fascinated with her subject that she produced scores of paintings and drawings of him. Excited about the important commission, she and her assistant, Eddie Johnson, traveled to West Palm Beach, where a studio had been established for her in an old theater. Having been chosen in part because of her ability to work quickly and under unusual circumstances, Elaine knew that she was to sketch the youthful Jack Kennedy as he went about his daily routine, and that she was not to require or expect long periods of posing. Each

day, after sketching her subject, she bundled the charcoal drawings off to the studio and began the process of laying out on canvas the drawings that she would work into completed portraits. She made hundreds of drawings, catching various aspects of the handsome, often animated, president—head studies, elongated full-length figure drawings, and a large collection of seated figures.

Prior to undertaking the commission, Elaine had supported Kennedy strongly, and she believed that he would change the country and the world. As she observed him in West Palm Beach, chatting with him and sketching him in myriad informal poses, she was fascinated by him—by his handsomeness, his humor and courtliness, and his mildly flirtatious bantering with her. When she returned to New York, Elaine surrounded herself with sketches and in-process paintings of John Kennedy, working exclusively on the evolving images. His presence literally surrounded her, and she thought of little else as she painted standing and sitting portraits, full-face and three-quarter poses of the president's head. She seemed slightly surprised when she realized that a growing army of presidential portraits covered every space in her large studio. As images of the man and president filled her studio and her vision of him as hero took hold of her imagination, she felt close to him.

"Any one of the Kennedy portraits that I did," she told students, "I could do again because I had to be so conscious about them. I could not work on them the same way, let's say, that I would work on a picture of a friend. When I have a friend to paint, I just say, well, come tomorrow and I'll paint your portrait. But the Kennedy portrait, I had to sketch from him. I had to go to this theater and work from the sketches, which is not generally my way of working. I generally work directly from a subject. And to paint from drawings became a whole different problem; and I had to be much more conscious; every stroke had to be conscious."

The project consumed her consciousness, and Elaine talked incessantly about Kennedy, telling over and over stories of sketching him, describing how he looked in sailing clothes, and combin-

ing fact with her own opinions (or wishes) as she speculated on what he would do to right wrongs in the world, change the lot of suffering peoples, and put to rout (her) enemies. In capturing his image, moreover, Elaine felt that she had captured an essential truth about the man; she believed that she knew him well, and she felt possessive. "Yes," she admitted, "I was a teeny little bit in love with him. In love with his mind, in love with the whole idea of such a gallant, intelligent, handsome man leading the country and the world. It really was like Camelot. I was proud of him, and proud to be working on his portrait."

When Kennedy was assassinated on November 22, 1963, Elaine quit painting for a year.

"I was just unable to go on," she said. "I couldn't believe it. I still can't believe it. I felt that I lost a brother or a lover. I felt shock and grief, and I still don't believe it happened. I can't believe that gunshots obliterated that brain, that personality, that energy. I was crushed. It was a personal loss."

Later, according to Elaine, Jackie Kennedy asked to visit her studio to look at the paintings and drawings. The president's widow had purchased several of the drawings from an exhibition at the Graham Gallery and wanted to see if there were others she might like to add to her collection. "She came in to the studio," Elaine said, "with an attitude of, well, here I am and I can have what I want. And I didn't like that. And then she looked at the charcoal drawings, and she looked especially at two of them showing Kennedy in dark glasses, seated with one leg thrown over the arm of a beach chair." Elaine laughed. "Well, of course, there was the presidential crotch, right at the center of the drawings. So, when Jackie said she wanted those pictures, I just said, no, they're mine. And then she said, 'Well, they make him look like a fag on the Riviera.' And I said, 'They look good to me.' And I knew right then that I would just never let her have my pictures of Jack Kennedy."

After a year of not painting, and of more than usual drinking, Elaine accepted an invitation to teach at the University of Califor-

nia at Davis. There she visited a foundry set up by a faculty member, saw flat sheets of wax, and was "hooked immediately. I picked one up and it was absolutely like a painter's medium. Because if you pick up a flat sheet of wax and begin to turn it and manipulate it—and it was kind of like maybe a three-dimensional collage. So for an entire year, I did no painting whatsoever. I just lived at that foundry and made thirteen pieces of sculpture. And if I had stayed on I would have been working with sculpture still, because it really hooked me."

In the next decade Elaine taught at Yale University, Pratt Institute, Carnegie Mellon University, Wagner College, the University of Pennsylvania, Parsons School of Design, Brandeis University, Cooper Union, and the University of Georgia, where she was the first person to hold the Lamarr Dodd Chair of Art. She was awarded honorary doctorates by Western College (Oxford, Ohio) and Moore College of Art (Philadelphia). And she accepted hundreds of invitations to judge exhibitions, to lecture, and to teach workshops in painting.

Even with notable success as a teacher and lecturer, Elaine needed money from the sale of paintings. But unlike Bill's paintings, Elaine's work excited little luster in the public eye and earned her almost no lucre. Moreover, without the protective eye and sheltering wing of a strong dealer, and often still dismissed as "de Kooning's cast-off wife," Elaine could count on few sales. "After all," argues a friend, "no one really admitted then Elaine's role in establishing Bill. Bill was *it;* Elaine was his wife. That's how the world is organized. And when they were no longer seen as man and wife, well, Bill was the important one. Elaine was left to fend for herself. She had a tough time of it, too."

During these decades of poverty after her separation from Bill, Elaine had resuscitated her skills as scrounger. She avoided bill collectors and landlords, and she was grateful for money donated by Bill or by friends, as well as for money that she was able to earn. "I wouldn't say that Elaine ever turned tricks," speculates a poet. "She was too classy, too fastidious for that kind of exchange of sex-

ual favors for money. But let's say, however, that she did appreci-
ate gifts from men. There was a small step between accepting
favors from Tom and Harold and accepting money from other
men with whom she was physically intimate.

"And remember," continued the poet, "Elaine had strong pro-
tective feelings about prostitutes—stronger, I think, than even
her brand of liberal politics would require. She read in one of the
tabloids that some cops had busted some very young hookers on
Tenth Avenue. She was just incensed. She was enraged. She said
over and over, 'How can they do that? It belongs to those girls and
it's all they have to sell and it's their business. Their business.'"

Many of Elaine's friends—men and women—recognized the
severity of her poverty and helped with gifts of meals or money.
As she took into her bed men who delivered booze or groceries,
who did her income tax, who patrolled her street, or who were
her students, she also took their help—whether money or help in
the studio or gifts—with both amusement and gratitude.

Regardless of the tactics by which she earned money and of the
drinking that often threatened her safety, Elaine painted and
drew continuously. Comfortable with a bohemian life-style, she
good-naturedly lived with little income and few comforts. Invita-
tions to meals were welcomed, as were free drinks at bars or a gift
bottle of booze brought to her studio by a visitor. Though she was
a craftsmanly painter by training and by disposition, Elaine was
forced by poverty to work with shoddy materials, to make her
stretcher frames from cheap lumber destined to warp, to use
hardware-store bargain-bin paints instead of the fine oils she
loved, and to find ways of turning assorted materials into the stuff
of art. She was, as she often laughingly told friends, "stony broke."

When Aladar Marberger, one of Elaine's students at Carnegie
Mellon, took her advice and moved to New York to become an art
dealer, he stayed a while with her in her studio loft. He confessed
his concern to a mutual friend: "I can't stand it. Elaine is so god-
damned poor and Bill is so fucking rich. He damn well owes her
something for all that she did for him. Has he no conscience?"

Aladar observed that Elaine "had to scratch up a living. She has nothing she can count on." And he promised, "I'm going to be her dealer, and I'm going to take care of her."

Before Aladar made good on his promise by becoming Elaine's dealer at the Fischbach Gallery, however, she was often too poor to endow each painting with its own stretcher frame. When she finished work on a stretched canvas, she removed it from its stretcher and rolled it face out—to prevent breaking the surface of the dried paint—around one of several cylinders that were designed to contain rugs and carpeting. One morning, she noticed the cluster of vertical columns of stored paintings around her loft on Broadway, liked what she saw, and set out immediately to collect more rug cylinders for use as surfaces for direct columnar paintings.

"I just always knew," she said, "that good ideas came from mysterious causes. I mean if I hadn't been poor, I wouldn't have rolled up those paintings and just immediately seen that painted columns could be very, very interesting. I mean, talk about plasticity and about the movement of color in space. Well, it was just meant to be, that's all."

In short order, an army of brightly colored columns stood at attention in Elaine's high-ceilinged studio. Spellbound by the technical and compositional problems of painting on the tall hollow shafts of thick pulpy gray paper, she applied gesso to the surfaces and then, with a series of interweaving and overlapping brush strokes of vividly contrasting liquid paints, she created "paintings in the round. I mean," she explained, "these are paintings that have no horizontal edges, and because they are so much taller than human beings, they seem to have no bottoms and no tops. You just meet them at eye level, in the middle, and walk around or among them. It's the same experience that you have when you walk down a street in New York—all those blurred movements of color, and half-glimpsed personalities. Well, I could just do these forever."

Elaine, fascinated by the idea of the cylinders, completed enough to show them at the Graham Gallery in New York. They

engendered less interest, however, than she had hoped. "No one," she said, "I mean *no one* was ready to look at them seriously. There are these conflicting ideas about works of art that are not standard—like paintings or sculpture or prints, forms that are known and understood by just everybody. The unconventional works are somehow regarded as trivial or, if truly trivial, they seem to be regarded as *avant-garde*. Part of this comes from critics just being lazy: they don't like to do the hard work necessary to really look and really understand art. New art. And they like to create only controversy that they can control. That is, they like to write that something is difficult when it is not, and then, as if they are the only ones smart enough to interpret or explain that difficulty, they write these dense, meaningless reviews. And artists turn to each other for understanding of what they do. That's one of the reasons I've always liked teaching. I like the community, the brotherhood and sisterhood of people working together and talking about what they do."

Elaine enjoyed little critical praise of her work, and even among artists and friends she received mixed reviews as a painter. Some found her "too facile"; others thought she had been "too influenced by Bill." Outside the small and tightly intertwined New York art world, however, on college campuses, in museums, and in galleries where she showed her work, Elaine was encouraged to think of herself as a major spokesperson for Abstract Expressionism. Her earlier articles in *Art News* had attracted a significant following on college campuses and were often required reading for courses in contemporary art. And, away from New York, in other parts of the country, as Elaine herself noted, "the name *de Kooning* was just magic."

Loyal to Bill even though separated from him and stalwart in her adherence to the gospel of Action Painting, Elaine preached to the students and people interested in art in almost every part of the United States. As she kept her dates across the land, she prepared for her public appearances as if for a political campaign. She costumed and made herself up skillfully, taking the lectern or

entering a classroom in stylish clothing calculated to catch and hold attention; she managed to look casually artistic and tastefully eccentric, thus pleasing most of her audience most of the time. Fond of long, flowing silk overblouses and slim-legged trousers, she often resembled an exotic dancer or Eastern noblewoman who unaccountably wore funky, often very high-heeled shoes. People looked at her, and they paid attention to what she said.

In her various public appearances, Elaine was a natural performer, a voluble conversationalist, and an enthusiastic proselytizer for Abstract Expressionism, for her artist friends, and for Willem de Kooning. She praised (and sometimes flattered) artists who felt themselves trapped in the outback of academe, as well as students who dreamed of stardom in New York. Always gregarious, she invited people wherever she traveled to visit her in New York. And they did.

As artists, collectors, and museum people came from other parts of the country to New York, they craved Elaine's company in seeing the latest exhibitions or visiting other artists. "She became everybody's network into the world outside New York," jokes one artist. "You'd be broke. And even though Elaine was just as broke, she'd cause some collector from Kansas or Texas or Missouri or someplace to buy one of your paintings. She did that for a lot of us. She was generous, but she also had the firm conviction that it was the *right* thing to do, that artists ought to help one another."

Throughout the sixties, Elaine cultivated particular people and places where she could always expect to make a sale or, as she said, "get a gig for a workshop or a slide lecture or a commission." Texas was such a resource for Elaine. And Texas—the actual place on the map as well as an idea about America-in-its-natural-condition—fascinated her. "I love Texans," she would say. "They just do everything in a natural and big way. An easy way. They drink big and drive fast in big cars. I think it has to do with all of that space, and all of that frontier energy that's still there. In Texas, everything is possible. And Texans are open to new ideas and to art. New things just make sense to Texans."

One particular tall Texan became Elaine's personal conduit to the Texas resources. Described by some as a "flim-flam artist for art" and by others as "a sort of holy-roller preacher who wanted to save souls by bringing them to the truth of art," Dord Fitz, according to painter Connie Fox, "showed up on the scene when Elaine came to Albuquerque." Fitz invited Elaine to Texas to give a lecture and a workshop. He was, says Fox, "like a circuit-rider of art. He adopted the manner of a hell-raising preacher, and would take Elaine's show on the road to a bunch of little towns in Texas and talk to them about art. He made money for himself and for Elaine."

Fox explained, "Fitz preached the message to his congregations: You go out. You spread the word. Promote the cause of art. If everybody in the room goes out and brings in five more, the word will spread. He was a revivalist for art. And then he brought in a medium—Elaine—to work the crowd. He often brought rich Texans to New York and he got portrait commissions in Texas for Elaine."

Fitz, who wore a wig and looked very trim, often drove to New York from Texas in his big car, a feat that further convinced Elaine of his energy and power. Although, as Fox says, "he was the kind of guy you wouldn't want to buy a used car from," he bought major works of art for collections in Texas, handling large sums of other people's money in the process.

Elaine recounted Fitz's caper with a sculpture by Louise Nevelson that he purchased from the artist for a client in Texas. The large black wooden work arrived in pieces, seriously damaged in transit. Fitz, according to Elaine, collected the insurance for the damages, then put the piece back together and collected the sale price from the client. This instance of beating the system proved to Elaine that he was both clever and "my kind of guy. I mean, he just understands how things work and he knows how to get things done. He can just get whatever he wants without upsetting the system."

Fox recalls, "One time, I picked Elaine up at the airport and

[Fitz] had paid her in cash. She had a shoe box full of five-dollar bills. He'd collected money from whoever was in those meetings in those little Texas towns. That's how they paid him; so he paid Elaine the same way."

When Elaine needed money, she telephoned Fitz. As soon as he arranged a tour for her, she flew to Texas for a week or so, charmed audiences and, as she said, "made just a lot of money. Real money. I mean, I could almost live on what I could make in Texas."

By the end of the sixties, Elaine's alcoholism and addiction to cigarettes were taking a visible toll on her health. She coughed violently, sometimes gasping for breath and unable to talk for several minutes. When friends expressed concern, she brushed their remarks aside with intended reassurances: "Oh," she said, popping several pills, "I've just learned that if you take vitamin C, there is absolutely no danger in smoking. So now I just take a pill every time I have a cigarette." She told other friends that she had been checked by one doctor who told her that her "lungs were like an athlete's lungs" and by another who suspected she "had an allergy that causes coughing."

Nonetheless, she periodically decided to quit smoking and, over several years, tried artificial cigarettes, which allowed her to keep her familiar mannerisms but not inhale nicotine. She also submitted to Smoke-enders, hypnosis, therapy, and pills. The addiction, however, had burrowed into her marrow.

Barbara Schwartz, a student from Carnegie Mellon who became a close friend, recalls one of Elaine's efforts to stop smoking. Barbara, Aladar Marberger, and Elaine were on a trip, driving through "the great clean air [of the Pacific Northwest]. And," according to Barbara, "Elaine would say every ten minutes, 'Well, I'm quitting smoking.' She made it through the one day. It was hideous. By the end of the day we were trying to get her to smoke."

Elaine's devotion to cigarettes, Barbara believes, was "a really terrible addiction. Much more than psychological. She used to spend the night at my house [when she taught at Carnegie Mellon]

and I spent the night at her studio in New York. And she coughed all night. Aladar and I would roll our eyes and say, 'Well we're going to have to take Mother [their pet name for Elaine] to the hospital for that cough.'"

Barbara believes that Elaine depended on cigarettes for all of her gestures, "for all of her conversation. That's what it was about, her smoking, but it just got control of her. And she connected it with painting. Just moving her arm, pausing to smoke. It was essential to painting."

As Aladar and Barbara shared one of Elaine's efforts to stop smoking, they both noticed that she glanced at her watch frequently and that she was agitated and testy. After a few hours Barbara thought the two friends should encourage Elaine to continue her abstinence, and that they should compliment her on not smoking all morning. But Aladar, who had already accommodated a few of Elaine's verbal barbs, thought it best not to remind Elaine of her problem. "No," he told Barbara, "don't bring it up to her because she'll be like a squirrel in a cage."

Barbara and Aladar were typical of Elaine's students who became her fast friends. Aladar, even as a student hip to the latest turn of the New York art world, announced to Barbara, "Elaine de Kooning is coming here to teach! Wow!" Barbara, then only vaguely aware of the de Kooning name, admitted that she really didn't know very much about Elaine de Kooning. Aladar, Barbara remembers, "had done his homework. And he filled me in. And filled me in some more. He was really excited. He said that we had a great opportunity, that Elaine was connected to everybody in the art world, that she was our entrée to New York."

The two students and the older New York artist became friends very quickly. When Elaine stayed over in Pittsburgh, the threesome went out for dinner and "many, many drinks," Barbara remembers. "Once," she said of a typical evening, "Elaine and Aladar got to drinking—I didn't drink much—and they had *twenty* drinks apiece. They thought that was a riot, and they talked about it for days after."

In previous decades, other friends joked or expressed envy and awe at Elaine's ability to "drink all night and never, never have a hangover. I mean," Sherman Drexler recalls, "she just never suffered for her excesses. Other people—normal people—would be moaning and throwing up and dying, but Elaine had an iron constitution and an iron will. She'd drink more than anyone, be so drunk she couldn't stand up, and the next morning she just got up and was ready to take on the day."

But toward the end of the sixties, Barbara observed that "Elaine would sometimes just be miserable."

THE ONCE AND
FUTURE KINGDOM

THE FRAGILE HARMONY: TOGETHER AGAIN

Bill was always home base.

—ELAINE DE KOONING

When Elaine and Bill reconciled in 1976, many friends smiled and talked about "the love affair of the century." Several cast-aside lovers talked about "suicidal tendencies." And gossips who maintained the money-watch in the art world wondered who would profit from the reconciliation.

"Of course," says Rudy Burckhardt, "Bill and Elaine never got divorced. That way Bill didn't have to marry anyone else—including the mother of his daughter."

Another friend says, "Elaine would never have considered divorce. I don't think it was so much that she had been reared a Catholic—though that may have had something to do with it—but that marriage, for her, was final. Bill was the complete center of

her life as an artist. He was her master in that sense—her teacher, her *god*."

For close to twenty years, Elaine and Bill had gone separate ways. She, despite poverty and alcoholic squalor, painted in New York; Bill, always at war with depression and drink, moved to Long Island. While both careers had prospered, his far more than hers, neither Bill nor Elaine faced a long or happy future.

By the time Willem de Kooning moved to Long Island in the early sixties, he reigned above the pop-art contenders spawned by his work. And, despite the changing fashions and fads of art-biz, he was the acknowledged king. Bill's reputation preceded his actual move to the Hamptons, where he was immediately a star in a celebrity-conscious society. A hostess's trophy, like rock stars or strutting corporate-takeover slicksters, he was invited to the swellest parties in the grandest houses of the community. Known to accept few invitations, Bill's appearance on the scene could send a charge through gatherings of Beautiful People. Among the Brie-and-cherry-tomato set of the Hamptons, Bill was a very popular guest, whose mere appearance racked up points for his hostess. The highest level of gossip fallout, however, radiated from outrageous behavior by "the greatest living American painter."

Called by social hypesters "the American Picasso," Bill usually arrived in his artist's uniform—paint-spattered shoes and some slightly neatened variation of the workmen's clothes he wore in his studio. Once Bill appeared, the routine varied only slightly from party to party: his hostess took him by the arm to display him (along with her jewels, capped teeth, and designer labels) to the other guests, taking special care to see that *Mister* de Kooning was given drinks, that the drinks were replenished efficiently, and that liquid in his glass never grew too watery.

Among the blasé revelers, Bill's amusing acts fell into two categories: he either raised uproarious hell or he dropped out. No one could reckon which tack the master would take, or where the winds would blow the party after he commenced to perform. When he appeared at a party, however, excitement was assured.

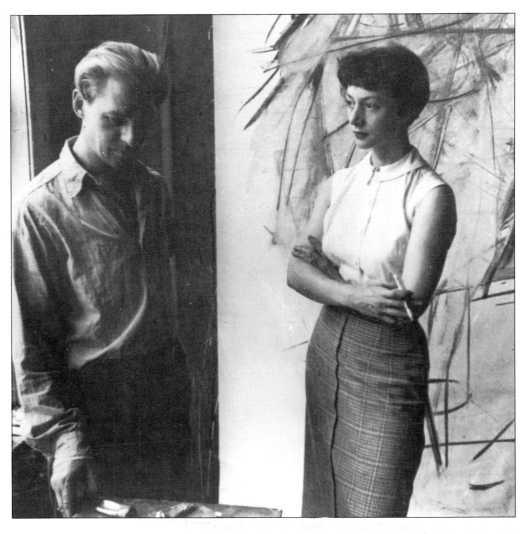

Elaine and Bill in their New York studio, early 1950s. (RUDOLPH BURCKHARDT)

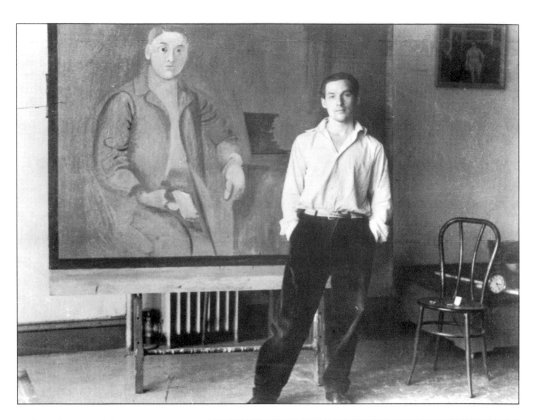

Bill with one of the series of male figures he painted in the 1930s, many of which resembled his neighbor, poet and critic Edwin Denby.

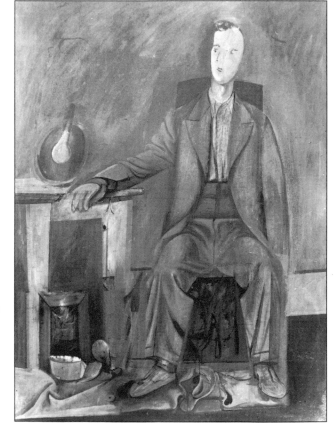

Bill's late 1930s portrait of Rudy Burckhardt, a striking likeness despite the sparsely defined facial features, also reflects the artist's fascination with composition and texture.

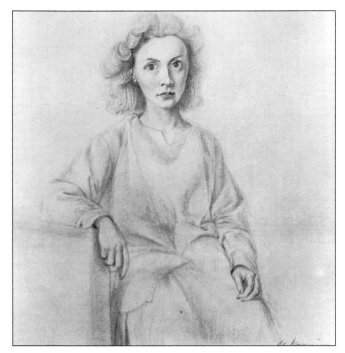

Bill's academic art training is evident in this early drawing of Elaine, in which meticulous attention to shading and detail combines in a powerful likeness.

(RUDOLPH BURCKHARDT)

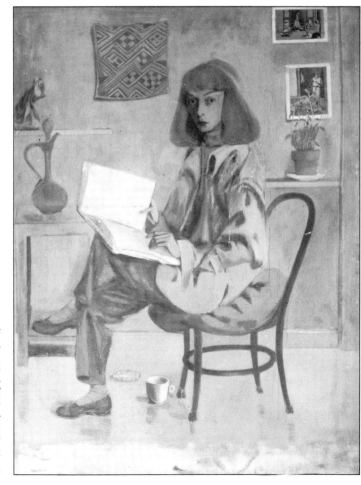

This 1947 self-portrait by Elaine shows her characteristic liquid brush strokes playing between large simplified areas and meticulously defined and painted details. (COURTESY OF THE ESTATE OF ELAINE DE KOONING)

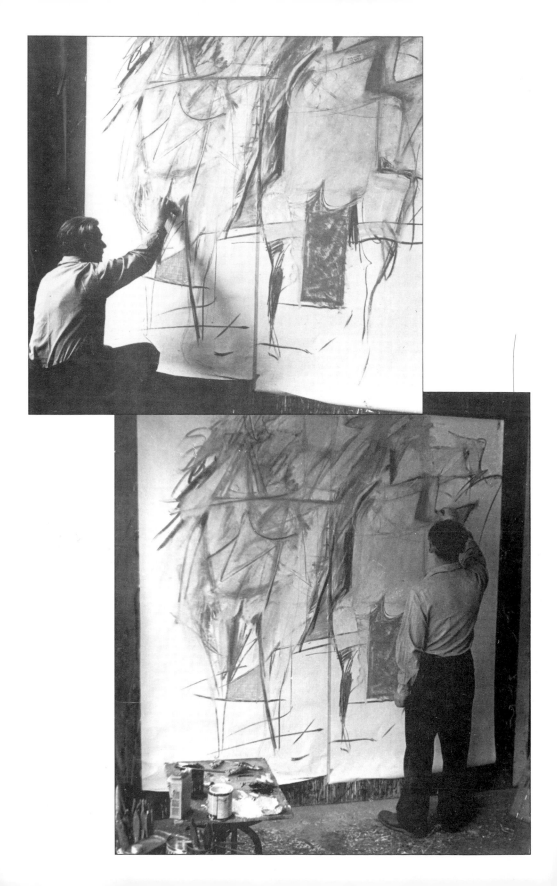

Shots from the Rudolph Burckhardt series of photographs that accompanied Tom Hess's seminal 1952 article for *Art News*, "de Kooning Paints a Picture." Capturing Bill during the slow, methodical evolution of *Woman I*, Hess's article helped catapult de Kooning to art-world eminence. (RUDOLPH BURCKHARDT)

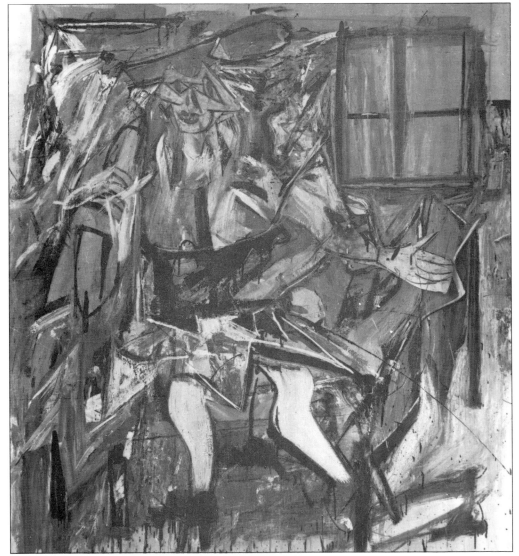

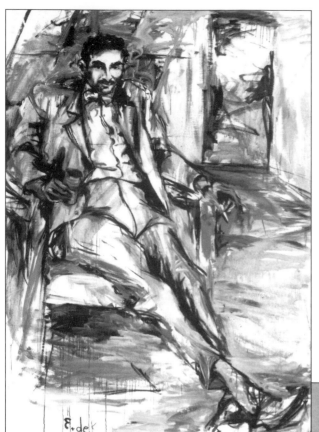

Portrait of Harold Rosenberg by
Elaine de Kooning, 1952.
(COURTESY OF THE ESTATE OF
ELAINE DE KOONING)

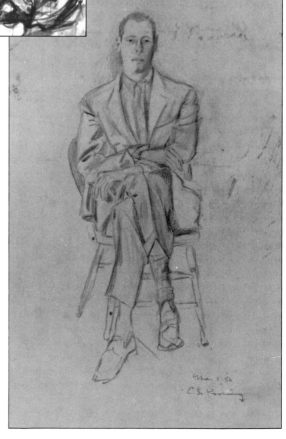

Pencil drawing of Tom Hess
by Elaine de Kooning, 1956.
(COURTESY OF THE ESTATE OF
ELAINE DE KOONING)

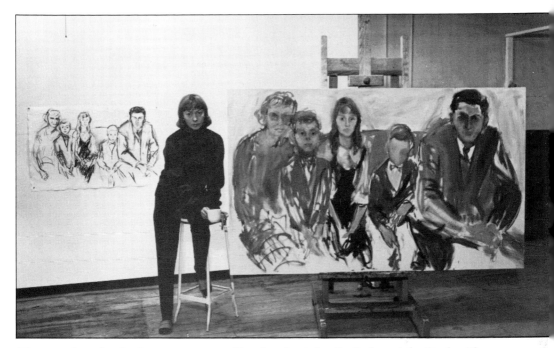

Elaine with unfinished group portrait of her brother's family. *Left to right:* Paula, Clay, Maud, Goy, and Peter Fried. (COURTESY OF THE ESTATE OF ELAINE DE KOONING)

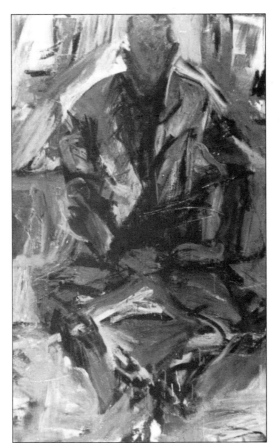

Portrait of Bill by Elaine, 1956.
(COURTESY OF THE ESTATE OF ELAINE DE KOONING)

Grace Hartigan, late 1950s.

(JOHN GRUEN)

Jackson Pollock and Lee Krasner, 1950.

(RUDOLPH BURCKHARDT)

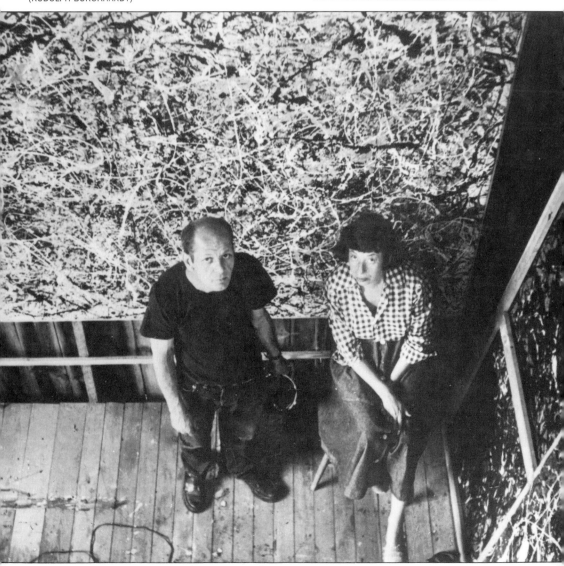

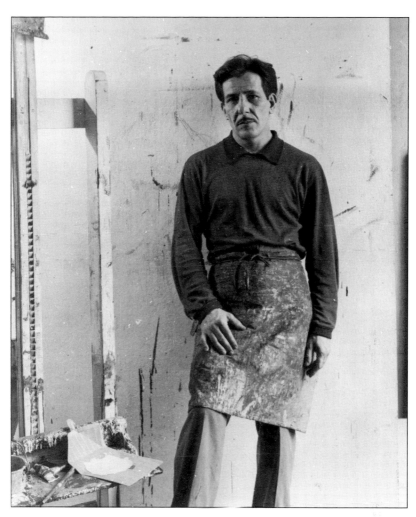

Franz Kline, 1947.
(RUDOLPH BURCKHARDT)

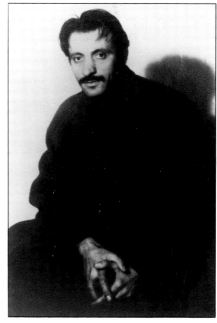

Arshile Gorky, early 1930s.

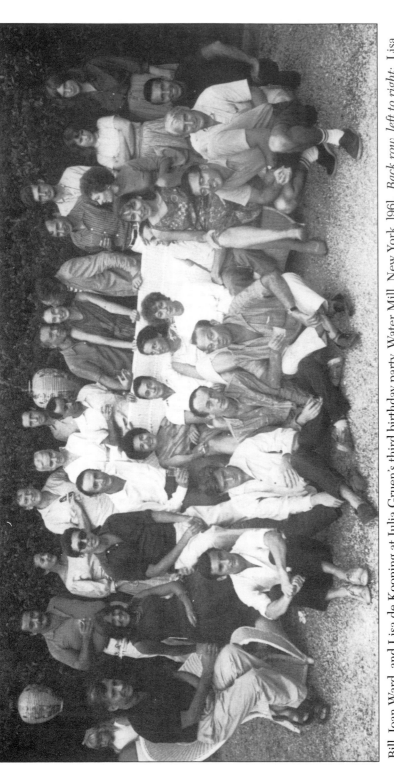

Bill, Joan Ward, and Lisa de Kooning at Julia Gruen's third birthday party, Water Mill, New York, 1961. *Back row, left to right:* Lisa de Kooning, film director Frank Perry and his wife, scriptwriter Eleanor Perry, John Myers, Anne Porter, Fairfield Porter, interior designer Angelo Torricini, pianist Arthur Gold, Jane Wilson, poet Kenward Elmslie, painter Paul Brach, Jerry Porter (behind Brach), Nancy Ward, Katherine Porter, friend of Jerry Porter. *Second row, left to right:* Joe Hazan, Clarice Rivers, Kenneth Koch, Larry Rivers. *Seated on couch:* Miriam Shapiro (Brach), pianist Robert Fizdale, Jane Freilicher, Joan Ward, John Kacere, Sylvia Maizell. *Kneeling on the right, back to front:* Alvin Novak, Bill de Kooning, Jim Tommaney. *Front row, left to right:* Stephen Rivers, William Berkson, Frank O'Hara, Herbert Machiz. (JOHN GRUEN)

Bill and Ruth Kligman, 1959.

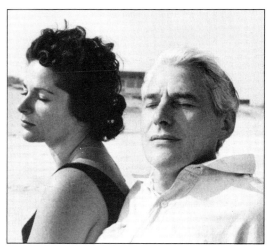

Bill, Water Mill,
New York, l959.

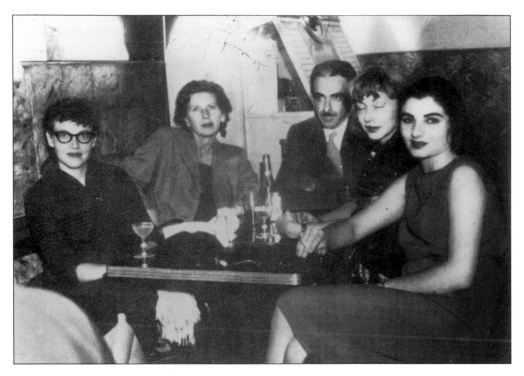

Elaine with friends in Juarez, Mexico, during her teaching stint at the University of New Mexico, late 1950s. *Left to right*: Connie Fox, Jane Goldman, Herbert Goldman, Elaine, Margaret Randall. (COURTESY OF CONNIE FOX)

Elaine in New York at the beginning of her official separation from Bill, 1957.
(JOHN GRUEN)

Elaine in Palm Beach, beginning her famous series of John F. Kennedy portraits, 1963.
(COURTESY OF THE ESTATE OF ELAINE DE KOONING)

Elaine with Kennedy portrait, 1964.
(AP/WIDE WORLD PHOTOS)

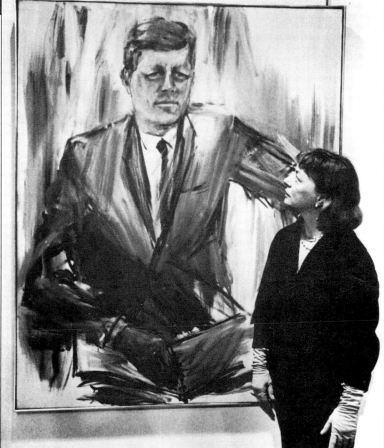

Bill returned to the
Netherlands for a
triumphant exhibit in
Amsterdam, 1968.
(AP/WIDE WORLD PHOTOS)

Opposite, near right:
During the last days of her
life, Elaine asked to have
her painting of her sister,
Marjorie Luyckx, mounted
in her view. (COURTESY OF THE
ESTATE OF ELAINE DE KOONING)

Opposite, far right:
Elaine de Kooning's
portrait of the author.
(COURTESY OF THE ESTATE OF
ELAINE DE KOONING)

Printmaking session in Bill's studio, 1981. *Left to right*: Bill, Conrad Fried (Elaine's
brother), printmaker Dan Welden, studio assistant Tom Ferrara. (CONNIE FOX)

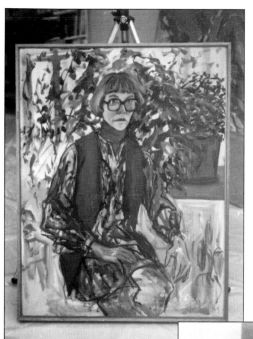

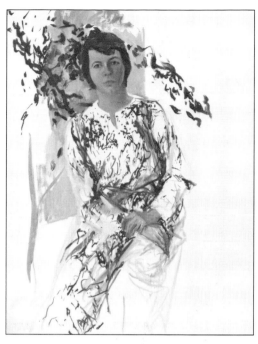

Friends surrounded Elaine. Painter Connie Fox (*left*), former student and art dealer Aladar Marberger (*seated, middle*), and artist and former student Barbara Schwartz (*standing*) joined Elaine and her beloved dog, Deidre, in her home in The Springs. (COURTESY OF BARBARA SCHWARTZ)

Elaine and Bill, 1980s. (JOANNE LOWENTHAL)

And so, almost on cue, Bill did his number. Did you hear, asked the Monday-morning party-planners, that he slapped a hostess, took a punch at a host, made a pass at someone's underage daughter, threw a chair through a window, peed in the swimming pool, turned over the buffet table, insulted X or Y or Z? Small events, reported and embellished and passed along the gossip network, became annotations in the established de Kooning hagiography.

Other stories, too, circulated about Bill's drunkenness, and about his danger to himself. He had never learned to drive, and when he moved to Long Island he enjoyed riding his bicycle over the flat country roads of his shore community. On several occasions when he had been drinking, he swerved in front of oncoming cars. Fortunately, the drivers managed to avoid collisions, but Bill's friends, hearing of his near-accidents, worried about his safety. They worried even more when they heard that, drunk, he had fallen from his bike and spent hours in a stupor in a ditch beside the road. What if the temperature had been colder? What if he hadn't been found when he was? What if . . .

But Bill, drunk or sober, was not interested in the stories that people told about him or what people thought of him. He was interested in his work when he was sober; the rest of the time he was busy drinking. Now as much at the mercy of his own craving for alcohol as under the sway of his obsession with painting, Bill found others of like mind and never wanted for willing companions for his binges. He did not have to go to parties to find a congenial drinker. He could enjoy his own friends in his own way. He was famous. He was rich. And he was a good-buddy drunk, one of the guys. Artists with less work to do and lesser reputations to maintain knew that a bottle of booze admitted them to Bill's presence, and soon there was a steady stream of guys-with-bottles—mostly de Kooning wannabes, often affecting the de Kooning style of dress and his manner of painting—at the door of the studio on Long Island. "Yah, yah, come in," Bill answered their greetings. "Yah, yah, a drink would be nice."

And so another binge would begin. Soon another artist buddy

would appear with another bottle. If someone thought about it, and if someone made sandwiches or cooked, the drinkers ate. If everyone forgot food, that was all right, too. They talked and drank until, one by one, they passed out. One of Bill's studio assistants from that period recalled:

It was like this. Bill liked to drink. He talked better when he drank. And he was lonely, I guess, and enjoyed the company of other artists. So, sure, they did what they had always done. They drank. They got drunk. They talked and argued and sometimes fought. The difference was money. Now Bill had enough money to have anything he wanted, and that included many, many bottles of scotch.

One of Bill's favorite fellow drinkers was a naive artist who lived on Accabonac Road, a man described by Elaine Benson as "an Appalachian sort of fellow who carved tree trunks into primitive sculpture. Bill loved the man, and loved his wife. From time to time, Bill and the naive sculptor would go on a drinking binge together." On one such occasion, the sculptor's wife summoned a doctor. The sculptor had passed out, and Bill was sick and needed help. Fast, the wife said. The doctor sped to the house on Accabonac Road.

Bill, after several days and nights of drinking, sat shivering and gasping on the edge of his friend's sofa, gripped by delirium tremens. He was terrified. His face stubbled by several days' worth of beard, his clothing soiled, his hands and voice trembling, Bill summoned enough energy and control to attempt to hide his condition from the doctor. On several previous benders, Bill had drunk himself into a state requiring medical attention and, to his horror, hospitalization. Now, as his body shook and as he sweated, he desperately wanted to impress upon the young doctor his ability to function. He wanted to avoid the hospital by whatever ruse he could muster.

The doctor asked Bill, "How are you?"

Bill shakily assured him, "Fine. I'm fine."

While the doctor was trying to determine the seriousness of Bill's plight and Bill was trying to hide the severity of his situation from this new doctor who posed a definite threat to him, a mouse scuttled across the floor, crossing the peripheral vision of both men. The doctor noticed that Bill concentrated on appearing not to see the mouse.

"Did you see anything?" the doctor asked Bill.

"No," Bill said. "No. I didn't see anything."

Then the doctor smiled and said, "Well, *I* saw a mouse run across the floor."

Bill smiled sheepishly and said, "Yah, me too."

They both laughed, and Bill, knowing when he had been bested in a psychological skirmish, submitted to the doctor's care.

Bill entered the hospital, where once again he received treatment for alcohol poisoning. Bill's aging system could no longer withstand the punishment of his life-style. In addition to life-threatening alcoholism, he had hardening of the arteries and high blood pressure. Although he still appeared to friends to be strong and energetic when he was sober, Bill could sustain, said his doctors, very little further alcoholic abuse. He needed care. He needed help in maintaining his life.

Who would help Bill?

As always, women vied for that distinction, some motivated by pity or affection, but some also seeking personal gain. One in particular made the biggest inroads into Bill's life and his fortune. "Elizabeth" (for purposes of this narrative) worked hard to convince the world that she was de Kooning's intimate friend, nurse, secretary, business manager, dealer, and publicity flack; that she was a surrogate wife to Bill and mother to teenage Lisa; that she was indispensable to his life, work, and household. Elizabeth, described as a "former Madison Avenue executive" offended many of Bill's old friends by "protecting" him from them and enraged his artist cronies by appearing to think, as one said, "the outrageous—that Bill de Kooning needed *her* to be a successful artist."

"Oh yeah," says an assistant who watched the drama unfold, "it was a scene. This [Elizabeth] was smart. She had this kind of hold over Bill because, you see, she had worked very hard to make Lisa like her, to make Lisa kind of dependent on her." Explaining that he believed Lisa was often "just out of control," the assistant saw that Bill was incapable of dealing with his daughter. "Like," said the studio helper, "there was this time when I came back from getting stuff at the store for Bill, and he was really upset. I asked why. And he just said, 'How would you like it if your daughter was hanging out with some guy you didn't like?'"

Lisa, according to Bill's assistant, "was a really spoiled brat. She probably loved Bill, and Bill loved her but didn't know how to deal with her, didn't even know what to think about her. So when she got in trouble, he just wanted someone else to take over. He just wanted Lisa to be all right and he didn't want to have to do anything to make her all right."

Bill did worry about Lisa, who had grown from an attractive and troubled little girl into a beautiful and rebellious teenager. Neither expensive schools nor counseling had reconditioned Lisa's personality. To those who knew her, Lisa seemed "resentful of both Joan and Bill," "rebellious," "moody and crazy," or "headstrong." Bill, says Elaine, "loved Lisa deeply, probably as much as Bill loved anyone, but he was confused when it came to dealing with her. And Lisa was just wild, and on her own, and headed for disaster."

As much as he loved her, Bill "just didn't know what to do with a crazy young dame," said Bill's assistant. "But she was somebody you wanted to like. Like a kitten. Yeah, I think Lisa had a sweetness, but she had more craziness and more bullshit and more trouble about her than sweetness. But it was like Bill always expected her to just turn into his perfect little daughter. Unreal."

Enter Elizabeth, says the assistant, who had met teenage Lisa at a party "and just spent all of the time with Lisa, just asking her questions and being interested and, like, being very attentive to every word Lisa said. [Elizabeth] was real smart. She knew what

Lisa was saying even when Lisa wasn't saying it, if you know what I mean. And she would nod her head and smile and, well, she just took Lisa over. And Lisa was really glad. She had never had so much attention, and she felt really insecure and unimportant. And here was this really sophisticated and together woman, not being a mother at all, but being a friend."

The assistant believes that Elizabeth got a hold on Bill's life through Lisa. "And pretty soon, well, it just worked. Bill gave her money to take Lisa to Europe. God, he just wanted to get on with his painting. So he was really happy to give someone—anyone— money to educate Lisa, or just keep Lisa out of trouble."

The assistant observed that it was a short hop from taking care of Lisa to taking care of Bill. "Well, pretty soon, [Elizabeth] was around all of the time. And she moved in. And she started acting like Bill's wife. Bill didn't care. He liked the attention. And she didn't keep him from painting. Or from drinking."

Moreover, speculates the assistant, "[Elizabeth] made out real good. She got quite a few of Bill's pictures, and he gave her money. It was a good deal for her. She was supposed to be some kind of helper, someone who handled publicity and arrangements for shows and all of that for Bill. She got onto this big power trip, and you could see that she enjoyed it."

Bill's drinking, whether it touched other lives or not, threatened his work. By all accounts Bill's life was in chaos. "The studio scene was pretty awful," says studio assistant Larry Castagna, "with no system for storage, a lot of Bill's work—both on paper and on canvas—was in pretty bad shape, and records in bad order." Another studio assistant, Tom Ferrara, agrees that "Bill hadn't paid any real attention to what happened in his work after he did it, and a lot of people were in and out of the studio. And a lot of the work sort of went out of the studio without the right kind of records."

A dealer speculates that "during this time, a lot of people had access to Bill's studio, and more than a few decided to pick up souvenirs. That is, a lot of work was taken from Bill's studio—draw-

ings and paintings of varying quality and value. They found their way to market quickly enough, and sometimes through decidedly unsavory channels." For example, he said, he was offered a "de Kooning drawing" by a Colombian "dealer" who sold artifacts labeled *pre-Columbian* to a number of rich clients. "First," says the legitimate and widely respected dealer, "most, if not all, of the so-called pre-Columbian pieces were fakes. Downright. No question. I know because I was asked to help in the valuation of a collection. In that case, the collector happened to be a close associate of Bill de Kooning.

"In the process of the inventory and valuation," continued the dealer, "I met the Colombian. In my opinion his dealing in art was a cover for his real dealing: he was almost blatantly a drug dealer. And dealing in art provided a good cover, and a good way to launder and account for money.

"He offered me a de Kooning drawing [direct from the studio]. I looked at the de Kooning drawing—not, I thought, a very good one. So I told the drug dealer that it was not a very good example, that most de Kooning drawings of this particular style contained color.

"He said, 'Oh, well, it wasn't finished,' and that he could get Bill to finish it.

"When the dealer returned with the drawing a few days later, [he asked] how I liked it now that Bill had 'finished' it, and [he wanted] to know what I would give him for it.

"I pointed out that it was not signed—you see, by this time I was beginning to enjoy making him sweat a little. He said, 'Oh, well, Bill had forgotten,' and he would take care of that right away.

"When he returned, he presented a drawing that probably had come off of Bill's studio floor to begin with, that had been colored by someone else—certainly not by Bill—and then was finished off with a faked or traced signature."

The legitimate dealer, who has acquired and sold a number of de Koonings, passed up the opportunity to own this particular so-

called de Kooning drawing. He believes that other galleries and private dealers, however, may have been less persnickety about basic matters of authenticity and provenance and may have accepted works not intended by the artist for the market. He says, "Bill was so out of it for so long, and so many questionable characters had access to him and his studio, that one can be certain that many 'de Koonings' that are on the market are, one way or another, not genuine works of that artist's hand [that is, works not intended by the artist to represent him]."

By the seventies, however, the market for de Koonings seemed inexhaustible. The Australian National Gallery paid $850,000 to Ruth Culberg Rosenberg (a Chicago collector) for de Kooning's *Woman V.* The Metropolitan Museum accepted the artist's *Attic,* which was completed in 1949, purchased originally for $2,700, and valued at $1.2 million at the time it was given to the museum. Other works by the artist were sought avidly by both private and public collectors around the world. As buyers scrambled to own art generally deemed "blue chip," Harold Rosenberg's book, *Willem de Kooning,* reinforced Bill's already-heroic reputation and in turn bolstered the ever-increasing prices paid for the artist's work.

Aladar Marberger, having shifted his role in Elaine's life from that of her beloved student to that of her dealer and protector, helped Elaine obtain "an allowance from Bill de Kooning. She was *his wife,* and she had worked damn hard for him, and she had *nothing,*" said Aladar. "She was entitled. Period."

But financial concerns aside, Elaine admitted to close friends that she missed Bill, and that he was still "my absolute center." She added, "Well, I just always thought that *marriage* was maybe too confining and too limiting. But separation from Bill was more confining and more limiting than marriage. I mean, I just thought about it and thought that it was not right."

Elaine wanted to be closer to Bill, but she did not want to be rebuffed by him or laughed at by gossips. She rented a small red

house on Shelter Island, a hilly chunk of land in the water between the two forks of Long Island. "You must come to Shelter Island," she said to a friend in New York. "It's only a very short ferry ride to the South Fork [of Long Island] where Bill and all of the artists live."

Elaine de Kooning frequently visited friends in the Hamptons, including the Rosenbergs, Mercedes Matter, Hedda Sterne, and others whom she included in "the brotherhood." Returning to the red house on Shelter Island, Elaine, according to visitors, spent more time drinking than painting. Bob Dash recalls visiting her in the "really dismal, awful hovel. There was a bare low-wattage light bulb swinging above a filthy and sticky oil-cloth-covered table. The place was just awful. And there was Elaine, drunk and incoherent and sadder than I could have imagined."

Dash looked around quickly and felt that Elaine would drink herself to death if he left her. "Elaine," he commanded, "get your things. You're going home with me." To his surprise, she obeyed docilely and stayed with him in his house and studio for several days. From time to time she muttered an intention to "catch the ferry and get back to Shelter Island," but, as Dash recounts, "she stayed. And she wanted company and she probably wanted help. Besides," he adds, "I couldn't bear to think of Elaine in that awful place on Shelter Island."

Dash and other friends on Long Island began to persuade Elaine to establish a place for herself in East Hampton, where, after all, "all the other artists lived." They recognized the seriousness of her alcoholism and her psychological state, and though they doubted their ability to deal with Elaine, they wanted to help her. Even so, some who urged her to move did so with misgivings, thinking that they were inviting into their lives a hopeless drunk who was often tedious if not difficult.

Everyone knew that she had had automobile accidents; it was, many felt, only a matter of time until she killed herself or someone else. Elaine herself boasted of "totaling seven cars and setting

one on fire" in an accident she caused in East Hampton. "I had only a bump on the head and a bruise," she said. "I mean, it was amazing. But this cop who came, and who couldn't believe what I had done—just could not believe that one car could wreck so many other cars—also could not believe that I had not been hurt." Relieved that no one else had been hurt either, she added, laughing, "I was, of course, *very* relaxed. Just too relaxed to get hurt. But I definitely did not want to blow up any balloons for the cops."

Elaine also liked to tell of her "amusing" adventure after leaving an East Hampton party alone, intending to catch the last ferry back to Shelter Island. "Well, I was in a bit of a hurry and I had had a very *social* evening and had drunk many, many martinis, so my outlook might have been, shall we say, somewhat altered," she explained. "And pretty soon I realized that I was following a car that seemed to be going very, very slowly. And pretty soon after that I realized that the car in front of me had stopped. Well, I naturally thought I should pass the car and hurry to catch the last ferry. So I pulled out and sped up smartly and then I realized that my car had stopped, too. For no reason. Just stopped.

"I thought that it was a very inconvenient time to have car trouble. But," she continued, "I decided to go get some help and try to make the ferry. Well, I opened the door and stepped out and found that I was knee-deep in water. I was in the bay. I had driven into the water.

"Who would have imagined," she concluded, "that I would just follow a car of teenagers who parked on the beach to neck. And that I would have forgotten all about the road—wherever it was by then—and passed them and driven into the ocean."

It was, she admitted, lucky for her that the teenagers were there. They helped her find a tow truck, helped her report the accident to the police, and helped her find a place to sleep for the night. When asked why she did not return to the site of the party and stay over with those friends, Elaine responded, "I never, never involve my friends with the police."

Elaine's drunken episodes, dutifully reported by herself or by friends, added color to gossip in East Hampton and New York art circles. "You know how drunks are," she later commented. "They are either oblivious or, like me, they're just having the best time in the world. And they don't know what's really going on. I mean, alcohol, after awhile, just destroys your judgment. You just see things your own way, and it's a very distorted way!"

A jolly and good-time drunk, Elaine, as she said, "just believed that's what you did—you drank and then you had a good time, and then you slept and got up and started over again." On the inevitable mornings after, Elaine liked to hear stories of her drunken escapades, and she tended to be more amused by her antics than hung over from her excesses. "I just rarely had hangovers," she conceded, "and I thought that I had been very, very clever—very amusing and brilliant—when I had been drinking. But then I heard a tape of myself when I was drunk. And I knew that I was not brilliant, and not amusing, and not clever. I was the opposite. It was a rude and awful awakening. And I knew that I had to quit."

Elaine did just that. She quit drinking. She sought help from a therapist and an Episcopal priest who had become her friend. She also turned to Alcoholics Anonymous. "And there was Marjorie," she said of her sister. "She was also determined that I was going to get dried out, and that I was never going to drink again."

But she did not discuss with her friends her intention to quit drinking or her difficulties in staying on the wagon. "We all realized that Elaine had quit," Sherman Drexler recalls. "And no one would have believed she could have done it. I mean, she was a real alcoholic. But she had this fantastic willpower. It was like she decided that she was going to do something—anything—and she had the willpower to just do it. She was remarkable in that way, really strong. But not strong enough to quit smoking."

"Of course I can stop smoking," she told a friend. "I've done it many times." But Elaine continued to smoke constantly, often

having two or three cigarettes burning at a time. She coughed constantly, too. Responding to expressions of concern for her health, she dismissed the persistent and wracking cough that interrupted her speech, intermingled with her laugh, and shook her body until tears formed in her eyes. Nothing worked, however, in her attempts to break her cigarette dependency. She said she would eventually quit smoking, that she would give up cigarettes at the right time. Just not yet. At least she had quit drinking, she argued. In time, she said, she would quit smoking, too.

Now, however, she could not be bothered—she had other miracles to perform. From her new sober vantage, Elaine recognized not only her abiding love for Bill but his deteriorating state. Bill, she believed, was in terrible trouble as an alcoholic. When his doctors turned to her—she was, after all, still his wife—and warned that he would die if he persisted in his drinking binges, Elaine knew that she had to do something. "I saw that he was surrounded by a lot of creeps—men and women—who encouraged him to drink, who lived off him, who sponged on Bill and didn't care what happened to him. They were living there. They were stealing work, and they took money when they could get it. But the worst thing was that they just made an effort to keep Bill drunk, because when he was drunk he was available to them."

Elaine turned to one of her most trusted friends, Ernestine Lassaw, for advice, and Ernestine told Elaine forthrightly that she believed Bill was killing himself with alcohol. Like the doctors, Ernestine implored Elaine to take charge of Bill's future. "If you want to save Bill," she said, "go back to him and take care of him."

To Ernestine's amazement and gratification, Elaine accepted her advice and embarked on a vigorous campaign to save Bill. "She, who had never willingly cooked a meal or managed a house," Ernestine marvels, "really did take over. And she really did save Bill's life."

"Ernestine," acknowledged Elaine, "has always told me the truth. I didn't always exactly like to hear the truth, but Ernie and

Marjorie, they both had that in common; neither of them could—or would—ever tell me a lie."

Elaine had already bought a house in the Springs, on Alewives Road, not too far from Bill's studio, and had begun to visit Bill, who welcomed her into his studio and into his life. Elaine added a large studio wing to her house and organized her days around painting and seeing Bill. Ernestine thought that they were on good terms if not fully reconciled by the time Elaine set out to keep Bill sober.

In order to take care of Bill, Elaine publicly reestablished her role as his legal wife and let it be known that she resented Elizabeth's attempts to usurp her position. Elaine hesitated, however, to confront either Bill or Lisa about Elizabeth's poaching on her territory. "I just knew," she said later, "that Bill really did not want her."

According to Bill's assistant, while Elizabeth was away on her own business, Elaine reclaimed her territory and began to reorganize Bill's life. The first thing that she did, according to numerous observers, was "to throw out all of Bill's helpers, a gang of thuggish drunks who hung around the studio, plying Bill with booze, and drinking themselves—all of them—into delirium tremens, and, in Bill's case, into the hospital."

Having sent the lot packing, says Elaine Benson, "Elaine took Bill upstairs and just laid it out to him: You will quit drinking or you will die; you cannot have any more—not even one—drinking binge." Elaine took over.

Jokingly, she later told friends, "I scared and threatened Bill. I said, 'You know how Sandy Calder got drunk and slobbered on himself?' I knew that had always disgusted Bill. So I said, 'Bill, you're just getting to be a lot like Sandy.' Well, I think that did it. That picture just gave him the determination to stop drinking."

When that determination flagged, as it often did, Elaine bolstered it. She was sober; Bill would be sober. And, so far as Elaine was concerned, that was the end of the discussion.

She decided to stop his demand and all supply of alcohol. To

stop Bill's demand—if not his craving—for alcohol, says a friend, "she started giving him Antabuse [a drug to induce nausea when alcohol is consumed]. When he managed to get a shot of liquor, he puked his head off." Then, to stop the supply, Elaine went to every delicatessen, every bar, every liquor store, and every other place on the island where she thought Bill might get liquor. In a posture that included both menace and sweet reasonableness, Elaine told bartenders and storekeepers not to give her husband anything; that if they did, they would be killing him.

"In a way," says Elaine Benson, who had not believed that Bill de Kooning would ever be totally sober, "Elaine became his jailer. He didn't want to take the Antabuse, and wouldn't take it willingly. Elaine always hid it in his food. And she insisted that he go to Alcoholics Anonymous. But, of course, Bill was so depressed he was just passive. And he was probably too weak to struggle with Elaine. It was," Benson thinks, "like he was grateful to Elaine, and glad to have her taking charge. It was like his life had got to be too much for him, and he just needed Elaine."

Bill told Ibram Lassaw that he "didn't like those meetings [of Alcoholics Anonymous], and all of the God stuff." But he went. And, whether he knew it or not, he took the Antabuse that Elaine dosed out. And she not only measured out his Antabuse, she also organized Bill's household, his studio, and his life—including his painting regimen.

While Elaine painted in her own house on Alewives Road, she managed Bill's household and spent the nights with him in his studio. Both of them stayed sober, and both worked hard through the days. Elaine added—or resumed—the care of Bill's career to her workload, and took responsibility for hiring and directing studio assistants. She hired people to put his work in order in storage bins and cabinets, and to make an inventory—complete with photographs—of his oeuvre. And she negotiated with curators, dealers, collectors for all sales and exhibitions of his work.

When Elaine felt that Bill was steady enough to be left in the care of others, she began to visit New York to see exhibitions and

friends, to call on dealers, and to shop. Not wanting to give even a vague impression that she might be neglecting Bill for her old ways in New York, she explained: "You know how important it is for artists to make the rounds, to go to openings, and to stay in touch. I always like to see what other artists are doing. And," she said, "I think it's important for artists to support each other."

Eager to see some shows in SoHo and in the uptown galleries, she kissed Bill good-bye one Wednesday afternoon, feeling confident that he was in good hands as she gave last-minute directions to his assistants and others hired to help run his house. On her return from New York, Elaine stopped by her own house before joining Bill for dinner at his studio. She had barely begun to change clothes, she recounted, when the telephone rang and she learned from a friend that, in her two days' absence, Elizabeth had moved again into Bill's studio.

Elaine was stunned. What did this mean? Had Bill asked Elizabeth to move in with him? No, she decided, Bill did not care enough to ask anyone to do anything. As always, he was passive, possibly depressed—traits that, Elaine knew, had become heightened by Bill's steady loss of memory. Bill needed Elaine, she said, "because he just had a hard time remembering anything and a hard time caring about anything except his work." Elizabeth had made the move on her own, Elaine surmised, in a bid to reestablish control over Bill's life.

"Well," said an assistant, "it was a real scene. I mean Elaine really hated the idea of [Elizabeth] and [Elizabeth] must have hated Elaine's guts. They always acted nice to each other, but you could tell that underneath there was a lot of hate, a lot of hostility waiting to explode."

The large explosion finally occurred when Elaine arrived at Bill's studio, confronted Elizabeth, ordered her out, threatened her with physical violence and legal action (in that order), and, as the incredulous assistant watched, began to "throw Elizabeth's things down the stairs and to kick them out of the house. It was some kind of fit. Elaine really got into it, and I thought Elizabeth

was pretty scared. I mean, Elaine made it really clear that she was prepared to do anything—I think that included murder—to get rid of Elizabeth. Bill just sat in front of the television set and tuned himself out. You could tell that he didn't want to get between those two women."

"Well," the assistant recounted, "Elaine won. And we had dinner. And Elaine was very sweet and nice to Bill. She kept calling him 'dear' and 'darling' and 'sweetheart.' Elaine was good at pretending that nothing had happened when really fantastic things had happened, you know. So Bill didn't say much, but he seemed happy."

Elaine embarked then on a program of keeping Bill safe from further intrusions, protecting him from strangers and would-be groupies. At the same time, she regularly invited old friends in for visits. She was in charge, and she let everyone know it.

"Look," says a dealer, "it was very important for Elaine to establish and protect her territory. Bill was an old man and a very, very rich man. His estate would belong in large part to Elaine. Elaine was his legal wife, and you can bet that she wanted that fully and widely understood and accepted. Once they reconciled and she took over, she made it very clear that *everything* related to Bill's career—including the people Bill saw socially, the interviews he gave, and all shows of his work—had to be negotiated with her."

Esteban Vicente too believes that Elaine coolly decided before her move to Long Island "to take over Bill's life, to become responsible for him, and to claim both the rewards and the responsibilities of being his wife. The rewards were great: Bill had become a rich man, and he was likely to become even richer; his reputation was set. He had critical acclaim and his paintings had an established market value that ensured increasingly higher incomes. Elaine, as his wife," notes Vicente, "was entitled to one-half of all that Bill owned or made; conversely, Bill, as Elaine's husband, was entitled to half of her ownings and earnings."

Continuing, Vicente speculated, "At that time, when Elaine and

her family and friends reasonably expected her to outlive the older Bill by some years, Bill's claim on Elaine's fortunes—such as they were—seemed inconsequential. Elaine's right to Bill's riches, however, guaranteed her—and those who depended on her—a standard of living that she—and they—had never expected."

Elaine Benson believes that Elaine "had a drawback in being Mrs. Willem de Kooning." Bill, during the separation from Elaine, had become an important person, sought after by party-givers and social climbers, honored and applauded even when he was the object of pity for his drunkenness and the subject of gossip for his numerous women friends. Bill, despite drunken rages and hostility, was "the king, the best, the greatest living painter in America." His place and persona were fixed—he was a legend, and no one expects a legend to change. For this reason, says Elaine Benson, "when Elaine returned to East Hampton after an absence of seventeen or eighteen years, it was socially awkward for a lot of people. She came back to take care of Bill. That's what she said; there's no reason to believe otherwise."

"There was gossip" about her return to Bill, Elaine said, "*of course* there was gossip. I mean it was just too delicious. And the art world is small and loves gossip." But, gossip be damned, Elaine chose to reclaim her territory in Bill's life, and to take responsibility for him, knowing that his mental state was deteriorating—whether as a result of decades of alcoholic abuse to the brain, a psychiatric disorder, senility, or (as later claimed by his conservators) Alzheimer's disease. Of course she knew her legal claims on Bill's fortune, and of course she probably enjoyed the prospects of directing his career. But Elaine also loved Bill.

At the time of her reconciliation with Bill in 1976, Elaine identified herself as a "recovering alcoholic," regularly attended meetings of Alcoholics Anonymous, and steadfastly refused any alcoholic beverage offered to her. In keeping with her optimistic nature and strong will, once she decided to embark upon a healthful regimen, she transferred her obsessive tendencies to a zealous routine of vitamins, health foods, exercise, and probity in

her dealings with people. She wholeheartedly adopted a life-style that she believed would extend her own life and increase her productivity as a painter.

And, with even more vigor than in the past, Elaine applied her considerable diplomatic skills on behalf of Bill's career and toward increasing her own professional recognition. Elaine acknowledged to only a few close friends that she knew that Bill (who was then in his seventies) was showing signs of aging, that his energy was diminished, and that he was not as mentally sharp as he had been before years and years of alcoholic abuse to his body and brain. "Bill was forgetful," she admitted. "But," she hastily qualified, "he had always been forgetful. And his doctors had given him a lot of drugs—things to prevent depression—and I think they reduced his energy even more. And no one—no one at all—had been taking care of Bill; everyone around him had been using him, taking *from* him." Elaine quietly decided to limit the world's view of Bill and to control his image as well as his daily routine and his career.

"Of course Elaine knew that Bill was failing," says Robert Dash. "It was obvious. A lot of people passed off Bill's forgetfulness, even his confusion, as some sort of fey thing. He was a painter, a great painter, and he wasn't expected to act like other people."

While Bill painted in the near seclusion of Elaine's making and keeping, Elaine cleverly furthered the perception that Bill had moved to Long Island to escape his own celebrity, to shun the boisterous business of the art world, and to reject the widening influence of glitzy Pop Art or ambitious museum directors and greedy collectors. De Kooning had his own work to do, she explained to those who wanted to see or interview him, and he did not want to take time away from painting. When young artists appeared, those who wanted to identify Bill's work as the antecedent of their images, Elaine deftly encouraged them in their veneration of the master.

But for those who knew Bill, troublesome signs and portents suggested that the aging painter was drifting into the quicksand of senility. He had always had a depressive tendency, they told each

other; but they noticed a new quietness, and they discussed Bill's seeming aloofness and tuning in and out from reality.

Shortly after Elaine and Bill reconciled, Robert Mallary, now a professor at the University of Massachusetts in Amherst, went to visit Elaine. "She was doing about a dozen things at once," he recalls, "and getting ready to go off somewhere and lecture. It was the most amazing scene. Joan Ward was in the kitchen doing the dishes; Elaine was running about giving everybody directions. And then she left, and I was left to talk to Bill and Joan and Marisol, another one of Bill's ex-girlfriends who was there.

"Well," he continued, "Marisol has *never* talked, so she sat there silently. And Bill didn't talk and seemed very remote. I sat there for about an hour, and I was really annoyed with Elaine for leaving me in that situation."

Another guest described a typical evening in the de Kooning household in the late seventies, well before rumors of Bill's "failing memory" were whispered along the outer edges of the de Kooning circle.

Bill just sat there watching old movies on the television, seemingly totally fascinated in some old Bing Crosby film. He seemed to be totally out of everything. At the dinner table, Bill obediently ate the food Elaine set before him, still seeming to be out of everything, to be totally withdrawn and, well, just out of it.

So we all sat there rather awkwardly eating a delicious vegetarian meal, and Elaine de Kooning talked and chatted and waved her arms, vivacious as always, and careful to include Bill by saying throughout what amounted to a monologue, "Isn't that what you always say, Bill?" "Don't you agree, Bill?" "Don't deny it, Bill."

Bill stoically munched through the vegetarian dinner. Finally someone said *Gorky*—just the word—in some context or another. And Bill lit up, came to life. He not only entered, but dominated the conversation, saying, in effect, he had always admired Gorky, felt that Gorky was a genuine original, with something important to say, and that Gorky was a more intellectually significant painter

than John Graham. John Graham, he said, was thought to be intellectual because he talked so much and talked about books. But Gorky, who talked less, had the better mind.

Then, Bill dropped back into his own silence.

He had this fragmentary lucidity then. And it's hard to explain or understand. Because he was so forceful when he said anything—and because he had always been expected to be brilliant—a lot of people just never noticed that his deterioration began much earlier than anyone admitted.

As dealers, curators, and collectors now cozied up to Elaine to curry favor with Bill, he painted. She exercised her newly affirmed artist's wife's power for Bill's benefit and for her own advancement. Elaine herself laughingly recounted "the romantic moment of reconciliation," recalling:

> After Bill and I had been back together awhile, we had got used to doing certain things at certain times. We had quit drinking, but we liked to have tea together in the late afternoon, after we had both stopped painting for the day.
>
> One day we were drinking tea, and Bill was looking at the television set, and I was making plans to complete an inventory of his work stored in the basement of the studio. We were holding hands.
>
> And Bill said, "You know, Elaine, you're my best friend."
>
> I said, "Well, that's good, because you're my best friend, too."
>
> He thought about that and then he said, "Elaine, you're not only my best friend, you're the most important woman in my life. Let's get married."
>
> "Bill," I said, "We can't get married. We never got divorced. We *are* married."

THE TREASURY OF THE KING

I'm glad that I sell so I can keep painting.

—**WILLEM DE KOONING**[1]

L isten," says an artist, "Elaine realized that Bill was a very rich man. And she liked money. God knows, she had had little enough of it during the first part of her life. And here was Bill, rich as a king and not caring at all about money, and she was still his legal wife and entitled to half of his wealth. Besides, she probably loved Bill as much as she loved anyone and by taking care of him, she put herself right at the center of the art world." He adds, "Don't forget. The de Kooning name really didn't hurt Elaine's career at all. So, with Bill needing her and in no position to disagree with her directions about his life, she had complete control. Control over him. Control over his work. Control over his career. And control over all of that money. And Elaine may have liked that kind of power as much as she liked that kind of money."

In the late seventies, Elaine told a friend, "Bill makes easily $4 million a year. And it's easy. Collectors would buy his work before

he finished it and some actually do buy work that they haven't seen. They just call up and say they want the latest de Kooning and they usually don't even ask Xavier [Fourcade] for a picture. They ask how much. They send a check. Xavier sends the painting."

For the first time in her life, Elaine de Kooning had easy access to money, and a clear view of what money could buy. "Being rich," she said, "is not at all bad. I remember when Bill used to say that the problem with being poor was that it took so much time. Well, now, I'd have to say that the good thing about being rich is that you have so much more time. You don't have to scrounge, and you don't have to do everything for yourself. You can buy what you want, hire somebody to do the things that keep you from doing what you want to do. Well, I just have to say that I think it's heaven. Pure heaven."

Many of the friends who had known Elaine and Bill when they were too poor to buy decent art materials, pay the rent, or count on the next meal, and who had known Elaine during her separation from Bill, when she never knew if she would have money for anything at all, commented on Elaine's childlike delight in being rich. She enjoyed knowing rich people and being a guest on corporate jets; she exulted in being able to hire helicopters to take her or Bill to New York for an afternoon; she avidly bought fashionable clothing and the latest electronic gadgets. She proudly showed friends her special racks in her basement for hanging her enormous collection of clothing and for storing her several hundred pairs of shoes. "Before there was Imelda," says Barbara Schwartz, "there was Elaine. She liked shoes. She had shoes. And she always was on the lookout for the next pair of gorgeous or outrageous or simply adorable shoes."

Elaine Benson believes that "Elaine was very impressed by Courtney Ross [filmmaker married to businessman Steve Ross], by trips to China and to Paris in the corporate jet. Once Elaine went to dinner at the Rosses' house and Steven Spielberg was also a guest. It was not like the artists' parties Elaine knew, however, in that no one talked; everything was quiet, conversation hushed, no

arguments, and not much talk. At the end of the meal, they all went into a screening room and looked at a movie. Elaine was just amazed. She didn't know that people lived like that. They were so rich; they had everything; they didn't talk. This, to Elaine, was the strangest thing in the world. And, I think, not her idea of very much fun. But then, Elaine really liked conversation."

Benson adds, "Out here [Long Island], in the last decades of her life, through friends like Courtney Ross, Elaine tasted a high-flying, very rich life, an ultrasophisticated life of consuming and power. She quite liked it. And she could have become easily fascinated by it and caught up with it. Elaine really and truly enjoyed being rich."

Elaine made no secret of liking the things that money could buy. "I always thought," Sherman Drexler commented, "that Elaine should have bought even more things for herself. She really loved beautiful things, beautiful clothes. She almost collected clothes, the way other people collect art. And she often said negative things about fashion and about fashionable people, but I thought she really liked rich clothing, rich things. I only wish," he adds, "that she had had more time to spend more money."

But, as pleased as she was with the indulgences that money bought for herself, Elaine enjoyed even more the wherewithal for being Lady Bountiful to her family and friends. She took nieces and nephews on trips and paid for expensive treats for them. "I've just always felt," she said, "that my family is important. I've always thought that the best role to play in life is the fairy godmother. Never mind being a princess, I always thought, and I can't imagine ever having been a real mother. But I love having the power to change things, to give something that will change a life. Someone makes a wish, and magically the fairy godmother makes it come true. What could be better?"

Elaine's generosity grew with her access to Bill's fortune. She gave money to friends who needed to pay rent, buy art materials,

keep an intellectual journal in publication, see a doctor, or pay a bill. Without being asked, she gave things—refrigerators, television sets, cameras, tape recorders, jackets, boots, chairs, and art supplies—to friends who needed them, or wanted them. Knowing that a young friend desperately needed money, she tucked a check in the back of one of her paintings, and gave him the painting for Christmas. Only months later, when the man's desperation was turning to panic, Elaine's picture dropped off the wall and the check fell free. Her gift of $5,000, he told friends, saved his life.

Bill, when told that he was a very rich man, shrugged in disbelief. "Bill never really cared about money," Elaine said. "When we were very, very poor and really had nothing at all, he would wish for money. He used to joke about being poor, saying that we were so poor we didn't ever have to worry about money at all. But he always hated having to stop painting and pick up a job, or do or make something that he could have bought if he had had money. But when he got money, he didn't care. It could have been too late, or it could have been that he just never wanted to do anything but be able to afford art supplies and a place to work anyway. He didn't particularly like to travel and he didn't care about clothes. He liked to have the best paint he could get, and the best materials for his work. I'd say that being able to give money to Lisa," Elaine speculated, "to pay for fancy schools and trips, and to give her a very substantial allowance—even if her life-style troubled him— that was the greatest pleasure he got from his money."

Elaine confided in a few friends that "Bill sometimes doesn't remember things. And he doesn't want to make plans about the future. He's superstitious. You know," she laughed, "he always says he knows doctors can't keep him from dying, but that he's too superstitious not to go to them." Elaine half joked: "I just wish he was too superstitious to go to lawyers!" When asked what she meant, Elaine raised her eyebrows, inhaled deeply on a cigarette before she stubbed it out, and measured her words. "Well the

lawyers all know that Bill is very, very rich. And of course they want to control all of that money. And, what's really the point, there are others who want large pieces of the pie.

"And Bill has never wanted to face those things, to make those decisions. He has always wanted to be responsible for Lisa, but he has wanted—*hoped*—that he just wouldn't have to think about anything or anyone else.

"Bill only wanted to paint. That was what mattered to him. That was really what mattered to both of us. Always. The money came later, and the power to influence the world. But we were always both just totally interested in our work."

In addition to her work and Bill's work, however, Elaine was concerned about Bill's condition, and about what would happen to his wealth. She told a former drinking companion that she did not plan to ever be poor again. "Money," she said, "can be good or bad. It's very, very good for me."

With her gifts for teaching and her reestablished authority as *Mrs.* Willem de Kooning, Elaine began to edify an expanding audience. Skilled in manipulating the mores and attitudes of the art world, Elaine now accepted numerous invitations to speak, and she adroitly used the classroom and the lecture hall to revise history in the making, and to insist on the primacy of Abstract Expressionism as a movement and of Bill de Kooning as *the* exemplar of that school of painting. With escalating frequency Elaine appeared on behalf of Bill to accept honors or represent him at openings and other art world functions.

As a lecturer and in conversation among friends, Elaine scoffed at Pop Art and questioned the basic integrity of Conceptualism and Minimalism, movements vying for the spotlight in the art press at that time. She mocked the "pretend ideas" behind the movements and the lack of sensuality and pleasure in the objects produced in their causes. And she scorned what she considered the raw ambition of the artists associated with the new movements, schools, and isms—all in some degree, she thought, the

handiwork of Johnny-come-lately brat critics and cravenly ambitious museum directors.

Elaine confided in her audiences and made them feel she admitted them to the inner circles of the art world. "I mean, money is just at the root of it all," she told a group of students. "A lot of artists around today just want to make money and they'll do anything to attract attention. They know that attention is bankable, that it translates into money. And critics want the power and the jet-set life that comes with being the spokesperson for a movement. Not to mention the fact that artists always, just always, give works of art to critics. And if critics can build up the value of those works, well, they're that much richer. And, don't forget the museums," she urged. "There are just a whole lot of directors who are making deals with dealers and collectors and critics.

"In the fifties," Elaine insisted, "artists worked for each other. Now they work to get fashionable. I don't trust the fashionable in art. I do think there is a very prevalent attitude today against the idea of work, in terms of the work of art. There is, or there are a great many styles of painting today where the idea of work is obsolete. The whole principle of conceptual art—I mean the concept is everything and if you have the concept, you don't need to work. And there are a good many artists today who do create art without working at it."

Elaine spoke without a hint of irony, ignoring the role of Abstract Expressionism in blasting standards for achievement in art and making it imperative—not merely acceptable—for an artist to "do his own thing" spontaneously. In the fifties, artists tried to produce work that appeared to be the result of accidents and of actions taken against traditional methods of painting; later generations of artists picked through the shards of Abstract Expressionism. If traditional technique had been rendered obsolete, they decided, so had traditional materials. Observing that no sensation (visual or otherwise) is free of connotation, or of emotional charge, some artists reasoned that one sensation was as good as the next,

and they assembled material to excite the human retina and, presumably, the brain. Others opted for the theory that concepts of order and meaning underlay all sensation; they employed the least possible amount of material—pigment, plastic, string, paper, or other substances—to objectify concepts.

Asked about the roots of the new art of the sixties and seventies, Elaine ignored the possibility that Abstract Expressionism might be its immediate antecedent, but she pointed to both Mondrian and Albers as "conceptual" in their approach to making art. She thought, however, that they differed from the Conceptual Artists in their willingness to change directions in the middle of their work—thus making them more akin to the Abstract Expressionists. Pursuing her line of thought, she added, "I think all art is conceptual; and Conceptualism is not really nearly as conceptual as we are told. Michelangelo is conceptual. Leonardo is conceptual. All art is conceptual."

Even though she found Conceptualism intellectually shoddy and visually not very satisfactory, she admitted that she was pleased by her own unabated ability to share another person's enthusiasm for work that was both unfamiliar and unappealing to her. She said:

> I can recognize someone else's emotion about an artist who, let's say, does not thrill me. For example, I spoke to Grace Hartigan's students at the Maryland Institute and one of the students very much admired the works of the earthworks artist [Robert] Smithson. And I never had any particular interest in Smithson. I'm not particularly excited myself about earthworks. But this student was so passionate about it that I became very interested. And I think that is what I mean. If someone else is excited about a particular painter, we recognize that excitement. This is the opposite from being contentious.

Waving her cigarette, however, to reemphasize her disagreements with Conceptualism, she added sarcastically, "I mean there

is such a thing as making a work of art today using the telephone." The students at the Maryland Institute laughed. Elaine nodded and smiled.

She insisted that she stubbornly wanted to find the unfashionable position at every point in her development as an artist. "First I painted portraits all of my life," she offered as proof, and explained "[portraiture] was simply so frowned upon. Today it's not really considered pure art. It has these literary elements; these psychological elements."

At another time, she said that she turned to portraiture because Bill turned away from that form, leaving it in effect free to her. "Bill thought of it as 'girl painting,'" she thought, "and therefore not very serious work." She confessed that she had found that Bill's mind and directions as an artist tended to "use up territory" and to make it impossible for her to do certain things. "He just always got there first. Or if he moved in the same direction that I did, there was soon no room for me."

As she traveled about the country conducting workshops, exhibiting her work, teaching, and lecturing, Elaine noticed that "there are in this country just hundreds of thousands of artists. And there are art departments and art faculties. And the general level of the students is very sophisticated, because of the art magazines." She noted the availability of art criticism and the role of the media in informing all segments of the culture about the latest events— including prices fetched at auction and the capers of the art world stars. Elaine said that, as a consequence of the proliferation of criticism during the preceding twenty-some years and the related growth in both audience and business surrounding art, "there really is no longer a place for an avant-garde. Everyone—but everyone—is involved in art."

Moreover, she noted, "the scene today is incredibly eclectic, simply because there are these tens or even hundreds of thousands of artists in this country alone—not to speak of the Orient or other places—and just so much variety and no such thing as shock;

I mean there is no possibility of shocking the world. There is no way to be avant-garde because anything is acceptable."

She told of a recent visit to Minneapolis and St. Paul, where she met an English artist who identified himself as a sculptor. "How large do you work?" she asked.

"Well," he told her, "my last piece was thirty miles long."

Elaine admitted that "that got me," and she said to the sculptor, "Wait till I tell them that back home."

She learned from the English sculptor that "he had bulldozed two channels in the landscape—and it was a drawing. He showed me photographs of it and it was fantastic."

It did not seem strange to her that a thirty-mile-long bulldozer-made drawing in the earth was beautiful. It did seem ironic to her, however, that "the bus company, right nearby, was terribly interested in having people ride this route just to see this work of sculpture. Now no bus company would have thought of any kind of financial scheme to go look at Soutine, in Soutine's day."

Elaine decided that "if corporations could paint, they would; and they are, through certain artists." She explained:

> There's a new kind of art that has sprung up—and I'm not too happy to see it, and I won't mention any names, but I call it corporation art. I mean there are certain artists today—like Frank Stella or Kenneth Noland—whose images are completely predictable. In other words, they know beforehand what the painting will be; and it's like they give themselves orders and they carry out the orders. And that, in a certain sense, is what I call corporation painting. It's very different from Mondrian, who theoretically would seem to be the father of this kind of painting in that it's all rectangles and very specific in its objectives. But Mondrian would work for months and months on those paintings, editing those forms back and forth. Which Frank Stella or Kenneth Noland do not do.
>
> For Noland and Stella, it's a matter of dividing the canvas. But Mondrian did not divide the canvas, he arrived at these forms. So there's an infinity—it's a totally opposite state of mind.

By these and similar pronouncements that served her own purposes, Elaine narrowed the definition of art, elevating expressionism over formalism and, by implication, sharpening the focus on Bill as the great master of the age. Her message remained the same as her audience expanded.

Despite the multiplicity of styles and the population explosion of artists in the seventies, Bill held his claim as the preeminent artist in the world. Stories about his drinking, about the women who pursued him, about his daughter's escapades—these added color to the heroic portrait of Willem de Kooning, genius and most important artist of the century. It was a reputation that exceeded the boundaries of the art world: Bill became the subject of articles in popular magazines and newspapers.

But it was also a reputation that grew on its own, attracting a growing string of awards and honors. In 1975, as Bill worked on a new series of oils in which landscape, figure, and abstract elements merged and which reflected his East Hampton surroundings, he received the Edward MacDowell Medal for "outstanding contribution to the arts." He also received the American Academy of Arts and Letters Gold Medal. As he worked on life-size bronze figures, black-and-white lithographs, and his new series of oils in the early seventies, his work was shown at the Baltimore Museum of Art, the Sidney Janis Gallery, and the Walker Art Center in Minneapolis. And he continued to receive critical acclaim.

Also in 1975, Fourcade, Droll, Inc. (later renamed Xavier Fourcade, Inc.), mounted a one-man show of Willem de Kooning's new work, beginning an association that would last through numerous shows, until Xavier Fourcade died in the eighties. Fourcade, a compact and elegant Frenchman previously employed by Knoedler for many years, had worked closely with Bill during his association with that gallery, had arranged major exhibitions and sales of his work, and had been especially effective in extending Bill's international reputation.

After his relationships with dealers Charles Egan and Sidney Janis, Bill looked cynically upon dealers in general. But he was

pleased with Fourcade's handling of his work at Knoedler, and he traveled to Europe with Fourcade for the opening of exhibitions there.

"Bill just doesn't relate to everybody. And he's just naturally suspicious of dealers," Elaine said. "So I was naturally glad when he liked and seemed to trust Xavier." Moreover, quite apart from Bill's own more complicated feelings about the dealer, Elaine thought Fourcade "one of the best dealers around. Smart about art and about business. I mean, he just knows how to look at Bill's work, and he knows how important Bill is." The admiration was mutual. Fourcade said, "Elaine de Kooning is the smartest woman I know about art and about business."

When Elaine encouraged Fourcade to open a gallery under his own name, she admitted that she thought it would be a good gallery for Bill. "I just knew that Bill would want Xavier for his dealer if Xavier went out on his own," Elaine said. "So, naturally, I was glad to help Bill make arrangements with Xavier. Bill didn't want to take even a minute away from his work, and he wanted me to organize his shows with Xavier."

Together, Elaine and Xavier made a formidable team. They increased the visibility of Bill's work, measuring their success by his growing international reputation and by the steady flow of honors that came his way. On Bill's seventy-fifth birthday, at a cocktail reception at the Guggenheim Museum, Leopold Quarles van Ufford, the Netherlands consul general, presented to the artist the Dutch government's highest decoration. Willem de Kooning, Officer of the Order of Orange-Nassau, told a reporter that he was "not conscious at all" of his European background. "That is all over," he said, "though I am not so much an American—I am a New Yorker."[2]

Elaine talked to both her sister, Marjorie, and Aladar Marberger on a daily basis. She may have confided more in Marjorie, however, than in voluble, mischievous, and lively Aladar, who openly adored her and credited her correctly with helping him become a

dealer. After Elaine moved to Long Island, she often stayed with Aladar when she went to New York. She enjoyed his zany humor as much as she savored his gift for gossip. "They were both huge gossips," recalls Elaine's studio assistant, JoAnne Lowenthal, "and they would have these long conversations about everyone they knew. And if one of them found out something, they called the other one, and then the two of them would spend hours talking and laughing."

She talked regularly with Fourcade, too. "I've just always thought an artist should keep in touch with a dealer if the dealer is a good one," Elaine said. "You might say that that's the gauge of a good dealer. The bad ones, those who are just in the business for money and prestige for themselves, aren't very interested in talking with artists; but the good ones, the ones who love artists and who want to be close to art, well, of course, they *want* to talk with artists. And Bill couldn't be bothered. He didn't want to take time away from his work. So I talked to Xavier and passed messages back and forth."

Elaine recognized that Fourcade and Marberger differed greatly in personality and in their styles of operation as dealers, and she found each valuable in his own way. Aladar respected the sometimes snappish, slightly prissy Xavier, who prided himself in dealing only with the top tier of artists, those whom he considered evident extensions of the great tradition of Western art. However, partly because of Elaine's influence and partly because of his own extroverted nature, Aladar wanted to deal with works not so easily categorized, and with artists he considered like himself—a little on the edge, perhaps a little outside the mainstream. While Fourcade wanted to invest only in sure returns, Aladar believed he could build a reputation and increase prices for any body of work or any artist he liked.

Years later, after both dealers had died of AIDS, Elaine looked back wistfully and recalled, "Bill had Xavier. I had Aladar. Both were perfect. Xavier for Bill; Aladar for me. It was the best of both worlds for Bill and me."

"Elaine had this *shtick*," recalls a dealer, "about the Abstract Expressionist good guys—all poor and dedicated and part of a community of artists—and about how they, these good guys, were victimized by bad guys. The bad guys, in the history of art according to Elaine, were all critics, except Tom Hess and Harold Rosenberg and maybe Rose Slivka; all art magazines that did not have an article about either Elaine or Bill in a current issue; all dealers except Xavier Fourcade, Aladar Marberger, and Joan Washburn—the dealers Elaine thought she controlled. Elaine, you see, really was a consummate politician and, with Bill under her control and his reputation and fortune more or less under her control, she felt that she had a lot of power. And she used it. It was as if she had apotheosized from artist's wife to artist's widow. That means," he adds with a laugh, "that while Bill was still alive Elaine set out to create and sell a mythology of art with Bill at the top of the hierarchy. I guess you'd have to say that she was going to do an even better job than Annalee Newman has done in selling the Barney [Newman] myth and than Lee Krasner did with the Jackson myth. Well, maybe she did."

BILL'S REALM

De Kooning is unplugged from art of the last three
decades as the soul is unplugged from the self is
unplugged from the body is unplugged from paradise,
and the parts lie around where anyone can ignore them.

—PETER SCHJELDAHL[1]

Willem de Kooning was both famous and very rich. His
paintings were being bought as fast as they went on the
market; and de Koonings fetched record-breaking sums
for contemporary art at auctions. In 1982, *Two Women*,
painted in 1954–55, sold for $1.2 million at an auction. Two years
later, another work identified as *Two Women*, a 1953 oil on paper
that had been mounted on a canvas backing became "the most
expensive post–World War II art work ever auctioned, a fact that
reportedly did not impress the artist when he was told," reported
Rita Reif in the *New York Times*.

Reif continued, "Mr. de Kooning's lawyer and friend, Lee East-
man, said he told the artist in a telephone conversation after the
sale that his painting had brought $1.98 million at Christie's from a

collector who was not identified. 'He said he couldn't figure how anyone would pay that kind of money for a smallish picture,' Mr. Eastman said."[2]

Three days before someone paid nearly $2 million for his 21-x-28-inch painting of two women executed in pinks, yellows, green, black, and reddish-violet, a collector had paid $1 million for three new works.

In 1982, Bill's exhibition of new paintings opened at the Xavier Fourcade Gallery and, among both friends and critics, generated surprised comment. John Russell, art critic for the *New York Times,* opened his review by stating, "It is possible to take Willem de Kooning for granted. It is also possible to say he has gone off, gone down and fallen apart."[3] To Russell, the seventy-eight-year-old artist had entered a new phase in his work and had begun to compete with himself and to bring forth paintings "not quite like anything that he has done in the last ten years or more."

Russell saw a stabilizing and firm architecture behind the paintings composed of "long, broad ribbonlike stroke[s]" and "peremptory juxtapositions of light and dark." Concluding his review, he noted, "Even five years ago he would not have shored up the composition as he does today, with big battens of paint that bring the kind of balance we expect in a shipyard. In the best of these new paintings, he doesn't have to worry about the competition, and neither do we."

The *Village Voice* art critic, Peter Schjeldahl, expressed none of Russell's slight reservations: "[The de Kooning exhibition at Xavier Fourcade] has given me more concentrated aesthetic pleasure than any other gallery show this season," he wrote, noting approvingly that "the paintings are complicated, violently self-contradictory, mockingly perverse. At first glance, they may look repellently both harsh and muffled."

Schjeldahl observed continuities in the artist's technique and style: "As usual with de Kooning, the handling is wet-in-wet—high-keyed color worked with lots of white paint, which keeps things lively and advancing." But he also pointed out sharp

changes apparent in the painter's recent work—for example, de Kooning's adoption of two difficult-to-use colors, Thalo green and alizarin crimson. And, apparently sensing a fundamental change in purpose or tone in the new paintings, he wrote: "Unlike other recent de Koonings, these don't appear caught in the act of tearing themselves apart."[4]

In the past, de Kooning's paintings had indeed had an unfinished appearance that might well have been described as "caught in the act of tearing themselves apart," a quality impressed in the painting by the complicated, multilayered, paint-and-destroy campaigns of the artist on the surface of the painting. In the past, through numerous changes in style and direction, de Kooning's work was always characterized by ambiguity born directly from working and reworking the surface of the paint, from laying paint on and scooping it off with a trowel, or sanding the top layers to reveal glimpses of underpainting, or drawing with charcoal into wet paint and then rubbing the image out with wads of newspapers. Whether he derived his images from landscapes or from the figure, de Kooning scraped and fretted the surfaces and allowed images to build on top of one another, resulting in richly textured and complicated skins of paint.

But something had happened in the artist's studio—the new paintings evolved from a new way of working. They gave only scant suggestion of modification by the artist in the process of painting. No reworking was visible, and new colors and gestures grappled with each other for attention. Most critics and most of the artist's friends praised de Kooning's new paintings, lauding Bill for his heroic willingness to embark on a new path so late in his life. As he suddenly veered away from his own past in painting, he appeared to reject much of what he had himself upheld in painting. Indeed, the new paintings often contradicted the message Elaine had preached on Bill's behalf.

De Kooning's new paintings of the early eighties consisted of long ribbons of paint, often brilliant colors, against a lighter background. Would these new paintings—with their thin, meandering

lines of color, their trivial and surface treatment of both action (as in Action Painting) and composition (as in painting)—have been shown, reviewed, or praised if they had carried a different signature? Indeed, a viewer recalling earlier de Kooning paintings might well have deduced from the new paintings that the anxious, fretful, sometimes violent artist had made up his mind to repudiate ambiguity, had taken a direction and not looked back or reconsidered.

Virtually all reviewers commented on the revolutionary change in the artist's new style, and most raved about de Kooning's new certainty, his compulsion to experiment and risk everything in his old age. John Russell, in his *New York Times* review, praised the artist for daring to depart so boldly from his past style. The paintings shown at the Xavier Fourcade Gallery in 1982, Russell found, were full of "many points of repose. White or near white areas speak for equilibrium. Color is pulled or pushed across the canvas with a long, broad ribbonlike stroke that is quite different from the twisty eel-like forms that fought for domination five or ten years ago." And he said, "These are 'late' paintings, inasmuch as he may no longer have energy to burn in the way that he had 20 years ago. But in place of that almost ostentatious energy there is a new spareness of statement."[5]

Grace Glueck lauded the sixty years of creativity and production represented in the artist's retrospective at the Whitney in 1983.[6] Several weeks later, John Russell offered *New York Times* readers another lengthy and highly favorable review of the de Kooning retrospective.[7]

When in 1983 Xavier Fourcade mounted an exhibition of Bill's sculpture, executed earlier, Russell found the works "full of inner torment that is fundamental to expression."[8] Vivien Raynor reviewed de Kooning's 1984 exhibition at Fourcade, finding the new work suggestive of "micro-organisms, and the space they tumble and squirm in" and not the figures and landscapes of the past works.[9] In 1985, a reviewer for the *Times* considered de Kooning's exhibition at the Fourcade to be "an attempt by

a major, if not a great artist to summarize and crown his career."

Regardless of the few dissenting voices, the new paintings carried high prices. Fourcade boasted, "I can sell anything de Kooning paints before he paints it. I can sell the *name*." That name—as in fame—seemed to hang over Kay Larson, however, as she warned *New York* magazine readers, "The vagaries of judgment are as intricate as they are mysterious." Reassessing de Kooning's history and his contribution to recent art—"if there is ever an Abstract Expressionist hall of fame his marble memorial will unquestionably be in it"—she traces the artist's predilection for working in directions contrary to prevailing trends. When others insisted that abstraction was the only moral and aesthetic path for an artist, de Kooning painted grimacing, squat, pendulous-breasted monster-women. These vehement paintings, Larson recalled, contained "pictorial energy [that] was astonishing." She wrote:

> Nobody would match him at tearing into the traditional subject of the female nude and reconstituting it *as a subject* from the ground up. De Kooning disemboweled his nudes with rapid slashes of the brush, flaying each ponderous madonna into a skin of paint, tacking her image to the canvas with his will.

When conventional criticism had assigned him to the niche of "figure painter," de Kooning turned to paintings derived from urban landscapes as well as from the light and sky of East Hampton, with imagery suggested by quick, dashing brush strokes that skittered and ricocheted across the surfaces of the paintings. But "the glow of his reputation dazzle[d] too many already widened eyes," cautioned Larson, admitting that she found the landscape paintings (shown at the Guggenheim Museum in 1978) "an embarrassment, and de Kooning would have been well advised to keep them at home."

The paintings on view at the Fourcade, completed in 1981–82—despite the expressed intention of curators from the Museum of Modern Art to purchase one, *Untitled II*, for the collection—seemed to Larson to be the work of an artist "determined

to investigate openness and expansiveness in painting without recalling that great precision is needed to do so." Larson saw the new paintings—quite unlike the earlier turbulent and "serenely machismo" de Kooning paintings—"drift[ing] without purpose, pleasant as churchgoers."

She confessed: "His admirers value his openness, or so they tell me; his dealer claims these liberated canvases point toward a whole new direction in abstract painting. Perhaps." But neither paeans from admirers nor claims from the artist's dealer convinced Larson that, as Fourcade told others, "these are the last great works by a great master."

While a few curators raised skeptical eyebrows at the fulsome praise heaped on the new de Kooning paintings, and a few artists privately joked about the triumph of "hype over quality," only one longtime de Kooning pal pointed openly to what he thought amounted to the naked emperor. Noting the shocking departure in style and manner of working apparent in the new exhibition, Herman Cherry, a close friend from the Cedars and the Club, said bluntly, "Why did Bill—or, to be exact, Elaine—ever let those silly paintings out of the studio?"

Now a few other artists hesitantly and privately criticize the paintings as "thin" or "empty" or "unfortunate." One or two doubt that Bill painted them without help. "Come on," says one, "look at them. Bill wouldn't have gone that way. The most charitable thing to think is that he did them with or without help from someone else after he had lost his mental acuity."

John Opper, however, says, "They're not as tough, as painterly, as strong as the earlier works. Anyone would say that. But, listen, I don't know how anyone else could have done them. Everyone says Bill went on painting, you know, after his mind weakened. Maybe that explains the change. Maybe these paintings were done without a layer of rational thinking—or hesitating."

Any doubt cast on the authorship of de Kooning's late paintings, of course, carries enormous financial ramifications. In the contemporary art market—and in a world where it is generally

agreed that works of art need not even claim to evoke or embody inherent value—prices rise or fall on a fabricated art market. And that market is built on reputation. If a painting like *The Polish Rider,* long ascribed to Rembrandt, can be revalued when scholars determine that it came from another artist's brush, then the same fate could await contemporary works that, on examination, prove unauthentic.

For a group of artists who have admired de Kooning since the fifties, who have simultaneously despised the mushrooming of art business, and who now see rich collectors as vultures feeding on the decaying carcass of a once-noble human endeavor, Art, the late de Kooning paintings pose a special problem. If they are the genuine late work of a master, and if they are superficial and trivial paintings, what do they suggest about the de Kooning reputation, and about his place in history? Do such works lower the artist's previous standing by revealing a flawed and exhausted talent?

Or, if these are not the works of Willem de Kooning but are composite efforts from the hand of a failing man and, as has been variously suggested, his artist wife, his assistants under her direction, or a studio assistant under direction from Xavier Fourcade, are they merely instances of fraudulent claims on an unregulated market? The question boils down to this: What makes a painting an authentic work by a particular artist?

European artists in the past employed assistants to work under their supervision on passages of their paintings but took responsibility for the quality of the work and laid claim to the authorship by affixing their signatures. Bill de Kooning, argues an artist, is a European artist "who knows all about using assistants, and about working within that tradition. Because he may not have had the physical stamina needed to make large paintings, it is possible that he asked some of the guys helping him to do this or to do that. You know that he masterminded the whole thing, and that he had other people execute his ideas. Matisse did it! Why not Bill?"

For the most part, however, doubts about both the quality and authenticity of Bill's new paintings remained behind the closed

doors of the art world.* His paintings were seen steadily during the eighties, and his reputation grew. In 1980, de Kooning's work was included in L'Amérique aux indépendants at the Grand Palais, in Paris, and in the Hirshhorn Museum and Sculpture Garden's grandly mounted exhibition, The Fifties: Aspects of Painting in New York. Other exhibitions followed, including Amerikanische Malerei, 1930–1980, organized by Whitney Museum director Tom Armstrong and seen at the Haus der Kunst in Munich, and the Whitney Museum's retrospective, Willem de Kooning: Drawings, Paintings, Sculpture, which was also seen in Paris and Berlin. Other shows appeared in London, New York, Amsterdam, Frankfurt, and The Hague. More celebrated than any other living American artist, de Kooning's exhibitions attracted large crowds of people around the world.

Awards and honors flooded the aging artist, often with Elaine or Lisa accepting on his behalf. As Xavier Fourcade, critics, and other artists celebrated de Kooning—the king, "the greatest living painter"—he was elected a member of the Akademie der Künste [West Berlin], became an Associate Elect of the National Academy of Design [New York], and was made an honorary member of the Royal Academy for the Visual Arts [The Hague] on the occasion of its tercentenary. During that same year, 1982, Architectural Digest featured an article on Bill and Elaine and Bill's Long Island studio.[10] Willem de Kooning also received the Governor's Arts Award from New York's governor, Mario Cuomo, and Mayor Koch of New York City presented him with the Mayor's Liberty Medal.

"Painting just didn't get any better than Bill's work," said one

* Harold L. Klawans, a distinguished neurologist, details an extended conversation between himself and a friend, both collectors of modern art. Dr. Klawans's friend mentioned that de Kooning, reported to be suffering from Alzheimer's disease, was "still painting as well as ever." Klawans doubted that, asserting that "either the diagnosis is wrong or there is something rotten in the studio of De Kooning." (Harold L. Klawans, Life, Death, and In Between, New York: Paragon House, 1992, p. 84)

admiring young woman. "It was the best, the very best. And maybe no one would ever equal it again. It sort of gave you chills just to think of that."

As the honors and praise accrued, exhibition followed exhibition. Elaine handled the logistics and preparation for Bill's shows; and she directed assistants in framing, packing, and moving the works. Elaine made arrangements with dealers, saw to it that critics were contacted and properly courted, and kept watch over sales. She took special pains to review press releases and to be of assistance to reporters, critics, and interviewers.

When she returned from a trip with Bill to the Netherlands, Denmark, and Sweden in 1983 Elaine told two stories to her friends—"droll stories," she said, "about Bill's absentmindedness." She recounted, "We were flying in the airplane. And after we watched about three-quarters of a movie, Bill got up and said, 'Elaine, this is boring. Let's go home.' And then he got up and started toward the door.

"So I had to convince him that he was on an airplane and couldn't just leave the theater." And she added, "He's always been absentminded, you know."

According to another of Elaine's stories, Bill's absentmindedness did not abate in the Netherlands, where, at a state dinner in his honor, he was seated beside the queen. Later, according to Elaine, he asked, "Who was that woman?"

Elaine said, "The queen."

"Oh," Bill said, "I thought she looked familiar."

Again, Elaine reminded her listeners that "Bill has always been forgetful about things that are unimportant. He just doesn't think state dinners and awards and royals are important."

But Bill's forgetfulness seemed to his friends to have increased. Perhaps in the past it might have been dismissed as an artist's tendency to forget or neglect what he considered trivial when he faced the more important concerns of his work. Now, however, he often sat for hours before the television set, watching old movies or, as one

studio assistant noted, "just watching out-of-focus zig-zags of color."

Elaine planted herself firmly between Bill and other people, often speaking for Bill. She answered questions put to him; she interrupted him to explain what he was saying. And she hired and supervised studio assistants and household staff to take care of him. The rules were strict. First, Bill was not to be left alone. There had been the unhappy instances of his confusion about cigarettes, which resulted in an attempt to eat rather than smoke tobacco. There had been, too, his adventures with the giant restaurant-type stove: he had fiddled with the controls and matches at the same time until an assistant had stopped him.

Second, Bill was not to be disturbed by dealers, agents, or collectors. Work time was to be sacrosanct, and social time was necessarily controlled by Elaine. She invited friends to dinner, arranged visits, encouraged people to visit Bill. As she knew they would, most of Bill's friends either did not or refused to acknowledge the severity of his "forgetfulness."

And third, Elaine encouraged others in her sphere to say like a mantra: "Isn't it amazing? No matter how forgetful Bill is, the part of his mind that controls painting just keeps on working. No matter what else goes, Bill still paints. That urge, that talent, is just so strong that it persists when everything else goes." That description of Bill's status, accepted and repeated endlessly by members of the de Kooning circle, became gospel.

Elaine gave the cues, and friends picked them up. "Bill is amazing," they would say, "painting all day at his age. Of course, he's tired at night. A little preoccupied. But isn't it wonderful that Elaine takes such good care of him?"

But JoAnne Lowenthal, Elaine's studio assistant during the summer of 1980, worried that Elaine did not prevent Tom Ferrara, one of Bill's favorite assistants, from actually working on some of Bill's paintings. Ferrara, an intense and quiet young painter, works slowly and deliberately; and, like de Kooning, he employs a vast knowledge of the chemistry and physical properties of paint. He can explain exactly how Bill used drops of water

and oil of cloves to keep paint from drying too quickly; how Bill sanded the surfaces of his paintings; and how Bill, in his later work, wanted to be "more like Matisse. More pure."

While acknowledging the mutual fondness between Bill and Tom, JoAnne says, "I was very annoyed by Tom. He was very close to Bill and very helpful to him. But I was annoyed by his apparent influence over Bill's paintings. He would tell Bill when the painting was finished and when to leave it alone. And I hated that. I watched that and I would tell myself to keep my mouth shut. It used to annoy me that Tom would actually work on some of Bill's paintings."

"Yeah," says another of Bill's assistants, "Tom was like really close to Bill, and really loved Bill. And he knew all this technical stuff, knew how Bill mixed paint and knew how Bill painted. And he was, like, resentful of anyone—maybe even Elaine—who didn't treat Bill the way Tom thought Bill should be treated. He really hated it, you know, that Elaine kept giving Bill all of those pills, and I guess he just blew it one day and yelled at her, and she fired him."

By the middle of the eighties, according to another disgruntled assistant fired by Elaine,

> [Bill] painted some. Mostly like he got real active, agitated, and sort of shot around the studio. Or like he just sat in his chair. He liked to smoke but we had to be careful because he was like not safe with matches.
>
> I don't know how much Bill thought about his painting. He wanted to be in the studio and was like worried if he was anyplace else. Except television. I mean he liked these really old movies and real junk and he would just sit in front of the television and kind of talk along with it. . . . No, I couldn't tell much what he was saying, just talk, maybe not English.

The young man believes that "Bill had to have like *help* with *every*thing, including the painting. We all helped Bill in one way or another." He also thought that Bill's friends resisted knowing the seriousness of the aging artist's conditions.

These guys, painters and other guys, would visit Bill and he would go "hello dere" and shake their hands and they like thought he knew them. So they'd all sit around and talk and Bill would smile and like nod and sometimes he'd go like "nice day, huh?" So all 'a these people who came to visit Bill got this idea that he was like okay. And Elaine kind of made sure of it, too. If she was there, she'd like interrupt and go, "Bill says something, something. Isn't that so, dear?" And Bill smiled and sometimes went, "Yah."

Elaine didn't want just anybody to like see or talk to Bill. She said she was just doing what he wanted, like keeping him free to paint. . . . No, I'm not sure that was the deal. Shit. Bill didn't know shit. It was like this game, everybody saying what Bill had said and Bill hadn't said shit. . . . How bad? Pretty bad. *Real* bad. There was this time when Bill like turned on all the gas on the stove—that great big stove, and like Elaine was pissed because I *let* him turn on the gas. And she didn't want him around the stove. It was like she didn't want him to have cigarettes unless I gave just one to him and watched him like smoke it. That was because once he had got confused and had tried to eat his damn cigarettes.

Remembering that "Elaine was big on health food and like vitamins and that stuff," the assistant added, "And she always had someone cook special things for Bill and she had dinner with him and like made sure he ate vegetables and fish and stuff like that. And she gave him vitamins. But Bill liked ice cream and so Elaine let him have ice cream. Häagen-Dazs. He liked that."

Elaine, he says, was the controlling force in the de Kooning world:

Elaine was like *there,* I mean *there,* when a dealer or somebody like that came to the studio. And she was really protective. She'd go, "Bill wants you to see something and something," or she'd go, "Bill thinks these are the ones that should be in the show." Yeah. Elaine kind of controlled things, like she took care of Bill, and like she knew all of that art world stuff and everyone trusted her, and

she just thought she knew more about what was good for Bill than some dealer did. That's why like she was his dealer, and she made these arrangements for shows and stuff like that. No. Bill didn't care. Bill didn't *know*. Bill was like in his own place in his head.

Still another young assistant, admitting that he and Elaine had differed over the proper treatment of Bill, described himself as having worked "for Bill, but really for Elaine. She was the boss." While he had been hired to help Bill in the studio, he understood soon that that meant he was to follow directions issued by Elaine. Bill, he said, "more just pointed to things and laughed. Or sometimes he said these fantastic things that didn't seem to make any sense—like you didn't know where they came from—but later you realized that they made a lot of sense, sort of like Zen, you know."

The young assistant observed that

everyone said how [Bill] hadn't changed at all, but I thought he must have changed because he was like somebody who had lost it. You know. Lost it. Like he got confused about things. And he forgot things. Elaine always made these jokes about how Bill had always been forgetful, absentminded, or something. She'd always go, "Well, Bill just forgets everything except his work." And I guess that's what everybody thought.

As for himself, the assistant said that he thought of Bill as "a great painter," but he "also thought he was like an old guy who had just lost it. I mean, like, lost a lot of brain cells. Or something."

But he felt that Elaine "worried a lot about Bill." And he recalled:

She was always giving him these vitamin pills and stuff, and she sort of played games to get him to take them. Like, he wasn't sure he wanted them. She was giving him this stuff [Antabuse] that made him, like, really puke his head off if he had a drink, just one drink, and she was giving him these other pills, too. Like sometimes she'd mess up the amounts or get the pills like confused. That was, wow,

bad. Real bad. She would go, "Bill is a little sick today." Or, like, she'd go, "Bill wants you to do these things today."

Shaking his head, the assistant admits, however, "Well, I didn't think Bill knew shit. . . . [He was] like out to lunch. Gone."

Enjoying her role as chatelaine, Elaine managed Bill's diet, wardrobe, and work and rest schedules; and she protected him from critical eyes. She arranged to have him taken by helicopter to New York for dental work, directed his accompanying assistant, adjusted his Greek sailor's cap, and kissed him good-bye. Bill, smiling, ambled off with his young chaperone. When Bill returned from the dentist with new tooth implants, Elaine issued strict orders for Bill's assistants to remind him to rinse his mouth with saltwater at regular intervals.

With the same attention to detail, Elaine talked to Fourcade about new work in the studio, about older work being invento-ried; she encouraged the dealer to call Bill's work to the attention of critics, museum directors, collectors. And, on behalf of Bill, she expressed approval or disapproval of suggestions for shows, for articles, for interviews.

Day by day, Bill was protected by Elaine, by the power and scope of his own fame, and by the segments of the art industry that grew rich in serving him. Old friends, young assistants, cheeky reporters, and on-the-make artists can only speculate about what Bill really thought and really did. In truth, only a few people saw him, infrequently and for short periods of time. He was effectively hidden.

Meanwhile, Fourcade, walking among Bill's paintings exhibited in his gallery, announced, "These are the last great paintings of an aging master. They are as great as the late Turners, the late Rem-brandts. They are from the mind of a genius."

EXIT ELAINE

How did she do it? How did Elaine do all that she did?
She was amazing, wasn't she? Taking care of Bill. Paint-
ing. Teaching. Being everywhere all of the time.

—HEDDA STERNE

In the last decade of her life, Elaine brought all of her political
and organizational skills to bear on anchoring Bill's reputation
as the greatest artist of the age, as well as on heightening her
own standing as an artist. As Hedda Sterne suggests, Elaine
seemed to be everywhere: speaking, representing Bill, attending
openings, showing her own work. She campaigned vigorously.
Even as an incumbent, she continued to run at a pace others
found incredible for high position in the art history texts.

During the eighties, while she fostered Bill's career with cun-
ning, charm, and devotion, Elaine herself received a number of
academic honors, including an Honorary Doctor of Humane Let-
ters from Adelphi University, an Honorary Doctor of Fine Arts
from the Maryland Institute College of Art, and another honorary
degree from Long Island University. Still she battled as if the cru-

sade had only begun. She lectured to audiences across the country; she taught workshops for art groups in small towns as well as seminars and masterclasses for graduate students in prestigious universities; and she telephoned or visited with friends regularly, "keeping in touch," as she said, "showing support for other artists."

She loved the whirl of activity that she created about herself and Bill, and she did not let it prevent her from fully exercising her powers as an artist during what may well turn out to have been the most productive period of her life. "The thing about being young," Elaine joked, "is it takes so much time. I mean you are just always late for something, or feeling that you are missing out on something. You are always on the run, and I think being young gets in the way of concentrating."

"Oh, yes, she concentrated. She concentrated on painting even when she wasn't painting. I still can't believe Elaine," says JoAnne Lowenthal, a young painting student at Rhode Island School of Design, who spent the summer of 1980 as Elaine's studio assistant. At their first meeting, Elaine looked her over, JoAnne remembers, and asked, "JoAnne, do you have a dog?"

When the younger woman said yes, Elaine asked if she would like to go for a walk with her and her assorted dogs—beloved Deidre and two other dogs with uncertain pedigrees and sad histories. "We went out to the beach," JoAnne recalls, "and the ice was broken. I knew I could say anything."

On the walk home, Elaine said, "I want you to meet Bill."

JoAnne "couldn't believe it. To me this was the king and queen of the art world. We drove up this long winding driveway, and Bill came out in his pajamas, and shuffled down into the kitchen."

Elaine said, "Come on, Bill, I want you to meet someone who is going to be working for us."

He replied, "Why didn't you tell me, Elaine? Why didn't you tell me that someone was coming? I would have put something on."

JoAnne was surprised to meet "this little old man in pajamas

and shuffling slippers" and was, she says, "overwhelmed." Knowing Bill's paintings, the young student had expected to encounter, if not a physical giant, at least a "large and strong man, not this frail old person, this distracted and sort of pitiful old guy."

Elaine reminded Bill that it was time to take his vitamins; he sat docilely while Elaine measured out a dozen or so capsules, including his daily dose of Antabuse, and rewarded him with ice cream. Elaine stroked Bill's hair, praised him for taking his medicine, and told JoAnne, "Bill is just too tired to talk very much. When he has been concentrating all day on painting, it's hard for him to shift gears."

Later, on the way home, Elaine stressed Bill's vigor as an artist, his discipline, and his continuing good health, telling JoAnne, "The reason Bill is going to outlive all of us is that he's such a hypochondriac. He complains about everything. And he comes from healthy stock. He'll live forever."

As the weeks passed, JoAnne noticed that Elaine tended every aspect of Bill's health, insisting that he rest, that he swallow masses of vitamin pills, that he eat a largely vegetarian diet, and that he consume—to JoAnne's amazement—"huge quantities of carrots" for breakfast. "Why carrots?" she asked Elaine, who cleaned the vegetables by scrubbing them with a Brillo pad. Well, Elaine explained, she believed that "doctors don't know or care about nutrition and they only want to see you when you're sick." She had also received advice from Connie Fox to send a clipping of Bill's hair to a nutritionist for analysis. When the results suggested carrots as a means for treating Bill's hemorrhoids, Elaine threw away his prescribed suppositories and made certain that he consumed the vegetable at breakfast each day. "At first," Elaine said, "he thought they looked funny, and he didn't much like the idea of carrots for breakfast. But he got used to them, and now he thinks carrots are the best of all breakfasts."

JoAnne described a typical day in the de Kooning household: "Elaine lived at her place. Sort of," JoAnne said, but she routinely

went to Bill's each morning, fed him breakfast, and set him to work in his studio. "She would make sure that Tom [Ferrara, Bill's assistant] and Bill were doing okay. And then Elaine was off."

After Elaine and JoAnne had breakfast together in a little coffee shop in town, where Elaine chatted up the owners and other customers, Elaine routinely dropped by to visit artist friends or sometimes shopped. Barbara Schwartz quipped, "For Elaine, a day without shopping was a day without sunshine. She was a world-class shopper. I thought maybe she had that compulsion because she had been so poor for so long, and now that she had money and could buy anything, I thought maybe shopping was a way of reminding herself that she had a lot of power."

But shopping was only one of Elaine's means for looking in the mirror to survey her power. People—whether other artists, new friends, old friends, or one of her thousand best friends— reflected Elaine's image of herself. JoAnne discovered that Elaine almost always spent a late morning hour or so "gossiping on the telephone. She talked on the phone by the hours. She would call everyone she knew to report that so and so was seeing so and so, or that something had happened. When Philip Guston died, she called everyone she knew and discussed his work. She even then had a portable telephone, which was still rare, and she would walk through her house talking on the telephone."

Elaine loved and deeply needed a group of stalwart friends, JoAnne realized as she watched the artist make her visits. She listened to Elaine talk regularly to the Lassaws, Hedda Sterne, Mercedes Matter, Rose Slivka, Herman Cherry, Aladar Marberger, Barbara Schwartz, Connie Fox, and other artists in the Hamptons, and she watched Elaine invite people to visit and stay a few days with her. "Marjorie was really important to Elaine," says Lowenthal. "She liked her brothers and she liked all of the kids and wanted to help them—the nieces and nephews—but Marjorie was Elaine's best friend as well as her sister. They were really close, closer even than Elaine and Bill."

Connie Fox and sculptor Bill King, neighbors and friends, were

"in and out of Elaine's all of the time. And Elaine often got Connie and her dog to walk with us, or to go swimming. They talked about art and people a lot, and they also did exercises together," JoAnne recollected.

At first, before she understood "the special way Elaine had of concentrating," JoAnne found Elaine's work habits disconcerting, and she worried that she could not respond to the chain of seemingly unrelated directions Elaine gave. "She would tell me a dozen things at once to do, and always change her mind. I could never finish anything. 'Now do the canvas'; 'now do the slides'; 'no, I think you should paint'; 'no, let's go swimming.'" Soon, however, the young assistant learned to adapt her pace to Elaine's and to anticipate the older artist's needs. Moreover, she knew that all would eventually be put in order by Elaine's sister. "Marjorie would come every week," she observed, "and organize all of the piles of mail and stuff in Elaine's studio, and go over everything with Elaine."

JoAnne observed that, despite Elaine's social life, Elaine "was always thinking about her painting, always kind of planning ahead and maybe even thinking about what her next painting would be like." As Elaine settled to work in her studio, JoAnne caught sight of the powerful concentration that enabled the artist to drop all other concerns, to set aside her interest in other people and events, and to "just give her whole head and heart to her painting. I watched her start and finish a portrait of President Kennedy— from memory!—in about three hours. I was amazed! I believed after that that Elaine could do impossible things."

Elaine arranged for an assistant to prepare lunch for Bill in his studio, while she gathered house guests and studio assistants in her own house for lunch, a meal often prepared by JoAnne. "Always chicken salad sandwiches or take-out chickens. You know Elaine didn't cook at all, at all," said JoAnne, who calls herself "a definite noncook. So even making a cup of instant decaffeinated coffee was a challenge for the two of us. We giggled a lot in the kitchen. We understood each other." After the community lunches and an hour

or so of leisurely talk, Elaine dispatched Tom Ferrara and the other assistants back to their chores at Bill's studio, and she and JoAnne swam and walked with the dogs.

Each evening, Elaine joined Bill at his studio for dinner, sometimes inviting JoAnne to share their meal. "I was dazzled," admits the assistant. "I thought of them as celebrity movie stars." But she noticed that "Bill was oblivious of anyone. His whole life was his work. And you could smell the supplies and the studio all over the house. It was wonderful."

After dinner, Bill liked to look at television, but JoAnne noticed that Elaine surreptitiously turned down the volume if she thought anything might upset him. "Bill didn't seem to notice. I would see him squinting at the television set and he would say, 'I don't look. I just watch the color.'"

Bill docilely accepted Elaine's administration of his life, and he smiled when she kissed or hugged or patted him. "You could tell that they really loved each other," JoAnne said. "But Bill was good-natured with everybody, and he was like a child when people were affectionate with him. A lot of the time, though, he was more just turned inward, thinking about whatever he thought about, not exactly caring who was around or what was going on."

In an otherwise idyllic summer, two things worried JoAnne: she thought Lisa's presence in Bill's studio seemed to upset Elaine, and she thought Tom Ferrara "worked too much on some of Bill's paintings, was too, like, familiar." Elaine, JoAnne observed, "would stay away from Bill's studio sometimes when Lisa was there. It was like Lisa made Elaine really tense.

"I met Lisa a few times," JoAnne recalls, "but we didn't connect. I knew rumors about how wild she was, how spoiled she was, and I didn't make much effort to know her. And I was bothered, you see, that she upset Elaine. I could tell when Elaine worried. She just wasn't as outgoing. And Elaine was not your quiet person ordinarily."

Elaine told JoAnne that Lisa had spent time in "a home for rich

depressed kids" and that she was mixed up "because her father had been an alcoholic." But, hoping to win Lisa's trust, Elaine offered her opinion that Joan Ward had been too strict with her daughter. She also told JoAnne that Bill, hoping to compensate for Joan's attempts at discipline, had spoiled Lisa too much, and she cited Lisa's spendthrift ways as evidence of Bill's unrelenting generosity to his daughter. As the summer progressed, JoAnne wrote in her journal, "Sometimes Lisa just spends money to impress other kids. She's that insecure. When Tom chauffeured Lisa and a girlfriend around, Lisa spent $600 on a necktie. Another time, Tom says, she gave a man $25,000 and never saw him again."

Elaine introduced Lisa to visiting friends as "Lisa de Kooning, a very good sculptor," and she helped set up a work space and kiln for the blond young woman who lived in her own house on the grounds adjacent to Bill's studio. When friends struggled to discuss politely the childlike clay monsters pressed into being by Lisa, Elaine enthused, "Aren't these terrific? And aren't they like some of Bill's sculpture? I mean, look at the outlines and the masses. I think," Elaine said as she smiled at Lisa, "she's just a terrific artist. And Bill is very proud of her work."

"Lisa is the product of her truly awful childhood," says one sympathetic observer, "a troubled young woman—a not-unpredictable result of her having grown up in the company of alcoholics, probably not even knowing Willem very well." A less sympathetic view is that Lisa is "a spoiled rich brat, addicted to spending Bill's money."

One of Bill's studio assistants believed that "Elaine really loved Lisa, and thought of her as her own daughter. She tried to help Lisa—help her get her life together and grow up." At a New York opening in the early eighties, a young artist assumed that Lisa was Elaine's daughter. Elaine, who did nothing to dissuade him, smiled broadly and said, "Bill and I are very proud of Lisa. She's into animal rights, and she's a terrific, terrific sculptor." On other occasions, when Lisa was not present, Elaine explained that she was "away in New England studying art."

While Bill often seemed vague and "tuned out," he sometimes expressed very strong preferences about food or objected to things he was asked to do. "If he doesn't get his ice cream," Elaine said, "he'll just not sleep very well."

However forgetful Bill might be, he was capable of more serious worries, too. JoAnne sympathized with him, for example, when Elaine asked him to sign some drawings that Xavier Fourcade dropped off, promising to return and pick them up later. Bill's temper flared. "Bill said," JoAnne wrote in her journal, "'He's not getting them. I don't like him—don't trust him.'" Bill, observed JoAnne, felt that Fourcade was "just a businessman, taking advantage," and that he wanted to "keep [his] drawings for [his] estate."

Throughout the summer, JoAnne Lowenthal kept her journal, recording her impressions of Elaine and Bill, of artists and friends who visited them, and of the glimpses her work with Elaine afforded her of the art world. The young painter listened to Elaine's stories about artists, savoring details about the work habits of Fairfield Porter, Wolf Kahn, Arshile Gorky, Philip Guston, Franz Kline, as well as Elaine herself. She noted Elaine's comments about other artists: "Mercedes Matter's drawings have the viscosity of a battlefield"; "Alex Katz uses irritating, arrogant impressions of line and color"; and "Philip Pearlstein paints the flesh of death but at least handles knees and knuckles well."

JoAnne noted, too, the advice Elaine offered. "Listen, JoAnne," she said, "no head on the pillow is better than the wrong head on the pillow." Another time Elaine told JoAnne that the first duty of an artist is to remain physically fit, and then told her "about her own fitness program. She said that she had not always taken care of herself, that once she had drunk too much. But now, she said, she ate right and exercised, and she planned to live to be a hundred and ten."

As the decade began, Elaine painted from her experience with and sketches of the Bacchus sculpture in the Jardin de Luxem-

bourg in Paris. In the summer of 1976, Elaine had gone to Europe for the first time, lived in Paris where she taught a group of American students in summer school, visited museums, and "just fell in love with the sculpture of Bacchus in the Jardin." Daily, she visited the exuberant, naked figures that intertwine in the large stone sculpture; and she sketched, making hundreds of quick notations of the figures and their relationship to the surrounding greenery and landscape.

"I always do my best painting," Elaine mused, "when I'm just totally obsessed with an image, when every work seems to initiate a new work, and when I can think of nothing else but the possibilities of more and more images in a series. Well, that's how it was with the Bacchus sculpture. I was just enchanted. First, I was captured by the big twisting figure, and I thought, well, doesn't he look a lot like Kaldis?

"Then," she continued, "I found out all about Bacchus and it was just too droll. I mean I was absolutely taken with the god of drinking. And so I began to do what I always do when I'm absolutely taken with something. I made drawings. And every day I visited Bacchus and made drawings."

When she returned to the United States, inspired by the Bacchus sculpture, Elaine undertook what was to become a major passage in her work as an artist. Using fast-drying, water-soluble acrylics for the first time, she heightened the values and tones of her palette, emphasizing ultramarine blues and greens, gentle violets, and insistent yellows—all woven and twisted by her fluid, spirited brush. Combining drawing—her sure and exquisite lines serving to knit the composition together—and painting, Elaine's Bacchus series seemed to spring from the wall with energy. She was elated.

When the Bacchus paintings were shown in October 1982, at the Gruenebaum Gallery, longtime de Kooning friend Rose Slivka wrote ecstatically about them and their creator. Slivka, a gifted poet with an uncanny ability to look at paintings through the painter's eyes, recognized that her friend Elaine had taken an

important turn as an artist, noting that "throughout the Bacchus series there is the unity of [a] big form, with the subordinate shapes within it. At the same time, the large, sensuous, voluptuous forms against the foliage and the sky get lost in the action of the colors, color and form going back and forth in an image of interchangeability. The statue of frozen action quivers and dissolves into vibrations of light."[1]

But Elaine not only imbued the work with energy, she drew power from the Bacchus series. Her work leapt onto still another plane when she visited the paleolithic caves of France and Spain in 1983 and 1984. In those primeval images deep beneath the earth, where her imagination lit the cave's darkness and the beasts came alive for her, she felt kinship with the most ancient members of the brotherhood of artists. "I just knew," she said, "how they had felt, what they had seen. I could feel them there in their work. And I knew what it had been like to *see* by fire-flicker a bison or antelope revealed on the surface of the cave walls and ceilings. It was just exactly—I mean *exactly*—the same experience a contemporary painter has when he works and works and, suddenly, *something* appears, mysteriously. And you know then that you've hit the mark."

Elaine, secure in leaving Bill with assistants loyal to her regime for him and realizing sadly that her presence made little difference to him, felt free to travel. And although she visited other parts of the world (notably, Kenya, where she found the modern-day counterparts of the cave animals; Egypt, with Xavier Fourcade; and with her friend Courtney Ross, China and Japan, where she bought Oriental brushes, papers, and inks), no other imagery caught and held her as the Bacchus or the cave animals.

In 1984, Elaine turned to a friend for confidential advice, saying, "I've been thinking about all of the money Bill and I have. How do you set up a foundation?" She explained that she could not discuss the matter with lawyers, saying, "The lawyers are Bill's lawyers. And that's the whole point. I just don't want to see all of

that money go to lawyers." Instead she thought "it should do some good, that it should help younger artists, that it should help the environment, and things like that."

But she emphasized her own primary concern, "I'd like to take care of my family."

When told that trusts could be set up for that purpose with a lawyer's help and with Bill's agreement, Elaine paused, stubbing out one cigarette and lighting another. "Only with Bill's agreement?" she asked.

"Don't I automatically get half of that estate? I mean, even with Lisa and all, doesn't half of it come to me no matter what?" she asked. "Because I just feel that there are people in Bill's life who will try to erase my rights. My legal rights as Bill's wife. I am," she emphasized, "the only one who really puts Bill's interests first."

Bill, Elaine insisted, wanted what she wanted—some sort of trust or foundation that would support noble causes and provide for her family as well as for herself and Lisa. Underlining her certainty about Bill's desires, Elaine said, "I just know that that's what Bill wants."

But, she acknowledged, there was a problem: "If Bill tried to change his will," she speculated, "the lawyers—Lisa—I don't know who else—would *say* that he's not mentally competent, that he can't make that kind of decision now, and I just think they'd use that wedge as a way of taking *total* control of his estate."

Pausing to draw deeply on her cigarette, Elaine added, "There just has to be a way. Look. I *know* Bill is competent, but sometimes he doesn't seem, well, let's say, *with it*. He has always been absentminded, forgetful. But now he's in his eighties and people just tend to think that his forgetfulness is a symptom of senility. But," she added, "I just know Bill, and I know what he wants, and I know that he wants what I'm telling you about.

"Remember that I am entitled by law to half of Bill's estate," she repeated, "and that *I* want to make sure that my family is taken care of."

And then Elaine began to cough. It was a dreadful, deep, and

tearing cough. As she looked up, with tears in her eyes from the coughing, her friend joked, "I don't know, Elaine, if you'll outlast Bill unless you give up those goddamned cigarettes."

"Exactly," said Elaine. And then she laughed.

Elaine's coughing fits, so frequent that she could scarcely utter a sentence without paroxysmal interruptions, worried her friends. But she assured everyone that she was fine, just as she insisted that Bill was fine and "painting better than ever."

But Bill's condition, as reported quietly among close friends, seemed far from normal. Some shook their heads sadly and said simply, "Poor Bill. He's not there."

Elaine Benson says, "Elaine did a very good job of hiding Bill's condition. No one *wanted* Bill to be diminished in any way, especially mentally, especially as a painter. He was a hero to many. And if Bill was not himself, then, well, something very much like the center of a whole movement in art, a whole period in American art history, would have died—and with it the point of living for a whole lot of people who justified what they did by invoking the authority of de Kooning."

Elaine encouraged old friends to visit Bill, to have dinner in the de Kooning studio. "Isn't he remarkable?" she would say. "He paints all of the time. It's a compulsion with him." She would often add an anecdote to bolster the notion that Bill, though suffering from impairment of short-term memory, remained in control of his legendary and vigorous creative powers. Visitors to the de Kooning dinner table noticed, however, that Bill was not always coherent, that Elaine finished sentences for him, that Elaine stopped him in the middle of what might be babble to laugh and exclaim, "Oh, yes, dear. I remember when you said . . ."

At the height of her career, Elaine was beautiful and rich; she had friends and power in the art world; she was recognized as Bill's wife and as an artist in her own right. She was also sick, and despite surgery to remove one lung, she convinced herself that she was invincible. Keeping her illness a secret from everyone

save Marjorie and a very few close friends, Elaine joked about death. When she heard someone say, "Oh, everyone has to die," Elaine responded, "Speak for yourself!"

But behind the positive spirit and the all's-well facade, Elaine knew that her days were numbered. And she counted them as she worried about the future.

On November 5, 1988, Elaine attended the opening of her exhibition of cave paintings at the Fischbach Gallery. Coughing, visibly sick, she told friends that she was recovering from Lyme tick disease, and that she was grieving over the death from AIDS of Aladar Marberger. She lied about her condition so successfully that very few friends knew that she had lung cancer, that she had undergone surgery for the removal of one lung, and that she breathed with difficulty. In obvious pain and unable to talk very much because of her insistent cough, Elaine nonetheless smiled, greeted friends, and accepted congratulations and praise for her exhibition. She watched as the works sold, and she listened as friends and strangers alike talked appreciatively about the new paintings.

She entered the hospital the next day. On February 1, 1989, Elaine de Kooning died of lung cancer in Southampton.

Long-standing friends of Bill and Elaine note with bitterness that Bill's "administrators" refused to pay funeral expenses for Elaine. After the funeral in East Hampton and her interment in the cemetery in the Springs, Elaine's friends gathered at Joan Ward's house—the house Bill had bought from Elaine's brother when he decided to move to Long Island—for food, drink, and shared recollections of Elaine Fried de Kooning.

Bill de Kooning, no longer able to understand things that happened around him and unaware of Elaine's death, did not attend the funeral or the party.

Later, Elaine's Black Mountain (1948) paintings were exhibited by her friend Joan Washburn in her gallery in New York. Joan, who had handled Elaine's work at the Graham Gallery and had cheered her will and fortitude as she quit drinking, shook her head when

asked to discuss Elaine. "No, I can't," she explained. "I've been asked by her estate—and I've agreed—to give no interviews about Elaine. I can only give out an outline chronology. That's the agreement. Until Elaine's memoirs are published."*

Despite such an unusual muzzling of an artist's dealer, Washburn presented Elaine's early paintings to the New York art world. The Metropolitan Museum of Art purchased one; others went to private collectors. Artists, friends, and former students stood in the Washburn Gallery, surrounded by the works of the young Elaine Fried de Kooning, and told stories about her, and told each other that no one would ever be quite like her. They pointed to the biomorphic paintings as evidence of Elaine's early and potent talent.

The exhibition also attracted the notice of *New York Times* critic Roberta Smith, who called the group of seventeen paintings "remarkable" and characterized them as "fresh and lively . . . [looking] almost too good to be true, adding to the history of Abstract Expressionism more than a footnote, if less than a whole new chapter." Noting the influence of Arshile Gorky, John Graham, and Willem de Kooning on the paintings, Smith closed her review with the enigmatic observation that "in their fluid curves, several are eerily similar to Mr. de Kooning's most recent canvases."

* Elaine de Kooning had contracted with a publisher to write her memoirs and had begun to file in her computer passages from her journals, letters, articles, and lectures. After Elaine's death, Marjorie Luyckx took over the editorial responsibilities for her sister's book.

THE DYING KING

Why should anyone see Bill in this state? Why does anyone think he has the right to see Bill suffering and humiliated? Lisa loves her father and he loves her. He is comfortable and seems happy. Isn't that enough?

—**JOAN WARD**

Well before Elaine's death, word had spread that Bill suffered from Alzheimer's disease and that Elaine was taking care of him. Few people knew, however, that Elaine was dying, and that she was worrying about what would happen to Bill's estate. Two weeks after Elaine's demise Lisa de Kooning and lawyer John Eastman (son of longtime de Kooning lawyer Lee Eastman) petitioned the court to be named conservators of his assets, estimated to be worth up to $150 million. They were widely quoted as saying that the eighty-five-year-old painter "continued to paint daily and masterfully" but that "his physical and mental condition prevent him from performing everyday tasks and managing his finances."

Today, de Kooning no longer works. And no one suggests that

"the part of his brain that controls painting is just fine. A left brain right brain thing"; not even his most ardent champions suggest that he still paints "daily and masterfully." Many ask when exactly de Kooning stopped painting; some speculate about when his mental condition—if not "assistance" from others—cast in doubt the authorship of late paintings bearing his signature.

Andy Warhol pointed to de Kooning as an important source of Pop Art. At least in part, de Kooning might also be cited as a model for the Warhol-perfected, media-celebrated persona—the artist as star, cashing in on his particular minutes of fame. De Kooning, no less than Warhol or Marilyn Monroe, has been defined and almost deified in public record. In photographs from the fifties and sixties, Willem de Kooning appears in workmen's clothing: a Navy watch cap pulled over his shaggy gray-blond hair, a sagging heavy-knit dark sweater, the painter's many-pocketed trousers. Pictures from the eighties show a Chaplinesque man: small, frail, frequently smiling self-consciously for the camera, yet still in his signature workmen's outfits, still shaggy-maned.

Friends recall the machismo, often drunken de Kooning of the fifties, and they reconstitute atta-boy images of his turbulent painting. "Look," says Ibram Lassaw, "Bill was one of the most talented artists of his time. He was daring. He had a vision. All of the artists looked to Bill to point the way."

Now, Bill's studio and the artist himself are off limits to the world in general and to the friends accustomed to thinking of themselves as important to Willem de Kooning. Old friends— many of them the painters, sculptors, and writers who make up the art community at the end of Long Island—are frustrated and hurt because they are not permitted to visit the aged painter. They walk or drive past the secluded driveway, and they remember days spent with de Kooning in drinking and conversation.

Some of the artist's oldest friends and most loyal cronies, many of them the aging dukes and earls of de Kooning's kingdom, as well as some of his detractors, note that Bill's life—such as it is—

has changed radically since Elaine died. They claim that Bill is virtually jailed, that he is heavily tranquilized and kept secluded behind the glass walls and sleek lines of the industrial-style studio he designed and built, that his keepers are nurses and others hired to keep him clean, fed, quiet, and out of the world's sight. Bill's old friends claim that Lisa de Kooning and John Eastman, his conservators, keep them from him.

Others, including Lisa de Kooning's mother, Joan Ward, insist that de Kooning's solitude is appropriate for a senile old man, a once mighty lion who is now diapered and unable to recognize or talk with the familiar friends of his sentient days. Moreover, Ward applauds the protective care with which Lisa surrounds her father. His isolation, she says, is what Bill would have wanted for himself.

But Bill probably does not and cannot make decisions for himself. Possibly no one can know what he really wants. His conservators, however, assert that they are doing what is best for the rich and dying king of the art world, and know their roles in ensuring de Kooning dignity and care in his final months or years of life.

Elaine, in the last six months of her life, confided her concerns to a few close friends. Later, the press broadcast questions regarding Bill's condition and Lisa's fitness to manage his affairs. "Since 1983," reported the *New York Times*, "[Lisa] de Kooning, an animal-rights activist and amateur sculptor, has lived in a house her father built for her on his property." Quoting an *Art News* article, the *Times* revealed that Bill's assets included $7 million in real estate, cash, and securities, as well as more than three hundred paintings, with an estimated average worth of between $300,000 and $650,000.[1]

In June 1989, Glenn Collins reported on the "legal drama quietly unfolding in a Long Island courthouse that will decide the fate of a vast and immensely valuable collection of Abstract Expressionist art assembled by one of the century's most prominent painters, Willem de Kooning." Citing the petition and the supporting doctor's affidavit filed by Lisa de Kooning and John Eastman,

the reporter noted, "A court-appointed guardian for Mr. de Kooning has recommended that the artist's daughter not be appointed sole conservator for her father's assets."

Bill's guardian in the proceedings to declare him mentally incompetent, Pierre J. Lundberg, reckoned that Lisa's annual allowance of $375,000 would soon deplete her father's assets. Mr. Lundberg, a lawyer in Riverhead, Long Island, and a former county court judge, visited and interviewed John Eastman, Lisa de Kooning, and Willem de Kooning. He "specifically stated in his report to the judge that 'I cannot recommend that Lisa ever serve as sole conservator,'" and suggested that, should she be named to that role, she be required at all times to serve with a coconservator to be appointed by the court. Mr. Lundberg believed that "as a conservator, she has some potential conflicts," which he indicated arose from "Mr. de Kooning's financial statement, which shows a loan receivable from Ms. de Kooning for $342,523," which "represents monies paid to construct the house on the land previously given to Lisa as a gift."

According to the *Times* report, Eastman and Lisa sought to continue paying Lisa "$25,000 a month—or $300,000 a year—and paying her income taxes which amounts to an additional gift of $75,000 or more a year." When asked why she needed such large sums of money, Lisa, now married to a Canadian-born gardener, replied that she maintained an "apartment in Canada in order to visit her husband's family and an apartment in New York City."

But according to Lundberg, Lisa's "other answers were vague or inconsistent. She said she had to support herself and her family since she had no income from her work, sometimes she just spent a lot of money, she traveled a lot—but then she said she only went to Canada and back, and said she had to pay a lot of money to her lawyers." Lundberg told a reporter, "I object to payments to Lisa and the payment of her income taxes. . . . It only seems reasonable that she be held accountable to pay her own taxes."

Lundberg was not alone in questioning Lisa's suitability to serve as her father's conservator. The *Times* article included infor-

mation long discussed among artists and other friends in the de Kooning circle:

> On May 3, 1985, Ms. de Kooning was cited in reports in several newspapers linking her to a Federal drug investigation of the Hell's Angels in which more than 100 members and associates of the motorcycle gang in a dozen cities were arrested. The operation followed a three-year undercover investigation. . . .
>
> An affidavit filed in Federal District Court . . . said information gained through telephone taps indicated that Ms. de Kooning had a number of drug-related conversations with Hell's Angels members, including Sandy F. Alexander, a Hell's Angels leader. Mr. Alexander and two other Hell's Angels pleaded guilty to narcotics charges in 1985.
>
> Ms. de Kooning was never charged and in 1985, through a spokesman, denied any drug-related activity.

While Lundberg found Bill's handshake firm, the former judge described a mentally impaired old man; he reported that the artist did not concentrate well or respond adequately to questions. The court representative observed Willem de Kooning, amiable and physically robust, read aloud legal papers without understanding them; shake hands numerous times with the same individual, seemingly having forgotten that he had just greeted the man; accept an offer for a cup of coffee but apparently immediately forget or lose interest in the beverage. When asked about receiving the Medal of Freedom from President Lyndon Johnson, de Kooning appeared to have forgotten that honor as well. Lundberg was convinced that, indeed, Willem de Kooning evidenced "mental weakness" that required court-appointed conservators, but he remained troubled by Lisa, the logical appointee, because of her former life-style and associations.

Despite Lundberg's reservations and recommendations, the court appointed Lisa and John Eastman conservators for Willem de Kooning.

In April 1991, the art world's chat about de Kooning's condition—was it Alzheimer's disease? the result of years of alcoholic insult to the brain? simple old-fashioned senility?—spilled again into the media when *Esquire* featured an article on the de Kooning drama. The article raised hackles in a number of stake-outs in the unclaimed territories of vested interest and elicited bleats of pain and anger from lawyers, dealers, collectors, and other artists, as well as from individuals with real or imagined claims on the de Kooning fortune and reputation. The author, Robert Katz,* wrote:

> His illegitimate daughter, the world's top art dealers, two white-shoe lawyers, and a Hell's angel all want a piece of ailing Willem de Kooning. Millions of dollars are at stake. At the center of the storm, the master watches.[2]

Esquire's unpretty picture outlined again daughter Lisa's capricious behavior and trouble with the law, her record of profligate spending of millions of dollars Bill doled out as allowances and salary for representing him at social and professional gatherings, her highly visible and eyebrow-raising association with a Hell's Angel drug dealer who had received a loan of money from Bill under clouded circumstances, and her public and private capers.

In petitioning to control her father's affairs, assisted by "white-shoe" lawyers, Lisa brandished her birth certificate—on which Willem de Kooning is listed as father—as proof of her claim to be the artist's sole heir, which in turn justified her claim over the de Kooning assets and affairs. With Elaine dead, will anyone legally contest Lisa's right to the de Kooning estate? Can anyone do so?

Now Willem de Kooning, a nearly ninety-year-old man described often as "the greatest living American painter" or as "the American Picasso," awaits his death in his grand, shiplike stu-

* Katz was described by *Esquire* as "no stranger to the dark side of the art world," with a book on the Carl Andre case, *Naked by the Window,* to his credit.

dio. The Dutch-born American Abstract Expressionist is legally incompetent and in the care of his daughter, Lisa, and lawyer John Eastman, who have admitted very few visitors to see de Kooning since they took over management of his affairs.

Neither Eastman nor Lisa de Kooning grant interviews, but they monitor Bill's reputation as galleries vie to show his work and as museums and private collectors compete to purchase de Koonings.

But Bill's old friends—Ernestine and Ibram Lassaw among them—pass the entry to the long drive leading to his studio, and they remember the artist who inspired Abstract Expressionism. "I try not to think about how Bill might feel," says Ibram, "if he feels anything now."

FALLING CHIPS

Bill de Kooning is dying a terrible, terrible death.

—ROBERT DASH

The de Kooning affair is a deadly serious matter. Fortunes are at stake, as are the reputations on which they rest. The drama surrounding Willem and Elaine de Kooning is part of a larger drama—that of the art world game, where uncertain rules guide the unregulated business of buying and selling art—whether through dealers or auction houses. The value of a work of art is determined by the reputation of the artist and by the prices fetched by similar works of art. The art game of buying and selling works of art—of manipulating their value upward—is played on an international scale, with high stakes and some very wild jokers wheeling and dealing alongside truth-believing innocents, willing dupes, and outright charlatans.

The art world, a microcosm of American capitalism, is shaped and colored by vast sums of money. And Willem de Kooning's worldly empire is based on paintings that, inch for inch, are worth

more than dollars. During his life as a painter, Willem de Kooning earned many millions of dollars and, moreover, built up a reservoir—an inventory—of paintings to be sold in the future for hundreds of millions of dollars. About four months before Elaine de Kooning died, a painting by Bill had sold for $2 million; and, slightly later, another fetched a staggering $20 million in auction. The artist's collection of his own works would be worth a considerable fortune by any measurement.

But Willem de Kooning's paintings, like all paintings, depend for their value on the artist's reputation and on his signature style: a de Kooning painting would not be valuable if, in fact, it had not been painted by the master himself. Quietly and insistently, talk spreads in the art world, and questions are raised: When did Bill actually stop painting? And when is a de Kooning not a de Kooning? Have his late paintings been sold as de Kooning's work when, in fact, they are not from his hand and mind?

One of Bill's friends, another artist, said bluntly, "The recent works are not—NOT—by Bill. I mean, look at them, for Christ's sake. Bill would not have gone that way; there is no logical progression at all. The new 'de Koonings' came from someone else. Bill did NOT do them."

When asked who might have done them, the artist shrugs his shoulders. "Who, indeed, would have the most to gain? Who would want to harm Bill—and that's what this does, it harms Bill by putting a shadow on his reputation, on his accomplishments as an artist. The so-called last de Koonings are thin soup." The late paintings, he argues, are "lamentable, just terrible. To attribute them to Bill is sinful."

De Kooning contemporary and old-hand Abstract Expressionist John Opper, however, does not believe it possible for anyone other than de Kooning himself to have authored the late works. "Bill's a genius. He's one of a kind. No one else can go where he has gone in painting."

But inquisitive skeptics in the art world ask, When did Willem de Kooning actually stop painting? And, they wonder, why was this

most important of living artists cloaked in secrecy—presumably fabricated by his legal wife, Elaine—while it was said that he painted compulsively, his changing style fueled by the part of his mind that controlled painting, the part that remained unimpaired by the "mental weakness" that threatened every other function in his life?

A dealer familiar with the art world and openly admiring of Bill as a painter and Elaine as "a world-class creator of myth—the Bill de Kooning myth"—agrees that some of the recent paintings could not be totally from the master's hand; or, if technically from his hand, not from the same mind—the Willem de Kooning mind—that created the masterworks associated with the artist. Moreover, this dealer conjectures, paintings largely (at least) created by others have been knowingly presented as paintings by de Kooning. "It could have been innocent," he admits. "That is, someone could have decided to give Bill a little help here, a little help there, until the whole canvas was saturated with that help, and not with Bill's actions and decisions. But in the end, paintings in which Bill had only a small role could hardly be called 'de Koonings,' could they?"

If Elaine had lived, her friends point out, Bill's "mental weakness" would never have been an issue. Moreover, just as Elaine hid Bill's condition from the world, friends speculate, she would have protected Lisa from the bad press that has dogged her in recent years. They are certain Elaine would have orchestrated Bill's (and perhaps Lisa's) life and would have kept Bill's myth intact, Lisa's youthful indiscretions in perspective. Moreover, questioning neither the quality nor the bona fides of Bill's late work, they believe Elaine would have continued organizing exhibitions of fresh work from his studio. A number of artists agree with Grace Hartigan, who says, "Bill was Elaine's master—you know, in the way artists have masters—and she admired and cared for him more than anyone. She was loyal to the *idea* of Bill, really an *idea* she helped create."

Friends of the de Koonings say admiringly, "Elaine kept him alive"; others say somewhat sourly, "Elaine kept the world away from Bill so that no one would know the extent of his mental deterioration." Friends say that Elaine selflessly served a great artist who happened also to be the husband she had never ceased loving ardently. Less friendly commentators suggest that Elaine—who insisted that she, as a painter, did not stand in Bill's shadow but in his light—furthered her own considerable ambition by affixing herself to him in the public mind.

Both sides agree on one point: Elaine was effective in furthering Willem de Kooning's reputation as the "greatest living American artist." And both sides agree—in different words and from different perspectives—that that is exactly what she did from the time she met Willem de Kooning in the thirties. Her motive—some say love of Bill, others say love of power over Bill—went with her to her grave in the Springs cemetery. Even during the bad times, friends assert, when Bill and Elaine were separated and were both snared in severe alcoholism, Elaine "worked for Bill."

Further, friends say, Elaine was fourteen years younger than he was—she expected to outlive him. Yes, answer Elaine's detractors, that expectation had been shared by Elaine's friends and family who enjoyed her largesse, who benefited from Elaine's gifts and support—all of which came from money earned by Bill's paintings. "Look," says one detractor, "if Elaine had outlived Bill—as everyone expected—she would have been his legal widow and, under New York State law, would have inherited 50 percent of his estate. No matter what. No questions asked. But now," he adds, "Jesus! What a mess." Just as Elaine's death threw into disarray her process of promoting the perception that Bill had withdrawn to devote all his energy to his last—and possibly greatest—works, it also removed a contender for his sizable fortune.

And what of Elaine's estate? "Well," says a collector, "Elaine was never the painter Bill was, and never had his reputation. Aside from her portraits—which, at least, are interesting because of her

facility—her work isn't much to brag about. Think. If she had not had the name—the de Kooning name—would anyone look twice at her paintings?"

Aladar Marberger, Elaine's dedicated dealer, had insisted, "Elaine is a great painter. She knows fucking everything about painting, and about life, and her paintings are full of life, full of energy, full of Elaine! She has spirit and class; her paintings have spirit and class."

Rose Slivka—poet, art critic, and close friend of Elaine—wrote for the catalog that accompanied Elaine de Kooning's posthumous traveling exhibition:

> Elaine de Kooning was always at the beginning of seeing, never finished with looking, extracting from the same scene the same seed of surprise. She liked to go against the grain, trusting the tension, the dialectics of the painting's resistance to the painter. Activating diagonal fields of strokes, she swept into motion the optic undertow that galvanized her works from the last forty years.

Elaine had expressed to close friends that she did not get along with Bill's lawyers, but she was wary of antagonizing them. True, says an old friend and respected art critic, "Bill's lawyers never liked Elaine," and now "they are doing everything they can to expunge Elaine from the record, to pretend that she didn't exist, and to drop her from Bill's history and life."

But separating Elaine and Bill in death will not be easy, any more than it was in life. Today, Willem de Kooning looms as a mythic genius and the quintessential mid-twentieth-century painter. And in the tribal society of the art world, Bill and Elaine ruled as the king and queen of Abstract Expressionism. Whatever history's verdict on their individual status as artists in the twentieth century, their separate fortunes are likely to be considerable, and their fame is secure. And, in the tangle of anguish, spite, and greed that defines the art world and encircles Elaine and Bill, no one denies the role of money. Or fame.

NOTES

Unless otherwise noted, material quoted throughout the book is from interviews, conversations, and letters to the author. Persons interviewed and spoken with are identified below for each chapter.

Several sources strictly requested anonymity, a condition honored by the author throughout the book; other individuals are noted by initials, as follows:

EdeK: Elaine de Kooning
WdeK: Willem de Kooning
WB: Will Barnet
EB: Elaine Benson
NB: Nell Blaine
JB: James Bohary
AB: Arlene Bujese
RB: Rudolph Burckhardt
LCA: Larry Castagna
LC: Leo Castelli
RD: Robert Dash
RsD: Roslyn Drexler
SD: Sherman Drexler
AE: Andre Emmerich
TF: Tom Ferrara
CF: Connie Fox
MG: Midi Garth
KG: Karen Gunderson
GH: Grace Hartigan
WK: William King
EL: Ernestine Lassaw
IL: Ibram Lassaw
ML: Millie Liss
JL: JoAnne Lowenthal
RM: Robert Mallary

PM: Priscilla Morgan
JO: John Opper
BS: Barbara Schwartz
SS: Saul Steinberg
HS: Hedda Sterne
EV: Esteban Vicente
JW: Joan Ward
JuW: Julian Weissman

THE EARLY YEARS

ELAINE AND BILL
Conversations with EdeK, EL, IL, WB, NB, MG, and GH.

BILL'S WORLD
1. Conversations with RD, EV, and EdeK.
2. EdeK repeated these observations (probably made initially to refute suggestions that WdeK's *Woman* paintings resulted from his feelings about EdeK) several times to the author. The same description appears in April Kingsley, *The Turning Point,* p. 339 (New York, 1992); and Jeffrey Potter: *To a Violent Grave,* pp. 67–68 (New York, 1987).
3. Ken Wilkie, "Willem de Kooning: Portrait of a Modern Master," *Holland Herald* 17, no. 3 (1982): 24.
4. Wilkie, 24, 28.
5. David Sylvester, "Interview with Willem De Kooning," *Location* (1963): 45.
6. Wilkie, 28.
7. Sylvester, 45.
8. Wilkie, 28.
9. Ibid.
10. Ibid.
11. Ibid.
12. De Kooning remained friends with the artists until their deaths: Gorky, 1948; Davis, 1964; and Graham, 1961.
13. *Art News* 72, no. 5 (1972): 54.
14. In 1937, Graham published *System and Dialectics of Art,* a book that incited discussion and fixed his reputation as an intellectual leader among artists of his day.
15. Sylvester, 46.

ELAINE'S WORLD
Extensive conversations with EdeK, EL, and IL. EdeK seminars with author's students at Drew University and State University of New

York—College at Purchase. Additional comments by EB, GH, NB, and RB.
1. Televised interview for LITV of Elaine Benson and Elaine de Kooning.

ONE AND ONE
Conversations with EdeK. Interviews with RB, NB, GH, EV, EL, and IL.
1. WdeK, quoted in Jeffrey Potter, *To a Violent Grave: An Oral Biography of Jackson Pollock* (New York, 1987), p. 229.
2. Ibid.
3. John Gruen, *The Party's Over Now* (New York, 1972), pp. 208–209.
4. Ibid., 209.
5. Marjorie Luycks, "Elaine de Kooning: A Chronology," catalog, University of Georgia, 1992.

GATHERING FORCES TOGETHER
Conversations with EdeK, Harold Rosenberg, Tom Hess, and Rose Slivka. Interviews with RB, EV, IL, and EL.

ART WORK
Conversations with EdeK, SD, RB, EV, IL, and EL.
1. Gruen, 209.
2. Ibid.
3. Ibid., 211.
4. Wilkie, 28.

THE SCENE

ELAINE AND BILL AND HAROLD AND TOM AND CHARLIE IN 1948
Conversations with EdeK, RB, and Harold Rosenberg.
1. Gruen, p. 206.
2. As quoted in "Our Box Score of the Critics," *Art News* 47, no. 2 (April 1948): 52.
3. Ibid.
4. Ibid.
5. Review by Renee Arb, *Art News* 47, no. 2 (April 1948).
6. Clement Greenberg, "Art," *The Nation* 116 (April 24, 1948): 448.

WIDENING THE CIRCLE
Conversations with EdeK. Interviews with IL, EL, JO, SD, RD, HS, and EV.

THE CLUB AND THE CEDARS
Conversations with EdeK. Interviews with IL, EL, JO, SD, EV, RD, and EB.
1. Willem de Kooning, "What Abstract Art Means to Me," written for a sym-

posium at the Museum of Modern Art, February 5, 1951. Published in *The Bulletin of The Museum of Modern Art*, pp. 4–5.
2. Ibid.

THE SHAPE OF WORDS
Conversations with Harold Rosenberg, Tom Hess, and EdeK. Interviews with SD, RD, HS, MG, and NB.
1. Harold Rosenberg, *The De-definition of Art* (New York, 1972), p. 55.
2. "Artists' Statements at Studio 35 (1950)," in *Modern Artists in America*, edited by Robert Motherwell and Ad Reinhardt, first series (New York, 1951), pp. 12–22.
3. Elaine de Kooning, review of Jackson Pollock, *Art News* 47, no. 1 (March 1949): 44.
4. Elaine de Kooning, "David Smith Makes a Sculpture," *Art News* (September 1951).
5. Harold Rosenberg, "The American Action Painters," *Art News* (December 1952).
6. Thomas Hess, "De Kooning Paints a Picture," *Art News* (March 1953), accompanied by photographs by Rudolph Burckhardt.

WHO SHALL WEAR THE CROWN?
Conversations with EdeK. Interviews with SD, RD, HS, JO, EV, AE, LC, NB, and GH.
1. Thomas B. Hess, "8 Excellent, 20 Good, 1133 Others," *Art News* 48, no. 9 (January 1950): 34.
2. Deborah Solomon, *Jackson Pollock: A Biography* (New York, 1987), p. 225.
3. Ibid., 701.

THE KINGDOM COMES

THE KING OF ALL HE PURVEYS
1. Carter Ratcliff, "Willem de Kooning," *Art in America* (Summer 1984): 122.
2. Willem de Kooning, "The Renaissance and Order," written in 1950 for a lecture series at Studio 35 in New York; published in *Transformation* 1, no. 2 (1951); quoted in Thomas B. Hess, *De Kooning*, pp. 141–143.
3. *The Journals of Ethel Schwabacher,* being edited by Judith Evelyn Johnson and Brenda S. Webster, in preparation for publication by Indiana University Press.
4. Leo Steinberg, *Other Criteria: Confrontations with Twentieth Century Art* (New York, 1972), p. 260.
5. Otis Gage, "The Reflective Eye: The Success of the Failure," *Art Digest* 27 (April 15, 1953): 4.

6. Robert M. Coates, "The Art Galleries," *The New Yorker* 29 (April 4, 1953): 96.
7. "Big City Dames," *Time* 61 (April 6, 1953): 80.
8. Harry F. Gaugh, Interview with Sidney Janis, New York, April 8, 1971, from his *De Kooning* (New York, 1983).

LORDS AND LADIES OF THE REALM: PRIVATE LIVES, PUBLIC VIEWS
Conversations with EdeK. Interviews with RD, GH, JO, EV, IL, EL, NB, SD, RsD, RD, HS, and JW.
1. From an unpublished dissertation, quoted by Dore Ashton; *American Art Since 1945* (New York, 1982), p. 37.

THE RULE OF BOOZE
Conversations with EdeK and Harold Rosenberg. Interviews with EB, NB, RD, SD, GH, EL, IL, JO.

A KINGDOM DIVIDED: UNEQUAL PARTS

THE QUEEN IS IN HER PARLOR
Conversations with EdeK. Interviews with SD.

THE KING'S PLEASURE
Conversations with EdeK. Interviews with EB, RD, AE, GH, RM.
1. *Art Journal* 48, no. 3 (Fall 1989): 232.
2. Curtis Bill Pepper, "The Indomitable de Kooning," *New York Times Magazine* (November 20, 1983): 6.43–47, 70–72.
3. Gruen, 203–204.
4. Harriet and Rudi Blesh, *De Kooning* (New York, 1960), p. 61.
5. Seldon Rodman, *Conversations* (New York, 1957), p. 102.
6. Vivien Raynor, "In the Galleries—Joseph Cornell, Willem de Kooning," *Arts Magazine* 39 (March 1965): 53.
7. Harold Rosenberg, "Interview with Willem de Kooning," *Art News* 71, no. 5 (September 1972): 58.
8. Ibid., 57.

THE KING IS IN THE COUNTING HOUSE
Conversations with EdeK, Aladar Marberger, and Xavier Fourcade. Interviews with EB, CF, WK, RD, JO, SD, RsD, KG, GH, HS, EV, and BS.
1. From an interview for the BBC with David Sylvester; quoted in Thomas B. Hess, *Willem de Kooning* (New York, 1959), p. 50.
2. Grace Glueck, "A Tenth Street Loft in the Woods," *New York Times* (July 25, 1965).
3. Stuart Preston, "New Frontiers," *New York Times* (March 11, 1962).

4. Stuart Preston, "Drawings and Paintings," *New York Times* (October 28, 1962).
5. Milton Esterow, "Willem de Kooning Files Suit Against Art Dealer," *New York Times* (March 31, 1965). The suit against Janis was settled out of court, and, in 1972, as part of the condition of the settlement, the dealer mounted a solo exhibition of the artist's work, including his sculpture, which was shown for the first time.
6. Ibid.

MEANWHILE ELAINE . . .

Conversations with EdeK. Interviews with EB, CF, BS, RD, SD, RsD, RM, WK, GH, NB, AE, and LC.
1. Elaine de Kooning, review of exhibition by Frederick Sommer, Egan Gallery, *Art News* 47, no. 10 (February 1949): 44.
2. Elaine de Kooning, review of Ary Stillman's show at Bertha Shaeffer, *Art News* 47, no. 10 (February 1949).
3. Elaine de Kooning, review of Melville Price's show at Peridot Gallery, *Art News* 47, no. 10 (February 1949).

THE ONCE AND FUTURE KINGDOM

THE FRAGILE HARMONY: TOGETHER AGAIN

Conversation with EdeK. Interviews with EB, EL, IL, RD, JL, JO, RB, GH, and EV.

THE TREASURY OF THE KING

Conversation with EdeK. Interviews with EV, BS, JL, GH, JO, IL, EL, RB, and AE.
1. Avis Berman, "Willem de Kooning: 'I am Only Half Way Through,'" *Art News* (February 1982): 71.
2. *New York Times* (April 26, 1979).

BILL'S REALM

Interviews with JL, LC, SD, RD, RM, EB, JO, EV, IL, and EL.
1. Peter Schjeldahl, "De Kooning Alone," *Art Journal* 48, no. 3 (Fall 1989): 247.
2. Rita Reif, "De Kooning Work Sold," *New York Times* (November 2, 1984).
3. John Russell, "Art: Lively Competitor to the Old de Koonings," *New York Times* (April 26, 1982).
4. Peter Schjeldahl, "Delights by de Kooning," *Village Voice* (April 13, 1982): 79.
5. Russell, "Art: Lively Competitor."

6. Grace Glueck, "De Kooning Retrospective of 60 Years at Whitney," *New York Times* (December 16, 1983).

7. John Russell, "De Kooning's Freedom Came Step by Exuberant Step," *New York Times* (February 5, 1984).

8. John Russell, "Art: The Sculpture of Willem de Kooning," *New York Times* (May 20, 1983).

9. Vivien Raynor, "Art: Recent de Koonings," *New York Times* (June 8, 1984).

10. "Architectural Digest Visits: Willem de Kooning," *Architectural Digest* (January 1982): 58–66.

EXIT ELAINE

Interviews with GH, EB, RD, CF, JL, EV, SD, RsD, IL, EL, JO, TF, and WK.

1. Rose Slivka, "Elaine de Kooning: The Bacchus Paintings," *Arts Magazine* (October 1982): 66–69.

THE DYING KING

Interviews with EL, IL, RD, JL, EV, JO, CF, WK, TF, LCA, and JW.

1. Associated Press, "De Kooning's Daughter Seeks Control of His Assets," *New York Times* (May 23, 1989).

2. Robert Katz, "Not a Pretty Picture," *Esquire* (April 1991): 110–118, 151.

EPILOGUE: FALLING CHIPS

Interviews with RD, RM, AE, LC, LCA, SD, RsD, IL, EL, EV, GH, and JO.

BIBLIOGRAPHY

GENERAL WORKS

Arnason, H. H. *History of Modern Art,* p. 498 *et passim.* New York, 1968; rev. and enl., pp. 522–523 *et passim.* New York, 1977.

Art Since Mid-century: The New Internationalism. Vol. 1, *Abstract Art,* with remarks on de Kooning by Werner Haftmann, Lucy Lippard, Michel Ragon, and Irving Sandler; Vol. 2, *Figurative Art,* with remarks on de Kooning by Mario Amaya, Jean Drypreau, Emil Langui, and Wieland Schmied. Greenwich, Connecticut, 1971.

Ashton, Dore. *The Unknown Shore.* Boston, 1962.

———. *The New York School.* New York, 1972.

———. *American Art Since 1945.* New York, 1982.

Bledsoe, Jane K., ed. *Elaine de Kooning,* with essays by Lawrence Campbell, Helen A. Harrison, and Rose Slivka. Athens, Georgia, 1992.

Cummings, Paul. *A Dictionary of Contemporary American Artists,* p. 98. New York, 1966.

Denby, Edwin. "Willem de Kooning." In *Dancers, Buildings and People in the Streets,* pp. 267–276. New York, 1965; abr. version published as "My Friend de Kooning," in *Art News Annual* 29(1963): 82–89.

Duberman, Martin. *Black Mountain: An Exploration in Community,* pp. xi, 291, 293, 294, 296, 301–302, 347, 528, 546. New York, 1973.

Feldman, Edmund Burke. *Art as Image and Idea.* New Jersey, 1967.

Geldzahler, Henry. *American Painting in the Twentieth Century,* with excerpt from earlier text by de Kooning. New York, 1965.

Hunter, Sam. *American Art of the Twentieth Century.* New York, 1972.

Kozloff, Max. "The New American Painting." In *The New American Arts,* edited by Richard Kostelanetz, pp. 88–116. New York, 1965.

———. *Renderings: Critical Essays on a Century of Modern Art.* New York, 1968. Reprints of earlier texts.

Kramer, Hilton. *The Age of the Avant-Garde.* New York, 1973.

Landau, Ellen G. *Jackson Pollock.* New York, 1989.

Lerner, Abram, ed. *The Hirshhorn Museum and Sculpture Garden,* pp. 501,

502, 531, 532, 591, 681, 699, 727, 971, with remarks on de Kooning by Milton W. Brown, Irving Sandler, and Dore Ashton. New York, 1974.

Lucie-Smith, Edward. *Late Modern: The Visual Arts Since 1945,* pp. 40, 45, 48, 60, 86, 224. New York, 1969.

Naifeh, Steven, and Smith, Gregory White. *Jackson Pollock: An American Saga.* New York, 1989.

O'Doherty, Brian. *Object and Idea: An Art Critic's Journal, 1961–67,* pp. 87–91, 99, 219; reprints of earlier texts. New York, 1967.

Rose, Barbara. *American Art Since 1900: A Critical History.* New York, 1967; rev. and enl., New York and Washington, D.C., 1975.

———. *American Painting: The Twentieth Century.* Geneva, 1970.

Rosenberg, Harold. *The Anxious Object: Art Today and Its Audience,* pp. 109–129 *et passim,* reprints of earlier texts. New York, 1964.

———. *Artworks and Packages,* pp. 157–170 *et passim,* reprints of earlier texts. New York, 1969.

———. *The De-definition of Art.* New York, 1972.

Rubin, William. *Dada and Surrealist Art,* pp. 19, 393, 394, 407, 409, 446. New York, 1969.

Sandler, Irving. *The Triumph of American Painting: A History of Abstract Expressionism,* pp. 122–137 *et passim.* New York, 1970.

Schapiro, Meyer. *Modern Art.* New York, 1982.

Sylvester, David, ed. *Modern Art: From Fauvism to Abstract Expressionism,* pp. 75–77, 204–205. New York, 1965.

Tauchman, Maurice. "Willem de Kooning." In *Peintres contemporains,* edited by Bernard Dorival, pp. 204–207. Paris, 1964.

Varnedoe, Kirk. *A Fine Disregard.* New York, 1990.

NEWSPAPERS AND PERIODICALS

Alloway, Lawrence. "Sign and Surface: Notes on Black and White Painting in New York." *Quadrum,* no. 9 (1960): 49–62.

———. "De Kooning: Criticism and Art History." *Artforum* 13 (January 1975): 46–50.

Armstrong, Richard. "Abstract Expressionism Was an American Revolution." *Canadian Art* 21, no. 5 (September/October 1964): 266–269.

Artforum 4, no. 1 (September 1965). Special New York School issue, with the following articles:

Alloway, Lawrence. "The Biomorphic Forties."

Kozloff, Max. "An Interview with Friedel Dzubas."

Rose, Barbara. "The Second Generation."

Tillim, Sidney. "The Figure and the Figurative in Abstract Expressionism."

Ashberry, John. "Willem de Kooning: A Suite of New Lithographs Trans-

lates His Famous Brushstroke into Black and White." *Art News Annual: Painterly Painting* 37 (1971): 117–128.

Ashton, Dore. "Willem de Kooning, Homo Faber." *Arts Magazine* 50, no. 5 (January 1976): 58–61.

Bannard, Darby. "Cubism, Abstract Expressionism, David Smith." *Artforum* 6, no. 8 (April 1968): 22–32.

Battcock, Gregory. "Willem de Kooning." *Arts Magazine* 42, no. 2 (November 1967): 34–37.

Beeren, W. A. L. "Nieuw aspecten van het realisme." *Museumjournaal* 10 (1964–1965): 70–81; French summary, p. 84.

Bowness, Alan. "The American Invasion and the British Response." *Studio International* 173, no. 890 (June 1967): 285–293.

Calas, Nicolas. "Venus: De Kooning and the Woman." *Arts Magazine* 43, no. 6 (April 1969): 22.

"Cash Expressionism." *Newsweek* (April 12, 1965): 96.

Dalí, Salvador. "De Kooning's 3000,000.000th Birthday." *Art News* 68, no. 2 (April 1969): 56–57, 62–63.

Davis, Doublas. "De Kooning on the Upswing." *Newsweek* (September 4, 1972): 70–73.

"De Kooning World Sold to Australia." *New York Times* (September 28, 1974): 27.

Denby, Edwin. "My Friend de Kooning." *Art News Annual* 29 (1964): 82–99, 156; reprinted as "Willem de Kooning," in Denby, *Dancers, Buildings and People in the Streets*.

Dickerson, George. "The Strange Eye and Art of de Kooning." *Saturday Evening Post* (November 21, 1964): 68–71.

Esterow, Milton. "Willem de Kooning Files Suit Against Art Dealer." *New York Times* (March 31, 1965), p. 11.

Feldman, Morton. "Give My Regards to Eighth Street." *Art in America* 59, no. 2 (March/April 1971): 96–99; reply: Clement Greenberg. "Letters: Mr. Greenberg Revises." *Art in America* 59, no. 5 (September/October 1971): 20.

Finkelstein, Louis. "Gotham News." *Art News Annual* 34 (1968): 114–122.

Glueck, Grace. "Art Notes: A Tenth Street Loft in the Woods." *New York Times* (July 25, 1965): 2.11.

Goldin, Amy. "Abstract Expressionism: No Man's Landscape." *Art in America* 64, no. 1 (January/February 1976): 77–79.

Goldwater, Robert. "Master of the New." *Partisan Review* 29 (Summer 1962): 416–418.

Greenberg, Clement. "Art." *The Nation* (April 24, 1948): 448.

Harrison, Charles. "Abstract Expressionism I." *Studio International* 185, no. 951 (January 1973): 9–18.

Hess, Thomas B. "De Kooning Paints a Picture." *Art News* 51 (December 1952): 22–23, 48–50.

————. "De Kooning's New Women." *Art News* 64, no. 1 (March 1965): 36–38.

————. "Pinup and Icon." In *Woman as Sex Object: Studies in Erotic Art 1730–1970*, pp. 222–237. New York, 1972. Softcover edition published as *Art News Annual* 38 (1972).

————. "Four Pictures by de Kooning at Canberra." *Art and Australia* 14, nos. 3–4 (January and April 1977): 289–296.

Hunter, Florence. "Letters." *Art in America* 62, no. 4 (July/August 1974): 112.

Hunter, Sam. "Abstract Expressionism Then—And Now." *Canadian Art* 21, no. 5 (September/October 1964): 266–269.

————. "De Kooning." *L'Oeil*, no. 244 (November 1975): 74–75.

Hutchinson, Peter. "De Kooning's Reasoned Abstracts." *Art and Artists* 3, no. 2 (May 1968): 24–27.

Kozloff, Max. "The Impact of de Kooning." *Arts Yearbook: New York, the Art World*, no. 7 (1964): 76–88.

————. "The Critical Famework." *Artforum* 5, no. 1 (September 1966): 36–55.

Kuh, Katharine. "The Fine Arts: Denials, Affirmations, and Art." *Saturday Review* (May 31, 1969): 41–42.

Laported, Paul. "Turner to de Kooning: Non-Euclidian Geometry to Quantum Theory." *Bulletin of the New York Public Library* 79, no. 1 (Autumn 1975): 4–39.

Larson, Philip. "Willem de Kooning: The Lithographs." *Print Collector's Newsletter* 5, no. 1 (March–April 1974): 6–7.

Marchiori, Giuseppi. "De Kooning et l'Europe." *XXe Siecle*, no. 40 (June 1973): 110–115; English summary, p. 189.

Namuth, Hans. "Willem de Kooning, East Hampton, Spring, 1964." *Location* 1, no. 2 (Summer 1964): 27–34.

O'Doherty, Brian. "De Kooning: Grand Style." *Newsweek* (January 4, 1965): 56–57.

————. "Willem de Kooning: Fragmentary Notes Towards a Figure." *Art International* 12, no. 10 (Christmas 1968): 21–29.

"Prisoner of the Seraglio." *Time* (February 26, 1965): 74–75.

Ratcliff, Carter. "Willem de Kooning." *Art International* 19, no. 10 (December 20, 1975): 14–19, 73.

————. "New York Letter." *Art International* 20, nos. 4–5 (April/May 1976): 51–56, 74.

Rosemarch, Stella. "De Kooning on Clay." *Craft Horizons* 32, no. 6 (December 1972): 34–35.

Rosenberg, Harold. "The Art Galleries: 'Painting Is a Way of Living.'" *New Yorker* (February 16, 1963): 126–137.

————. "De Kooning." *Vogue* (September 15, 1964): 146–149, 186–187.

————. "The Art World: Art of Bad Conscience." *The New Yorker* (December 16, 1967): 138–149; reprinted in 1969 as a book.

Rubin, William. "Arshile Gorky, Surrealism and the New American Painting." *Art International* 7, no. 2 (February 25, 1963): 27–38.

Ruchs, R. H. "Willem de Kooning: The Quest for the Grand Style." *Delta* 13, no. 2 (Spring 1970): 29–44.

Schjeldahl, Peter. "De Kooning's Sculptures: Amplified Touch." *Art in America* 62, no. 2 (March/April 1974): 59–63.

Sollers, Phillippe. "Pour de Kooning." *Art Press International,* no. 11 (October 1977), n.p.

Steinberg, Leo. "Month in Review: Willem de Kooning Shows Recent Painting in 'Woman' Series. . . ." *Arts* 30 (November 1955): 46–48.

Swenson, G. R. "Peinture americaine 1946–1966." *Aujourd'hui* 10, nos. 55–56 (January 1967): 156–157; English summary, p. 3.

Sylvester, David. "De Kooning's Women." *Studio International* 176, no. 906 (December 1968): 246–251.

Wilkie, Ken. "Willem de Kooning: Portrait of a Modern Master." *Holland Herald* 17, no. 3 (1982): 22–31.

Willard, Charlotte. "In the Galleries." *New York Post* (August 23, 1964): 44.

————. "De Kooning: The Dutch-Born U.S. Master Gathers in the International Honors." *Look* (May 27, 1969): 54–59.

Yard, Sally E. "Willem de Kooning's Women." *Arts* 53 (November 1978): 96–101.

————. "Willem de Kooning's Men." *Arts* 56 (December 1981): 134–143.

MONOGRAPHS

Arkus, Leon. *Willem de Kooning* (exhibition catalog, Pittsburgh Museum of Art); includes statements by and interview with the artist. Pittsburgh, 1979.

Blesh, Rudi, and Janis, Harriet. *De Kooning.* New York, 1960.

Cummings, Paul; Merkert, Jorn; and Stoulling, Claire. *Willem de Kooning: Drawings, Paintings, Sculpture* (exhibition catalog, Whitney Museum of American Art). New York, 1983.

Denby, Edwin. Untitled essay. In *The 30's: Painting in New York,* edited by Patricia Passloff (exhibition catalog, Poindexter Gallery). New York, 1957.

Drudi, Gabriella. *Willem de Kooning.* Milan, 1972.

Gaugh, Harry F. *De Kooning.* New York, 1983.

Hess, Thomas B. *Willem de Kooning.* New York, 1959.

————. *De Kooning: Recent Paintings.* New York, 1967.

————. *Willem de Kooning* (exhibition catalog, Museum of Modern Art); includes statements by the artist. New York, 1968.

————. *Drawings of Willem de Kooning.* Greenwich, Connecticut, 1972.

————. *Willem de Kooning Drawings.* Greenwich, Connecticut, 1972.

Larson, Philip, and Schjeldahl, Peter. *De Kooning: Drawings/Sculptures* (exhibition catalog, Minneapolis Walker Art Center). New York, 1974.

Rosenberg, Harold. *De Kooning.* New York, 1974; excerpt reprinted in Richard Gray Gallery, Chicago, exhibition catalog, 1974; includes statements by and interview with the artist.

Schjeldahl, Peter. *De Kooning: Paintings, Drawings, Sculpture 1967–1975* (exhibition catalog). Florida, 1975.

Waldman, Diane. *Willem de Kooning in East Hampton* (exhibition catalog). New York, 1978.

Willem de Kooning: the North Atlantic Light, 1960–83 (exhibition catalog, Stedelijk Museum). Amsterdam, 1983; includes foreword by Edy de Wilde and essays by de Wilde and Carter Ratcliff.

Yard, Sally E. "Willem de Kooning: The First Twenty-six Years in New York, 1927–1952." Ph.D. diss., Princeton University, 1980.

FILMS AND TELEVISION TAPES

Falkenberg, Paul, and Namuth, Hans (producers). *Willem de Kooning: The Painter.* c. 1961.

Falkenberg, Paul; Lanier, Richard; and Namuth, Hans (producers). *De Kooning at the Modern.* 1969.

Gill, Michael (producer). *De Kooning.* Ten Modern Artists series, no. 10, 1964.

Slate, Lane (producer). *Willem de Kooning.* U.S.A. Arts series, no. 10, 1964.

BY WILLEM DE KOONING

"Content Is a Glimpse . . . " *Location* 1, no. 1 (Spring 1963): 45–53.

De Kooning Drawings. Facsimile reproductions and statement by the artist. New York, 1967.

"The Renaissance and Order." *Trans/formation* 1, no. 2 (1951); reprinted in exhibition catalog, Smith College Museum of Art, Northampton, Massachusetts, 1965.

"What Abstract Art Means to Me." *Bulletin of the Museum of Modern Art* 18, no. 3 (Spring 1951): 4–8; reprinted in exhibition catalog, Museum of Modern Art, 1969.

INTERVIEWS

Mooradian, Karlen. Interview with de Kooning on Gorky. *Ararat* 12, no. 4 (Fall 1971): 48–52

Rosenberg, Harold. "Interview with Willem de Kooning." *Art News* 71, no. 5 (September 1972): 54–59.

Sandler, Irving. "Willem de Kooning: Gespred de Kooning's atelier, 16 juni 1959." *Museumjournaal* 13, no. 6 (1968): 285–290; English summary, p. 336.

Staats, Margaret, and Matthiessen, Lucas. "The Genetics of Art." *Quest/77* 1, no. 1 (March/April 1977): 70–71.

Sylvester, David. "Painting as Self Discovery." BBC broadcast (December 3, 1960); transcript published in Sylvester, "De Kooning's Women," *Sunday Times Magazine*, London (December 8, 1968): 44–57.

Valliere, James T. "De Kooning on Pollock." *Partisan Review* 34, no. 4 (Fall 1967): 603–605.

INDEX